THE CAMERA VIEWED

Volume I: Photography Before World War II

THE CAMERA VIEWED

WRITINGS ON TWENTIETH-CENTURY PHOTOGRAPHY

Edited by PENINAH R. PETRUCK

A Dutton Paperback E. P. DUTTON · NEW YORK

For information contact:
E.P. Dutton, 2 Park Avenue, New York, N.Y. 10016

Library of Congress Catalog Card Number: 78-55776

ISBN: 0-525-47535-4

Published simultaneously in Canada by Clarke, Irwin & Company Limited
Toronto and Vancouver

10 9 8 7 6 5 4 3 2 1

First Edition

Grateful acknowledgment is made to the following for permission to quote from copyright material.

Jonathan Green: Introduction to *Camera Work: A Critical Anthology.* Reprinted from *Camera Work: A Critical Anthology,* by permission of Aperture, Inc. Copyright © 1973 by Aperture, Inc.

Alfred Stieglitz: "Looking for Mr. Stieglitz" and "Random Thoughts." Reprinted from *Twice a Year,* 5–6 (1940–1941), and 10–11 (1943), by permission of Dorothy Norman.

Georgia O'Keeffe: "Stieglitz: His Pictures Collected Him." Reprinted from *The New York Times Magazine,* December 11, 1949, by permission. Copyright 1949 by The New York Times Company.

Carl Sandburg: "Steichen the Photographer," an excerpt from *Steichen the Photographer* by Carl Sandburg, copyright, 1929 by Harcourt Brace Jovanovich, Inc.; copyright © 1957, by Carl Sandburg. Reprinted by permission of the publishers.

Marius De Zayas: "Photography" and "Photography and Artistic Photography." Reprinted from *Camera Work,* nos. 41 and 42/43 (1913), by permission of Rodrigo De Zayas.

Paul Strand: "Painting and Photography." Reprinted from *The Observer Weekend Review,* February 24, 1963, by permission of *The Observer.*

Calvin Tomkins: "Paul Strand: Look to the Things Around You." Copyright © 1974 by Calvin Tomkins. Originally in *The New Yorker,* September 16, 1974.

Edward Weston: "Photographic Art," an excerpt. Reprinted from "Photographic Art" in *Encyclopaedia Britannica,* 14th edition, by permission. Copyright 1942 by Encyclopaedia Britannica, Inc.

Andy Grundberg: "Edward Weston Rethought." Reprinted from *Art in America* (July/August 1975). Copyright © 1975 by *Art in America.*

Charles Millard: "The Photography of Charles Sheeler." Reprinted from the catalogue of the Charles Sheeler exhibition at the National Collection of Fine Arts in 1968, by permission of the author. Copyright © 1968 by Charles Millard.

Leslie Katz: "Interview with Walker Evans." Reprinted from *Art in America* (March/April 1971). Copyright © 1971 by *Art in America.*

This anthology was compiled in response to the growing enthusiasm for photography. Its aim is to stimulate serious looking at and thinking about twentieth-century photography.

This anthology brings together previously published primary and secondary sources from various publications. The idea for this kind of compilation is based on the landmark references: Beaumont Newhall's *On Photography: A Source Book of Photo History in Facsimile* (1956) and Nathan Lyons's *Photographers on Photography* (1966). I have tried to add to these books, to make available material more recently published by a wider range of authors and of an analytic and theoretical nature.

Divided into two volumes, the anthology is organized to follow a loose chronological reading of twentieth-century photography. The first volume focuses on photography before World War II, the second on more current developments. Each selection is introduced with a brief explanation of its significance and identification of its author. Both volumes contain photographs that highlight the author's viewpoint.

Criteria for selection of essays and photographs are admittedly arbitrary. Any such undertaking inevitably has glaring omissions and selections comparatively easy of access. I ask my readers' understanding in advance. Foremost in my consideration were quality of thought and expression, historical significance, and value as representative of different attitudes toward and developments of twentieth-century photography. Also I favored interpretative and theoretical rather than technical, biographical, and appreciative commentaries.

A review of the writing on photography suggests that its preoccupations do not mirror photography's history. My hope is that this anthology will help generate fresh and solid scholarship. The unevenness of attention to the various aspects of photography is surprising. For example, photography's relation to the other arts, fashion and commercial uses of

photography, and its role as a conveyer of psychological, sociological, and political information are areas that require further study in depth. Moreover the works of Steichen, Stieglitz, Strand, Weston, Atget, to name just a few, have not received treatment comparable to equally noted figures in the other arts.

Still, the writing on twentieth-century photography is as diverse as the medium itself. Photographers as well as writers known for their ideas on painting, sculpture, film, aesthetics, and culture at large contribute to that diversity. And in writing about photography, they pursue different, often conflicting, themes and approaches. The range covers specific and comparative studies on photographers and types of photography, essays on theory and technique, and personal statements.

The concerns of twentieth-century photography grew up with its invention. The earliest writings on the "camera machine" are the seeds of the discussions in this anthology. Current questions focus on photography as a fine art, the distinction between fine and vernacular photography, the kind of printing process that effects a meaningful final image, the unique or varied potential of photography as a mimetic or symbolic expression, its relation to other media, and an appropriate vocabulary for its analysis and evaluation.

That there are no definitive answers, no one way to interpret what a photographer does and why, is a measure of photography's vitality.

My thanks go to the photographers and writers who permitted me to include their work in this anthology. Others whose cooperation was invaluable were the staffs of The Museum of Modern Art's Library and Photography Department, the Art Reference Library of The New York Public Library, and Light Gallery. I should especially like to acknowledge Michael Boodro, who helped to edit the manuscripts; Neal Slavin, who created the photograph for the cover; and Julie Van Haaften, who offered bibliographic and countless other suggestions.

Jonathan Green

The choice of an essay on Alfred Stieglitz and Camera Work *for the begin-
ning of this anthology reflects the man's and the magazine's seminal place in
the history of modern photography.* Stieglitz published Camera Work *from
1903 to 1917 as part of his pioneering effort to establish the integrity of mod-
ern art and photography as fine arts in America. In this introduction to*
Camera Work: A Critical Anthology *Jonathan Green summarizes their in-
terrelated histories. His analysis is unlike most of the literature on Stieglitz:
Green is informative and appreciative but not overwhelmed with praise.*

*Jonathan Green, formerly an associate professor of photography at
M.I.T. in Cambridge, currently teaches at Ohio State University in Co-
lumbus. A photographer and photomuralist, Green free-lances in advertising
and architectural photography. He is author and editor of* The Snapshot
(1974).

ALFRED STIEGLITZ AND PICTORIAL PHOTOGRAPHY

When Alfred Stieglitz published the first issue of *Camera Work* in Jan-
uary 1903, he was taking only the latest in a series of major steps in his
fight to establish photography as a legitimate and recognized medium of
artistic expression.

Stieglitz had become fascinated with the camera during the 1880s,
while he was an American engineering student in Berlin. Already imbued
with the vitality of European music, theatre, art, and craftsmanship, he
began to pursue photography with a vigorous concern for its expressive
potential. Studies under H. W. Vogel, the inventor of orthochromatic
plates, gave him the basis for a thorough knowledge of optics and photo-
chemistry; and he soon abandoned engineering entirely to spend his last
student years traveling and photographing in Germany and Italy. Con-
stantly experimenting with the new medium, he felt very much a part of
the growing expressionistic movements in art which were to blossom into
the German Secession. He began at this time to enter his work in compe-

* Reprinted from *Camera Work: A Critical Anthology* (Millerton, N.Y.: Aperture,
Inc., 1973).

titions and to write occasionally for photographic journals. In 1887 he was awarded his first silver medal by the English photographer Peter H. Emerson, the most articulate spokesman of the day for photography as a fine art and future author of the seminal *Naturalistic Photography*.

Photography had been practiced as an expressive medium since the 1840s, but it had not been accepted as an equal to painting or the other visual arts. It was considered by the institutionalized art world as a curiosity, a painter's aid, a craft, or at best, a mechanical art. As late as 1890 photography had never been shown on a level with painting at the salons, nor had it been acquired for museum collections. During the 1880s, in England and on the Continent, the introduction of ready-sensitized platinum printing paper, together with continuing technical advances in equipment and film materials, encouraged serious amateurs to reexplore the aesthetic possibilities of the camera. They banded together in clubs and societies and demanded that photography be accepted as an art. Their active campaigning resulted in the first international photography salon in Vienna in 1891 and exhibitions in London and Hamburg in 1893.

Caught up in the beginnings of this aesthetic movement in European photography, Stieglitz soon came to regard photography with a seriousness and dedication unknown in America. On his return to New York in 1890, he found amateur photography thriving. Nearly a dozen photographic journals were being distributed nationally, and almost every town had its camera club or society. Yet, nowhere did Stieglitz find the passionate concern with photographic expression he had known in Europe. The editor of the *American Amateur Photographer* wrote in 1890 that photography "is largely a matter of an hour now and then, a brief vacation, snatched from the cares of a busy life."[1]

With characteristic intensity, Stieglitz determined to put aside his initial feelings of dismay at American provincialism to demonstrate, at least through his own work and writings, his belief in the medium. He became an active participant in the New York Society of Amateur Photographers and he soon gained international attention through his articles and photographs shown at the salons in Vienna, Hamburg, and London. During the early 1890s Stieglitz produced a series of remarkable images of

[1] "English vs. American Amateurs," *American Amateur Photographer,* 2, no. 8 (August 1890), p. 309.

everyday New York metropolitan scenes. Such photographs as "The Terminal" and "Winter, Fifth Avenue," were not only technical revelations—the first successful images made during driving snowstorms—they were also aesthetically revolutionary; for they were unretouched, hand-held "detective camera" snapshots of real, precisely observed moments.

Most of Stieglitz's fellow photographers identified aesthetic expression with a painterly effect. Indeed, at the turn of the century, they had few other examples. Since 1850, photographic production had been divided into two distinct categories: the scientific and the artistic. Artistic photography was considered to be an extension of the painted image, demonstrating its legitimacy by a formal and conceptual congruence with painting. Thus, the aspiring artistic photographer imitated not only the style but also the subject matter of high art. Since photography was generally practiced as a popular art form, it reflected public expectations of art and popular taste. In the popular mind art was defined by the current academic standards. The majority of photographers, even those who were painters, followed these standards. Their aesthetic taste and comprehension were frequently decades behind the avant-garde of their day.

For example, Oscar Gustav Rejlander's ambitious allegorical photograph, "The Two Ways of Life," which created a sensation at the Manchester Art Treasures Exhibition of 1857, was based on the neoclassical allegorical style of the 1780s. The chief contemporary exponent of this style was the French academic painter, Thomas Couture. In England, Lake Price's illustrations of Cervantes and his genre photographs, as well as H. P. Robinson's sentimental anecdotes and pastorals, were similar to hundreds of paintings that lined the academy walls.

Under the delayed influence of Constable, Corot, and the Barbizon School of painting, allegorical and picturesque concerns began to give way in the 1880s to a more naturalistic style. Peter H. Emerson championed this new direction by word and example. His finest photographs sensitively record the quiet mood and atmosphere of peasant life and watery landscape along the Norfolk Broads in East Anglia. While his work was free of the sentimentality and artificiality of the earlier pictorialists, his theory of focusing introduced a new rigor to photography. Emerson believed that the principal subject should be separated from the secondary elements by differential focusing. The slightly diffused quality which resulted was pushed to an extreme in the 1890s by some of Emerson's fol-

lowers who, under the influence of Impressionism, used out-of-focus, uncorrected, or pinhole lenses to destroy detail and outline. The introduction of the gum process gave these photographers a printing technique by which they could further suppress detail, accentuate the tonal massing of light and shade, and even simulate the surface texture of brush, charcoal, or pastel.

When Stieglitz returned to New York, there were three major forces in artistic photography: the allegorical and genre tradition inherited from the earliest days of the camera; the slightly soft-focused naturalism advocated by Emerson; and photographic impressionism. These were not mutually exclusive; many photographers not only worked in more than one area, but developed hybrid personal styles. Since these directions were deeply tied to the aesthetics of painting, they became known collectively as "pictorial photography."

In 1893 Stieglitz became an editor of the *American Amateur Photographer,* where for three years he pursued his campaign to encourage American photographers to do expressive work and to promote the establishment of a dignified, European type of photographic salon. Though Stieglitz's own approach to photography was closest to Emerson's naturalism, as editor he favored no single style. Rather, he published the freshest and most dynamic work he could find in all three of the major styles. He constantly demanded excellence and exploration, harshly criticizing mediocrity and the cliché. Stieglitz resigned the editorship in 1896 because of business obligations, ill health, and his realization of the limited possibility of developing a new photographic spirit through an established magazine whose ownership and subscribers were more concerned with technique than with expression

Camera Notes and the Establishment of the Photo-Secession

In 1897 the Society of Amateur Photographers merged with The New York Camera Club. Stieglitz, sensing a chance to inaugurate a publication which would deal seriously with the issues of expression and give vigorous direction to the aesthetic movement in photography, became chairman of the club's publication committee.

He then presented the club with a plan to establish an illustrated quarterly to replace their leaflet *Journal.* Hoping to set the publication above the petty disputes and provincial concerns of the organization, he asked

for and obtained "unhampered and absolute control of all matters, direct and remote, relating to the conduct" of his quarterly.[2] Ostensibly the new publication, *Camera Notes,* was "the official organ of The Camera Club"; nevertheless, Stieglitz used it as a vehicle to "reach a class outside of the membership, and to stimulate them to artistic effort . . . to take cognizance also of what is going on in the photographic world at large . . . in short to keep . . . in touch with everything connected with the progress and elevation of photography."[3]

It was in *Camera Notes* that the basic format and attitudes which would later mature into *Camera Work* were evolved and tested. While the letterpress of the first issue of *Camera Notes* had much the same tenor as the *American Amateur Photographer,* the quality and choice of the illustrations immediately distinguished it. Each issue contained two hand-pulled photogravures chosen by Stieglitz to illustrate "the development of an organic idea, the evolution of an inward principle; a picture rather than a photograph."[4] The plates were the foremost examples of pictorial expression selected from both European and American photographers. "Landscapes breathing atmosphere and light, mysterious allegorical figure studies . . . picturesque genre studies, and true portraits, which put life and character into the subject, were presented to the readers."[5]

Stieglitz demanded that the plates serve as more than a record of what was being produced in the photographic world; they had to interpret fully the spirit and quality of the original print. As a method of reproduction, the photogravure process was uniquely suited to reproduce the subtle platinum prints of the day. Considered by many a direct photographic printing technique, photogravure was able to capture in printer's ink a subtle tonal gradation and a delicate luminosity that is unknown in any contemporary mechanical reproduction process. Many of the gravures in *Camera Notes* and later in *Camera Work* were made directly from the original negatives. Frequently supervised, sometimes actually etched and printed by the photographers themselves, these reproductions are vital equivalents of the original prints.

[2] "Valedictory," *Camera Notes,* 6, no. 1 (July 1902), p. 4.
[3] *Camera Notes,* 1, no. 1 (July 1897), p. 3.
[4] *Ibid.*
[5] Robert Doty, *Photo Secession, Photography as a Fine Art* (Rochester: George Eastman House, 1960), p. 19.

Because he wanted to expand the critical basis of the magazine, Stieglitz began to look outside of the club for sources of articles and illustrations. He soon gathered a dedicated group of editors and contributors—drawn both from photography and from the worlds of art and literature—who shared his strong belief in the power and legitimacy of the medium. Included were the noted art critics Charles Caffin and Sadakichi Hartmann, who had published in such widely read periodicals as *Forum, Century, Harpers Weekly,* and the *International Studio;* the humorist and literary critic J. B. Kerfoot; and the lawyer and photographer Joseph Keiley. The excellence of *Camera Notes* acted as a magnet on many serious photographers throughout the country, bringing Stieglitz in touch with Clarence White, then a grocery clerk in Newark, Ohio, and Edward Steichen, a young lithographer from Milwaukee. Many prominent Eastern pictorialists such as Gertrude Käsebier and Eva Watson-Schütze also became part of the *Camera Notes* group. By 1902 Stieglitz had published all the major photographers and critics whom he would later bring together to form the Photo-Secession.

Since 1890, Stieglitz had actively campaigned for an American photographic exhibition in which the superficialities of classes and medals would be eliminated, in which only the finest works would be shown. This campaign was partially realized in 1898 and 1899 when the Pennsylvania Academy of Fine Arts hosted exhibition salons sponsored by the Photographic Society of Philadelphia. But the egalitarian spirit of the camera clubs would not permit the forming of a photographic elite. The Philadelphia salons soon succumbed to popular pressure to liberalize the aesthetic standards and to make the salons more representative of the total membership of the sponsoring clubs. *Camera Notes* had been under increasing attack from members of The Camera Club who complained about Stieglitz's "tyranny" and the publication's "artiness." These discontented members felt that *Camera Notes,* rather than emphasizing the range of pictorial photography and the aesthetics of the medium, should be devoted exclusively to their own work.

As a result of these pressures, Stieglitz readily accepted, late in 1901, an unsolicited request from the National Arts Club of New York to organize an exhibit of pictorial photographs. He now had the opportunity to take photography out of the hands of the clubs and present it to the public as an independent art. Stieglitz turned to the photographers whom he had

encouraged and published, assembling their finest prints for exhibition at the National Arts Club in March 1902 under the title, "The Photo-Secession." By choosing this name, Stieglitz signaled his spiritual alliance with European groups in photography and art which had recently revolted from the established viewpoint: the photographers of the Linked Ring Brotherhood in England, who in 1892 had broken away from the Royal Photographic Society; and the painters of the Munich, Berlin, and Vienna Sezession who had reacted against official German and Austrian salon art. In less than a year the Photo-Secession developed into an affiliation with elected members, a Council, and Stieglitz as Director.

Shortly after the Arts Club exhibition Stieglitz resigned from *Camera Notes* and made plans for a new publication which would "owe allegiance to no oganization or clique," but, paradoxically, would be the "mouthpiece of the Photo-Secession."[6] To ensure its independence, Stieglitz took upon himself the total responsibility for its editing and publishing. He soon had received 647 subscriptions—sight unseen—for the new periodical. Consequently, in January 1903 there appeared the first issue of *Camera Work,* the "illustrated quarterly magazine devoted to Photography."[7]

CAMERA WORK

Freed from allegiance to formal clubs and established publications, Stieglitz was now able to produce a publication radically different from anything that had gone before—a magazine as integrated and diverse as his own maturing sensibility. *Camera Work,* wrote Paul Rosenfeld, "is a constantly progressive, steadily cumulative work of art."[8]

In order to follow this growth, we may conveniently divide the fifty issues of *Camera Work* into four major periods. While these periods are not sharply delineated, the essential tendencies of each may be emphasized by referring to them as *consolidation,* 1903–1907, the time of transition from *Camera Notes; expansion,* 1907–1910, the development of The Little Galleries of the Photo-Secession, *Camera Work*'s initial contact

[6] Alfred Stieglitz, "An Apology," *Camera Work,* no. 1 (January 1903), p. 16.
[7] Title page, *Camera Work,* no. 1 (January 1903), p. 1.
[8] Paul Rosenfeld, "The Boy in the Dark Room," *America and Alfred Stieglitz,* Waldo Frank, Lewis Mumford, Dorothy Norman, Paul Rosenfeld, Harold Rugg, eds. (New York: Doubleday, Doran & Company, 1934), p. 83.

with modern art, and the last major exhibitions of the Photo-Secession; *exploration,* 1910–1915, when *Camera Work* and The Little Galleries were vitally concerned with the radical new art movements of Fauvism, Cubism, and Futurism; and the final period, 1915–1917, when *Camera Work* offered an effective *summation* of the interests and activities of the preceding twelve years by publishing photographic tributes to Stieglitz and Paul Strand.

The First Period: Consolidation, 1903–1907. In its earliest years *Camera Work* represented a deepening and broadening of the concerns inherited from *Camera Notes.* Charles Caffin, Sadakichi Hartmann, Joseph Keiley, Dallett Fuguet, and J. B. Kerfoot—who had come with Stieglitz to *Camera Work*—took advantage of the scope and freedom of the new publication. They began to publish more extensive analyses of photographers and their work, and more sensitive explorations of photography's relationship to the other arts. These articles, as well as essays on photography by George Bernard Shaw (a keen amateur photographer and supporter of photography as an art) and by Maurice Maeterlinck (introduced to photography by Steichen, then an art student in Paris), more than fulfilled Stieglitz's pledge in the first issue that *Camera Work*'s literary contributions would be the best of their kind.

Sadakichi Hartmann's record of his visit to Steichen's studio—published in issue 2 under the pen name Sidney Allan—exemplifies the early emotional and critical concerns. One's first impression of this article is of its style rather than its content. Like the photographs reproduced at first, Hartmann's prose projects a distinctly *fin-de-siècle* atmosphere. There is a romantic brooding, a sensitivity beyond passion, the transcendental melancholy of Maeterlinck's German forests. Like the European Symbolist and Decadent writers and artists of the time, Hartmann was profoundly nostalgic for a lost elegance. Underlying his writing was a weary yet continual search for essential emotional expression, for the beautiful and the visionary. This sensibility was echoed in Stieglitz's home, which in 1903 contained reproductions of the paintings of Franz von Stuck, founder of the Munich Secession, and Arnold Böcklin, the Swiss painter. For these painters, as for a great many of the photographic pictorialists, aesthetic profundity was associated with darkness and sensual melancholy. Stuck's main themes were sin and death, portrayed through erotic personifica-

tions of evil and sphinxlike nudes. Böcklin found meaning and drama in grotesque figures drawn from classical myth and in images of the foreboding quiet of melancholy ruins. This mood reappears during the first two periods of *Camera Work,* both in the plates and in the text, and especially in Joseph Keiley's Visions and Dallett Fuguet's poems and articles.

Although it would be superseded in later issues by the bright, hard, direct concerns of modernism, this kind of romantic sensibility was significant in elevating the photograph from a mechanically produced object to a work of art. The very style of Hartmann's prose certified the worth of the object, providing the dignified response formerly reserved for the other arts. Moreover, the *fin-de-siècle* concern with "beauty" forced the critic to perceive the photograph with a fresh eye, permitting a response from the expression rather than the technique. "In art the method of expression matters naught," Hartmann wrote, after comparing Steichen's paintings to his photographs. "I believe that every effort, no matter in what medium, may become a work of art provided it manifests with utmost sincerity and intensity the emotions of a man face to face with nature and life." And again, "Biographical data do not interest me. What is the difference where a man is born, how old he is, where he studied, and where he was medaled? His art must speak—that is all I care for."[9] Steichen's photographs did, indeed, speak to Hartmann; and he followed his prose article with two poems inspired by Steichen's prints.

While Hartmann's article and poems reveal the intensely serious concerns of the early *Camera Work,* another aspect is evident in the humorous pieces that dot the early text. These function as comic relief, allowing the camera workers to pause and look at themselves with detachment and objectivity. The comic perspective, in fact, helped forge the unity and spirit of the Secessionists. Centered around the prominent members of the Secession, and frequently focused on Stieglitz, the humor, born of conviviality and mutual respect, reinforced the exclusiveness of the group. In J. B. Kerfoot's good-humored "Black Art," Stieglitz, Steichen, Coburn, and Käsebier are elevated to the photographic round table with Stieglitz as Alfred the Great. Stieglitz's expulsion from The Camera Club in 1908 provided the background for Charles Caffin's fable, "Rumpus in

[9] Sidney Allan [Sadakichi Hartmann], "A Visit to Steichen's Studio," *Camera Work,* no. 2 (April 1903), pp. 27, 25.

a Hen House," in which the comic effectively differentiates the Seces-
sionists from the philistines. It allows Caffin an opportunity to question
established values and summarily dispose of them.

The comic imagination is an integral facet of the critical, skeptical in-
telligence that animates *Camera Work.* Expressed in the early issues
through fable, aphorism, and jest, it will mature in the later numbers into
sophisticated irony and caricature. It will be transformed in the writing of
Benjamin De Casseres and the caricatures of Marius De Zayas into a
scathing Dadaistic attack on American civilization.

The Printing and Format. Stieglitz's demand for excellence, apparent in
the text, becomes manifest in the plates. Throughout the fifteen years of
publication, all but one of the regular issues—which were consistently
printed in editions of one thousand copies—contained a hand-tipped
gravure portfolio by a single camera worker or artist, as well as several
additional plates. In the early issues the photogravures were printed on
Japan tissue and placed on colored mounts. Steichen went to the extent,
in issue 19, of hand-toning copies of his photogravure, "Pastoral-Moon-
light." Stieglitz, who had been briefly involved in the photoengraving
business, always took great pains to equate the reproduction with the
qualities of the original. As a result, *Camera Work* is a small encyclope-
dia of the mechanical printing processes available during the first seven-
teen years of this century. Along with straight photogravure there are
mezzotint photogravures, duogravures, one-color halftones, duplex half-
tones, four-color halftones, and collotypes. It has been frequently re-
marked that the reproductions in *Camera Work* are often finer than the
original prints.

While the photogravures were made from grained, intaglio plates,
inked and printed by hand, the mezzotint photogravures and duogra-
vures were screened intaglio plates printed by machine. These processes
offered a full-bodied impression and were eminently suitable for the re-
production of the heavy, dense gum prints, particularly if the originals
were produced on highly textured papers. The double printing of the
duogravure, as with the duplex halftone, offered the possibility of intro-
ducing an overlay tint that could approximate the color of the original.
Camera Work's reproduction of Steichen's Lumière Autochromes was
one of the first published examples of the four-color, halftone process ap-

plied to color transparencies. Because of their random color structure, the Lumière plates were not considered reproducible; yet, the famous Bruckmann printing firm of Munich made such miraculous halftones from them that they retain unequaled color saturation and intensity. The Bruckmann Verlag did a great deal of the engraving for *Camera Work*. It was their modified version of the almost grainless collotype process that was responsible for the reproductions of Rodin's wash drawings. These plates were made with such sensitivity to line, tint, and density of shading that it is impossible to tell them from the originals without the closest inspection.

The format of *Camera Work* displayed the same concern for quality. The cover, marque, and typography were designed by Steichen in a refined, rectilinear version of the Art Nouveau style. Paul Rosenfeld has written that *Camera Work* "is itself a work of art: the lover's touch having been lavished on every aspect of its form and content. Spacing, printing, and quality of the paper, the format of the pages, the format of the advertisements, even, are simple and magnificent."[10]

The Second Period: Expansion, 1907–1910. After the plates, it is the articles about its own history that best capture the spirit of *Camera Work* and the Photo-Secession. During the first two periods, 1903–1910, the Photo-Secession's chief activity centered around exhibitions of photographs. Under Stieglitz's direction collections of selected American prints were shown here and abroad with the avowed and slowly realized intention of raising the standards of pictorial photography and gaining respect for the medium. The three principal exhibitions of this time occurred at the Carnegie Institute, Pittsburgh, in 1904; the Pennsylvania Academy of Fine Arts in 1906; and the Albright Gallery, Buffalo, in 1910. *Camera Work* as spokesman for the Photo-Secession diligently reviewed these exhibitions. The factual richness of its extended commentaries on these shows and on other Photo-Secession activities has provided the main source for all subsequent inquiries into the period.

In 1905, to further the exhibition work and to give the Secession a headquarters, Stieglitz, encouraged by Steichen, leased three rooms at 291 Fifth Avenue. With Steichen as decorator and designer, the space

[10] Rosenfeld, "The Boy in the Dark Room," p. 82.

became The Little Galleries of the Photo-Secession. The first exhibitions held there were of European as well as American photography and attracted widespread attention from photographers and the press.

But however successful *Camera Work* and the Photo-Secession exhibitions, Stieglitz and Steichen realized that the position of photography could be most firmly established by direct comparison with other visual media. In January 1907, therefore, Pamela Colman Smith exhibited the first nonphotographic work at The Little Galleries—a group of wash drawings. Stieglitz's brief comment on this exhibition, published in issue 18, inaugurated *Camera Work*'s formal entry into the world of modern art. "The Secession Idea is neither the servant nor the product of a medium," Stieglitz wrote. "It is a spirit."[11]

This comment marks the beginning of the second period of *Camera Work,* that of its *expansion.* During the next two years The Little Galleries at 291 Fifth Avenue were transformed into "291": "Mr. Stieglitz's Gallery for the newest in art."[12] Before returning to Paris in 1906, Steichen, who was already close to the sculptor Rodin, promised to send some of the master's drawings back to Stieglitz. Consequently, in January 1908, The Little Galleries exhibited wash drawings by Rodin. This show was followed in April by a group of drawings, lithographs, watercolors, and etchings by Henri Matisse. Fascinated by the bold new art of Paris, Steichen began to seek out additional work. A year later he obtained oil sketches by Alfred Maurer, watercolors by John Marin, and lithographs by Toulouse-Lautrec. Except for Rodin, these were the first exhibitions of these artists in the United States.

The New York press looked on the new art at "291" with suspicion and hostility, the art columns frequently dismissing modernism as immoral, unintelligible, and technically incompetent. Matisse's female figures "are of an ugliness that is most appalling and haunting, and that seem to condemn this man's brain to the limbo of artistic degeneration."[13] And Rodin's sketches were "not the sort of thing to offer to public view even in

[11] [Alfred Stieglitz], "The Editors' Page," *Camera Work,* no. 18 (April 1907), p. 37.
[12] Eduard Steichen, "291," *Camera Work,* no. 47 (dated July 1914, published January 1915), p. 66.
[13] J. E. Chamberlin, *Camera Work,* no. 22 (July 1908), p. 11. Reprinted review from the *New York Evening Mail.*

a gallery devoted to preciosity in artistic things."[14] Stieglitz remained sure of his direction. "The New York 'art world' was sorely in need of an irritant," he noted, "and Matisse certainly proved a timely one."[15] To indicate the extent of the irritation, he began to reprint the criticism that appeared in the daily press. Thus *Camera Work* preserves a great many of the textual documents that relate to the introduction of modern art into America.

The reprinted articles helped to encourage a spirit of debate which made *Camera Work* an open forum where painters, photographers, and critics could explore the issues surrounding the emerging aesthetic sensibility. Since its inception, *Camera Work* had contained essays based on broader critical grounds than those of the popular aesthetics of the day. Such articles as "Photography and Natural Selection," "The Unmechanicalness of Photography," and "Unphotographic Paint: The Texture of Impressionism" brought together a wide range of scientific, philosophical, and ideological concerns, and centered them on the theory and practice of painting and photography.

Other articles, such as Caffin's "Is Herzog Also Among the Prophets?" and Hartmann's "Puritanism: Its Grandeur and Shame," attempted to articulate an aesthetic uniquely suited to the American artist. Caffin analyzed Herzog's composite academic photographs in terms of their painterly tradition, the characteristics of American society, and the particularities of photography. He concluded that photography could be a powerful tool in the hands of the modern artist who wished to "body forth the forms and ideals and emotions of actual present life," for the photograph can both "capture" and "transmit" sight. Herzog looked to the past rather than to the future for he ignored the "complexity of sensations in himself and . . . in the world about him."[16]

Hartmann pushed the analysis of American society even further. Seeing Puritanism as a monster octopus which had entangled its tentacles in America's customs and manners, he concluded that "there can be no vital art of any sort until there has grown up an appreciation of the Rubens-

[14] W. B. McCormick, *Camera Work*, no. 22 (July 1908), p. 40. Reprinted review from the *Press.*

[15] [Alfred Stieglitz], "Henri Matisse at The Little Galleries," *Camera Work*, no. 22 (July 1908), p. 10.

[16] Charles H. Caffin, "Is Herzog Also Among the Prophets?," *Camera Work*, no. 17 (January 1907), pp. 21, 22.

Goya spirit; until we dare face our passions, until we are unashamed to be what we are, until we are frank enough to let wholesome egotism have its sway."[17]

The Third Period: Exploration, 1910–1915. In January 1910 *Camera Work* abandoned its policy of limiting reproductions to photography and, in issue 29, published four caricatures by the Mexican artist, Marius De Zayas. This change marks the beginning of the third period, characterized by a dynamic *exploration* of all that was new and vital in artistic expression. *Camera Work* expanded its inquiries into the aesthetics and spirit of photography and Post-Impressionism, becoming the voice and catalyst of the American avant-garde.

It was natural that *Camera Work*'s concern with the new art should significantly alter its treatment of all media. At the end of the second period articles dealing with photography had become increasingly sophisticated and abstract, and many subscribers, unable to comprehend *Camera Work*'s growth, withdrew their support.

Ironically, even the triumphant 1910 retrospective exhibition of the Photo-Secession at the Albright Gallery in Buffalo contributed to a radical change in the audience. "The aim of the exhibition," the catalogue stated unequivocally, "is to sum up the development and progress of photography as a means of pictorial expression."[18] Stieglitz, with Secessionists Paul Haviland, Clarence White, and the young painter Max Weber, made the Albright exhibition the most comprehensive ever held in the States. Five hundred and eighty-four prints were shown, representing four national groups and sixty-five photographers. These included photographs by all of the Secessionists, as well as work of historical interest made in 1843 by the Scotch painter David Octavius Hill. More than fifteen thousand people visited the galleries during the four weeks of the exhibition. At its conclusion the Albright Gallery purchased twelve prints and reserved one room for a permanent display of pictorial work. The scope and strength of the images and the prestige of the gallery finally brought the Secession the endorsement it had long sought from estab-

[17] S[adakichi] H[artmann], "Puritanism, Its Grandeur and Shame," *Camera Work,* no. 32 (October 1910), p. 19.
[18] "The Exhibition at the Albright Gallery—Some Facts, Figures, and Notes," *Camera Work,* no. 33 (January 1911), p. 61.

lished institutions. The exhibition was immediately acknowledged as a summation and demonstration of photography's place in the fine arts.

With this decisive recognition the Photo-Secession lost some of the sense of purpose that had held it together. Moreover, the exhibition contained new work that went beyond the pictorial techniques of soft focus and hand manipulation and demonstrated a more straightforward style. The introduction of other visual art at "291" had begun to shatter the old pictorial aesthetic. A year before the Buffalo exhibition, *Camera Work* had sensed this change.

> Photography in order to assert its esthetic possibilities strenuously strove to become "pictorial"; and this endeavor produced in recent years the singular coincidence that, while men of the lens busied themselves with endowing their new and most pliable medium with the beauties of former art expressions, those of the brush were seeking but for accuracy of the camera plus a technique that was novel and—unphotographic.[19]

Stieglitz was working more frequently with pure photography. After the Buffalo exhibition he could no longer support Secessionists who continued in the pictorial tradition. The organization soon disbanded. "The Photo-Secession," Paul Haviland wrote, "can be said now to stand for those artists who seceded from the photographic attitude toward representation of form."[20]

In 1911 a double issue of *Camera Work* (34/35) was devoted to reproductions of Rodin's drawings and analyses of his, Paul Cézanne's, and Pablo Picasso's work. Half the remaining subscribers, bewildered by Rodin's breezy wash sketches of the nude and annoyed that the issue lacked even a single article on photography, canceled their subscriptions. *Camera Work* now became the quarterly publication of "291," written by and addressed to an extremely small group consisting mainly of the artists whom Stieglitz supported, the writers who frequented the back room at "291," and the few remaining subscribers.

Beginning with its first entry into modern art with the Rodin exhibition in 1908, "291" had slowly developed into the center for avant-garde activity in New York. In addition to the revolutionary Fauves and Cubists,

[19] "Unphotographic Paint: The Texture of Impressionism," *Camera Work,* no. 28 (October 1909), p. 23.

[20] "Paintings by Young Americans," *Camera Work,* no. 30 (April 1910), p. 54.

Stieglitz showed the work of the young Americans Alfred Maurer, John Marin, Marsden Hartley, Arthur Dove, Max Weber, Abraham Walkowitz and, by 1916, Georgia O'Keeffe. It was not only artists in every visual medium who gravitated toward Stieglitz; many writers were attracted by his experimentation. Alfred Kreymborg, William Carlos Williams, Mina Loy, Paul Rosenfeld, Djuna Barnes, Waldo Frank, Sherwood Anderson, and Carl Sandburg became frequent callers at "291." Their intense discussions about the theories of the new art soon made their way into *Camera Work.*

This was the period of the publication's radical maturity. The letter press contained articles by Max Weber, Gertrude Stein, Benjamin De Casseres, Mabel Dodge, Gabrielle and Frances Picabia, Oscar Bluemner, Paul Haviland, John Weichsel, and Marius De Zayas, as well as by the mainstays of the magazine, Caffin, Hartmann, and Kerfoot. The subjects discussed ranged from photography to primitivism to the new theories of expression—Amorphism, Futurism, and Cubism. The explorative atmosphere of "291" became so intense that Maurice Aisen could announce in the special issue of 1913 that "the dominant note of the present epoch is revolutionary, not only in the plastic arts and in music, but in everything that exists."[21]

The plates of this period are reproductions—many for the first time in any publication—of drawings and etchings of Rodin, De Zayas, Matisse, Picasso, Craig, Manolo, and Walkowitz; watercolors of Marin; paintings of Steichen, Cézanne, Picabia, Van Gogh, and Picasso; and sculpture of Matisse, Picasso, Brancusi, and Nadelman. While these artists had little impact outside of *Camera Work* and "291," *Camera Work*'s constant search "for the deeper meaning of Photography" nourished the avant-garde attitude and initiated the formal modernist revolution in America that exploded in 1913 at the famous Armory Show. This International Exhibition of Modern Art at the Sixty-ninth Regiment Armory in New York introduced post-Impressionism to a shocked and outraged American public. Though he played but a minor role in the actual organization of the show, Stieglitz was aware of his responsibility for its revolutionary character. "The Big International Exhibition was held at the Armory," he wrote a friend,

[21] Maurice Aisen, "The Latest Evolution in Art and Picabia," *Camera Work,* special number (June 1913), p. 15.

and was really the outcome of the work going on at "291" for many years, was a sensational success, possibly primarily a success of sensation. One thing is sure, the people at large and for that matter also the artists, etc., have been made to realize the importance of the work that has been going on at "291" and in *Camera Work.* This much the Exhibition accomplished for us.[22]

The Fourth Period: Summation, 1915–1917. The disruptive forces of the war, the rising expense of publication and the lack of support—the last issue had a total of thirty-seven subscribers—forced *Camera Work* to suspend publication in June 1917. Though there is a sense of finality in the last three numbers, Stieglitz had no notion that the periodical would end with issue 49/50. Indeed, this issue describes future articles and reproductions.

Three years earlier Stieglitz had asked "twenty or thirty people, men and women, of different ages, of different temperaments, of different walks of life . . . to put down in as few words as possible" what "291" meant to them.[23] In issue 47 he published these statements along with over twenty others he had received in order to summarize the inquiring spirit that *Camera Work* and "291" had nurtured. It was a demonstration of the freedom and openness of *Camera Work,* for it contained not only many positive replies but also statements by Steichen and others that were sharply critical of Stieglitz and "291." Steichen believed that the aims of "291" had already been accomplished in terms of photography and art. While he acknowledged Stieglitz's importance in his personal development, he saw the gallery as merely marking time, with issue 47 as Stieglitz's egoistic "project in self-adulation." Deeply affected by the German invasion of Belgium and France, Steichen urged "291" to broaden its work into something that could become a civilizing "vast force instead of a local one."[24]

Issue 47, *Camera Work*'s last regular number, was published in January 1915. Issue 48 was not to appear until twenty-one months later.

[22] Alfred Stieglitz, unpublished letter, April 30, 1914, Stieglitz Archive, Collection of American Literature, Yale University Library, New Haven, Conn.; quoted from Doty, p. 63.
[23] Alfred Stieglitz, *Camera Work,* no. 47 (dated July 1914, published January 1915), p. 4.
[24] Eduard Steichen, "291," *Camera Work,* no. 47, p. 66. See Also Edward Steichen, *A Life in Photography,* "World War I and Voulangis" (Garden City, N.Y.: Doubleday & Co., 1961).

During the interim, the spirit of *Camera Work* generated several important "little" magazines.

291, edited by Marius De Zayas, Paul Haviland, and Agnes Ernst Meyer under Stieglitz's sponsorship, appeared in March 1915. Its twelve issues (1915–1916) had a decidedly proto-Dada nature, containing typographical experiments such as one of Apollinaire's *ideogrammes,* and thought flashes constructed of interconnected words, drawings, and advertising slogans. The text and illustrations were done by many of the same writers and artists who contributed to *Camera Work.* Even Steichen, who never resolved his differences on the issue of the war with Stieglitz, contributed two drawings to *291.* Of particular interest are several Freudian dream narratives by Stieglitz and a series of erotic, meticulously executed drawings of machine parts by Picabia.

Another magazine, *The Seven Arts,* appeared in November 1916. It, too, was short-lived (1916–1917), but it gave the young photographer Paul Strand an outlet for his far-reaching statement on photography which was reprinted in the last issue of *Camera Work.* These magazines also prepared the way for five other brief but important expressions of the closely integrated New York avant-garde group: *391* (1917–1924), edited by Picabia; *The Blind Man* (1917); *Rongwrong* (1917); and *New York Dada* (1921)—all edited by Marcel Duchamp; and *Manuscripts* (1922–1923), edited by Paul Rosenfeld.

Having summarized the effect of Stieglitz and the spirit of "291," *Camera Work* seemed to have ceased publication. Yet, Stieglitz revived the magazine for two last issues in order to preserve the photographs of Paul Strand and to summarize *Camera Work*'s concern with photography. In 1913, during the Armory Show, Stieglitz had presented a major selection of his own photographs at "291." Repeating this procedure of contrasting photography with other art, "291" showed the photographs of Paul Strand during the Forum Exhibition of American Art of 1916. No photographs had been shown at "291" in the interim, and for many people Strand's work was a revelation. In his statement on photography, Strand clearly presented the photographic aesthetic for which Stieglitz and *Camera Work* had been groping. This aesthetic relied on the actual characteristics of the photographic process and neatly synthesized the expressive concerns of the pictorialists with the abstract and formal concerns of modern art. The photographs published in the last issues demonstrate Strand's ability to find form and evoke feeling through images of such or

dinary objects as kitchen bowls and porch railings. In these photographs, particularly, as the art historian Samuel Green has remarked, in "The White Fence," we find the *"locus classicus* for the subsequent development of the main tradition of American photography."[25]

CAMERA WORK AND PHOTOGRAPHIC AESTHETICS

Camera Work appeared at exactly that moment in the history of Western art when the conventions of representation were undergoing radical transformations. The pictorial structure and elevated subject matter which had dominated Western art since the early Renaissance were giving way to new forms and concepts. During the nineteenth century, the avant-garde artist, nourished by romantic ideals of sensibility, vigorously began to explore his subjective response to the visible world. The invention of photography contributed to this search. It made the minutiae of the physical world poignantly available and provided new equivalents of direct experience. Moreover, the photographic method of reproduction, by summing up in an absolute way the facsimile tradition of representation, emphasized the need for new creative elements. It encouraged experimentation which stressed visual sensation as opposed to optical perception. Photography's detailed scrutiny thus contributed to the literal topographic studies of the early pre-Raphaelites and, more significantly, to the analysis of color and atmosphere that was the innovating contribution of the Impressionists.

When *Camera Work* appeared, advanced painting had effected a major shift in sensibility. The real no longer resided in the external world of nature, institutions, and religion; it was now centered squarely in each individual's unique capacities for experience and perception. Painting was no longer seen as a window opening onto the objective, visible world, but as a record of the infinite variations of subjective experience. In applying this new aesthetic to photography, *Camera Work* was able to synthesize the two paramount photographic traditions of the day—the straight and the pictorial. During its fifteen years of publication, it evolved and articulated the transition from brooding pictorialism to hard-edged modernism: an aesthetic that continues to be the principal approach of creative photographers.

At the turn of the century the aspiring artistic photographer knew

[25] Samuel Green, *American Art, a Historical Survey* (New York: The Ronald Press, 1966), p. 622.

nothing of post-Impressionism or the contributions of Cézanne, Van Gogh, or Gauguin. While these photographers may have been aware of the *fin-de-siècle* paintings of the Decadents and Symbolists, this art only reinforced the dominant painterly aesthetic that demanded diffusion or modulation of observed natural forms. Indeed, in the popular mind, emotion and feeling in art were equated with mood and atmosphere. By the end of the century the search for new content led by the early romantics in literature and the early Impressionists in painting had degenerated in popular art into an acceptance of the shadowy and the beautiful—the inventions of neoclassical pastoralism and pre-Raphaelite medievalism—or had become stylized in the forms of Art Nouveau. Even Peter H. Emerson's attempt in *Naturalistic Photography* to formulate an aesthetic based on the pure use of the medium and "truth to subject" was thwarted by his advocacy of differential focusing, a practice which encouraged the diffuse Impressionistic manner. The reality that lay before the camera's lens was not a poetic enough subject. If the camera was to produce art, it must be freed from the tyranny of the visible world. The photographer could become an expressive artist only by reshaping the sharp, optically corrected image, or by consciously arranging in front of the lens the accepted symbols and devices of the world of feeling.

Not all the photographers, however, desired to produce art. The vast majority of the photographs produced from the 1840s to the turn of the century were inherently photographic. Directly seen, composed on the ground glass, and printed with full attention to detail and tonal values, they showed unquestioning acceptance of the visible world. For the photographers who made them, they were a means of documentation. While many of these men were concerned with craft, few had any pretentions toward self-expression. Photography for them was "The Mirror with a Memory" or "The Faithful Witness," not "Rembrandt Perfected."[26]

[26] The distinction is of course between photography as document and record and photography as personal expression. A book of photographs, *Paris Under the Commune* (1872?), is subtitled "By a Faithful Witness, Photography." Oliver Wendell Holmes called the daguerreotype "the mirror with a memory." See Beaumont Newhall, *The History of Photography*, 1839–1965 (rev. ed.; New York: Doubleday & Co., 1964), pp. 71, 22. Samuel F. B. Morse published a letter in the *New York Observer* in March 1839, in which he calls the daguerreotype "Rembrandt perfected." See Robert Taft, *Photography and the American Scene: A Social History, 1839–1889* (New York: The Macmillan Co., 1938; Dover edition, New York, 1964), p. 12.

The finest of these early straight photographs made by the Americans Hesler, Brady, O'Sullivan, Gardner, Jackson, and by untold numbers of anonymous photographers retain a psychological impact and strength of vision.[27] These photographers possessed an uncomplicated attitude toward nature. Their straightforward interest in the landscape, architecture, place, or person in front of their lens produced accurate, detailed studies in which the freshness of the composition and viewpoint conveys the presence of an intensely human eye. We have no trouble acknowledging their photographs as products of heightened consciousness and sensibility. Nonetheless, during the last half of the nineteenth century there was no recognized aesthetic that would certify the straight photograph as an expressive object, no sense that a personal point of view of the objective world could reveal "the vital essences of things."[28] That we now acknowledge their work as classic is due in large part to *Camera Work*.

Those few individuals like Stieglitz, Frederick Evans, and J. Craig Annan who were determined to make conscious, expressive statements through the use of straight photography could look only to their own intuition for aesthetic justification. Acutely aware that some of his own straight work did not meet the dominant pictorial aesthetic, Stieglitz called his prints "snapshots" and "explorations of the familiar." He was more concerned with the spirit and vitality of the photograph than with its style or approach. "There are many schools of painting," he wrote in 1893. "Why should there not be many schools of photographic art? There is hardly a right and a wrong in these matters, but there is truth, and that should form the basis of all works of art."[29]

When *Camera Work* appeared, the pictorial photographers were divided into two camps: those who favored hand manipulation of the negatives and prints and those who believed in the use of purely photographic methods. While their methods were different, their ends were the same, and Käsebier's and White's "straight" platinum prints are as diaphanous and elaborately posed as Steichen's and Demachy's painterly gum. There was a far greater distance between the classic straight photographer and

[27] For discussion of similar attitudes in early French photography, see "French Primitive Photography," *Aperture*, 15, no. 1 (Spring 1970).

[28] Edward Weston, "What Is Photographic Beauty?," *Camera Craft*, 46 (1939), p. 254.

[29] Alfred Stieglitz, "The Joint Exhibition at Philadelphia," *American Amateur Photographer*, 5, no. 4 (April 1893), p. 203.

the pictorialist than between the two pictorial camps. Nevertheless, the distinction between the manipulated and unmanipulated pictorial print reflected a crucial difference in aesthetic viewpoint, and the gradual realization of the significance of this difference allowed photography to develop a new aesthetic.

Edward Steichen. During *Camera Work*'s first seven years of publication, the freshness of its plates were the strongest motivation for change. The impact of these pictures lay not in their style, for they were admittedly painterly, but in the very fact that they were *photographic* restatements of painterly concerns.

Edward Steichen's work received the most extensive publication and examination during these early years. A recognized painter as well as photographer, he provided living proof that a photographer could possess aesthetic sensitivity. His individuality, enormous productivity, and technical virtuosity, as well as his personal associations with Shaw, Maeterlinck, and Rodin, made him the acknowledged standard-bearer of the Photo-Secession. Steichen's prints, more than those of any other single individual, helped force the acknowledgment of the photograph as an expressive statement.

Though Steichen was one of the first Americans to recognize the importance of the new art of Paris, his own photographic work was deeply tied to the late nineteenth-century fondness for mood and reverie. The essence of Steichen's photographs is sensibility itself; the sensual is secondary to atmosphere, mystery, and nostalgia. In his prints the intricacies of the visible world are condensed through the controls of gum printing and soft focus into monumental forces of darkness and light. In such photographs as "Rodin-Le Penseur," "Self-Portrait," "In Memoriam," "The Big White Cloud," "Moonrise," and "Nocturne, Orangerie Staircase," and even in the more photographic prints like "Steeplechase Day," Steichen is primarily concerned with light as an emotional force. The graphic fluency in these prints emerges from the bold juxtaposition of shadow and source, from the tense interplay of black and white.

Steichen's portraits are conceived in the same spirit as his other work; yet, the necessity of concentrating on a real human face gives his finest portraits a subtlety and sensuality that his other works lack. While Steichen's anonymous nudes are, as Hartmann keenly observed, "non-moral,

almost sexless," his portraits of real women like Eleanor Duse and Mrs. Philip Lydig are profoundly ambivalent.[30] One feels in them both the spiritual and the sensual, the sacred and the profane. A similar dichotomy is embodied in his portraits of J. P. Morgan and Gordon Craig, each an amalgam of innocence and malevolence; and the "Portraits—Evening," though overtly innocent, is one of the most sensuous photographs of the period.

While Steichen's range was far broader than that of most of the Photo-Secessionists, his prints reflect the quintessence of the Secessionists' aesthetic. Like Keiley, Käsebier, Seeley, and White, Steichen found truth and being in suggestiveness and reverberation. His prints exist in the transitory worlds of dawn and dusk; they search out the mystery and the dream—the reality beyond the edge of actual visible experience.

Marius De Zayas attested to the continuing power of Steichen's work in issue 42/43, long after the manipulated print had fallen into disfavor. "Up to the present, the highest point . . . of Photography has been reached by Steichen as an artist and by Stieglitz as an experimentalist. The work of Steichen brought to its highest expression the aim of the realistic painting of Form. In his photographs he has succeeded in expressing the perfect fusion of the subject and the object."[31]

George Seeley and the Blessed Damozel. While Steichen's work constitutes the major achievement of the pictorial school, it was George Seeley who took the single most pervasive motif of pictorial photography—the Blessed Damozel—and pushed it to its limit. This image was not unique to photography. She appears as a psychic symbol of the revolt against neoclassicism—an image derived from the rebellion against the conventional sources of energy and creativity in religion and morality. A synthesis of the inaccessible woman of secular romance and the major female figures of the sacred world—the Virgin Mother and the temptress Eve— her languid, sensual beauty continually reappears in all nineteenth-century art forms. Her inaccessibility suggests modern man's inability to escape from the materialistic present, and her latent sensuality may be seen

[30] Sidney Allan [Sadakichi Hartmann], "A Visit to Steichen's Studio," *Camera Work,* no. 2, p. 28.

[31] Marius De Zayas, "Photography and Artistic-Photography," *Camera Work,* no. 42/43 (April–July 1913), p. 14.

as a libidinous manifestation of the yearning for the supposed sexual and psychic energy of the medieval and mystical past. We find her early as "la belle Dame sans merci" of Keats's literary ballad, and as the maidens of Poe's dreamland. Later she is seen in the poetry of Baudelaire, Mallarmé, and Yeats, the plays of Maeterlinck, the paintings and poems of Rossetti, the elaborate orchestral coloring of Debussy, and in the countless femmes fatales and sphinxlike images of the Symbolists and Decadents.

She first appears in photography in the 1860s in H. P. Robinson's photomontage, "The Lady of Shalott," and in Julia Margaret Cameron's illustrations of Tennyson's romances. In the first issue of *Camera Work* she emerges in the guise of Gertrude Käsebier's "Miss N." Continually modulating through such photographs as Steichen's "Poster Lady" and Keiley's "Leonore," she reaches her pictorial perfection in the work of Clarence White and George Seeley. She did not die with *Camera Work,* and her most spectacular apotheosis occurred in Stieglitz's early photographs of Georgia O'Keeffe. While Stieglitz approached the O'Keeffe portraits through a more radically photographic style, their essential spirit can be traced back to *Camera Work.* From Clarence White's "Lady in Black" and "Morning," Stieglitz drew a meditative calm and an air of aesthetic timelessness; from Seeley's "Firefly" and "The Burning of Rome," he inherited an underlying eroticism and an incredible lushness and luminosity.

The Seeley prints in issue 20 are perhaps the richest and subtlest photogravures contained in *Camera Work.* While these plates are not radically photographic in vision, they are intensely photographic in medium, for they have an exquisite sense of value, tone, and chiaroscuro. They achieve a vitality and sensuality that is matched only by the Rodin reproductions. In his review of Seeley's work, Caffin was unable to comprehend their power; yet Stieglitz, with his uncanny sense of rightness, exhibited Seeley's prints in 1908 as the sequel to the extraordinary Rodin show at "291."

Portraits of the Secessionists and the Work of Frank Eugene. If Seeley's variations on the Blessed Damozel point toward truth to feeling—the visual embodiment of pure emotion and sentiment—then the Secessionists' portraits of each other exemplify truth to subject. In Steichen's portrait of White, White's portrait of Coburn and his mother, and Coburn's and

Eugene's portraits of Stieglitz, we have the most genuine statements of the pictorial school. These portraits were created out of mutual sympathy and understanding. In spite of their soft focus they evince a psychological penetration that is distinctly photographic; they are both authentic records of physical appearance and acute revelations of character.

That the camera can accurately reveal both physiognomy and psychology was perhaps most clearly apprehended by Frank Eugene, whose work was unique among the Secessionists. First, he took optically sharp rather than soft-focused negatives. Second, he modified them, not by manipulating the print, but by using an etching needle on the negative itself.

It has been exceedingly difficult during the last fifty years to look at Eugene's work—as at a great many of the plates in *Camera Work*—with any degree of sympathy or objectivity. The publication itself helped foster this attitude, for the later issues implicitly denounced the modified print. After 1917 the straight aesthetic was slowly dogmatized, and it became impossible to speak of the early mixed-media work except as historical curiosity.

Today, we are not so sure that we know what a photograph should look like. The work presented during the last few years in The Museum of Modern Art's exhibition, "Photography as Printmaking" (1968), and in an exhibition at George Eastman House, "The Persistence of Vision" (1967), has demonstrated that photographers are again vitally concerned with the interpenetration of various art forms. Like the Photo-Secessionists, though perhaps with less innocence, contemporary photographers are concerned with the final image as a new experience.[32] They well realize that its power depends on the strength and persistence of the artist's vision, not on the purity of his means.

Eugene demonstrated this strength and persistence: his finest work deserves to be much better known. At least six of his plates—"Sir Henry Irving," "The Horse," "Adam and Eve," "Frau Ludwig von Hohlwein," "Prof. Adolph Hengeler," and "Alfred Stieglitz"—must be ranked among the most powerful reproductions in *Camera Work*. These images are constructed out of a union of eye and hand, vision and feeling. Their spontaneity of expression grows out of the tension set up between photog-

[32] See *The Persistence of Vision* (Rochester, N.Y.: George Eastman House, 1967).

raphy and etched lines. Eugene reveals a certain clairvoyance of the relationship that exists between substance and shadow, between the object and the image it projects, not in the real world of things, but in the psychic world of sight. His scratchings have a profound rightness: they provide both halo and ground, surrounding the directly seen person or object with indirect and subtle modulations of memory and insight.

The Impact of Modern Art. The variety and excellence of the plates in *Camera Work* encouraged the critics to establish new means of evaluation and scrutiny. They began to sort out the painterly and the photographic. Having become consciously aware of the mannerisms and style of the Secessionists, they made first attempts at defining photography's unique capacities for personal expression. By 1910 Hartmann could write: "The photographer interprets by spontaneity of judgment. He practices *composition by the eye.*" [33]

In spite of such insights the style and concerns of the Secessionists did not significantly grow during the last half of the second period; even Stieglitz, who had rejected genre subjects for an exploration of the city, still saw the city veiled in romantic mists. For him it was still hieratic rather than actual: New York was "The City of Ambition" and the railroad was "The Hand of Man." Only in a few of his reproductions, such as "Going to the Start," and in Rubicam's "In the Circus," and in some of Coburn's and Annan's work do we get a hint of what will come.

After the 1910 Buffalo exhibition it became quite clear that new expressive methods and critical perspectives had to be discovered if photography were to retain its spirit and vitality. And it was from art rather than from photography that this new blood and energy came. The art Stieglitz showed at "291" was dramatically different in style and intent from the work of the Photo-Secessionists. While the Photo-Secession prints looked backward in time to "the beauties of former art expressions," the new art seemed unequivocally modern. [34] It demonstrated a new way of seeing and a new attitude toward life and toward nature.

The early Rodin and Matisse exhibitions emphasized the spontaneity

[33] S[adakichi] H[artmann], "On the Possibility of New Laws of Composition," *Camera Work,* no. 30 (April 1910), p. 24.

[34] "Unphotographic Paint: The Texture of Impressionism," *Camera Work,* no. 28, p. 23.

of line and the relationship of shape and tone, substance and weight. In their renditions of the human form these men disregarded external appearances and traditional chiaroscuro for the sake of the internal logic of shading and design.

The design element became even more apparent in the work of Picasso, Braque, and Marsden Hartley. The first two, the founders of Cubism, used geometric forms and many-faceted planes to build up highly structured correlatives of sight and sensation. Hartley used pattern and rhythmic decorative notation in his search for expressive form. These concerns were further mirrored in Gertrude Stein's prose, which was published for the first time anywhere in *Camera Work*'s two special 1912 and 1913 numbers on modern art.

It was not the art museums but the museums of natural history that stimulated these new artists. Matisse and Picasso turned to African sculpture. Max Weber and Hartley looked closely at American Indian quilts and blankets, Coptic textiles, and Chinese dolls in order to intensify their sense of form, abstraction, and color. Influenced by these new directions and by a growing realization of the significance of non-Western conceptions of form, Stieglitz exhibited African sculpture and children's drawings at "291."

These exhibitions, as well as the work of the three artists who were to remain closest to Stieglitz—O'Keeffe, Marin, and Dove—offered alternatives to traditional expression and form. Dove's art, as well as O'Keeffe's, was built up from abstract simplifications of natural forms like the wave, the cloud, and the flower. Marin's lyrical watercolors derived their power from the spatial tension implicit in natural and man-made forms. The work of these artists was fundamentally optimistic, nourished by a joy that came from the rediscovery of the basic elements of natural form and of the graphic medium. Stress on shape, line, color, texture, and pattern revealed the expressiveness of form in its own right.

The contrast between pictorial photography and the new art was striking. While the Secessionists had softened reality in the interests of sentiment and mood, the new artists radically distorted the visible world. Where the Secessionists had conceived of space in terms of atmosphere, the new artists depicted it in terms of form. Where the Secessionists had sought contentment and serenity, the new artists—more truly and radically romantic—sought essence.

Most significantly, where the Secessionists had avoided and rejected the particular and the immediate in the belief that feeling could be embodied only in generalized form and stereotyped motifs, the new artists demonstrated that formal coherence by itself could generate emotional meaning. For the new artists, the visible world no longer existed as the model of reality. What the inner eye conceived rather than what the external eye perceived defined the subject and the technique of their art.

This new vision forced Stieglitz and his friends to reevaluate their medium and their relationship to the world around them. It brought into sharp perspective their continually growing awareness of both the basic characteristics of the photographic process and the strength of the photographer's eye. It forced them to develop an aesthetic that was both unique to photography and congruent with modern art. They slowly realized that a photograph could express inner significance through outer form and that a straight photograph could be charged with the same emotional intensity as the finest pictorial print.

This new aesthetic was forcefully though somewhat obscurely expressed by Marius De Zayas's articles "Photography" and "Photography and Artistic Photography." Looking at such photographs as "Steerage," De Zayas wrote that Stieglitz was "trying to do synthetically, with the means of a mechanical process, what some of the most advanced artists of the modern movement are trying to do analytically with the means of Art." De Zayas realized that the camera could be used as a "means to penetrate the objective reality of facts, to acquire a truth . . . it is the means by which the man of instinct, reason and experience approaches nature in order to attain the evidence of reality."[35]

While pictorial prints continued to be shown in *Camera Work* during the period 1910 to 1915, this new aesthetic can nevertheless be sensed. In issue 36—which also included a Picasso drawing—Stieglitz published "The Steerage" and three striking, straight prints of New York: "The Ferry Boat," "The Mauretania," and "Old and New New York." Issue 38 was devoted to a newcomer, Karl Struss, whose work hinted at an apprehension of a photographic as opposed to painterly design. In issue 39 Paul Haviland published "Passing Steamer," a photograph whose formal tension is very similar to Stieglitz's "Going to the Start." In Haviland's

[35] Marius De Zayas, "Photography and Artistic Photography," *Camera Work,* no. 42/43, pp. 14, 13.

image the momentary visual intersection of two passing ocean liners is emphasized by an unbalanced yet vigorous network of lines and spaces. Together with J. Craig Annan's "The White House," published in issue 32, and Stieglitz's "The Steerage" and "Going to the Start," Haviland's print stands out as one of the seminal examples of the instantaneous snapshot wedded by vision to the formal concerns of modern art. In issue 40, Baron De Meyer's directly apprehended street scenes defined a course that Strand would soon follow. Issue 45 was given over to J. Craig Annan, who with Stieglitz and Evans remained throughout the period one of the major exponents of the straight approach.

Paul Strand. The mature manifestation of the new photography was reached in the last two issues when Stieglitz published seventeen gravures of Paul Strand's photographs. Relating Strand's work to the art he had been showing at "291," Stieglitz wrote:

> For ten years Strand quietly has been studying, constantly experimenting, keeping in close touch with all that is related to life in its fullest aspect; intimately related to the spirit of "291." His work is rooted in the best traditions of photography. His vision is potential. His work is pure. It is direct. It does not rely upon tricks of process. . . . [These] photogravures . . . represent the real Strand. The man who has actually done something from within. The photographer who has added something to what has gone before. The work is brutally direct. Devoid of flimflam; devoid of trickery and any "ism"; devoid of any attempt to mystify an ignorant public, including the photographers themselves. These photographs are the direct expression of today.[36]

While Strand's photographs deal with the immediate, they reveal in their design and formal organization an acute comprehension of modern art. His work achieves a memorable union of the abstract and the concrete. Stimulated by the formalistic painting, drawing, and sculpture shown at "291," Strand experimented with the camera's ability to create abstraction and design. In "Kitchen Bowls" and "Porch Shadows" the rhythmic repetition of light and shadow construct lyrical compositions that attest to his delight in the object and the mind's ability to perceive form. In "Wall Street" wide-angle convergence and the extreme modeling power of low sunlight registers a Cubistic composition of white light

[36] [Alfred Stieglitz], "Our Illustrations," *Camera Work,* no. 49/50 (June 1917), p. 36.

bands and clean-cut geometric shapes. Bird's-eye distortion and the checkerboard surfaces of signs and rooftops are used to organize the picture surface in "From the Viaduct." Formal concern sustains even the detailed candid close-ups of New York street characters. In the "Sandwich Man" the rectilinear signboard cuts boldly into the frame. In the "Blind Woman" the juxtaposition of the circular shapes of the eye, the face, the peddler's badge, and the starkly lettered neck tag are the formal foundation for an unforgettable portrait.

Perhaps the most powerful example of Strand's ability to wed abstraction to personal expression is "The White Fence." The linear tenseness and energy of the picket fence are emphasized by the geometric solidity of the organization and by the abrupt tonal transition between fence and pasture. The subject is rendered with unequivocal objectivity, yet the image is more than a neutral recording—the intensity of Strand's vision has charged the balance of shapes, tones, and point of view with unique and personal meaning.

Strand's sharply focused work represented the rebirth of the classic style and the rediscovery of the American scene. Stieglitz had photographed the city; White had captured the mood of the small town. With a few significant exceptions, each began by seeing his subject through the impressionistic mists of the pictorial style. Then Strand began to search out indigenous America and to deal directly with the people, the land they inhabit, and the objects they create. He turned to the city, not so much to explore urban injustice as to reveal character; and he turned to the rural to explore the vitality of the landscape and native architectural forms.

Strand's photographs demonstrate his belief—articulated so clearly in the final issue of *Camera Work*—that "it is in the organization . . . that the photographer's point of view toward Life enters in, and where a formal conception born of the emotions, the intellect, or of both, is as inevitably necessary for him, before an exposure is made, as for the painter, before he puts brush to canvas."

"Photography," Strand affirmed,

> finds its raison d'être, like all media, in a complete uniqueness of means. This is an absolute unqualified objectivity. Unlike the other arts, which are really anti-photographic, this objectivity is of the very essence of photography, its contribution and at the same time its limitation. . . . The photographer's problem, therefore, is to see clearly the limitations and at the same

time the potential qualities of his medium. . . . This means a real respect for the thing in front of him. . . . The objects may be organized to express the causes of which they are the effects, or they may be used as abstract forms, to create an emotion unrelated to the objectivity as such. This organization is evolved either by movement of the camera in relation to the objects themselves or through their actual arrangement, but here, as in everything, the expression is simply the measure of a vision, shallow or profound as the case may be. Photography is only a new road from a different direction but moving toward the common goal, which is Life.[37]

Strand's photographs defined the direction that modern photography would take. The force of his words and images may be traced through Stieglitz's later work and that of Charles Sheeler, Edward Weston, Ansel Adams, and Minor White to many young contemporary photographers, Paul Caponigro and Bruce Davidson among them. Strand's photographs not only point to the present but also define the past. For the difference between Käsebier's portrait of Miss N., published in the first issue, and Strand's portrait of the blind peddler woman is precisely the difference between 1903 and 1917. Romance has given way to reality, idealization to documentation. Miss N.'s soft, velvet background has been transformed into a hard-edged wall, her classic cup into a street peddler's badge, her subdued sensual eyes into the terrifying eyes of blindness.

Few publications are at once as diverse and as unified as *Camera Work*. Animated for fifteen years by Stieglitz's deeply creative spirit, it ranged from photography through modern art and modern literature to the larger concerns of freedom and vision. Profoundly sensitive to its time and place, *Camera Work* represents the crystallization, in written and visual form, of the most vital intellectual, emotional, and artistic currents of its day. It will endure as an affirmation of the possibilities of growth and as a tribute to Stieglitz's belief in significant expression.

"I have not received *Camera Work* for a very long time, probably due to the war, censorship," Frank Eugene wrote Stieglitz from Leipzig in 1916.

The older I grow the more I appreciate what you have accomplished with your very wonderful publication. When I see you I shall be delighted to tell you how largely the possession of *Camera Work* has helped me in my work

[37] Paul Strand, "Photography," *Camera Work*, no. 49/50 (June 1917), p. 3. Reprinted from *Seven Arts*.

as a teacher, and what an incentive it has always been to my pupils toward a higher standard. It does that for the man with a camera, what the Bible has, more or less vainly, for centuries, tried to do for the man with a conscience.[38]

[38] Frank Eugene Smith, "Extract from a Letter," *Camera Work,* no. 49/50 (June 1917), p. 36.

Alfred Stieglitz

Alfred Stieglitz (1864–1946) became a legendary figure during his lifetime. He was admired as a photographer, a fighter for photography's recognition as a creative art, and a prophetic supporter of American and European modernist art. At The Little Galleries co-founded with Edward Steichen and later known as "291," Stieglitz acquainted the public with Americans— Dove, Marin, O'Keeffe, Hartley, and Strand—and Europeans—Picasso, Rodin, and Matisse.

In the first selection Stieglitz relates the kind of incident that inspired his legendary status. The second selection reflects his passionate attitude toward life. In all his activities he evoked an appreciation, often enigmatic, of the world.

It was about half-past two. A spring day at "291." There were Marins on the wall. A beautiful series.

A woman of about thirty, quite excited, walked in. I had been alone. In a sort of hectic way, she said, "I leave for California—San Francisco—in about three hours. I've been in New York for four weeks. I have a friend in California, a woman who told me I dare not return without having seen Alfred Stieglitz."

"Now," she said, "I've been so busy doing this and that, that I left seeing him to the last, and for some hours I've been looking high and low and I've been unable to locate him. Maybe you can tell me where he is to be found."

I asked her if she liked pictures. "Yes," she replied.

She hadn't looked at the Marins. She wasn't even aware of them. All she could think of was that she dare not return home without having seen Mr. Stieglitz.

"Why don't you look at the pictures and forget Mr. Stieglitz? I know him—I know him pretty well—and if I were you I wouldn't bother about him. Just tell your friend you met a friend of Mr. Stieglitz's, and that he said it wasn't worthwhile getting into a stew about finding him."

"Are you sure?," she wondered. "Maybe you're jealous of him?"

* Reprinted from *Twice a Year*, 5–6 (1940–1941).

"Oh, look at the pictures," I insisted. "They're very worthwhile. You won't see their like in a hurry."

She took a glance, but they meant nothing to her.

"Well, here I am with time passing so fast. Soon I'll have to check out of my hotel and catch the train. And I haven't seen Mr. Stieglitz!"

"Haven't you enjoyed being with the Marins and me?," I asked.

"Yes," she answered, "I'm glad I came. But having Mr. Stieglitz on my mind and going back to my friend and telling her that I couldn't find him makes me positively miserable."

"Well," I suggested, "take a message from me. Tell your friend that you met a man who's every bit as good as Mr. Stieglitz and you will be telling her the truth."

The poor woman was so bewildered that she didn't know what to say. During these last few minutes several people had come in who knew me. I had a chance to beckon them to keep quiet. They had heard my last remarks to the woman. I could see that they were ready to burst out laughing.

The woman left. The people who had come looked at me askance, saying, "Why in the world do you do such things to an innocent woman?"

I answered, "She received more of the spirit of '291' in this way than if I had introduced her to 'Mr. Stieglitz.' "

Alfred Stieglitz

MAN: Did you read about the ships that were sunk today?

STIEGLITZ: Yes, I did. But every time I hear that a life is lost in the war, I think of the thousands of innocent lives destroyed every day, irrespective of the war. I think of wheat having been destroyed while people have been starving. An important film has been made that the government says it cannot show while the war is going on, a film showing how food has constantly been destroyed and how land has constantly been destroyed. The government says it cannot show the film because it feels it inadvisable to show what has happened and what has helped to lead up to this war—in this country and in every other country. And in the meantime we have not known what to do with our surplus food that has been government-protected.

At least when a person drowns he is not left to linger on the earth in a maimed condition.

MAN: That is easier to say about another than it would be to say about oneself.

STIEGLITZ: If lives could be brought back through dying oneself, I would be willing to die.

MAN: You talk in terms of choice. Who can choose? Those who are dead cannot choose.

STIEGLITZ: I am not speaking of choice. One virtually chooses nothing in life except in a very limited sphere. My heritage being what it is, and I being what I am, and the world being what it is, there is little choice for me in what I do. The same holds true for everyone else. I can do no differently than I am doing. You say I speak in terms of choice. That is not true. Do you think that I believe that the American people actually choose the way of life that our so-called leaders have led us to believe is the "way of life" we have been leading? People get tired of rebelling. People in the United States have been spoiled. They have been too well fed, even though some may be underfed.

* Reprinted from *Twice a Year*, 10–11 (1943).

I was in business myself, from 1891 to 1895—the printing and photoengraving business. At that time I knew about the workmen and I do not believe the situation has changed basically. When I was in business, I knew that but the fewest of the men were really thinking of their jobs, and not only about working fewer hours for higher pay. Not that I have any objection to that, if a man is thinking about his job first, if his entire being is dedicated to his job. My whole life has been really dedicated to the fight for all those, in whatever field, who insist on doing their work supremely well, and on giving those who are ready to give all of themselves to whatever they may wish to do, a full chance to do whatever they may be fitted to do, and to let them live.

I have heard myriads of times about the search for truth. When the wise men—and who isn't a wise man today—are cornered, they will tell you that their occupation is the search for truth. But, it recently struck me, how can the truth be found if people themselves actually haven't the courage to be truthful? And who in America dares to be truthful? Anyone who dares to be truthful risks losing his job, risks losing everything. The truthful man risks being crucified, or excommunicated—and so the really truthful man is not permitted to live. And now there is no longer anyplace to escape to.

I know what has happened with the artists at "291," at the Intimate Gallery, and here at An American Place—and I am myself no exception. I merely am giving a picture of what I see.

Americans are better fed than others. Even people who have little in America are still better off than the rest of the world. The people who go out in ships are filled with the thought that they will be remembered as heroes by the people, but for the most part people really don't give a damn. Oh, yes, there are moments when people seem to care, or maybe do care—for the moment. And sometimes monuments are erected. But as for myself, I feel, for example, that Mozart was one of the lucky ones. People do not know even where he was buried. There is no monument to him. And there is no "monument" that could possibly equal the spirit that was Mozart, the spirit that he put into the music that he sent out into the world. Isn't he lucky to escape a lot of sculpture that would probably be done by someone who could sculpt, but who had not a trace of art in him. Such a sculptor would undoubtedly be given the official order to

produce the monument for Mozart's grave. I know that this kind of talk is bad for business, and bad for the monument makers.

People everywhere are trapped. The more one does one's job, the more one is near the point of being annihilated. You see, I am thinking of people all over the world. You can say that if people suffer and accept it, they have only themselves to blame. But I feel just as sorry for the Japanese as for the Chinese. I feel equally sorry for the Russians, the Germans, the Norwegians, the Spanish—for all the human beings who are being slaughtered; I feel as sorry for all of these people as I do for the Americans who are being lost. The world seems to be so constituted that it seems to be the history of man for people to suffer and to be slaughtered. And people seem to learn nothing from history. A few people rebel and want to liberate man, and then what they substitute is usually turned into something just as false as what they have rebelled against. Every value seems to be reversed. Everyone, the richest as well as the poorest, beyond choice, is involved.

There has been much talk and noise about art in our country. That is, there have been a growing number of art institutions, art galleries, art dealers, art teachers, art whatnot. There was the WPA art project. Art everywhere. But my experience covering over fifty years in my own country has shown me that those who are seemingly the most "wildly enthusiastic" about art really do not care for it when put to the test. With such people art is mainly a topic of conversation. Or it is a medium for gambling, or it is a fetish. There is little genuine humility and wonder before the manifestation which we know by the name of art. And all true art is a religious manifestation.

Some years ago the United States went off the gold basis and much gold was buried somewhere in Kentucky. And now recently the mining of gold was entirely stopped. What I should like to know is what this myth called gold really is?

Now, too, the supposedly priceless treasures of art housed in The Metropolitan Museum of Art as well as in other art institutions have also been transferred from New York to the Middle West. Not far from the buried gold. Why this? Is it not now, precisely in a time like this, that the people should be given the opportunity to see the marvels of art, instead of being confronted with the pseudo-examples which the art museums are now showing, and that they must consider of little consequence or they

would also have sent them to be buried—which means that the authorities do not think that what is being shown now to the public would be a great loss if bombed out of existence. It might be asked would I challenge fate and show the greatest art in the face of the possibility of its destruction? My answer is a positive yes, for—in large letters—I BELIEVE.

Georgia O'Keeffe

The story of Alfred Stieglitz's art collection is a measure of his varied and sincere interest in photography and art. The American modernist painter Georgia O'Keeffe recollects that story from a privileged viewpoint. Stieglitz and O'Keeffe shared a satisfying personal and professional relationship. \O'Keeffe's interpretations of nature, ranging from precise realism to reductive abstraction, exemplified the spirit of creative freedom Stieglitz devotedly cultivated.

Stieglitz and O'Keeffe met in 1917 during her first one-woman show at "291." They married in 1924. That year Stieglitz began an intimate and exhaustive portrait series of O'Keeffe. These and other photographs are included in Alfred Stieglitz: Photographer *(1965) by Doris Bry and* Alfred Stieglitz: An American Seer *(1973) by Dorothy Norman.*

The last part of the late Alfred Stieglitz's collection of 850 modern paintings, both European and American, plus uncounted photographs, has finally been placed in museums. Recently Fisk University in Nashville, Tennessee, formally accepted 101 paintings, photographs, and photoengravings. The rest of the collection is dispersed among The Metropolitan Museum of Art, which received the bulk of it—589 items—The Art Institute of Chicago, the National Gallery of Art—which received 1,500 of his photographs—the Philadelphia Museum of Art, and The Library of Congress. The intimate story of how the collection, one of the finest in modern art, grew out of Stieglitz's passionate interest in photography as an art and the development of a group of American artists is told here for the first time by Stieglitz's widow and executrix, the distinguished American artist, Georgia O'Keeffe.

Stieglitz often said that he didn't collect pictures, that the pictures collected him. I think he had no particular feeling of ownership about the

* Reprinted from *The New York Times Magazine,* December 11, 1949. Original editorial introduction retained.

collection. It was more a feeling of protecting the artist—that the artist and his work are something rare among us that no one can own, that should be given to the people. For this reason, as I did not wish to keep the collection and preferred not to sell it, I had no choice but to give it to the public.

The Alfred Stieglitz Collection represents what accumulated around him during a long life, a human interest as much as an interest in art. Stieglitz had a passionate interest in photography and a firm belief that something of importance in the arts must come from America. As a photographer he worked to establish photography as one of the fine arts. He was interested in a group of American workers as if they were his children, first a group of photographers, later a group of painters. He never showed work that didn't interest him. He showed it with respect and fought for it. His work in the art world brought him no money.

The collection does not really represent Stieglitz's taste. I know that he did not want many things that were there, but he did not do anything about it. There were often pictures by other painters that he would rather have bought, but, with his fanatical belief that something alive in the arts must come out of America, when he found himself tempted to buy a painting by a European, he usually bought an American painting instead, even if he didn't want it. When he really wanted to give himself a treat, he went out and bought himself a book on racing horses.

Maybe his collecting was started when, as a boy with a toy racing stable, he collected lead and wooden models of horses and jockeys, stabled the horses, and ran the great races of racing history again and again. He always followed the races. The sporting page was the first part of the paper he looked at every day. I have known three of the men who were his playmates with this toy racing stable. It was obvious that he had been the leader. It was his racing stable and they played his games.

This continued on through his life. He was the leader or he didn't play. It was his game and we all played along or left the game. Many left the game, but most of them returned to him occasionally, as if there existed a peculiar bond of affection that could not be broken, something unique that they did not find elsewhere.

Stieglitz grew up during the period when photography was young, began working at it while studying mechanical engineering at the Berlin Polytechnic. As a very enthusiastic young worker he soon decided to

make himself an authority on photography and went about it by sending his photographs everywhere to exhibitions to get all the medals that were given in the world at that time. He started by winning his first medal at the age of twenty-three. He seems to have done very well, as there are boxes and boxes of them, photographic medals from everywhere.

Although the photographs that he was making at this time were very much admired by painters and artists generally, the artists seemed to have the idea that photography could never be accepted as one of the arts. Stieglitz denied this. As he was naturally a fighter, he began to work for its recognition as one of the arts, not particularly for himself but for the idea of photography. Photography was something definite in his life that he always had a very special feeling about. Painters would often say they wished they had painted what he had photographed. He always said he never regretted that he had not photographed what they were painting.

In 1890 Stieglitz returned to America from his European student period, twenty-six years old. Years of feverish activity with photography followed. He finally decided that for photography to be recognized as one of the arts, the work of a group could bring about this recognition better than the work of an individual. He was invited to send exhibitions of American photographers who interested him to many European and American cities: London, Paris, Budapest, Brussels, Amsterdam, Turin, Milan, Dresden, Vienna, Glasgow, Toronto, Philadelphia, Chicago, Pittsburgh, Buffalo, Washington, and other places all over the world, e.g., Calcutta. It is interesting that in our country, where even the soil is becoming industrialized, nothing but photography in our Art World has been really wanted for European exhibitions, unless maybe today, if they knew it, they could not have a great watercolor exhibition without John Marin as the outstanding world figure.

The Photo-Secession group was formed in 1902, with Eugene, Käsebier, Keiley, Steichen, White, and others. Stieglitz was thirty-eight. He was the leader. In 1905 they began having photographic exhibitions at the little gallery known as "291." It was in a brownstone house, top floor back, at 291 Fifth Avenue. "291" was classed as an educational institution, so that all the work that came from Europe, until 1913, was sent over and held in bond for the duration of the exhibitions because of the duty on art. Here the beginnings of modern art were also shown.

New York was not always full of exhibitions of modern art as it is today. The first year I was in New York was 1908, five years before the Armory Show. I was sent, like all the other students, by the instructors of the Art Students League to see the first showing of Rodin drawings at "291." One instructor told us that he didn't know whether Rodin was fooling Stieglitz and America too by sending over such a ridiculous group of drawings to be shown here, or maybe Stieglitz knew what he was about and had his tongue in his cheek trying to see what nonsense he could put over on the American public.

However, we should go and see the drawings, as they might be something. He even assured us that Rodin was certainly a great sculptor, but who had ever heard of anyone's making a drawing or a watercolor with his eyes shut? I very well remember the fantastic violence of Stieglitz's defense when the students with me began talking with him about the drawings. I had never heard anything like it, so I went into the farthest corner and waited for the storm to be over. It was too noisy. I was tired. There was nothing to sit on, so I stood. It was always that way around Stieglitz; until he was an old man he stood, and if you wanted to be there you stood too.

The record of "291" and the years before can be found in the *American Amateur Photographer, Camera Notes* (the magazine Stieglitz edited for The New York Camera Club), and in *Camera Work,* the magazine he published mainly during the "291" years, from 1903 to 1917. They were active years that had made him known throughout the photographic world as it developed and in American art as the idea of modern art began to grow.

There wasn't anyplace in New York where anything like this was shown at this time or for several years after. Rodin and Matisse in 1908. Marin, Maurer, Hartley, Japanese prints by Sharaku, Utamaro, and others, Toulouse-Lautrec in 1909. Dove, Weber, Cézanne, Rousseau, and Gordon Craig in 1910. Picasso in 1911. Walkowitz in 1912. Picabia in 1913. Brancusi and Braque in 1914. Nadelman in 1915. Paul Strand photographs in 1916. Severini and S. Macdonald-Wright in 1917, and the first exhibitions anywhere in the world of children's art (1912) and African Negro sculpture as art (1914). My first two exhibitions were at "291"

in 1916 and 1917, before he knew me personally. These exhibitions were shown to an annoyed, scoffing, and sometimes angry public. They helped the young to find their way.

When the first exhibitions of modern painting were held, I think it was not that Stieglitz understood what it was all about, but he was aware that something was happening in the world that was the opposite of photography, something new and alive, and he was interested. I have also heard that the photographers had become very difficult.

Living with the exhibitions, watching the reactions of the public, Stieglitz learned. He always learned that way. That may have been one reason why he kept on having exhibitions for so many years. Maybe he had the habit and could not stop. He would have said that the artist's yearly living depended on his continued showing. He had taken on a feeling of personal responsibility about getting the yearly living for the artists he believed in and worked for. Although he complained a great deal about all this, I think Stieglitz enjoyed seeing the artists' new work every year and the public's reaction to it. He also enjoyed complaining about the problems and difficulties of the artists, even when they were most difficult. He would have denied this.

When I first began to know Stieglitz well in 1918, he was fifty-four, "291" was closed, and this thing called a "collection" already existed as something to worry about, something there was no place for.

He always grumbled about the collection, not knowing what to do with it, not really wanting it, but in spite of the grumbling, it kept growing until the last few years of his life. In 1918 the collection included many photographs from The Camera Club and "291" periods, and many paintings, watercolors, lithographs, etchings, and pieces of sculpture from his earliest exhibitions of modern art, a disorderly lot of material, showing something of what his interests had been. He did not weed out the unimportant things as he added better ones. He seldom got rid of anything once it was there.

From the European exhibitions held at "291" Stieglitz had sometimes bought because the prices asked were so low he was embarrassed to return the work. Some things he undoubtedly liked and wanted. Some were bought at the Armory Show, in 1913. Others at the first auctions of mod-

ern art, when they were going for almost nothing. American artists gave him things. He often gave *Camera Work* to artists when they wanted it, and they would sometimes give him a picture. Framing and storage bills were paid, rent was paid, and pictures were taken for the collection.

Most of his collection of photographs by other people assembled during this time was given to The Metropolitan Museum of Art in 1933. Stieglitz was throwing it away when Carl Zigrosser came in and, seeing what was happening, telephoned the Metropolitan Museum. They sent a van and took it immediately.

The one rather orderly thing about the collection is that he kept the evolution of the American painters he showed most often: Marin, Dove, Demuth, Hartley, and myself. Others had been shown who for one reason or another drifted away. When the dealers became interested in modern French art, he did nothing more about it. Stieglitz had the idea that if an artist was of interest and importance, his evolution should be kept, that people would be interested, or, to put it his way, the people should have it.

With the American painters, as with photographers for many years, he bought from almost every show. He felt that if he thought work worth showing, he should himself buy something from what was shown. He had very little money to spend, but he lived simply, and during the early hard years when no one else would buy, he bought. As the artists developed, he kept their evolution year by year.

The prices he asked for living American artists often outraged the people who wanted to buy, but the prices of all American artists were pushed up by the prices he asked and got for the group he worked for. He made no commissions from sales. When I was first around, it was harder for an artist to get two or three hundred dollars for a painting than it is today to get five thousand. The first time he asked a thousand dollars for a watercolor Montross and Charles Daniel, the dealer, thought he was losing his mind, that a watercolor would never bring a thousand dollars. Anyone who has not witnessed these scenes cannot imagine their violence. His interests were intense and he enjoyed fighting for them. Many artists thought that if his interest had backed them, their financial problems would have vanished. I doubt it. He chose really to take care of a few rather than halfway take care of many.

During the Intimate Gallery and An American Place days the collec-

tion continued to grow. Paul Strand was shown at both the Intimate Gallery and An American Place. At An American Place Ansel Adams and Eliot Porter were added to the list of photographers shown. Charles Demuth died and willed his oil paintings to me. Stieglitz was very pleased to have them with the collection. Demuth was one of us. The collection became a record of a few people working in America at this time, I think the most important group of that generation. Maybe they were good to start with. Maybe Stieglitz's interest made them better than they would have been without him. We cannot say.

He didn't know what to do with the collection. Wouldn't do what he could do with it. So he left it for me to decide. He would not have done what I have done with it. In the opinion of many of his friends and acquaintances I knew that no matter what I did, I could not be right, but I think he would not object too much to what I have done. He would not mind my doing what it was impossible for him to do.

Today it is impossible for me to give the collection to any one institution and expect his idea to be housed. The collection had grown too large. As it is mostly contemporary work, public opinion concerning it is still being made. If the material is not seen, opinion is not being formed. Having in mind that the pictures should be hung, I had to divide it, as I always told him. I saw no other way.

During Stieglitz's life the Philadelphia Museum of Art kindly showed part of the collection for two years, 1944 to 1946. It was a testing period. Several things hung there are not listed in the collection as it stands today. It has been sorted and many things left out. First James Johnson Sweeney and I sorted it carefully and set aside the things we thought no institution should be expected to give public hanging space. Later it was gone over by Daniel Catton Rich of The Art Institute of Chicago and Alfred Barr of The Museum of Modern Art, and a very few changes made. What is listed represents our choice from the accumulated material.

Stieglitz had encouraged a generation of artists to work. He finished his fight in July 1946. He was eighty-two.

As I pass the collection on to public institutions, it must make its own way. The three largest groups of the collection as it has been divided have gone to The Metropolitan Museum of Art because Stieglitz was so defi-

nitely a New Yorker; to The Art Institute of Chicago because of its central location in our country; and to Fisk University, Nashville, Tennessee, because I think it a good thing to do at this time and that it would please Stieglitz. The National Gallery of Art, the Philadelphia Museum of Art, and The Library of Congress received smaller groups.

He and I never believed in sending pictures traveling, but they can be loaned for a period of not less than three years to other interested institutions. After twenty-five years they can be sold if the institutions have no further use for them.

The Alfred Stieglitz photographs made up an entirely separate unit, to me the most important part of the collection. In order that his work might be seen as a whole, a "key set" of the Stieglitz photographs was made, consisting of the best single original mounted print from every negative made by Stieglitz of which he had kept mounted prints till the time of his death.

This has been asked for by the National Gallery of Art and has gone there, to the Print Department. The Stieglitz photographs are the first photographs in the National Gallery of Art. With the key set will eventually be a 35mm photographic record of every photograph by Stieglitz that has been found. The Metropolitan Museum has received early and late prints to complete the group of his middle period that it already had. The Art Institute of Chicago will start a photographic section with a group of Stieglitz prints, the largest group excepting the key set. Representative collections have been given to The Library of Congress, the Philadelphia Museum of Art, and a small group to Fisk University.

The Boston Museum of Fine Arts started their photographic collection in the Print Department when they asked Stieglitz for a group of his photographs in 1924. The Metropolitan Museum asked him for prints to start a photographic collection in 1928. They were given by a group of friends.

He seems to have won.

Carl Sandburg

Edward Steichen (1879–1972), like Alfred Stieglitz, was a presence larger than life. Steichen's career was multiphased. He was a painter, photographer, museum director, and filmmaker. In these fields Steichen successively explored art's expressive potential.

Photography, however, was his favored medium of expression. Considered chronologically, Steichen's and Stieglitz's photographic work helped to innovate the range of stylistic choices available to modern photographers. Together they set the standards for soft-focus pictorialism at the turn of the century and sharply focused, straight photography after World War I. Steichen's celebrity portraits, fashion photographs, and frank realistic nature and still-life compositions are included in Steichen the Photographer *(1929) by Carl Sandburg and* A Life in Photography *(1968) by Edward Steichen.*

In this excerpt from the first monograph on Steichen (1929) the noted poet Carl Sandburg pays homage to his brother-in-law's vital ambitions for photography. This excerpt was also reprinted in the catalogue for Steichen's exhibition (1961) at The Museum of Modern Art.

An American, a mechanician, a chemist, a workman, a commander of tried loyalty to the men of the line, and the men higher up, Steichen is a blend of courage, efficiency, and vision. He sees and feels the pageant of American industry, the workshops, bridges, chutes, elevators, the fascinating forms of fire and fog, smoke and steel, shaping civilization in its dominant contours today. He is intensely a Machine Age man, breaking from the past and employing hitherto unheard-of devices and procedures in the free style of those Americans who know what is meant by the Chicago proverb, "Independent as a hog on ice," or the coast-to-coast apothegm, "Nothing is as dead as yesterday's newspaper."

If Steichen should ever take it into his head to lay off from his regular work and photograph the Steel Industry, for instance, the basic epic and the immense album then produced would be at once a record, document, and titanic work of art.

* Reprinted from *Steichen the Photographer* (New York: Harcourt Brace Jovanovich, 1929).

Old words do not hit off Steichen. The well-worn phrases can't find him. Out of many years of talk with him (and he is a measurably silent man whose words count when spoken) one may find certain words coming from him more decisively than others; they are nearer to authoritative value than the older words now dead of dry rot. Among such words are *essence, Alive, kick.* When enthusiasms ride Steichen, these words are likely to be heard.

He defines art hesitatingly and tentatively. "Art is the taking of the essence of an object or experience and giving it a new form so that it has an existence of its own and an essence of its own." He recalls Rodin declaring, "All art not based on nature is tommyrot, bluff, blague." He says, out of long free meditations, "A thing is beautiful if it fulfills its purpose—if it functions. To my mind a modern icebox is a thing of beauty."

On looks Steichen might be taken for a priest. He is solemn, with grave spiritual quality; reverence is a commanding element in his makeup; life is sacred to him; all life; plants and bugs perform best for him while they are alive where his camera can register them. True, as a plant breeder he ruthlessly goes among selected rows and aborts their growth; yet even this he does seeking for the "sports," the individuals out of which may be created superior species.

Riding through Goshen, Indiana, he recalled, "This is the town where a man named Kunderd lived who developed ruffled petal gladiolus and he was thrown out of the Baptist church on the charge that he was trying to improve on God's handiwork, The argument was: If God had wanted ruffles on a gladiolus He would have made them that way."

A passionate and grave sincerity governs Steichen's work and is told on his face; he might be taken for a piano or violin virtuoso; we say virtuoso because physical dexterity, capacity with hands and arms, goes with his equipment. He has large hands; they are an outstanding feature; he has needed well-sized, gifted hands.

He eats rapidly, finishing his victuals before others at the table. He is six feet high, has never been sick except two or three times in his life when overwork and overeagerness about work brought him down; his father and mother are marvels of strength and endurance. Summer and winter he sleeps with his feet sticking out from the bedcovers; he sleeps as a child of Adam, wearing neither pajama shirt nor trousers. He works in a blue or gray negligée shirt, coat off, through a camera portrait sitting. He cir-

cles camera and sitter, darts swiftly from under the camera hood and back, on his own errands. His coat invariably has in it the little crimson quarter-inch silk ribbon, the Legion of Honor award. He used to work all day and most of the night till in the winter of 1926 he found he had lost the habit of sleeping at all; old Mother Nature was handing him revenge and pay: he was sent to Asheville, North Carolina, to stay in bed a month and sleep. Since then he has reorganized his habits and learned to forget his work more, get outdoors more, and sleep more.

Once in his middle thirties when responsibilities and work loomed heavy ahead of him, he said to his father, mother, and sister on leaving the Midwest for New York, "Well, if the worst happens we'll die with our back to the wall." He gives all he has to the work in hand, bets big on the future, has play and song hours with two daughters, and idolizes two baby granddaughters.

He has had defeats and bitter disappointments; enough to kill off any army mule; and is a classical instance of man stubbornly controlling the design of his life to a far degree. . . . Asked why an artist of much promise a few years earlier was turning out no work worthwhile, he said, "It's simple—he won't work—that's all."

Two of his nieces were shown a certain photograph of Abraham Lincoln and were asked, "Who is it?" They answered, "Uncle Ed." Though essentially melancholy and brooding, he has a comedian's heart for difficulties, for hours with friends, children, good fools.

He recites Longfellow's "The Wreck of the Hesperus" with gusto, once carrying it so far that a seven-year-old girl burst into tears over the angry sea, the lost ship, and drownded passengers. He knows dogs, has a repertoire of dog barks, crouches, and attacks with dog-fight growls—and would be a popular hit at running a vaudeville dog act.

He can imitate after-dinner speakers and in his talk about any scene or people, his voice and face accompany with mimicry, rhythm, and intonation. He takes off Charlie Chaplin's imitation of Raquel Meller's impersonation of an old Spanish woman peasant with a shawl—or tells of a sky ride with General Billy Mitchell trying to beat a storm that almost overtook them, and if it had would have finished them—or the entrance of Geraldine Farrar into his studio to be photographed before a concert tour. "Such a grand sweet old lady that has a girl heart yet and knows just how to play her role for her age." He can tell of persons who say "photo"

or "photygraft" or a nice old codger who for years has been saying "phortorgraph" with a screwed-up face.

Once when a woman snob frozen with dignity, sickly superior, obeyed all suggestions with patronizing contempt, refused to sit in and have a nice photograph made, Steichen said afterward, when it was all over, "It was too bad—I saw she was trying to meat-ax me—I couldn't help it—but when the photographs were finished—I had meat-axed her." After a big sitting sometimes the studio looks like a cyclone had blown through. A very neat lady arrived by appointment. "Oh, you are moving?" "No, madame, it's always like this."

He can be a child with children, loose, easy, make-believe. He can eat an apple with big bites, loud smacks, and a ravenous face. He knows, with children, when to clump and guffaw and when to walk on tiptoe, beckon, whisper, and mystify.

Steichen is first of all interested in life, while art, as the word is used, is a secondary interest with him. He stands before the swarming and the exfoliation of life, wondering about it as all humble, contemplative men do—and yet haunted by it and letting it occupy his thoughts incessantly and restlessly. As a youth he mastered the technic of the camera, of developing processes, of print papers; he had not found a master conception as to what he should do with the camera or how he should handle his negatives and prints; that came many years later; the point is that before he was full-grown, he dug out for himself all about camera manipulation that was to be known.

A scientist and a speculative philosopher stands back of Steichen's best pictures. They will not yield their meaning and essence on the first look nor the thousandth—which is the test of masterpieces. They are lurking and baffling with the gleaming and the running of those arrangements of fact and those riddles of harmonics that bring contemplation to the mind or reverie to the heart in gazing on them. Henry James, in writing about a brilliant painter who was making a name for himself among critics and smart people, referred to the elements of "struggle" and "discipline" and how sorry is the case eventually of the artist who wins by tricks, glitter, surprises, stunts.

> It may be better for an artist to have a certain part of his property invested in unsolved difficulties . . . The highest result is achieved when to the element of quick perception a certain faculty of brooding reflection is

added . . . the quality in the light of which the artist sees deep into his subject, undergoes it, absorbs it, discovers in it new things that were not on the surface, becomes patient with it, and almost reverent, and in short enlarges and humanizes the technical problem.

This tells of Steichen. He has pushed on and out from stunts, surprises, effects. He has had to pay the penalty of too early success, has eaten ashes—and gone on.

"Contemporary criticism is merely opinion." There is a pathos of estimates, appraisals and prophecies as to the range and value of performers in our time. Donald Francis Tovey, the Scottish historian of music, tells of Sebastian Bach spending a lifetime making no other impression on even his most intimate circle of admirers than that of a scholar fussing with antiques. And Tovey notes,

> There will never be any reason to suppose that the keenest observer of our own day will be any wiser as to what is now quietly coming into an existence which shall outlive all else that gains immediate fame. The greatest art takes ample time before its impulses reach the mainstream of historic tendency, so that the contemporary view of the mainstream is naturally, and not unjustifiably, preoccupied with work that will not interest posterity; while, on the other hand, future historians will, as always hitherto, have great difficulty in finding any historic importance in the works which prove immortal.

There was a poet in Steichen's time who issued a book of verses in the year 1920 with this dedication:

To
COL. EDWARD J. STEICHEN
Painter of nocturnes and faces, camera engraver
of glints and moments, listener to blue
evening winds and new yellow roses,
dreamer and finder, rider of great
mornings in gardens, valleys,
battles.[1]

Steichen knows where he is going, if, when, and where, better than anybody who reviews his work or offers commentary on its import, size,

[1] Carl Sandburg, *Smoke and Steel* (New York: Harcourt Brace Jovanovich, 1920).

or lasting value. He could write books about his own work, experiments, discoveries, speculations; there isn't time. "I would like to see more people doing photography," he says. "I am doing everything I can to develop it. I am only beginning. I don't expect to be any good until I am sixty-five or seventy. I am still in my apprenticeship—I mean that. I am speaking seriously."

He will die telling God that if he could live a few years longer he might be the photographer he wanted to be.

His mother once said at the yearly Christmas dinner, "I suppose you want a camera in the coffin with you when you are buried." He answered, "Yes—and over the grave put my radio set." He will die a seeker and a listener.

Marius De Zayas[1]

Marius De Zayas (1880–1961) was a versatile member of the Stieglitz circle. He co-authored with Paul Haviland A Study of the Modern Evolution of Plastic Form *(1913) and wrote* African Negro Art: Its Influence on Modern Art *(1916). As a writer, collector, dealer, and caricaturist he promoted the appreciation of modern and primitive art and photography as a fine art form.*

De Zayas's definition of photography's dual nature—artistic and nonartistic—is his attempt to settle the still current controversy about whether photography is art. De Zayas allows that photography may be both artistic and nonartistic. The determining factor is the intention of the photographer. For De Zayas, artistic photography is a symbolic expression of feelings, and nonartistic photography is objective mimetic representation. Note that his distinctions were shared by contemporary modernist critics.

Photography is not Art. It is not even an art.

Art is the expression of the conception of an idea. Photography is the plastic verification of a fact.

The difference between Art and Photography is the essential difference which exists between the Idea and Nature.

Nature inspires in us the idea. Art, through the imagination, represents that idea in order to produce emotions.

The Human Intellect has completed the circle of Art. Those whose obstinacy makes them go in search of the new in Art only follow the line of the circumference, following the footsteps of those who traced the closed curve. But photography escapes through the *tangent* of the circle, showing a new way to progress in the comprehension of form.

Art has abandoned its original purpose, the substantiation of religious conception, to devote itself to a representation of Form. It may be said that the soul of Art has disappeared, the body only remaining with us,

*Reprinted from *Camera Work,* no. 41 (1913).

[1] The attention of readers of this essay is called to Mr. De Zayas's essay "The Sun Has Set," *Camera Work,* no. 39 (1912).

and that therefore the unifying idea of Art does not exist. That body is disintegrating, and everything that disintegrates tends to disappear.

So long as Art only speculates with Form, it cannot produce a work which fully realizes the preconceived idea, because imagination always goes further than realization. Mystery has been suppressed, and with mystery faith has disappeared. We could make a Colossus of Rhodes, but not the Sphinx.

Each epoch of the history of Art is characterized by a particular expression of Form. A peculiar evolution of Form corresponds to each one of the states of anthropological development. From the primitive races to the white ones, which are the latest in evolution and consequently the most advanced, Form, starting from the fantastic, has evolved to a *conventional naturalism*. But, when we get to our own epoch, we find, that a special Form is lacking in Art, for Form in contemporary Art is nothing but the result of the adaptation of all the other forms which existed previous to the conditions of our epoch. Nevertheless we cannot rightly say that a true eclecticism exists. It may be held that this combination constitutes a special form, but in fact it does not constitute anything but a special *deformation*.

Art is devouring Art. Conservative artists, with the faith of fanaticism, constantly seek inspiration in the museums of art. Progressive artists squeeze the last idea out of the ethnographical museums, which ought also to be considered as museums of art. Both build on the past. Picasso is perhaps the only artist who in our time works in search of a new form. But Picasso is only an analyst; up to the present his productions reveal solely the plastic analysis of artistic form without arriving at a definite synthesis. His labor is in opposite direction to the concrete. His starting point is the most primitive work existing, and from it he goes toward the infinite, de-solving without ever resolving.

In the savage, analysis and discrimination do not exist. He is unable to concentrate his attention upon a particular thing for any length of time. He does not understand the difference between *similar* and *identical,* between that which is seen in dreams and that which happens in real life, between imagination and facts; and that is why he takes as facts the ideas inspired by impressions. As he lives in the sphere of imagination, the tangible form to him does not exist except under the aspect of the fantastic. It has been repeatedly proved that a faithful drawing from nature, or a

photograph, is a blank to a savage, and that he is unable to recognize in it either persons or places which are most familiar to him; the real representation of form has no significance to his senses. The many experiments that Europeans have made with African Negros, making them draw from nature, have proved that the Negroes always take from form only that which impresses them from the decorative point of view, that is to say, that which represents an abstract expression. For instance, in drawing an individual, they give principal importance to such things as the buttons of the clothes, distributing them decoratively, in an arbitrary manner, far different from the place which they occupied in reality. While they appreciate abstract form, the abstract line is to them incomprehensible and only the combinations of lines expressing a decorative idea is appreciated by them. Therefore what they try to reproduce is not form itself, but the expression of the sentiment or the impression represented by a geometrical combination.

Gradually, while the human brain has become perfected under the influence of progress and civilization, the abstract idea of representation of form has been disappearing. To the expression through the decorative element has succeeded the expression by the factual representation of form. Observation replaced impression, and analysis followed observation.

There is no doubt that while the human brain has been developing, the imaginative element has been eliminated from Art. There is no doubt also that all the elements for creative imagination have been exhausted. What is now produced in Art is that which has caused us pleasure in other works. The creative Art has disappeared without the pleasure of Art being extinct.

The contemporary art that speculates with the work of the savages is nothing but the quantitative and the qualitative analysis of that which was precisely the product of the lack of analysis.

Imagination, creative faculty, is the principal law of Art. That faculty is not autogenous, it needs the concurrence of another principle to excite its activity. The elements acquired by perception and by the reflective faculties, presented to the mind by memory, take a new form under the influence of the imagination. This new aspect of form is precisely what man tries to reproduce in Art. That is how Art has established false ideas concerning the reality of Form and has created sentiments and passions that

have radically influenced the human conception of reality. To those under this influence, its false ideas of Form are considered as dogmas, as axiomatic truths; and to persuade us of the exactitude of their principles they allege their way of *feeling*. It is true that nature does not always offer objects in the form corresponding to those ways of feeling, but imagination always does, for it changes their nature, adapting them to the convenience of the artist.

Let us enter into some considerations upon imagination, so many times mentioned in this paper. Leaving aside all the more or less metaphysical definitions offered by the philosophers, let us consider it for what it is, that is to say, *creative* faculty, whose function consists in producing new images and new ideas. Imagination is not merely the attention which contemplates things, nor the memory which recalls them to the mind, nor the comparison which considers their relationship, nor the judgment which pronounces upon them an affirmation or a negation. Imagination needs the concourse of all these faculties, working upon the elements they offer, gathering them and combining them, creating in that way new images or new ideas.

But imagination, on account of its characteristics, has always led man away from the realization of truth in regard to Form, for the moment the latter enters under the domination of thought, it becomes a chimera. Memory, that concurrent faculty of imagination, does not retain the remembrance of the substantial representation of Form, but only its synthetic expression.

In order fully and correctly to appreciate the reality of Form, it is necessary to get into a state of perfect consciousness. The reality of Form can only be transcribed through a mechanical process in which the craftsmanship of man does not enter as a principal factor. There is no other process to accomplish this than photography. The photographer—the true photographer—is he who has become able, through a state of perfect consciousness, to possess such a clear view of things as to enable him to understand and feel the beauty of the reality of Form.

The more we consider photography, the more convinced we are that it has come to draw away the veil of mystery with which Art enveloped the represented Form. Art made us believe that without the symbolism inspired by the hallucination of faith, or without the conventionalism inspired by philosophical autointoxications, the realization of the

psychology of Form was impossible; that is to say, that without the intervention of the imaginative faculties, Form could not express its spirit.

But when man does not seek pleasure in ecstasies but in investigation, when he does not seek the anesthetic of contemplation but the pleasure of perfect consciousness, the soul of substance represented by Art appears like the phantasm of that *Alma Mater,* which is felt vibrating in every existing thing by all who understand the beauty of real truth. This has been demonstrated to us in an evident manner, if not in regard to pure Art, at least in regard to science, by the great geometricians like Newton, Lagrange, and La Place; by the great philosophers like Plato, Aristotle, and Kant; and the great naturalists like Linnaeus, Cuvier, and Geoffroy Saint-Hilaire.

Art presents to us what we may call the emotional or intellectual truth; photography, the material truth.

Art has taught us to feel emotions in the presence of a work that represents the emotions experienced by the artist. Photography teaches us to realize and feel our own emotions.

I have never accepted Art as infinite nor the human brain as omnipotent. I believe in progress as a constant and ineludible law and I am sure we are advancing, though we are ignorant how, why, and whither; nor know how far we shall go.

I believe that the influence of Art has developed the imagination of man, carrying it to its highest degree of intensity and sensibility, leading him to conceive the incomprehensible and the irrepresentable. No sooner had the imagination carried man to chaos, than he groped for a new path which would take him to that "whither," impossible to conceive, and he found photography. He found in it a powerful element of orientation for the realization of that perfect consciousness for which science has done and is doing so much, to enable man to understand reason, the cause of facts—Truth.

Photography represents Form as it is required by the actual state of the progress of human intelligence. In this epoch of fact photography is the concrete representation of consummated facts. In this epoch of the indication of truth through materialism photography comes to supply the material truth of Form.

This is its true mission in the evolution of human progress. It is not to be the means of expression for the intellect of man.

Marius De Zayas

Photography is not Art, but photographs can be made to be Art.

When man uses the camera without any preconceived idea of final re-
sults, when he uses the camera as a means to penetrate the objective real-
ity of facts, to acquire a truth, which he tries to represent by itself and not
by adapting it to any system of emotional representation, then, man is
doing photography.

Photography, pure photography, is not a new system for the represen-
tation of Form, but rather the negation of all representative systems; it is
the means by which the man of instinct, reason, and experience ap-
proaches nature in order to attain the evidence of reality.

Photography is the experimental science of Form. Its aim is to find and
determine the objectivity of Form; that is, to obtain the condition of the
initial phenomenon of Form, phenomenon that under the dominion of
the mind of man creates emotions, sensations, and ideas.

The difference between Photography and Artistic Photography is that,
in the former, man tries to get at that objectivity of Form which generates
the different conceptions that man has of Form, while the second uses the
objectivity of Form to express a preconceived idea in order to convey an
emotion. The first is the fixing of an actual state of Form; the other is the
representation of the objectivity of Form, subordinated to a system of
representation. The first is a process of indigitation, the second a means of
expression. In the first man tries to represent something that is outside of
himself; in the second he tries to represent something that is in himself.
The first is a free and impersonal research; the second is a systematic and
personal representation.

The artist photographer uses nature to express his individuality, the
photographer puts himself in front of nature and, without preconcep-
tions, with the free mind of an investigator, with the method of an ex-
perimentalist, tries to get out of her a true state of conditions.

The artist photographer in his work envelops objectivity with an idea,
veils the object with the subject. The photographer expresses, so far as he

*Reprinted from *Camera Work,* no. 42/43 (1913).

58

is able to, pure objectivity. The aim of the first is pleasure; the aim of the second, knowledge. The one does not destroy the other.

Subjectivity is a natural characteristic of man. Representation began by the simple expression of the subject. In the development of the evolution of representation, man has been slowly approaching the object. The History of Art proves this statement.

In subjectivity man has exhausted the representation of all the emotions that are peculiar to humanity. When man began to be inductive instead of deductive in his represented expressions, objectivity began to take the place of subjectivity. The more analytical man is, the more he separates himself from the subject and the nearer he gets to the comprehension of the object.

It has been observed that Nature to the majority of people is amorphic. Great periods of civilization have been necessary to make man conceive the objectivity of Form. So long as man endeavors to represent his emotions or ideas in order to convey them to others, he has to subject his representation of Form to the expression of his idea. With subjectivity man tried to represent his feeling of the primary causes. That is the reason why Art has always been subjective and dependent on the religious idea.

Science convinced man that the comprehension of the primary causes is beyond the human mind; but science made him arrive at the cognition of the condition of the phenomenon.

Photography, and only Photography, started man on the road of the cognition of the condition of the phenomena of Form.

Up to the present the highest point of these two sides of Photography has been reached by Steichen as an artist and by Stieglitz as an experimentalist.

The work of Steichen brought to its highest expression the aim of the realistic painting of Form. In his photographs he has succeeded in expressing the perfect fusion of the subject and the object. He has carried to its highest point the expression of a system of representation: the realistic one.

Stieglitz has begun with the elimination of the subject in represented Form to search for the pure expression of the object. He is trying to do synthetically, with the means of a mechanical process, what some of the most advanced artists of the modern movement are trying to do analytically with the means of Art.

It would be difficult to say which of these two sides of Photography is the more important. For one is the means by which man fuses his idea with the natural expression of Form, while the other is the means by which man tries to bring the natural expression of Form to the cognition of his mind.

Paul Strand

Paul Strand (1890–1976) was an articulate spokesman for the use of straight photography as the fullest realization of photography as an art form. He received his first recognition from Alfred Stieglitz, who devoted the last issues of Camera Work *to Strand's sharply focused straight photography. Strand's precise realistic vision found expression in animate and inanimate subjects and in representational and abstract images. His many books include* Paul Strand: A Retrospective Monograph *(1945),* Time in New England *(1950), text edited by Nancy Newhall, and* Tir a'Mhurain (Outer Hebrides) *(1962), text by Basil Davidson.*

Strand's disagreement with cultural historian John Berger marks the continuation of the controversy over the artistic value of photography. A purist, Strand believed that the photographer must cultivate those elements unique to his medium. For Strand the essence of photography is its ability to make permanent objective and ephemeral perceptions.

Berger agrees that photography reveals a specific sense of existing reality. However, he argues that photography as an art form is only possible in a society that shares a common visual vocabulary. Otherwise, according to Berger, photography's significance is restricted by its specificity (John Berger, "Painting or Photography?," The Observer Weekend Review, *February 24, 1963).*

Sir: Here are some of my thoughts in connection with John Berger's interesting essay "Painting or Photography?," which you reprinted from *The Observer.* I hope that these may be of interest to your readership.

I was disappointed, to be sure, that Mr. Berger only mentioned *Tir a'Mhurain*[1] in passing and did not discuss this recent book of mine and of Basil Davidson in the light of his remarks about photography. Nevertheless, his use of my photograph, "The Family," together with some of his evaluations of photography as an art medium, interested me greatly.

* Reprinted from *The Observer Weekend Review,* February 24, 1963.
[1] *Tir a'Mhurain (Outer Hebrides).* Photographs by Paul Strand; text commentary by Basil Davidson (London: MacGibbon & Kee, 1962).

Especially evocative and cogent was the long-needed clarification which he makes as follows: "The idea that art is the privilege of certain special media is one of the great aesthetic illusions of our time. . . . The truth is that a work becomes great only by virtue of the effect it has on those who experience it." And again: ". . . art is *not* a quality eternally inherent in a particular object made of a particular material in a particular way. To believe that it is is to return to primitive fetishism."

As a matter of fact, photography has been the victim of this same fetishism throughout its development over the past one hundred twenty-odd years. Even today I understand that (though I should be only too happy to be corrected if I am wrong) a great museum like the Tate Gallery refuses to show photographs as an art form because "they are not made by hand."

But I fear that Mr. Berger himself is not entirely free from prejudice. He asks ". . . is it conceivable that a potential painter of genius should choose to be a photographer?" I would say no to that. Furthermore, I would say it is equally unlikely that a photographer of genius would choose to be a painter; because in reality the true artist gravitates, I think, towards the medium in which his natural talent and his response to life combine to allow him the greatest freedom and effectiveness. Thus Mr. Berger's question becomes significant, purged of prejudice, and answerable in the affirmative, when we rephrase it as follows: "Is it conceivable that an *artist* of genius should choose to be a photographer?"

Time, of course, will be the final arbiter of this question, but there are people the world over who have felt the effects of some photographs as an aesthetic experience, differing in no way from experience of other arts. A growing number of collections, private and in museums of art in America and elsewhere, take clear cognizance of photography as an art form. They say, unequivocally, that this medium given to us by science has long since had its "artists of genius" and they present, as evidence, the works of these men and women in permanent collections, in exhibitions, and in books. How worthwhile it is to recall that the unsurpassed portraits made in 1843–1845 by the Scotsman David Octavius Hill only a few years after the discovery of photography reflect the first use of the new medium by an artist of considerable genius.

It has always been my belief that the true artist, like the true scientist, is a researcher using materials and techniques to dig into the truth and

meaning of the world in which he himself lives; and what he creates or, better perhaps, brings back are the objective results of his explorations. The measure of his talent—of his genius, if you will—is the richness he finds in such a life's voyage of discovery and the effectiveness with which he is able to embody it through his chosen medium.

Finally, it seems to me that the title of Mr. Berger's essay (perhaps not *his* title?) announces an opposition which he himself declares to be false; better "Painting *and* Photography" than the essay's "Painting *or* Photography?" Mr. Berger puts it with such fine clarity that I beg leave to re-quote: "The idea that art is the privilege of certain special media is one of the great aesthetic illusions of our time." "Art is *not* a quality eternally inherent in a particular object made of a particular material in a particular way." Furthermore, let it be said that no medium at all annuls or cancels out another. The symphonic art of the cinema, for instance, with its base in photography, does not take the place of or diminish in the least the older art of the theatre.

On the contrary, all the techniques of search and of research we now have, as well as those which the future may add, *all the media,* are they not to be welcomed for what they are: the invaluable means by which man increases his knowledge, his understanding of life, and expands his cultural heritage.

PAUL STRAND

Orgeval, Seine/Oise, France

Paul Strand: Look to the Things Around You (1974)*

Calvin Tomkins

In this review of Paul Strand's career Calvin Tomkins also explores the nature of the visual experience of a photograph. Tomkins shows that Strand's respect for what he sees is the resilient source of his expression. Strand exemplifies for Tomkins the idea that photography can reveal the inexhaustible variety of the world.

Calvin Tomkins, a staff writer for The New Yorker *since 1961, is the author of numerous essays on artists. Some of these are collected in* The Bride and the Bachelors: The Heretical Courtship in Modern Art *(1965), and* The Scene: Reports on Post Modern Art *(1976). He is also the author of* Intermission *(1951), a novel.*

Photography has been with us now for nearly a hundred and fifty years, and the old argument over its aesthetic status—is it or is it not an art?—was resolved long ago. The major art museums all collect and exhibit photographs as a matter of routine, many art schools offer courses in photography, and the number of galleries that sell photographic prints is steadily increasing. So far, however, the medium has produced surprisingly few major artists. There are, of course, any number of great photographers—men and women whose perception, diligence, and technical mastery have made them famous in such fields as pictorial journalism and fashion photography—but the number of photographers who have gone beyond this level of competence to produce images that will bear comparison with the work of, say, a Matisse or a de Kooning is extremely small. In this century, by general agreement, America has produced only three photographic artists of this caliber: Alfred Stieglitz, Edward Weston, and Paul Strand. Stieglitz died in 1946, Weston in 1958. It comes as a surprise to some people to learn that Strand, who has lived in France since 1950, is still adding quietly to an immense body of photographic work that dates back to 1915.

The word *quietly* applies to the work as well as to the man. Strand's photographs do not call attention to themselves. They lack the dramatic

* Reprinted from *The New Yorker,* September 16, 1974.

intensity of nearly any print by Weston or Stieglitz, whose images often seem to be straining to escape from the frame. Strand's images are at rest within the frame—at rest in a space charged with a dense and complex life of its own. The longer one looks at them, the more they reveal. His career is a rare modern case of the artist virtually disappearing into his art. And yet, paradoxically—as several critics noted in reviewing the large retrospective of Strand's work that opened at the Philadelphia Museum of Art in 1971 and subsequently toured the country—what is almost as remarkable as the quality of the work is the consistency of Strand's vision. Although his range of subject matter is wider than that of many other well-known photographers—portraits, landscapes, abstractions, machinery, details of natural forms, architecture, and village life in various parts of the world being among his recurrent themes—his methods and his ways of seeing have changed so little that the photographs he made in Mexico in 1966 are impossible to differentiate from those he made there thirty years earlier. It would be hard to think of another twentieth-century artist whose work is characterized by such a serene and untroubled self-assurance, and in this sense it might be said that Paul Strand is an anachronism. He believes in the almost extinct virtues of craftsmanship, asserting (as he did in 1922) that "quality in work is prerequisite to quality of expressiveness." He has worked for much of his life without much material reward, and only in recent years has he attained anything like wide recognition. Moreover, as his pictures eloquently demonstrate, he has retained all his life the unfashionable conviction that human dignity is not only desirable but frequently attained.

"I remember travelling with Strand in Italy some years ago and introducing him to the magnificent frescoes of Piero della Francesca in the Church of San Francesco in Arezzo," the art historian Milton Brown has written.

> The rapport between the two artists was immediate. Strand wanted to see all of Piero's works available in northern Italy, and we did, in Borgo San Sepolcro, Urbino, Rimini, and Milan; his appreciation of the great Renaissance master was intuitive and profound. It was not strange, since they have so much in common, that Strand should respond to Piero's serene grandeur, the peasant robustness transformed into patrician dignity, the real transmuted into the ideal, the ordinary in man and the transitory in nature converted into eternal symbols, all expressed with an impeccable sureness of means

and a not too easy elegance, since it is not an elegance of fashion but of spirit. Strand's art, like Piero's, is the expression of a nobility of mind as well as style. In his sight the meanest things take on importance, the lowliest of people assume heroic stature.

Well into his eighties now, Strand makes very few concessions to the years. He is a compact, sturdy man with an upright bearing and a strong, calm presence that makes him seem both taller and younger than he is. Recently, he has had cataract operations on both eyes, and his hearing is none too good, but he continues to work with all his customary energy and precision, in the darkroom and behind the camera. A few of the nearly five hundred prints in the Philadelphia retrospective were old platinum prints that he made before 1937, but the majority were new, printed by Strand in the darkroom that he designed for himself in his house in the village of Orgeval, some thirty kilometers west of Paris. Since it often takes Strand three days of solid work to print a negative to his satisfaction, the printing job required more than two years, and during that period he had little time left over for photographing. But his picture book on Ghana, with a text by Basil Davidson, is expected to appear this coming February [*Ghana: An African Portrait,* 1976], and he talks impatiently of going back to Morocco to finish his work for a book on that country. Except during his early years, when he used a 3¼- by 4¼-inch reflex camera, Strand has worked mainly with the big, heavy equipment of an earlier era—with an 8- by 10-inch Deardorff view camera and with the 5- by 7-inch Graflex that he started using in 1931. "I just don't like that little 35-millimeter image," he says. He has no interest in color, which he looks upon as insufficiently developed for the kind of work that interests him. "It's a dye," he has said. "It has no body or texture or density, as paint does. So far, it doesn't do anything but add an uncontrollable element to a medium that's hard enough to control anyway." In Egypt in 1959, he began working with a 2¼- by 3¼-inch hand-held reflex camera, because certain subjects seemed to require more mobile equipment. These days, he tends to favor the smaller camera, but there are also occasions when he still works in the manner of a nineteenth-century master like Atget, setting up his tripod, retreating under the black headcloth, and composing on the ground glass the images that he will then reproduce, with absolute fidelity, in the darkroom.

John Szarkowski, director of the Department of Photography at The

Museum of Modern Art, has compared the career expectancy of most creative photographers to that of left-handed pitchers. "The medium is so transparent," Szarkowski says. "There's so little to hide behind. When your perceptions fail you—when your seeing begins to get lazy or habitual—there's no place to hide. A painter has millions of ways of putting one color next to another. He can hide in the richness of the painting process. But not the photographer. Strand's achievement is really heroic. He's been making great photographs for sixty years."

Strand's own view of the matter is typically anachronistic. In a century whose major artists have continually stressed form over content, he believes in the sustaining power of subject matter. "Almost all the things of the world have their own character," he said last summer. "I think that what exists outside the artist is much more important than his imagination. The world outside is inexhaustible. What a person feels about life is not inexhaustible at all." Strand was sitting in a canvas chair in the small basement apartment that he and his wife keep on East Fifth Street, near St. Marks Place, for their visits to this country. He spoke slowly, reflectively, his unmistakably New York intonation softened by a slight but agreeable lisp. "Hazel and I just flew back from Los Angeles," he said. "From the opening of my exhibition out there. And looking down at parts of Nevada and Arizona from the air was—well, thrilling. The world is such a complex of marvelous things, and if you can find a way of using that complexity in your work, then it's endless. What counts for the artist is to do something he's never done before. That's what stretches him, makes him grow."

The conversation touched on contemporary art, which Strand does not really follow anymore, and on the deliberate denial of craftsmanship in such avant-garde forms as Conceptual and "process" art. Could art really exist without craftsmanship? "I suppose so," Strand said after a moment.

Although I don't personally know any significant form of art in which craftsmanship plays no part. It's one of the instruments of graphic speech, it's part of the orchestra. Some artists use the full orchestra, some use less, but I don't know of any who throw it away. People want to know what the content is, I think. What you describe, and what I haven't seen, sounds like coming to the end of the road and not yet finding another road to travel. But to announce that you have come to the end of the road is not a very interesting announcement.

Strand was born and brought up in New York City. The family's name was originally Stransky; Strand's father changed it shortly before Paul, his only child, was born, in 1890. The family was living then in a brownstone on East Seventy-third Street, but three years later they moved to a house on West Eighty-third, near Riverside Drive, which was where Strand grew up. The household consisted of Strand and his parents, an unmarried aunt, and Strand's maternal grandmother, Catherine Arnstein, who was the real center of the ménage. She and her husband had come over from Bohemia (now western Czechoslovakia) about 1840. Grandfather Arnstein had done well in the lathe business in New York but then had lost nearly everything in the stock market, leaving little inheritance. The house on Eighty-third Street was bought and given to Grandmother Arnstein by her son-in-law, a successful lawyer for the U.S. Rubber Company named Nathaniel Meyers, and the family lived on the combined earnings of Strand's Aunt Frances, who taught one of the city's first public kindergarten classes, and his father, Jacob Strand, who was for many years a salesman of French bric-a-brac, German enamel cooking ware, and other household items.

Strand was given a Brownie camera by his father when he was twelve, but he was so taken up then with the pleasures of spinning tops, roller-skating, and bicycling on the uncrowded streets (the first automobiles were just starting to appear, and the fire engines that Strand loved to chase after were horse-drawn) that he paid little attention to it. In 1904, however, Strand's parents, alarmed at the rough behavior of a number of kids from Hell's Kitchen in the local public school, enrolled him, at considerable financial sacrifice, in the Ethical Culture School, on Central Park West. One of the science teachers there was Lewis W. Hine, a young sociologist whose powerful photographs of children in factories would soon play a major part in the passing of new child-labor laws. Hine, who by this time had begun to photograph immigrants arriving at Ellis Island and then to follow them into the slums where so many of them became trapped, gave an extracurricular course in photography at Ethical Culture. Strand and about six other students signed up for it. They learned the fundamentals of camera and darkroom work, and how to use an open-flash pan of magnesium powder for indoor photography. Hine also took them to Stieglitz's Photo-Secession Gallery, at 291 Fifth Avenue, and it was here that Strand, discovering the work of David Octavius Hill

and Robert Adamson, Julia Margaret Cameron, Gertrude Käsebier, Clarence White, and other pioneers—including, of course, Stieglitz himself—decided, at seventeen, what he wanted to be in life. No matter what else he had to do to support himself, he wanted from that day to become "an artist in photography." He had no interest in going to college, which would have been a further strain on the family finances in any case. For a year or so after he graduated from Ethical Culture, he worked as an office boy in his father's importing firm. The firm was bought out by another company in 1911, whereupon Paul, in the face of severe family misgivings, took all his savings and spent them on a trip to Europe. For six weeks, he devoured the Continent country by country, visiting all the major museums and monuments and covering vast distances on foot. ("I had boundless energy in those days.") He came back in the fall to a job with an insurance firm, which he loathed. A few months later, toward the end of 1911, he quit and went into business for himself as a professional photographer.

Ever since his class with Hine, Strand had been spending most of his free time photographing, at first with the cumbersome 8- by 10-inch view camera, which he had on more or less permanent loan from his well-to-do uncle with U.S. Rubber, and later with an English-made Ensign reflex plate camera that he bought himself. He joined The Camera Club of New York, which had good darkroom facilities, and which he was also able to use as a portrait studio. Strand's mother felt that photography was not a suitable profession for anyone who wanted to get ahead, but his father seemed from the outset to understand it. "I think he knew right away what kind of photographer I wanted to become," Strand has said. "My father was not an intellectual man, but he was immediately interested by what he saw when I took him to the Photo-Secession Gallery, and he developed an extraordinary feeling for pictures. He felt that art was important."

Strand did a good deal of portrait work at first. He also traveled around the country taking pictures of colleges and fraternity houses, which he would then hand-tint and sell to students. His expenses just about equaled his income, but he saw a lot of the country, and in the work that he did for himself he steadily sharpened his vision and developed his personal style. Since his days with Hine, he had been experimenting constantly. He worked his way through most of the currently fashionable

photographic styles, which were, for the most part, attempts to make photographs look like paintings. Subjects were exposed in diffused light, and were slightly out of focus, or even deliberately blurred—one English landscape photographer of this period achieved his effects by kicking his tripod during exposure—and prints were made by a variety of chemical processes that thickened the pseudopainterly soup. Although Stieglitz had often championed the work of the better practitioners of such "pictorial" photography and shown it at "291," most of Stieglitz's own groundbreaking prints were examples of what was coming to be known as "straight" photography—that is, photography without special effects or manipulation. For several years, Strand had periodically been taking his work to "291," and receiving criticism from Stieglitz. He had also been absorbing the Stieglitz credo. As Nancy Newhall put it in the catalogue for Strand's 1945 show at The Museum of Modern Art, "Stieglitz pointed out that photography in its incredible detail and subtle chiaroscuro has powers beyond the range of the human hand. To destroy this miraculous image, as some members of the Photo-Secession, and Strand himself at the time, were doing, was to deny photography."

Stieglitz made no distinction between photography and other forms of visual art, and at "291" he showed—frequently for the first time in America—the work of Cézanne, Matisse, Picasso, Braque, and other European painters. Strand found it all fascinating and baffling. "Like most of the critics then, I was puzzled by it," he has said. "But I had a feeling that something very important was happening, and I wanted to know more about it." In an effort to understand what Picasso and Braque were up to, Strand made a number of abstract photographs—close-ups of pottery bowls, patterns of shadows on a front porch. It was a vital step in his development, he feels. "From it I learned how you build a picture, what a picture consists of, how shapes are related to each other, how spaces are filled, how the whole must have a kind of unity." Having learned this much, he never again felt the slightest need to work in pure abstraction; he simply applied the new knowledge to photographs like "White Fence," whose striking composition arises from the relationship between nine brilliant fence posts in the extreme foreground and the dark barn behind them.

"White Fence" was taken in 1916, during a visit to the upstate town of Port Kent, and it could be said to contain the seeds of all Strand's future

work. At this point, however, he still felt like a New Yorker, and the city, its inhabitants, and its dynamic patterns of movement and life fascinated him. "One of the elements I wanted to work with then was people moving in the street," he said recently.

> I wanted to see if I could organize a picture of that kind of movement in a way that was abstract and controlled. I became aware, for instance, of those big dark windows of the Morgan Building, on Wall Street. One of my classmates from school worked there, I remember; it always seemed too bad, because I thought he could have done something more in keeping with his abilities. Anyway, I was fascinated watching people walk by those huge, rectangular, rather sinister windows—blind shapes, actually, because it was hard to see in—and one day I went and stood on the steps of the Sub-Treasury Building and made a photograph trying to pull all that together. I don't know how I did it, really. At that time, film emulsions were so slow, and I couldn't have been shooting faster than a twenty-fifth of a second.

Strand's New York photographs are light-years away from the misty moods of the pictorialists. His New York is a harsh and threatening place, and the strains of living in it are etched into the faces of the poor and the elderly whom he photographed. "I suddenly got the idea of making portraits of people the way you see them in the New York parks—sitting around, not posing, not conscious of being photographed," he recalls. "People involved in the process of daily living. But how could you conceal the camera in order to do this? There was no such thing as a candid camera in those days." Strand's solution was to take the shiny brass lens from his uncle's old view camera and screw it to one side of his Ensign reflex. By holding the camera so that the false lens pointed straight ahead and the real lens stuck out under his left arm, partly concealed by his sleeve, he was able to photograph someone at right angles to the apparent subject. Most of the early portraits, including the famous "Blind Woman"—a close-up of a blind newspaper dealer on the corner of Lexington Avenue and Thirty-fourth Street—were made this way. It was a nerve-racking method, because there was always the possibility that someone would realize what Strand was doing. "I never questioned the morality of it," he has said.

> I always felt that my relationship to photography and to people was serious, and that I was attempting to give something to the world and not exploit

anyone in the process. I wasn't making picture postcards to sell. But then one day, out walking with the camera, I saw an old woman with a cage of para-keets. She was selling fortunes, which the birds would peck out. I walked by her without even opening the camera, and then a little later I came back, and she immediately attacked me. "You're not going to take my picture!" she said. It was like mental telepathy. Anyway, that finished me, at least for the time being. I decided to wait for a better technique.

About every two years, Strand brought his work to Stieglitz for criti-cism. He also showed it to Clarence White and to Gertrude Käsebier, whose advice was kind but not particularly useful. "They didn't help me develop," he says.

Stieglitz did. He had this great clarity of purpose, and he had no desire to use the camera to paint with. Anyway, in 1915 I really became a photographer. I had been photographing seriously for eight years, and suddenly there came that strange leap into greater knowledge and sureness. I brought a group of my things in to show Stieglitz, and when I opened up my portfolio he was very surprised. I remember he called to Edward Steichen, who was in the back room at "291," and had him come out and look, too. Stieglitz said, "I'd like to show these." He also told me that from then on I should think of "291" as my home, and come there whenever I wanted. It was like having the world handed to you on a platter. It was a very great day for me, match-ing, in a sense, the day that Hine took us to Photo-Secession and I saw the work of those other photographers for the first time.

Stieglitz showed Strand's work at "291" in March 1916, and he pub-lished a number of Strand's photographs that year in *Camera Work,* the magazine that he had made into the leading organ of modernism, not only in photography but in all the visual arts. *Camera Work* ceased pub-lication in 1917, for financial reasons; the final issue was devoted entirely to Strand's new photographs. In his introductory note to this issue, Stieg-litz wrote that in the history of photography there were very few photog-raphers who had done work of any lasting quality. Strand, he said, was someone "who has actually done something from within. . . . The work is brutally direct. Devoid of all flim-flam; devoid of trickery and of any 'ism'; devoid of any attempt to mystify an ignorant public, including the photographers themselves. These photographs are the direct expression of today."

It was an auspicious launching. At the age of twenty-five, Strand had

become a respected member of the Stieglitz inner circle, which included the painters Max Weber, John Marin (Marin, who lived in New Jersey, would come across the river to play billiards with Strand), Arthur Dove, Georgia O'Keeffe, and Marsden Hartley; the critic Charles Caffin; the caricaturist Marius De Zayas; and the photographers Edward Steichen, Frank Eugene, and Alvin Langdon Coburn. It was a lively period in American art, with the repercussions of the 1913 Armory Show still spreading rage and glee in unequal measure. "The atmosphere around Stieglitz and '291' was that of a group of people with strong common interests," Strand recalls. "Stieglitz provided the central leadership—no doubt about that. He used to speak of '291' as a laboratory, a place to evaluate the quality of the pictures and of people's reactions to them." The art critics and the derrière-garde painters continued angrily to repudiate the "senseless" aspects of Cubism and other advanced trends; many of the same people also clung to the notion that photography, because its tools were mechanical and chemical, could not be considered a valid form of art. "We were consciously fighting for the recognition of our medium," Strand has said, "and the painters fully supported us." Strand joined the skirmish lines and laid out his own artistic credo in an article that appeared in the magazine *Seven Arts* in 1917. Photography, he wrote, found its raison d'être as an art form in its unique and absolute objectivity. The photographer must develop and maintain "a real respect for the thing in front of him, expressed in terms of chiaroscuro through a range of almost infinite tonal values which lie beyond the skill of human hand," he said, and he added, "The fullest realization of this is accomplished, without tricks of process or manipulation, through the use of straight photographic methods. It is in the organization of this objectivity that the photographer's point of view toward life enters in, and where a formal conception born of the emotions, the intellect, or of both is as inevitably necessary for him before an exposure is made as for the painter before he puts brush to canvas. . . . Photography is only a new road from a different direction, but moving toward the common goal, which is life."

As a polemicist, Strand lacked the slashing eloquence of Stieglitz. On the other hand, he was even more uncompromising than his mentor in judging fellow artists. Speaking before the Clarence H. White School of Photography in 1923, Strand said flatly that the only two photographers who had met the test of art so far were Stieglitz and David Octavius Hill,

the nineteenth-century Scottish portraitist. (Today, he would enlarge the list to include Atget and perhaps Mathew Brady.) Most photographers, he explained, still made the absurd error of trying to use the medium as a shortcut to painting, instead of recognizing and working with the elements that were unique to photography. The essential photographic element, as he had written earlier, is time—the unique moment in time, captured and held forever. "If the moment be a living one for the photographer—that is, if it be significantly related to other moments in his experience, and he knows how to put that relativity into form—he may do with a machine what the human brain and hand through the act of memory cannot do." Strand never had the least desire to try painting or sculpture; for him, the challenge of photography was infinite, and so was the subject matter. "Above all, look to the things around you, the immediate world around you," he told the students at the Clarence H. White School. "If you are alive, it will mean something to you, and if you know how to use it, you will want to photograph that meaningness."

Strand printed nearly all his early negatives on expensive platinum paper, which he imported from England. Platinum offered a longer and richer scale of tonal values from black to white than silver bromide or chlorobromide papers did, and platinum prints would last a great deal longer. Strand experimented with ways to deepen and enrich the tones even further, adding to the prepared paper a platinum emulsion he had made himself and then gold-toning it to intensify the blacks. His results astonished other photographers. Walker Evans once said that the original platinum print of Strand's "Blind Woman" (now owned by The Metropolitan Museum) influenced his whole development. Strand made platinum prints until 1937, when the paper became impossible to get. He often says sadly that any photographic material of high cost and superior quality is apt to become unobtainable sooner or later, because the industry is geared to producing for the amateurs who have made photography the world's most popular hobby.

It was not possible, of course, to earn a living from Strand's sort of photography. Stieglitz sold a few Strand prints at "291" for between two hundred and two hundred and fifty dollars each, but the prices barely covered the expensive and time-consuming process of making the prints. By 1922, at any rate, Strand was supporting himself not by still photography but by work as a free-lance motion-picture cameraman. Drafted into

the Army in 1918, he had been sent as a hospital-corps trainee to the Mayo Clinic, in Minnesota, where watching the Mayo brothers operate gave him the idea of filming surgical operations and showing the films to medical students. Strand served for eighteen months as an X-ray technician in the Army hospital at Fort Snelling, Minnesota. When he got out of the service, in 1919, he tried his hand for a while at advertising photography—his clients were Hess-Bright ball bearings and Eno's fruit salts— but early in 1922, just as this new field was becoming commercially rewarding, he was approached by some people who wanted to form a small company to make medical films, and Strand, remembering his Mayo Clinic experience, agreed readily to become their cameraman. He had acquired a little experience in movie work already, having collaborated in 1921 with Charles Sheeler, the painter, who owned a French motion-picture camera, on a short documentary film about New York, entitled *Mannahatta*. The film, which was silent, had subtitles taken from Walt Whitman's writings, and it played for a week at a Broadway movie house under the title *New York the Magnificent* (the theatre owner thought Whitman's title too arcane), but neither Strand nor Sheeler could afford to make another. In 1922, though, Strand's new backers authorized him to go out and buy the best movie camera available for making medical films. The best camera, Strand found, was the Akeley. It had been designed by Carl Akeley, the African explorer, specifically for taking pictures of wild animals in the bush. Movie cameras in those days were cumbersome behemoths, mounted on huge tripods that had one handle for moving the camera up and down and another for moving it sideways ("panning"); it was almost impossible to work both handles simultaneously so as to follow a fast-moving subject. Akeley, however, had worked out a series of friction gears in the tripod head which enabled the cameraman to pan and tilt smoothly and simultaneously using only one handle, and a small company had been set up to meet the demand for his invention. No sooner had Strand arranged to buy the Akeley camera, however, than he was informed that his backers were withdrawing their support. "I never did find out what had happened," he said later. He went back in some embarrassment to the Akeley company, to explain his dilemma. The Akeley people suggested that Strand buy the camera himself. There were four or five "Akeley specialists" working in New York then, they told him, making a good living by doing free-lance film work for

newsreels and Hollywood studios. Strand, with no job and no prospects, had just inherited twenty-five hundred dollars from the estate of his wealthy uncle, and twenty-five hundred dollars happened to be precisely what the Akeley cost. He bought it. "It was a very beautiful camera," he said. "I'd already fallen in love with it anyway." The first thing he did was to take it home and photograph it with his still camera, taking a series of close-ups of the interior mechanism that are among the most beautiful machine photographs ever made.

For the next ten years, Strand earned his living as an Akeley specialist. He filmed sports events for Pathé News and Fox Films, and went down to Louisville every spring to cover the Kentucky Derby. He lugged his heavy equipment—camera, tripod, and film case weighed in at ninety pounds—to the top of the Yale Bowl and the Harvard Stadium for football games, and he shot, edited, and put together films for several successive graduating classes at Princeton, depicting the athletic and social highlights of the senior year. Occasionally, he was hired to shoot action sequences for Hollywood films. He climbed twenty-two stories above the street to film Richard Dix's double clinging to a steel girder of the Telephone Building, on West Street, which was then under construction, and he helped to shoot the Battle of Lexington—in Plattsburgh, New York— for *Janice Meredith,* starring Marion Davies. "I accepted every job that came my way, and it didn't do me a bit of harm," he has said. He earned thirty-five dollars a day at first, and eventually, by demanding it, he got fifty. His real interest, though, remained still photography, which he practiced on weekends and whenever else he could find the time.

In 1922, Strand had married Rebecca Salsbury, a strikingly handsome artist, whose father, Nate Salsbury, had been Buffalo Bill's partner and manager. Becky Strand was a great friend and admirer of Georgia O'Keeffe, whom Stieglitz married in 1924; friends considered the two women remarkably similar in looks and personality. To save money, the Strands lived with Strand's family in the house on West Eighty-third Street—Strand's mother and grandmother had both died by that time, his mother in the influenza epidemic of 1919—in an upstairs suite that they transformed into a modern atelier, with white walls and very little furniture, and with photofloods pointed at the ceiling for light. It was not until 1926 that the young Strands had enough money saved to go away in the

summer. They went to Colorado, where Strand photographed at Mesa Verde National Park, experimenting with close-ups of tangled roots and blasted tree trunks. Later, they went to Taos. Mrs. Mabel Dodge Luhan, to whom they had an introduction, let them use one of her houses there for two weeks. Strand liked the country but was put off by Mrs. Luhan, whom he thought domineering, destructive, and rather silly in her self-appointed role as the doyenne of Taos. "I hadn't the slightest interest in photographing her," he said once. The next two summers, the Strands went to Georgetown Island, in Penobscot Bay. Their neighbors there were John Marin, Marsden Hartley, and Gaston Lachaise, all of whom he did photograph, either then or later. (Strand considered Lachaise one of the three leading modern sculptors—the others were Brancusi and Lehmbruck—and he was both flattered and pleased when Lachaise offered to trade a small bronze for a Strand print, something no other artist has done to this day.) Strand spent the two summers photographing mushrooms, rocks, plants, a cobweb in the rain, and other natural details—usually in extreme close-up.

"I've always had an interest in the things that make a place what it is, which means not exactly like any other place and yet related to other places," Strand said recently.

> Growing things are part of the quality and the character of a place; the things that grow by the sea are not like the things that grow, say, in the middle of Kansas. It's the same with rocks. Rocks by the sea are different, because the sea has washed them and done things to them, and trees by the sea are very special, too. Incidentally, I discovered something that first summer at Georgetown that was vitally useful to me. You see, if you want to photograph growing plants, flowers, grass, or whatever, and if you want to do it at a very small lens opening and with a long exposure—two or three minutes—then you have a problem, because there's always a wind, and they move. I solved that by trial and error. I found that when I sensed the wind coming I could close the shutter, wait until the wind had passed, and reopen the shutter. The plant would have always returned to the exact same spot it had been in before. That way I could get an absolutely clear, needle-sharp picture.

The problems of dealing with larger landscapes did not really emerge for Strand until the summer of 1929, when he and his wife went around the Gaspé Peninsula. "The landscape problem is the unity of whatever is

included," Strand has said. "In a landscape, you usually have fore-ground, middle ground, distance, and sky. All these have to be related. This is very difficult to do, of course. There are plenty of landscapes in art where the sky has no relation to the land—some of the Impressionists, like Pissarro, made that mistake. I would say that the landscapes of Cézanne are the greatest of all, because not only is every element in the picture unified but there is also unity in depth; there is this tremendous three-dimensional space that is also part of the unity of the picture space. Anyway, I became very conscious of the need to master this problem."

Strand's work in the Gaspé that summer, done with a 4- by 5-inch Graflex hand camera, was a continuation of his "search for what might be called the essential character of a place and its people," as he has termed it. In Strand's pellucid Gaspé landscapes, with their marvelously balanced images of land and sea and sky, of boats and houses, of fences and barns, it is almost possible to infer the sounds and smells of the place; the sense of peace and stillness seems to emanate from the land itself, rather than from the photograph. Strand's landscapes are seldom spectacular or awesome, in the way that Edward Weston's and Ansel Adams's are. Weston, a Californian who had come to New York in 1922 and met Stieglitz and Strand, noted in his daybook in 1929 that both he and Strand were using trees and rocks as subject matter—"he on the Atlantic Coast, I on the Pacific"—and a year later he was wondering anxiously whether this might lead to accusations of plagiarism. In reality, their work was profoundly different. Weston's images had a dynamic, sculptural power that riveted the eye; Strand's were like tapestries, with every part of the picture space working together. As for Ansel Adams, he and Strand first met in New Mexico, where Strand photographed during the summers of 1930, 1931, and 1932. Adams, who had been trained as a musician, was staying in one of Mabel Dodge Luhan's houses; the Strands had rented another. When Mrs. Luhan abruptly informed Adams that she needed his house for someone else, the Strands invited him to come and stay with them for a few days. The Strand house was about four miles from the adobe church of Ranchos de Taos, whose thick walls and buttresses were replastered by hand every year by the Indians. Strand used to watch the sky, and when he saw a storm coming he would get in the car, head for the church, and have his camera set up by the time the storm got there. What have come to be known as "Strand clouds"—heavy, lowering shapes holding rain and threat of storm—appear in a

great many of his photographs of the arid Southwest, suggesting that the essential character of a region may have a good deal to do with the essential character of the artist who is depicting it. A friend of Strand's in those years remembers him cursing under his breath whenever fluffy, cottony cloud formations, which he referred to as "Johnson & Johnson," took over the sky; they never appear in his prints.

Henwar Rodakiewicz, a photographer who was then living in Taos, took Strand around to some of the ghost towns of the Old West—to St. Elmo and to Aspen, Colorado, which had not yet been discovered by Walter Paepcke. Strand photographed their crumbling wooden houses and caught echoes of the frontier in a worn door latch or a corner of adobe wall. The quality of Strand's negatives impressed Adams so deeply that, as he said later, he decided to devote himself exclusively to "straight" photography. Strand, however, was not at that period a great encourager and promoter of young photographers. Wholly concentrated on his own work, uncompromising in his standards, and rather stiff in personal relations, he kept even his admirers at a distance. His sense of humor took the form of elaborate and elephantine puns and limericks, some of which were days, or even weeks, in the making. He had no talent for simulating polite interest or for disguising what he thought or felt. Strand's admiration extended to very few photographers aside from Stieglitz, and even Stieglitz was not sacrosanct. Stieglitz's aestheticism, which expressed itself toward the latter part of his life in photographs of cloud formations that he called "equivalents," seemed to Strand increasingly removed from what he himself wanted to do in photography. "I'm a politically conscious person," Strand said not long ago. "I've always wanted to be aware of what's going on in the world around me, and I've wanted to use photography as an instrument of research into and reporting on the life of my own time. It was probably just inevitable for us to come to some sort of parting of the ways." The parting was never complete, for the two men continued to meet on friendly terms until Stieglitz's death. But after 1932—when Strand went to Mexico and stayed for two years—they saw one another far less frequently.

In 1932, Strand's marriage was coming apart. Toward the end of the summer—the third they had spent in New Mexico—Mrs. Strand returned to New York, and Strand headed down into Mexico. He had made friends with Carlos Chávez, the Mexican composer, in Taos the previous summer (Chávez, too, was on Mabel Dodge Luhan's string) and had

written to him about the possibilities of photographing in Mexico. Chávez urged him to come, and Strand set off in his Model A Ford. The Mexican landscape awed him. "The minute you get into Mexico, you begin to see a range of mountains that must be part of the American chain but are completely different," Strand recalls. "They have a different feeling—something I found a little threatening and sinister." For many years, Strand had believed that one had to know a country well before attempting to photograph in it, but in Mexico he found himself paying no attention to this dictum. Some of his finest Mexican photographs, he says, were made during his first few days in the country. In Mexico City, Chávez extended a warm welcome. As conductor of the Mexican Symphony Orchestra and director of the National Conservatory of Music, he wielded considerable authority. He arranged for Strand to exhibit his photographs in a Ministry of Education building and he also wangled a government commission for Strand to work with his nephew, Augustine Velasquez Chávez, on a report on art education in rural schools in the state of Michoacán. Strand and the younger Chávez traveled together, and Strand began for the first time to make portraits with the aid of a prism. Ever since his experience with the woman selling fortunes in New York, he had been looking for a better technical method of making portraits of people who were not aware of being photographed. In 1931, in New York, he had sold his 4- by 5-inch Graflex and bought a 5- by 7 Graflex, which had a shutter that allowed for automatic exposures of up to one minute, and he had had the lens fitted with a removable extension that concealed a fine optical prism. With this extension in place, the lens would photograph at ninety degrees to the angle at which it was pointed. The portraits that Strand took in Morelia, Pátzcuaro, and other towns in western Mexico with this device were extraordinarily successful. The subjects are usually shown full-face, looking gravely at the big camera that they do not suspect is focused on them. There is a beauty and a gentle dignity about each face—even the faces of the children—that suggest Strand's feelings about them. More than ever, his portraits were acts of love.

Strand was enthusiastic about the work of the great Mexican mural painters Rivera, Siqueiros, and Orozco, and also about the social reforms that were taking root in Mexico after decades of insurrection and bloodshed. When Carlos Chávez suggested that Strand take charge of a five-year plan to make films that would reflect the real concerns of the Mexi-

can people, Strand immediately set to work drawing up a series of pro-posals. He and Chávez and Narciso Bassols, the Minister of Education, were in agreement that the principal audience for these films would be Mexico's eighteen million Indians, most of whom were illiterate. According to Strand, the three men were also agreed that there should be no "filming down" to anyone; the highest aesthetic standards would always apply, on the theory that the best art would appeal to the largest number. The first—in fact, the only—film to come out of this high-minded endeavor was *Redes* ("Nets"), whose English title is *The Wave*. Strand and Augustine Chávez conceived the idea and wrote the outline for the film, a part-documentary, part-fictional feature whose plot had to do with a strike by poor fishermen against a merchant who was exploiting them. Strand got his Taos friend Henwar Rodakiewicz to come down and work out a detailed shooting script, and when Rodakiewicz had to go back to the States for a prior commitment he got *his* friend Fred Zinnemann, then an aspiring young Hollywood director with no films to his credit, to direct it. The film is about sixty-five minutes long and contains many stunning images that could very well have been Strand stills; one critic said later, a trifle sardonically, that it was "the most beautiful strike ever filmed." Strand photographed it with his Akeley, hand-cranking at three revolutions a second instead of the customary two, because that was what sound film required; according to Rodakiewicz, Strand would get excited now and then and crank the handle even faster, which has led some film historians to credit him with the first use of slow motion as a cinematic device. Only one professional actor was used—the exploiting merchant—and he turned out to be the film's only obvious ham. The rest of the cast consisted of local fishermen of the town of Alvarado, on the Gulf Coast, near Veracruz. *The Wave* took nearly a year to make, in part because of Strand's insistence that every detail be perfectly realized. The shooting of one scene was held up for a month because one of the fishermen, the helmsman in the lead boat, took the notion one morning to get a haircut. By the time the film was finally edited, in the fall of 1934, Lázaro Cárdenas was President of Mexico and the previous administration's five-year film plan had been shelved.

Strand packed up and went back to New York. He was feeling somewhat at loose ends. Divorced—Rebecca had gone to live permanently in New Mexico—and no longer so close to Stieglitz, he gravitated to what

might appear an unlikely new association: the Group Theatre. Harold Clurman, Lee Strasberg, and Cheryl Crawford, the three Group directors, wanted to build a permanent repertory company that would perform contemporary plays on the highest possible artistic level, and Strand, although never much of a theatregoer, had become interested in their work. Consequently, when he got back to New York in late 1934 he was delighted to find that the Group was riding high; in fact, its production that winter of Clifford Odets's *Waiting for Lefty* was the hit of the season.

In those Depression years, the Group was considered to be somewhat left-wing in its political sympathies. Actually, as Clurman pointed out in his book *The Fervent Years,* the Group's directors and players were political naïfs, concerned almost totally with the aesthetics of the theatre. They were particularly interested in the aesthetics of the theatre in the Soviet Union, and Strasberg had modeled his own work with actors on the celebrated "method" of Stanislavsky. The productions of the Moscow Art Theatre; the films of the Russian directors Eisenstein, Pudovkin, and Dovzhenko; and the social context that had given birth to this creative ferment—all were a source of great interest to many American intellectuals of the period. Indeed, in 1935 Clurman told Strand that he and Cheryl Crawford were going to Moscow to see for themselves. Would he come along? Strand was eager to go. He met Clurman and Crawford in Moscow that summer, and stayed a little more than two months. They received tickets to all the major theatres and met the great theatre figures and film people. Sergei Eisenstein looked at a few feet of film stock from *The Wave,* holding it up to the light, and said jovially that he could see Strand was essentially a still photographer rather than a filmmaker—a comment that struck Strand as "a little overfast, but I didn't mind." (Actually, Strand took no photographs at all in Russia.) Later, Eisenstein invited Strand to work with him on a new film (Strand had brought his Akeley along), but the difficulties of getting a work permit proved to be insuperable.

In New York at this time, a number of young photographers were becoming interested in the possibilities of documentary films. Excellent documentaries were then being made in England, but in spite of the great legacy of Robert Flaherty's *Nanook of the North* (1922) and *Moana* (1926), the form was dormant here, and Flaherty himself was working in England. In a period when perhaps twelve million Americans were un-

employed, the newsreels of the day featured naval vessels docking and bathing beauties pirouetting. The "March of Time" series, which started in 1934, was a big improvement in this field, but serious filmmakers wanted to go much further with the form; influenced by the work of the Group Theatre, they wanted to make documentaries that dealt with complex social issues, and did so with all the resources of the cinematic art. "We felt the need for the development of an independent film movement run by artists," Leo Hurwitz, one of their number, put it not long ago. Hurwitz, Ralph Steiner, Sidney Meyers, Lionel Berman, Irving Lerner, and Ben Maddow had banded together in an informal association called Nykino (with a nod to the Soviet director Dziga Vertov's Kino-Pravda newsreels). Although Strand's Mexican film had not yet been released in the United States, they knew about it, and Strand had attended several of their meetings in Steiner's studio before going to Moscow. "They had the same attitude toward filmmaking that I had in Mexico," Strand said recently. "They felt that a documentary should have the highest possible aesthetic content and dramatic impact."

On his return from Russia, Strand was invited by Steiner and Hurwitz to work with them on *The Plow That Broke the Plains,* a documentary on the Dust Bowl. Sponsored and financed by the United States Resettlement Administration, one of the New Deal agencies, it was to be produced and directed by Pare Lorentz, a film critic who had never yet produced or directed a film, and, as Hurwitz and Steiner outlined the project, it was to show how the misuse of the land for short-term profits had combined with nature to produce what would today be called an ecological disaster. None of the three photographers knew Lorentz well, and in Strand's view this was the real root of the troubles that began as soon as they left New York for Wyoming and Montana, to film farmlands as they had looked before the Dust Bowl.

"Lorentz saw us off at the railroad station and handed us the shooting script, which he had written himself, and which none of us had seen until that moment," Strand recalls. "We read it on the train with mounting astonishment. We couldn't understand it. It just wasn't a guide to the sort of action that we could take with the camera."

Leo Hurwitz felt the same way. "The script was full of personal visions and fantasy," he said recently. "For example, Lorentz had one scene in which a lot of men in top hats would walk across a field, get on tractors,

and plow up the field. The idea was clear enough—that the rich who profited by grain deals were the ones who were destroying the land—but there was no way that we could see to make the scene work with the rest of the material."

When their train stopped at Buffalo, they sent a wire to Lorentz saying they couldn't understand his script and would he please send them another as soon as possible. No new script was waiting for them when they got to Montana, so, rather than lose time, they decided to go ahead on their own with background work. They filmed what the Great Plains had once looked like, with cattle and sheep grazing on the tall grass that, farther south, had been plowed up indiscriminately to plant wheat. But unless the film was to be all background, they needed a script. "Finally, we wired Pare again to say we were writing our own script," Hurwitz recalls. "We headed down to the Texas Panhandle to film the real Dust Bowl stuff, and on the way we stopped off in Alliance, Nebraska, where I rented a typewriter and knocked out a script."

Lorentz met them in Dalhart, Texas. There was no direct clash of wills, but matters were sufficiently tense. Steiner, who had become increasingly uneasy about the revolt—he now feels that they could perfectly well have shot from Lorentz's script, as he himself did later from Lorentz's equally poetic script for *The City*—worked with Lorentz, and Strand and Hurwitz worked together as a separate film unit, and notwithstanding a certain lack of communication, they managed to shoot the necessary footage. None of the three photographers had any further contact with the picture, which Lorentz edited, and which struck them all, when they saw it, as surprisingly good. Hurwitz has said it was "a great surprise" to him to find that Lorentz had done such a brilliant editing job, although he insists that the finished film bore little relation to Lorentz's original script. (The men in top hats were not included.) "The film is first-rate, so I don't understand why people are so busy being resentful," Strand said not long ago.

Filmmaking, in any case, had become Strand's full-time occupation. The informal Nykino group evolved in 1937 into Frontier Films, a nonprofit production company dedicated, as Strand once put it, to making films that would be in some sense warnings. "We were very concerned about what was going on in the world," Strand has said. "We were very concerned about the Spanish Civil War. Elmer Davis, who later became

head of the Office of War Information, called people like us 'premature anti-Fascists,' which was pretty shocking and infuriating. It wasn't that we told an untruth—it was that we told the truth too soon." Strand was president of Frontier Films from 1937 until the company dissolved, in 1942. During this time, Frontier completed seven documentaries: *Heart of Spain,* edited by Strand and Hurwitz from footage that was shot, mostly in Madrid, by two amateur cameramen, and that dealt with the pioneering blood-transfusion work being done for the Republican side by the Canadian doctor Norman Bethune; *China Strikes Back,* about the training of the Red Army in Shensi Province, with shots of the young Mao Tse-tung and Chou En-lai; *People of the Cumberland,* about a school in Tennessee, filmed by Steiner and directed by a novice named Elia Kazan; *Return to Life,* another film shot in Spain, produced and directed by the young French photographer Henri Cartier-Bresson; *White Flood,* about glaciers, filmed by the naturalist Osgood Field, who was a Frontier trustee; *United Action,* about the daily lives of striking UAW workers in Detroit, sponsored by the union; and *Native Land,* with a commentary by Ben Maddow, and directed, filmed, and edited by Strand and Hurwitz. By far the most ambitious of the lot, *Native Land* was based on the Senate's LaFollette–Thomas Committee hearings on civil-rights violations throughout the United States, and, in particular, on the campaign by some large corporations to break the developing power of the labor unions. The film lasts nearly two hours, and it took two years to make, with one eight-month hiatus when Strand and Hurwitz ran out of money and had to raise additional funds. Strand is still very proud of the film, which mixes straight documentary material with dramatic reenactments—his second wife, a young Group Theatre apprentice named Virginia Stevens, is featured in the final scene at the grave of a slain labor leader—but, unlike some of the other Frontier films, it was not widely shown. It was released in 1942, after the United States had entered World War II, and exhibitors were not eager for films about civil-rights violations.

During the war, some of the Frontier people worked for the government or for the Army, making training or propaganda films. Strand and Hurwitz went to Washington to propose the formation of a film unit that would work with troops in the field, but they were turned down. Later, they were assigned to write a script for a film about the cargo run to

Murmansk, but the film was never made. Hurwitz feels sure that in both cases they were rebuffed because of their "premature anti-Fascism" and their work on *Native Land.* Strand did do some film work for government agencies in 1943. He also conceived and put together for the Vanderbilt Gallery a large photographic chronicle of the first twelve years of the Roosevelt Administration—he was a great admirer of Roosevelt, and the exhibition was intended to help his reelection. But after 1942 he made no more films of his own. "Things do have an ending, although not always one you can be happy about," he said once. "I'm proud of all the films Frontier made. We were learning how to dramatize documentary material, to involve people emotionally, just as the story films did. But I never had any desire to be simply a cameraman." After ten years as a filmmaker, Strand returned, at the age of fifty-three, to still photography.

He had never really left it completely. In 1936, there had been a new series of photographs of the Gaspé, where he and Virginia Stevens spent their honeymoon. In 1940, he had spent months working with a printer on a hand-gravure portfolio of his Mexican prints. (The portfolio included twenty gravures and sold for fifteen dollars; today The Museum of Modern Art insures its copy for a thousand.) For ten years, Strand had been working under great pressure in collaboration with others, and now he was content to work quietly and on his own. In the spring of 1944, he went to visit his friend Genevieve Taggard, the poet, and her husband, Kenneth Durant, in the West River Valley of Vermont, a region that appealed to him so much that he got a room at a neighboring farmhouse and stayed several months, photographing. The haunting portrait of "Mr. Bennett," a farmer who lived across the road from the Durants, dates from this period. "He died six months later," Strand has said. "That's one of the things in his face, although I didn't know it then." In 1945, Nancy Newhall, in charge of the Department of Photography at The Museum of Modern Art while her husband, Beaumont Newhall, the regular curator, was in the Army, proposed a Strand retrospective. Strand and Mrs. Newhall worked together on this show, which contained a hundred and seventy-two photographs, covering thirty years' work, and was the first major retrospective that MOMA ever devoted to a photographer. During their collaboration, Mrs. Newhall suggested to Strand that they do a book together about New England. She had been struck by the powerful "sense

of place" running through his work. A New Englander herself, she thought it would be interesting to combine Strand's photographs of the region with writings by New Englanders from the earliest days to the present. Strand was much taken with the idea. For the next few years, then, while Nancy Newhall combed the New York Public Library for quotations, from Cotton Mather to Van Wyck Brooks, Strand traveled and photographed in various parts of New England. He spent six weeks with his old friend John Marin at Cape Split, Maine; their neighbor was a lobsterman, whose wife, Susan Thompson, became the subject of what may be the loveliest of all Strand portraits. Strand, as he later wrote, was looking for "images of nature and architecture and faces of people that were either part of or related in feeling to [New England's] great tradition." Eventually, he and Mrs. Newhall sat down together and worked out the combination of text and photographs, in associations that were poetic rather than concrete. The result was *Time in New England,* published in 1950. Although the reproduction of Strand's photographs fell far short of his expectations, he found that the process of making a book in which text and photographs interacted so as to enrich one another appealed to him enormously. "It was a major turning point in my whole development," he said.

Needless to say, there was little money to be made from books of this sort, but by now Strand no longer needed to earn a living. After years of marginal struggling, his father had become quite successful in business—among other things, he was the distributor of Domes of Silence, the little metal devices that keep chair feet from scraping the floor. Jacob Strand believed in what his son was doing, wanted to help him, and did so. "He had gone to work at the age of twelve, but he retained a marvelous openness and tolerance," Strand recalls. "He must have had something of the artist in him. During the twenties, when John Marin was having financial problems, Stieglitz got together a group of people who each agreed to give Marin two hundred dollars a year for three years, at the end of which they would be entitled to a Marin watercolor valued at twelve hundred dollars. My father joined, and when it came time for him to pick his watercolor he picked the top one. I always felt great support from him. He made me feel that what I wanted to do with the camera was all right."

One thing that Strand had long wanted to do with the camera was to make a book about a village—a book in which he would try, as he put it,

"to find and show many of the elements that make this village a particular place where particular people live and work. The idea came from my great enthusiasm for Edgar Lee Masters's *Spoon River Anthology*," he says. "I had considered doing it in Taos when I was there, but then I left and never went back, and the filmmaking started." The book that Strand envisioned would in no way derive from the sort of photojournalism that such magazines as *Life* and *Look* were helping to develop. "I haven't really got a journalistic streak," he said once. "That was always the part of my work with the Akeley that I detested. I wanted to avoid anything that would take me away from my particular way of looking at things." Interest in doing his village book was rekindled during his travels in New England. But by the time *Time in New England* was published, Strand had begun to feel a little uncertain about doing a book on an American village. He was disturbed by what he saw happening in this country. Leo Hurwitz and a number of his former colleagues had been blacklisted as dangerous radicals by the film industry and were having trouble finding work. Strand's thoughts turned to Europe. "The intellectual and moral climate of the United States was so abused, and in some cases poisoned, by McCarthyism that I didn't want to work in an American village at that time," he said recently. "It was not in any way a rejection of America; it was a rejection of what was happening in America just then. Also, I had an impulse to travel—to see what was happening elsewhere in the world." He had not been to Europe since 1911, when he was twenty-one. Moreover, there was another honeymoon in prospect. In 1949, the year his second marriage ended in divorce, Strand met Hazel Kingsbury, who, after working for several years as an assistant to Louise Dahl-Wolfe, the fashion photographer, had enlisted in the Red Cross during the war and served as a photographer, traveling extensively in the European and Far Eastern war zones. She and Strand were married in the spring of 1951 and soon afterward left for France, intending to stay only a few months.

For some time after Strand got to France, he took no photographs. For weeks, the Strands traveled around the country, looking for the right village in Brittany, in the Charente, in Provence, and elsewhere. They never found it. "That was our fault," Strand said not long ago. "We could have worked in many places. But we didn't know anything about French life or French people, and it was discouraging to find that at six-thirty every evening all the houses were shuttered. We had the feeling of being barred from close contact. On the other hand, I did eventually begin to see things

to photograph that I thought were very much France—things I'd never seen anywhere else. So although we didn't find our village, I ended up doing a lot of work."

Strand's French photographs, published in a book called *La France de Profil,* show a countryside and a way of life that now, twenty years later, have all but disappeared. There are no shots of familiar monuments, and not a single picture taken in Paris—just as in his New England book there are no pictures of Boston or any other large city. Strand's France is rural, particular, and very old. As Claude Roy wrote in his introduction to the book, "He let himself drop into the taciturn depths of the French nation with the submissiveness of a pebble that falls to the bottom of a well, and made all kinds of everyday discoveries on his way. What he had to tell us on his return, that wise New Englander companion of the Tour de France—ah! it wasn't so gay, or flattering, or delightful . . . it was very beautiful."

The Strands found their village the following year, in Italy. The screenwriter Cesare Zavattini had agreed to work with Strand on a book about an Italian village, and, after doing some work in the town of Gaeta, near Naples (where the poverty was so overwhelming that women offered to sell their babies to them), they settled on Zavattini's own home town of Luzzara, in the Po Valley. "There was nothing immediately stirring or attractive about the place, but Hazel and I weren't looking for picturesqueness," Strand said later. "The plainness was a challenge; it meant you had to look closer, dig into the life with more intensity." The Strands spent about two months photographing Luzzara and its inhabitants—five weeks in the spring of 1972 and three weeks in the fall. The resulting book, called *Un Paese,* with an Italian text by Zavattini, strikes some people as an unaccountably somber portrait of Italians (in whom somberness is not exactly a national trait), but it contains some of the strongest and most eloquent photographs that Strand has ever done. The book's summation is in the famous group portrait of the Lusetti family, tenant farmers, in front of their house—a composition that the British art critic John Berger found thoroughly comparable in expressiveness and moral authority to the work of the French seventeenth-century painter Louis Le Nain.

The moral dimension in Strand's work has become more and more apparent since his move to Europe. Over the next twenty years, in all the

places where he chose to work—the Outer Hebrides, Egypt, Morocco, Ghana, Romania—what he has looked for, and frequently found, is the enduring dignity of those to whom he once referred in a speech as "the plain people of the world, in whose hands lies the destiny of civilization's present and future well-being." Avoiding cities and crowds, working slowly with his big cameras, he has seemed sometimes to be making statements about the present in terms of the undying past. Even in his series of portraits of French artists and intellectuals, made during the 1950s and published in part in the *Aperture* monograph of his collected work, what strikes the viewer is not so much the uniqueness of each individual as the moral energy that has shaped his or her character. Strand approached his famous subjects directly, making no effort to pose them. Climbing onto the wooden stepladder that an Italian carpenter had made him so that he could place his camera on a level with the subject's eyes, he photographed them in their homes and in natural light, without tricks or effects of any kind, and he rarely even spoke to them while he was working. Strand did not want to "create" the situation or the atmosphere of the portrait by telling his subjects where to stand or sit or how to look. Somehow, they all—Picasso and Cocteau and Sartre and Malraux and the others—seemed to reveal themselves, at the moment Strand pressed the shutter, with the simple and unselfconscious directness of Hebrides Islanders or Egyptian fellahin. "There are a lot of people in the world I have no desire whatsoever to photograph," Strand said once. "I like to photograph people who have strength and dignity in their faces; whatever life has done to them, it hasn't destroyed them. I gravitate toward people like that."

Some critics believe that Strand's post-1950 photographs are not as strong, overall, as the work he did earlier in his career. There is a certain ambiguity about human character in the early Strand—an ability to look unblinkingly on meanness and ugliness as well as on strength and dignity—which is rarely evident in his later work. He has been criticized for photographing Egypt and leaving out the flies and the dirt and the poverty. "You just can't have *all* heroes," a Strand admirer said recently. There is another view, however, which finds in the European photographs a depth and complexity of pure image-making that no photographer before him has ever approached. "Look at some of the photographs of Moroccan markets," says Michael Hoffman, publisher of *Aperture* and the person mainly responsible for organizing the Strand retrospective in

1971. "Look at the detail, and the relationships of the figures, and the sense of complex, dense life. One could really *live* in that time and that place. The image itself takes on a life inside the print. It's very mysterious, what goes on in a Strand print, and I don't think it can be explained."

Until 1971, at any rate, there was very little discussion of Strand's more recent work, because very few Americans had seen it. *Time in New England* went out of print almost immediately, and the books that were published in Europe—*La France de Profil,* in 1952; *Un Paese,* in 1955; *Tir a'Mhurain,* in 1962 (the title is Gaelic for "Land of Bent Grass," which is the old name for South Uist Island, in the Outer Hebrides); *Living Egypt,* in 1969—were not readily available in the United States. The consequent neglect of his reputation had no appreciable effect on Strand. He kept right on doing what he wanted to do, living simply on the inheritance from his father, and dedicating himself wholly to work of the most exacting standards. He has been helped immeasurably by his wife. Having been a professional photographer herself, Hazel Strand has been able to take over many of the technical details of his work. She develops most of his negatives, does the spotting and cataloguing of finished prints, and handles much of the correspondence with publishers and museums. In the field, she makes a rough sketch and notes down the pertinent information for every photograph he makes, and she also smooths the way for him through bureaucracy, dealing easily and tactfully with, for example, African officials and natives whose language she may not speak but with whom she manages somehow to communicate with great good humor. It is doubtful whether Strand could have done what he has done in the last decade—the decade of his seventies and early eighties—without her help. "I've had enough experience in my life so that I don't worry much about things," Mrs. Strand said recently. "Once Paul gets under the dark cloth, he's completely oblivious of everything. I'm the one who sees to it that no bare feet get caught under the tripod." When Strand talks these days about "our" work, as he does, he means to imply that it is a full-fledged collaboration.

The Strands say that they never really made a decision to live permanently in Europe—that it just seemed to happen that way. For several years, while they were working on the French and the Italian books, they had their base of operations in Paris—first in the Hôtel l'Aiglon, on the

Boulevard Raspail, and later in a fifth-floor walk-up apartment on the Boulevard Auguste-Blanqui. In 1955, they began to look for a house in the country, mainly so that Strand, for the first time in his life, could have a fully equipped darkroom; for one nearing sixty-five, makeshift accommodations in converted bathrooms seemed an unnecessary handicap. When they bought an old house in the tiny village of Orgeval, near Paris, they were thinking vaguely of eventual resale. But Strand had his ideal darkroom built there, and Hazel restored and enlarged the garden, "and now," she says, "we're so settled in we couldn't think of leaving." The house is airy and comfortable and full of books (*all* the latest photography books), and the walled garden, with its rows of espaliered pear trees and its flowering walks and borders, is a delight in all seasons. Strand photographs in it a good deal these days; he has spoken of making a book of these pictures, to be called "On My Doorstep." Their trips in to Paris are increasingly few and far between, but they visit the United States at least once a year, and keep in touch with what is going on here. In 1965, Strand refused, along with Robert Lowell and others, to attend a White House arts-festival luncheon because of his opposition to American policies in Indochina, and he published a letter to that effect in the *Times*. Although Strand could be mistaken for a Frenchman—his handsome, nearly bald head is thought by many people to bear a striking resemblance to Picasso's—he still speaks very little French, and when the Strands go for dinner to the house of one of their French friends, that and his increasing deafness make it hard for him to follow much of the conversation. It doesn't seem to bother him.

In recent years, among the visitors who have made their way to Orgeval to see the Strands have been a number of young American photographers, and this has pleased Strand enormously. He likes to talk with them, and they like to listen to what he has to say. The subject, of course, seldom veers from photography. "The young people often ask me how I choose the things I photograph," Strand said last summer.

> The answer is, I don't. They choose me. All my life, for example, I've been photographing windows and doors. Why? Because they fascinate me. Somehow they take on the character of human living. Why did I photograph that white fence up in Port Kent, New York, in 1916? Because the fence itself was fascinating to me. It was very alive, very American, very much part of the country. You wouldn't find a fence like that in Mexico or Europe. Once

when I was in the Soviet Union, I was taken out into the country by Edouard Tisse, the cameraman for Eisenstein and others, and along the way I saw a fence against dark woods—it was a very special fence, containing the most amazing shapes. And I felt then that if I'd had the camera with me I could have made a photograph that had something to do with Dostoevski. That fence, and those dark woods, gave the same sort of feeling you get in reading *The Idiot*. You see, I don't have aesthetic objectives. I have aesthetic *means* at my disposal, which are necessary for me to be able to say what I want to say about the things I see. And the thing I see is something *outside* of myself—always. I'm not trying to describe an inner state of being.

Strand also likes to disabuse his visitors of the notion that he is unbendingly "pure" and uncompromising in his use of the medium. "I've made lots of compromises in my time," he said, laughing softly.

There was a period when the photographers around Stieglitz thought you should never enlarge—that you should only make contact prints. I got the reputation of never making an enlargement, but that wasn't true even then. All those early things I did in New York—the "Blind Woman" and the bowls and the Wall Street pictures—were taken with that small Ensign reflex camera. When I got ready to print them, I'd first make a contact positive on a glass plate, and then put it in the enlarger and project it onto an eleven-by-fourteen-inch glass plate, and from that I'd make a contact print on platinum paper. You couldn't enlarge directly on platinum, because the enlarger lights weren't strong enough then; you had to expose in daylight. I've always felt that you can do anything you want in photography if you can get away with it. Another one of those early pictures of mine—it was published in *Camera Work*—was taken from the window of a courtroom the first time I was ever called for jury duty. I shot down at some people in City Hall Park. Well, there was one group of three people that should really have been two people. I took the third person out. Retouched him out in the darkroom. I had no great feeling of guilt over that. Of course, I don't agree with this method of just shooting and shooting and hoping to find something later in the darkroom. I've done all sorts of retouching when there's been a functional reason for doing it, and I crop negatives in the enlarger all the time. In general, I agree with Cartier-Bresson, who says he always uses the whole negative. That's the best way to work. It's only when you know how to work that way that you have the right to crop. But it's not a great issue. The only great issue is the necessity for the artist to find his way in the world, and to begin to understand what the world is all about.

"Cartier-Bresson has said that photography seizes a 'decisive moment,' " Strand went on.

That's true, except that it shouldn't be taken too narrowly. For instance, does my picture of a cobweb in the rain represent a decisive moment? The exposure time was probably three to four minutes. That's a pretty long moment. I would say the decisive moment in that case was the moment in which I saw this thing and decided I wanted to photograph it. Many of Cartier-Bresson's photographs are truly capturings of moments that were exceptional—for example, his great photograph of the children playing in the ruins of a Spanish town; it's like a dance that could be interrupted at any moment by the fall of another artillery shell. But with me it's a different sort of moment.

For several months last winter, before the successful cataract operations on both his eyes, Strand could barely see. Walter Rosenblum, a photographer and teacher of photography, and one of Strand's closest friends, went with his wife to Orgeval during this time and stayed a few days. "He never stopped working," Rosenblum recalls. "He'd put a negative in the enlarger and get Hazel to tell him what was showing on the easel and when it was in focus. He reminded us of Renoir at the end of his life, painting with brushes strapped to his wrists. Now that he can see again, he wants to buy an eight-by-ten enlarger. He's interested in big-scale prints—at the age of eighty-four. He also talks of getting himself a 4 by 5 view camera, to replace the old 8 by 10. I've never met any man who knew so completely who he was and what he wanted to do."

Strand himself speaks a trifle wistfully about the future. "I think Thoreau's comment that 'you cannot say more than you see' is profoundly true," he said last summer. "It's the final measure. When you reach the point where you come to the end of seeing—when seeing is only looking—then you've reached the end of your road. In some artists, it certainly does go on for a considerable length of time. Did you ever see the black Goyas in Madrid? They came at the end of his life, and they show that at the end of his life he was seeing more, and deeper, than at any other period. Whereas when Hazel and I went to see the Matisse exhibition at the Grand Palais just recently, we had the impression that the end was not as interesting as the beginning. I don't know. It seems to me that if I could go on for another fifty years I'd have no hesitation in saying that I would be very busy."

Edward Weston

Edward Weston (1886–1958) was one of the leading advocates of straight photography on the West Coast. Like Strand, Weston asserted that photography has unique potentials and limitations. He encouraged photographers to exploit the fact that the camera can see more and differently than the unaided eye. For Weston the photographer's talent rests in his ability to previsualize the final print before exposure. Against any form of manipulating the negative, he insisted that the photographer perfect his understanding of how and what a camera sees. His approach was the foundation of Group f-64, whose charter members include Ansel Adams, Imogen Cunningham, and Willard Van Dyke. (See selections in volume 2.)

This excerpt from an article written for Encyclopaedia Britannica *synthesizes ideas Weston noted in a more subjective tone in his journals,* The Daybooks of Edward Weston *(1961). Other publications of his work include:* My Camera on Point Lobos *(1950), and* The Flame of Recognition *(1965), edited by Nancy Newhall.*

AESTHETIC BASIS OF PHOTOGRAPHIC ART

Anyone who has mastered a few simple instructions can make printable negatives with a pocket camera. Because it is impossible for the untrained beginner to achieve such acceptable results in any other medium, photography has sometimes been called "the easy art." But to bridge the gulf between the taking of such casual snapshots and the production of photographs that can be classed as art is certainly no easy task. To the mastering of his tools and the perfection of his technique, the photographer must devote just as much time and effort as does the musician or the painter. Since the nature of the photographic process determines the artist's approach, we must have some knowledge of the inherent characteristics of the medium in order to understand what constitutes the aesthetic basis of photographic art.

* Reprinted from "Photographic Art," *Encyclopaedia Britannica* (1942), vol. 17, pp. 801–802.

Photography must always deal with things—it cannot record abstract ideas—but far from being restricted to copying nature, as many suppose, the photographer has ample facilities for presenting his subject in any manner he chooses. First, an infinite number of compositions can be achieved with a single stationary subject by varying the position of the camera, the camera angle, or the focal length of the lens. Second, any or all values can be altered by change of light on the subject, or the use of a colour filter. Third, the registering of relative values in the negative can be controlled by length of exposure, kind of emulsion used, and method of developing. And finally, the relative values in the negative can be further modified by allowing more or less light to affect certain parts of the image in printing. The photographer is restricted to representing objects of the real world, but in the manner of portraying those objects he has vast discretionary powers; he can depart from literal recording to whatever extent he chooses without resorting to any method of control that is not of a photographic (i.e., optical or chemical) nature.

But the artist's use of these controlling powers must be conditioned by two factors: (1) the nature of his recording process, and (2) the nature of his image. There is a frequent cause of mistaken understanding in the belief that the camera's image reproduces nature as the human eye sees it. On the contrary, its ability to record things as the unaided human eye can never see them is one of the most important attributes of photography. The human eye can focus on but one small area at a time; consequently we observe an object or a scene only by letting our eyes rove over it in a series of short jumps. The assortment of images thus recorded is flashed to the brain, which sorts and edits them, automatically discarding some as of no importance and emphasizing others, according to its individual conditioning. The impersonal camera-eye makes no such distinctions; every detail within its field of vision can be recorded instantly and with great clarity. In the time the eye takes to report an impression of houses and a street, the camera can record them completely, from their structure, spacing, and relative sizes, to the grain of the wood, the mortar between the bricks, the dents in the pavement. The image that is thus registered has certain characteristics that at once distinguish it from the products of all other graphic processes. In its ability to register fine detail and in its ability to render an unbroken sequence of infinitely subtle gradations, the photograph cannot be equalled by any work of the human hand. For this

reason any manual interference with the image at once destroys those very qualities that give the true photograph value as an art form. From these two facts we may draw an obvious deduction: if the recording process is instantaneous and the nature of the image such that it cannot survive corrective handiwork, then it is clear that the artist must be able to visualize his final result in advance. His finished print must be created in full before he makes his exposure, and the controlling powers enumerated above must be used, not as correctives, but as predetermined means of carrying out that original visualization. As in the mastery of any other graphic form, years of experience are necessary in photography before technical considerations can be made entirely subordinate to pictorial aims. The ability to prevision the finished print is the photographer's most important qualification and in order to attain it he must concentrate on learning to see in terms of his tools and processes. Having chosen the simplest possible equipment (so as not to complicate his task needlessly), he first learns by experiment the potentialities and limitations of each instrument and process. He must learn the field of his lens, the scale of his film and paper emulsions; he must learn to judge the strength and quality of light; he must learn to translate colours into their relative monochrome values and know how those values are affected by the use of different filters.

He must learn the kind of negative necessary to produce a given kind of print, and then learn what kind of exposure and development will produce that negative; then, having learned how those needs are fulfilled for one kind of print, he must discover how to vary the process to get other kinds of prints. Gradually, with experience, this knowledge becomes intuitive; the photographer sees a scene or object in terms of his finished print without having to think of these processes any more than a musician playing a piece thinks of the whereabouts of the next note he will sound or how much pressure he will use in sounding it.

THE PRINT

The value of the photograph as a work of art depends primarily on the photographer's seeing before exposure, but its artistic value can be determined only by an examination of the finished print.

Exposure records the photographer's seeing; developing and printing execute it; so no matter how fine the original vision, if it has not been

faithfully carried out in subsequent procedures, the resulting print will suffer. The clarity of image and delicacy of gradation that characterize a fine photograph demand a special kind of surface for their best presentation. A rough surface destroys the integrity of the image; a smooth surface retains it. A shiny or reflecting surface enhances the beauty of image quality, while a dull or absorbing surface tends to obscure it.

For beautiful image quality, the best of the old daguerreotypes have never been equalled. The positives were made directly on the metal base and the small pictures were esteemed for their exquisite rendering of fine detail. The photo-painters, who did away with all things characteristically photographic, often used papers of independently beautiful surface texture for their prints. The result of such a combination is that the paper competes with the image instead of becoming a part of it.

Among modern processes the nearest approach to the fine image quality of daguerreotypes is a waxed or glossy print. Unfortunately, glossy paper is still held in general disfavour among artist-photographers. It is said to be harsh and cold and only suitable for commercial work.

These erroneous beliefs are partly a hangover from the heyday of photo-painting and partly a result of the difficulty of making good glossy prints. The glossy surface reveals the image with such clarity that minor blunders, which might escape detection on the more veiled, dull-surface papers, are at once exposed. However, the glossy surface has the advantage of a longer scale which makes it possible to reproduce more of the negative and allows a greater latitude in reproducing extremes of tone from the strongest to the most subtle and delicate. When a photographer speaks of the warm or cold tone of a print, he is usually referring to its colour—a cold blue-black as opposed to a warm green-black. But to use such variations of colour to emphasize the feeling of his picture is to misuse his medium. If he prints a snow scene blue-black so that it will look cold and a forest scene green-black so that it will appear warm, he is introducing a foreign element into his monochromatic process just as surely as if he coloured the print by hand. In black-and-white photography the effect of warmth or coldness should be communicated by the values in the print, whose colours should—at the extremes of the scale—be as nearly pure black and pure white as possible (use of obvious colour tone belongs in the province of colour photography). Obviously then, the longer scale of glossy paper gives greater opportunity of producing through the values

in the print whatever effect is desired. And lastly, the luminous surface of the glossy paper, by making the image light-giving, comes nearer to rendering the effect of the original scene and so heightens the illusion of reality. A good glossy print reveals the delicacy of subtle gradation, the lucidity of tone, and the brilliant clarity of image that are unique characteristics of the photographic process.

SUBJECT MATTER

It is impossible to make any sharp distinction between the subject matter appropriate to one graphic medium and that more suitable to another. But in the case of photography we can at least draw a few general conclusions, based on an examination of the work of the past and our knowledge of the special properties of the medium. From the wet plate era we may draw two contrasting examples that serve to indicate a field of endeavour in which the photographer is least likely to be successful. On the one hand is the work of O. G. Rejlander and Henry Peach Robinson, two men who achieved prominence for their photographic work in England during the '50s and '60s. In their best-known pictures (Rejlander's "Two Ways of Life," and Robinson's "Fading Away") they attempted to depict allegorical and dramatic situations by combining a number of negatives of posed and costumed figures into composite prints. On the other hand is the work of Mathew Brady, Alexander Gardner, and many anonymous photographers who documented the American Civil War. These men were bound by no artistic purpose; their sole aim was to record to the best of their ability every phase and aspect of the hostilities that their clumsy and limited equipment could encompass. Yet it is in these straightforward records that we perceive true photographic quality: here is the tremendous power and appeal of the camera's realism, the intensity of its vision undiluted; and these documents of the past still move us profoundly with their clear, objective picture of the horror and pathos of war. Beside these photographs the artistic efforts of Rejlander and Robinson appear self-conscious, stilted, and artificial. Their carefully posed and costumed figures look absurd and unreal.

Now this comparison makes one fact apparent: the camera lens sees too clearly to be used successfully for recording the superficial aspects of a subject. It searches out the actor behind the make-up and exposes the contrived, the trivial, the artificial, for what they really are.

But if the camera's innate honesty works any hardship on the photographer by limiting his subject matter in one direction, the loss is slight when weighed against the advantages it provides. For it is that quality that makes the camera expressly fitted for examining deeply into the meaning of things. The discriminating photographer can direct its penetrating vision so as to present his subject—whatever it may be—in terms of its basic reality. He can reveal the essence of what lies before his lens with such clear insight that the beholder will find the re-created image more real and comprehensible than the actual object.

The photograph isolates and perpetuates a moment of time: an important and revealing moment, or an unimportant and meaningless one, depending upon the photographer's understanding of his subject and mastery of his process. The lens does not reveal a subject significantly of its own accord. On the contrary, its vision is completely impartial and undiscriminating. It makes no distinction between important detail and meaningless detail. Selection, emphasis, and meaning must be provided by the photographer in his composition. Nowhere has the painter's influence had a more lasting hold on photography than in the field of composition. Photographers who have put to use every other resource of their medium still try to emulate the work of painters in this respect. They consider composition as a thing apart, having no relation to a specific medium, but consisting of a set of tested rules and conventions that must not be contravened. To compose a subject well means no more than to see and present it in the strongest manner possible. The painter and the photographer will have two different ways of doing this because of the basic differences between their mediums. Its capacity for rendering fine detail and tone makes photography excel in recording form and texture. Its subtlety of gradation makes it admirably suited to recording qualities of light or shadow, and its ability to record sharply everything within the angle of lens vision from the immediate foreground to the distant horizon carries it far beyond the painter's province. The photographer cannot depend on rules deduced from finished work in another medium. He must learn to see things through his own eyes and his own camera; only then can he present his subject in a way that will transmit his feeling for it to others.

An intuitive knowledge of composition in terms of the capacities of his process enables the photographer to record his subject at the moment of deepest perception; to capture the fleeting instant when the light on a

landscape, the form of a cloud, the gesture of a hand, or the expression of a face momentarily presents a profound revelation of life.

The appeal to our emotions manifest in such a record is largely due to the quality of authenticity in the photograph. The spectator accepts its authority and, in viewing it, perforce believes that he would have seen that scene or object exactly so if he had been there. We know that the human eye is capable of no such feat, and furthermore that the photographer has not reproduced the scene exactly; quite possibly we would not even be able to identify the original scene from having seen the photograph. Yet it is this belief in the reality of the photograph that calls up a strong response in the spectator and enables him to participate directly in the artist's experience.

There can be no doubt that photography is potentially a powerful and vital medium of expression. But even today many photographers who attempt to use it as such still cling to the weak effects of photo-painting, while others imitate the work of abstract painters with "shadow-graphs" (recording shapes, shadows, and sometimes a degree of texture by laying various objects on sensitized paper and then exposing it to light).

However, there has been in the past decade a perceptible growth of interest in and understanding of photography as an art medium. Museums are holding more photographic exhibitions every year and private collections of fine photographs are more numerous. The unique advantages that photography offers are being recognized by an increasing number of artists. The camera has extended their visual horizons by opening their eyes to new perspectives and new subject matter.

Conception and execution so nearly coincide in this direct medium that an artist with unlimited vision can produce a tremendous volume of work without sacrifice of quality. But the camera demands for its successful use a trained eye, a sure, disciplined technique, keen perception, and swift creative judgment. The artist who would use his photographic powers to the full must have all these, plus the first requisite for the artist in any medium—something to say.

Edward Weston Rethought (1975)*

Andy Grundberg

Andy Grundberg understands Weston's work in psychoanalytic terms. His approach is unique in the literature on Weston, which is dominated by Weston's own writing. Weston denied the validity of psychoanalytic interpretations of his photographs of female nudes, vegetables, and plant forms. Grundberg, however, argues that the approach illumines Weston's stylistic evolution.

Andy Grundberg, picture editor at Modern Photography, *frequently writes on photography for* Art in America. *This essay was written in response to the Weston exhibition at The Museum of Modern Art in 1975.*

In the less than twenty years since Edward Weston's death, his work has been hurried off into photographic history, buried there like an artifact of an earlier civilization. Today it is fully admired but not fully appreciated; what is lacking is an understanding of the entirety of Weston's various career, from the first soft-focus platinum-print commercial portraits of 1911 through the razor-sharp vegetables and shells of mid-career to the dark, moody late landscapes.

We have, of course, Weston's own testament—two volumes of journals (*The Daybooks of Edward Weston,* Millerton, N.Y.: Aperture, 1961) plus numerous magazine articles and letters, in all of which he intertwined personal and aesthetic insight; but he was a blustery, insecure man with a cloying prose style and only a limited sense of his own genius. His biographer, Ben Maddow (*Edward Weston: Fifty Years,* Millerton, N.Y.: Aperture, 1973), largely filled the mold Weston prepared, and Weston's conception of his mission is only tangentially mirrored in his images. Clearly he should not be completely trusted to account for himself.

Recent critical characterizations have ranged from that of Weston as modernist, attempting to purify the visual vocabulary with the same absolutist spirit as William Carlos Williams's in poetry and Hemingway's in fiction, to that of Weston as latter-day pictorialist, veiling a preindustrial Weltanschauung in twentieth-century guise. However, none is adequate

* Reprinted from *Art in America* (July/August 1975).

in face of the final decade of Weston's work (1938–1948), which has re-markable if overlooked affinities with photography today. Any critical approach to Weston should encompass his whole career; at the same time it should account for the formal and affective transitions between the early and middle work and again between the middle and the late, mean-while taking Weston's own claims into consideration at something other than face value.

The Museum of Modern Art's recent 275-print exhibition, its second Weston retrospective (the first, during his lifetime, was in 1946), con-tained a rare and beautiful image that, I believe, suggests the possibility that some criticism based on psychoanalytic observations may broaden our understanding of his work. Titled "Charis, Lake Ediza,"[1] it was taken in 1937, when a radical shift was underway in his personal life and in his work as well. Indeed, the photograph seems pivotal, containing elements of the formal approach and the symbolic matrix of both his middle and late styles.

"Charis, Lake Ediza," possesses a fragile accessibility, as if poised on the edge of a knife, and it has the sense of revelation that Weston con-sciously sought in all his photographs. It contains a good bit of paradox, too: Charis's gaze is assured and inviting, but her turban (protection against insects, Weston's son Cole has explained) implies concealment. The hands, like half-shells, either have just opened or are about to close—are either surrendering personal privacy or reclaiming it. In any case, they emphasize an erotic tension between the innocence of her ex-pression and the suggestiveness of the pose. (As also seems true of Wes-ton's nudes, portraits, and still lifes of the 1920s and early 1930s, the existence of a primal, universal sex force is at least part of the image's in-herent message.)

The paradoxical nature of this portrayal may be related to Weston's own ambiguous attitude toward women, ranging from the occasional scorn in his writings— "All she [woman] wants is sex, and all her gestures

[1] For consistency's sake, all dates for photographs mentioned are taken from *Ed-ward Weston: Fifty Years,* with the exception of "Charis, Lake Ediza" [which is not available for reproduction—Ed.], and "Exposition of Dynamic Symmetry," which do not appear in the book and which are dated according to The Museum of Modern Art exhibition.

are directed by sex"—to the awe evident in many of his most powerful portraits. And while, more often than not, the faces of his nudes are concealed or cropped, robbed of individuality, he was no misogynist—witness, for example, his predilection for appearing at parties in a dress and stockings.

Coincident with the figure's sexuality are some black holes in the rock face behind Charis's head. Such isolated dark elements—caves, rocks or simply heavy shadows—occur with sufficient frequency in Weston's photographs after 1937 that they may be said to comprise a motif; while in this image the context may be partly sexual, the motif later comes to suggest death. Even here, the permanence of the rock face (its inanimate immortality) enhances the transitory youth and beauty of the woman above whom it looms.

This interpretation would not, of course, have set well with Weston, who rejected psychoanalytic interpretations of his work out of hand. His own credo was carefully formed to leave meaning in abeyance. "This then, to photograph a rock, have it look like a rock, but be *more* than a rock" (Weston's italics).[2] Yet his strident denials regarding symbolic content—even to himself—are what makes the interpretation of his images so tempting.

"If there is any symbolism in my work," he wrote in his *Daybook* in 1931, "it can only be in a very broad consideration of life, the seeing of parts, fragments as universal symbols, the understanding of relativity everywhere, the resemblance of all natural forms to each other"—this in response to a physician's Freudian critique of his work. "The good doctor found nothing else—but the desire to see 'reproductive organs' in kelp, vegetables, rocks, peppers—natural forms. It was too good a chance—I had to come back, and blamed his own 'psychopathological' condition, turned his own words back upon himself, hinted that he belonged with the sexually unemployed, with the hordes of neurasthenic disciples of Freud, who find sex in one's every word or gesture."

While the vehemence of this response suggests a grain of truth in the

[2] This was written in 1930. Of the shell series he had written in 1927: "I am not blind to the sensuous quality in shells, with which they combine the deepest spiritual significance; indeed it is this very combination of the physical and the spiritual in a shell like the Chambered Nautilus, which makes it such an important abstract of life. . . . No! The shells are too much a sublimation of all my work and life to be pigeon-holed. Others must get from them what they bring to them: evidently they do!"

doctor's assessment, the tone was enough to scare off other critics. Not that Weston really understood Freud; he evidently believed that the presence of Freudian symbolism automatically signaled sexual repression, about which he noted in the same passage: "so far as I know I have none—am about as free from inhibitions as one can possibly be." True, he slept with practically all the models for his nude photographs (often interrupting the sittings) while assiduously avoiding his first wife, whom he finally divorced fifteen years after he had left her. A model of sexual freedom, perhaps—but in retrospect, his sexual bouts have a compulsive, gladiatorial aspect.

Also in need of critical reconsideration is the all-too-common assumption that Weston's major contribution was to the aesthetic of the medium itself, in the form of "straight" photography—a direct, nonmanipulative way of seeing—supposedly essentially photographic—that conquered the misty, painterly style in vogue during the early years of this century. Many critics have sought to establish Weston's historical importance on this basis, but they ignore or slight Alfred Stieglitz, who had abandoned the pictorial approach long before Weston and was the leading advocate of the "straight" approach. Stieglitz's landmark "The Steerage" appeared in *Camera Work* in 1911, and Stieglitz published Paul Strand's revolutionary "straight" photographs in the same magazine in 1916–1917. Weston, however, continued to work in the pictorial style into the 1920s; his abandonment of it coincided with a 1922 trip to New York during which he met Stieglitz, Strand, and Charles Sheeler.[3] In fact, this contact at first affected only Weston's technique, not his way of seeing; he battled to come to grips with the full implications of nonpictorial representation during his Mexican years, 1923–1927.

Weston's relationship with Stieglitz was complex. To again tread gingerly into the psychoanalytic sands, witness a dream Weston reported having in Mexico two years after they met: in the dream a messenger arrives with the news: "Alfred Stieglitz is dead." (He actually died in 1946,

[3] Nancy Newhall, in her introduction to the Mexican *Daybooks,* would have it earlier: "In [1917] he found himself involved in the reaction against Pictorialism. . . . Weston was becoming sick of shimmer and simper and the human ego, including his own. He sought bolder structure, deeper space, sharper seeing, a more humble and objective approach to life" (p. xvii). The photographic evidence from this period, however, is hardly persuasive.

without having given Weston the unreserved affirmation he sought.) Since, at the time, photography was wearing Stieglitz's ring on its finger, the Oedipal overtones seem less than farfetched. Stieglitz, after all, had prepared the soil in which Weston was to plant his seed. In any case, the older man was on the decline while the younger was on the rise. Stieglitz, intellectual by nature but adamant in his belief that unconscious impulses loomed large in artistic creation, most likely had read Freud;[4] Weston, by all accounts, never did. Yet paradoxically Weston was able to give expression to the raw unconscious in his own photographs while Stieglitz by and large was not.

Weston's stunning accomplishment of the 1920s and early 1930s was to reveal the pervasive presence of libido in vegetables, rocks, faces, dunes, and, it goes without saying, nudes. Even the anti-interpretive camp concedes that these images are "sensual." Questions of "straight" photography and precedents for Weston's approach are rendered irrelevant by the achievement of these photographs, for here Weston's images move photography beyond Stieglitz's shadow.

The recent Museum of Modern Art show was arranged only roughly chronologically, with several groupings by subject matter, instead. The Witkin Gallery's concurrent exhibition of 133 prints ignored order altogether, with no ill effects. In both shows it was evident that Weston's work changed distinctly about 1937–1938.[5] This shift usually is mentioned in connection with the Guggenheim grant he received in 1937 (Weston was the first photographer to receive one). Today Cole Weston jokingly refers to his father's "three periods": pre-Guggenheim, Guggenheim, and post-Guggenheim. It is unlikely, however, that the cash award spurred artistic change.

In 1938 Weston married Charis Wilson, who would be the last in his string of assistants/models/lovers, and settled into the house near Carmel, California, in which he was to live out the rest of his life (he stopped photographing in 1948 and died ten years later), except for a transcontinental trip cut short by the outbreak of war. Weston was fifty-two, Charis

[4] Stieglitz wrote a sequence of three short dream fictions, published in the magazine *291* in 1915, which in imagery and intent furnish circumstantial evidence that his acquaintance with Freudian thought was more than nodding.

[5] A case could conceivably be made that a psychological shift took place earlier, based on Weston's abandonment of his journal in 1934.

a teen-ager. His personal life took new form: the random love affairs stopped, the uphill struggle for recognition was ended by national acclaim.

Weston's final decade of work in many respects was an experimental one. He felt no need to reconsider his by-then antiquated technique, continuing to use his large-format (8- by 10-inch) view camera to obtain negatives suitable for contact printing, but he expanded his repertory. For example, in sly tribute to the naïve snapshooter, he explored the family-album tradition, picturing kin and friends, sometimes informally but also at times in prearranged groupings. Where before he had been concerned with the idea of veracity, worrying over "Shell and Rock, Arrangement" (1931) because he had repositioned the shell for the exposure, many of the 1940s pictures are transparent "setups"—in one, a Weston family member appears at every window of his house ("Exposition of Dynamic Symmetry," 1943). He also tried his eye at social statement, photographing dummies and backdrops at the M-G-M movie lot in 1939. And, in the late 1940s, he experimented with color.

As is true of the Mexican period, which produced both outstanding portraits and insipid still lifes of folk trinkets, the results of all this experimentation are mixed. The portraits of friends, which now include the full figure, lack drama. The satire misses when the photograph functions as a cartoon; however, the M-G-M series is an understated revelation of movieland's underpinnings. His color work did not satisfy him (and was not included in either recent show); his photographs of his many cats are at best uninspired. On the other hand, the pictures from the Guggenheim travels and prewar trip succeed, especially the landscapes, cityscapes, and portraits of plain folk at home; for the first time Weston seems to have a sense of America-as-place.

Throughout this final decade he also continued to photograph in a vein that resembles, in subject matter and style, the work on which his larger reputation rests. But, while superficially many of his late photographs seem continuous with what came before, they are now predominantly dark in tone, as if taken at evening instead of midday, and their imagery is plainly morbid: dead pelicans, broken glass, abandoned plantations, cemeteries, a dead man in the desert. "Wrecked Car, Crescent Beach" (1939), is a telling example: the torsolike shape of the automobile's detritus cutting diagonally across the frame recalls the rock in "Point Lobos" (1931), or the human torso in "Tina on the Azotea" (c.

1924–1926). Looking chronologically, one perceives a progression from human contours to inanimate organic form to debris. In addition, significantly, the distance between camera and object increases. Through this device, emotional content is progressively sublimated. His later work is less "theatrical," although Weston continued to see "important forms importantly."

His post-1937 photographs of women, nude or clothed, lack the intensity of the earlier ones. They are no longer erotically charged; when not aimed, rather flaccidly, at social commentary ("Civil Defense," 1942), they suggest repose and death. Quite a distance has been traveled from the supercharged eros of the portrait of Nahui Olin (1924) to the tone of "Nude Floating" (1939), in which Charis appears at the edge of a large dark pool—looking much like the floating bird-corpse in "Pelican" (1945).

The later photographs taken on Point Lobos provide a direct means of comparison, since Weston throughout his career used this site as a yardstick with which to measure his progress. In the final years he tended to turn his camera away from the water's edge toward the cliffs dotted with gnarled vegetation, eliminating any hint of sky in the process. Highlights are suppressed; the darker end of the gray scale is dominant. As is the case with many others of the late subjects, the most striking shift is formal: single images centered on unobtrusive, flat grounds give way to complex, even turgid compositions that tempt the eye out of the frame. Order waits to be discovered rather than insisting on its own primacy, as the camera backs farther and farther off. While there is a rather relaxed surface as a result (perhaps due to the effect of seeing objects at reduced scale), there is also an undeniable undercurrent of anxiety, suggesting an unconscious rush to encompass as much of the world as possible.

Obviously, these changes in Weston's vision reflect something quite other than domesticity and public acclaim, and something much more than the consequences of his simultaneous experimentation. Indeed, more than one observer has perceived that there is a turn toward darkness in the later work.[6] However, this has often been ascribed to an apprehen-

[6] Maddow notes succinctly: "But the astonishing fact is, that in the midst of this full and happy and famous year [1940], Weston's photographs were, a good half of them anyway, astonishingly, and quite frankly, funereal" (*Edward Weston: Fifty Years,* p. 268).

sion of impending Parkinson's disease, although in 1938 Weston, at fifty-two, was likely to have been facing the implications of old age regardless of his state of health.

Other critics have ignored the signs of gloom: John Szarkowski has said that Weston's later work shows a "new spirit of ease and freedom,"[7] and he pictures the Westons in the prewar years wandering happily like ordinary tourists, citing as proof Charis's descriptions of their trips in their book *California and the West.* But the evidence of Weston's pictures at this time suggests otherwise; unconsciously, at least, he seems to have been no more at peace than before. Later, after the war, the gloom is even harder to escape; Charis has said, in retrospect (and referring directly to "Nude Floating" and "Pelican"): "During the last years [in which] he was able to photograph, he was particularly taken with situations where an interface separated life and death."[8]

While he would have denied it,[9] Weston in his mature years apparently faced the paradox of creatively expressing creativity's antithesis—Thanatos replacing Eros—and, whereas sexual repression could be "solved" photographically by direct confrontation, death presented an enigma. Hence the stylistic experimentation and, despairing of that, the use of symbolic materials to portray his plight.

Ironically, it is the later works that have a direct lineage to the present, for it was Weston himself who freed photography from the inevitable straitjacket of his own middle-period style. Indeed, he seems to have anticipated many of today's concerns and resources. The influence of Atget, for instance, which shows quite clearly in his late photographs, makes Weston one of the important mediators between the French documentarian and current United States social landscapists, such as Robert Adams and Henry Wessel, Jr. Of the experimental photographs, the M-G-M series possesses a cool irony analogous to that of Robert Frank's influential book *The Americans;* the posed family situation comedies, while hopelessly corny and dated, share with Duane Michals's sequences the

[7] John Szarkowski, "Edward Weston's Later Work," *MoMA* (Winter 1974–1975).

[8] Maddow, *Edward Weston: Fifty Years,* p. 240.

[9] In a December 1946 letter he wrote: "As for death as a theme—it certainly didn't start with the dead man in the Colorado desert. Before 1920 I did skulls and dead Joshua trees on the Mohave desert. But then—as now—death was not a theme—it was just part of life—as simple as that" (*The Flame of Recognition,* Nancy Newhall, ed., Millerton, N.Y.: Aperture, 1965, p. 95).

presence of the directorial spirit. Above all, it is the quality of Weston's unshakable anxiety that gives the photographs of his last ten working years their contemporary feel. While the graphically powerful images of the 1920s and 1930s, which in our age appear pure and nostalgic, have dominated public and critical attention, they mislead to the extent that Weston is viewed as an isolated figure, without legacy, in the development of twentieth-century photography.

Charles Millard

Charles Sheeler (1883–1965), well known as an American modernist painter, is only recently receiving attention as a photographer. In this essay Charles Millard revises our conception of Sheeler. Millard interprets Sheeler's straight photographs as studies for his precisionist painting but also as independent compositions. Both Sheeler's photographs and paintings are investigations of the underlying geometry of immediate facts. Acknowledging that Sheeler respected the merits of each medium marks another breakdown of the prejudice against photography.

Charles Millard, formerly director of the Washington Gallery of Modern Art, is chief curator of the Hirshhorn Museum and Sculpture Garden, Smithsonian Institution. He is the author of many articles on modern art and sculpture and a monograph, The Sculpture of Edgar Degas *(1976). This essay was included in the catalogue for the Sheeler exhibition at the National Collection of Fine Arts in 1968.*

> Photography has the capacity for accounting for things seen in the visual world with an exactitude for their differences which no other medium can approximate. —CHARLES SHEELER

Forty-five years have passed since Henry McBride described Charles Sheeler's "Side of a White Barn" as "one of the most noteworthy productions in the history of photography" and since Sheeler himself was intimately connected with the most significant formative talents in the history of American photography—Alfred Stieglitz, Paul Strand, Edward Steichen, Edward Weston, and Ansel Adams. In those years, Sheeler's photography has almost completely disappeared from public view. Few photographers are now aware that Sheeler was other than a painter or

*Reprinted from the catalogue of the Charles Sheeler exhibition, National Collection of Fine Arts, Smithsonian Institution, Washington, D.C., 1968. This essay is an abridgment of material gathered for an issue of the magazine *Contemporary Photographer* (6, no. 1, 1968) devoted exclusively to Charles Sheeler's photography. Because full documentation is to be found in that article, in the interest of continuity all footnotes and source references have been omitted here.

that his photographs were once considered revolutionary in both vision and quality. This is due partly to the fact that, as with everything revolutionary, what once seemed innovative is now commonplace. Sheeler's "straight," unsentimentalized, sharply focused pictures of urban and industrial life, so remarkable in an era steeped in pictorialism, helped shape the vision on which almost all the best contemporary photography is based. Now that Sheeler's photographs fit into an accepted visual convention, they attract attention less easily than they did, and since Sheeler's sensibility was extremely reticent and his pictures lack the monumentality and drama of the work of, say, Stieglitz, Weston, or Adams, the photographs can easily be overlooked when their novelty has worn off.

Equally important as a factor in the neglect of Sheeler's photography were his own attitudes. Increasingly, Sheeler deemphasized photography in favor of painting. He seldom tried to sell his photographs and never taught photography or was associated with any organization in the field. He last allowed his photographs to be exhibited at a commercial gallery in 1931, although important museum shows included his photographic work in 1939 and 1954. Nor were Sheeler's photographs widely published after the early 1930s. Those that were resulted from the commissions with which Sheeler helped support himself or were concessions to friends—as when, in the early 1940s, Edward Weston used a Sheeler photograph as one of the few to illustrate his article on photography for *Encyclopaedia Britannica*. Although his work progressively disappeared from public view, Sheeler never ceased taking photographs for their own sake, nor has the passage of time tarnished the inherent quality of his photography, that basic strength on which its reputation and importance will ultimately rest.

Charles Sheeler first took up photography in 1912 at the age of twenty-nine. Having finished his painting studies with William Merritt Chase, he soon discovered that he could not support himself as a painter and, casting around for a source of income that would in some way relate to his chosen vocation, he determined on photography and trained himself in its technique. His first work was for Philadelphia architects, making records of their work and supplying them with pictures for portfolios to be shown to prospective clients. During the two years which were occu-

pied with this work, Sheeler spent a good deal of time in New York, gradually becoming involved with the circle of avant-garde artists and collectors centered around Alfred Stieglitz and his "291" gallery. Through contacts made on these trips, Sheeler began photographing works of art for dealers, such as Parish-Watson and Knoedler, and private collectors such as Albert Barnes. By 1914 he had given up architectural photography altogether for this more lucrative work.

In 1915 Sheeler's friend Marius De Zayas opened a New York gallery, and throughout 1916 he employed Sheeler extensively to photograph his stock. In 1917 De Zayas published a portfolio of Sheeler photographs of African sculpture in his collection, the work which first drew general attention to Sheeler's photography, and in the same year De Zayas twice showed photographs by Sheeler in his gallery. In 1919 Sheeler moved from Philadelphia to New York, and the following year he began to work for De Zayas, managing the gallery when its owner was away. This arrangement continued until 1923 when the gallery closed.

Luckily for Sheeler, the closing of De Zayas's gallery and the consequent curtailment of his income were closely followed by an invitation from Edward Steichen—then head of photography for Condé Nast Publications—to make fashion and portrait pictures for *Vogue* and *Vanity Fair*. This studio work lasted until 1929. During the same period, Sheeler developed a flourishing business in free-lance advertising photography, which helped support him through the early years of the Depression. His most important client was the advertising firm of N. W. Ayer and Son of Philadelphia, an association that was to bring him the most important commission of his photographic career. In 1927 Sheeler was sent to photograph the Ford Motor Company's River Rouge plant in Michigan by Vaughan Flannery, art director of N. W. Ayer, who had persuaded Ford that it should have a photographic record of its operations to serve as a permanent document of contemporary American industry. Sheeler spent six weeks at River Rouge, studied his subject carefully, and took thirty-two photographs. These pictures drew wide public and professional attention almost immediately. They were published in several periodicals in the United States, as well as in Europe and Asia. Five years after taking the Ford pictures Sheeler used four of them to create a photomural triptych for The Museum of Modern Art's 1932 exhibition "Murals by American Painters and Photographers," which was intended to suggest

mural projects to the architects of Rockefeller Center. The center panel of Sheeler's triptych was an overprinting of two separate negatives, resulting in the double-exposure effect that he was to exploit much later in his painting.

In 1932 Sheeler gave up commercial photography, which had kept him solvent, and returned to painting almost full time. During the 1930s, he worked on no photographic commissions as such, although he often made extensive photographic studies for painting commissions to be executed in his studio. With the onset of World War II, however, Sheeler foresaw a drop in the demand for his paintings and accepted the invitation of Francis Henry Taylor, director of The Metropolitan Museum of Art, to take a position photographing the museum's treasures, which were being put into storage for the duration of the war. Since the museum was also expanding its program of publications and needed photographs for that purpose, Sheeler's pictures were used for the museum's *Bulletin* as well as for its various other publications. Sheeler's first color work was done for *Bulletin* covers, and the influence of this experience may be seen in the heightened color in his painting after he left the museum in 1945. During the period he worked for the Metropolitan, Sheeler took on one other photographic commission: two still-life compositions in the style of nineteenth-century painting for a *Fortune* magazine series, "Americans Whose Careers Are Relevant Today." His subjects were Thoreau and Whitman.

After the war Sheeler continued to pursue photography with vigor, although he had no further involvement with commercial photography and the photographs he took were largely kept to himself. As in the 1930s, he frequently made photographic studies for commissioned paintings that he wished to execute in his studio. From 1959, when he suffered an incapacitating stroke, until his death in 1965 Sheeler's photographic activity was restricted to supervising his wife in printing some of his pictures.

Although his work in commercial photography helped sharpen Sheeler's photographic vision and technique, as well as providing him with a livelihood, few of his best creative efforts resulted from it. Among the African and Ford pictures are some that can be ranked with the best of his independent work, but in general he seems to have confined himself in commissioned work to producing an acceptable, workmanlike product. His portraits for *Vogue,* for instance, although they sometimes

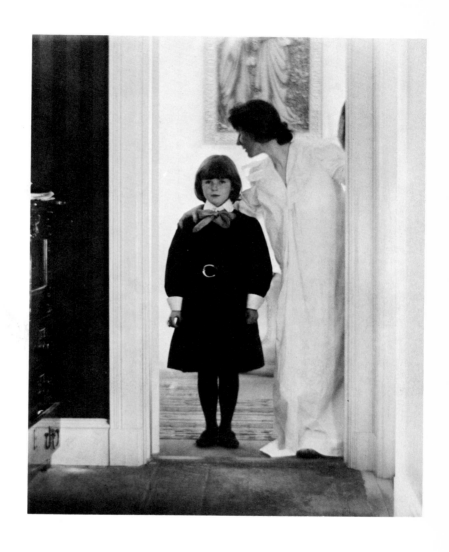

Gertrude Käsebier: "Blessed Art Thou Among Women," c. 1898. Courtesy
The Library of Congress.

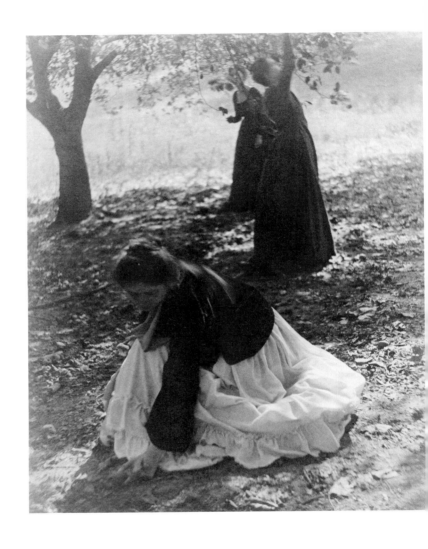

Clarence White: "The Orchard," 1902. Courtesy The Library of Congress.

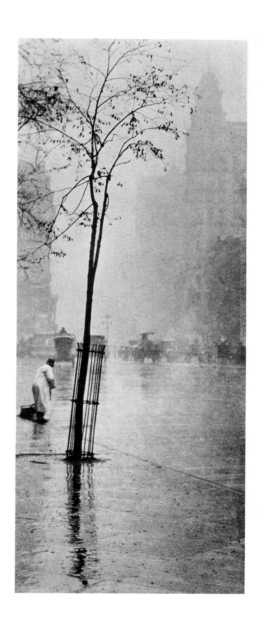

Alfred Stieglitz: ''Spring Shower,'' 1902. Courtesy The Library of Congress.

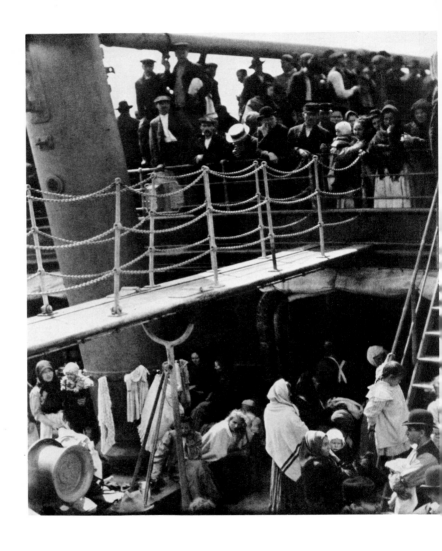

Alfred Stieglitz: "The Steerage," 1907. Courtesy The Library of Congress.

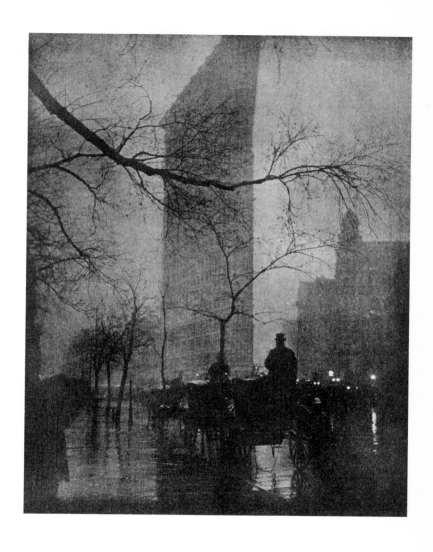

Edward Steichen: ''The Flat Iron Building—Evening,'' 1905. Courtesy The Library of Congress.

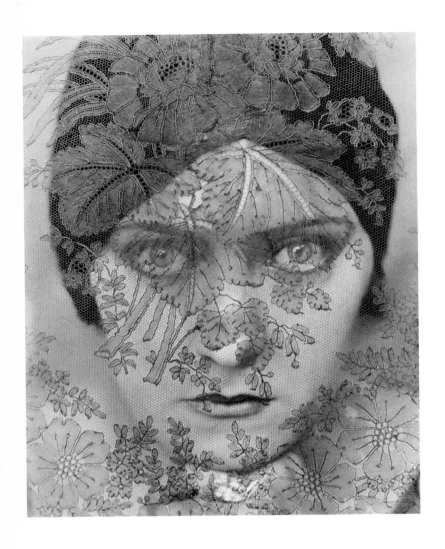

Edward Steichen: ''Gloria Swanson,'' 1924. Reproduced by permission of Joanna T. Steichen.

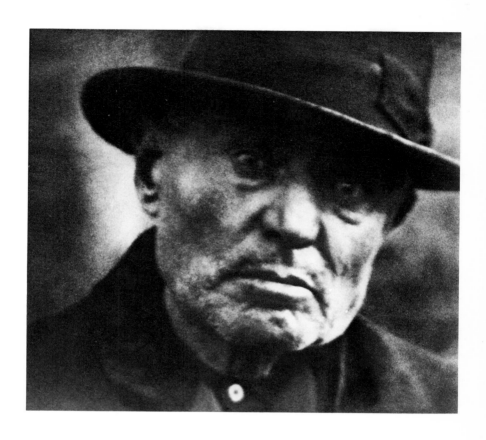

Paul Strand: ''Portrait—New York,'' 1917. Courtesy The Library of
Congress.

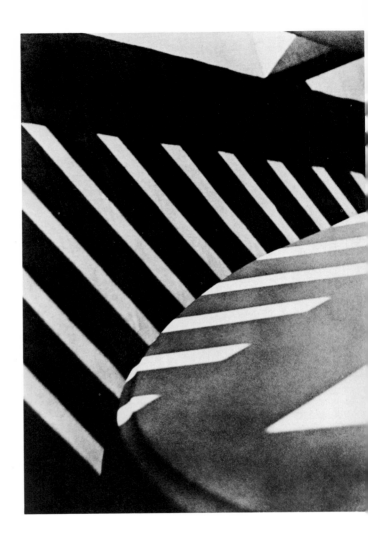

Paul Strand: "Abstraction—Porch Shadows," 1917. Courtesy The Library of Congress.

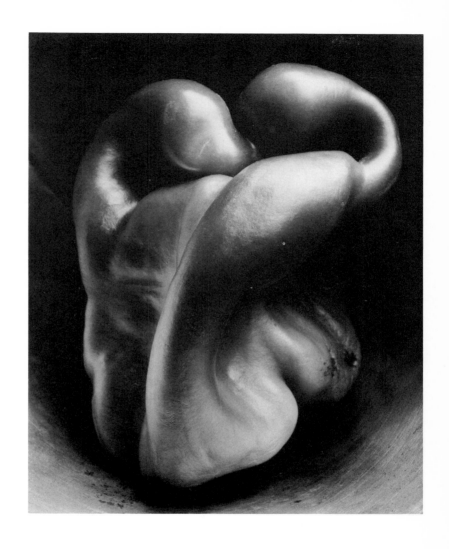

Edward Weston: ''Pepper No. 30,'' 1930. Courtesy Cole Weston.

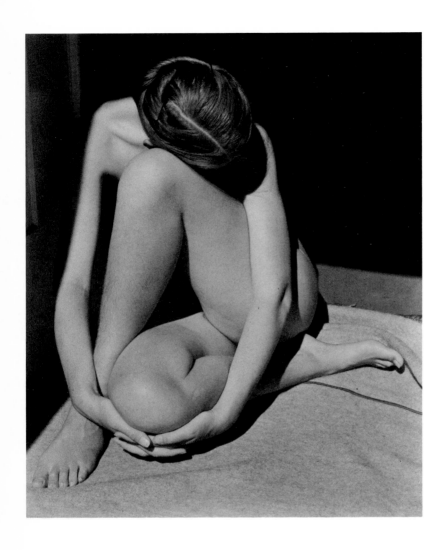

Edward Weston: ''Nude,'' 1936. Courtesy Cole Weston.

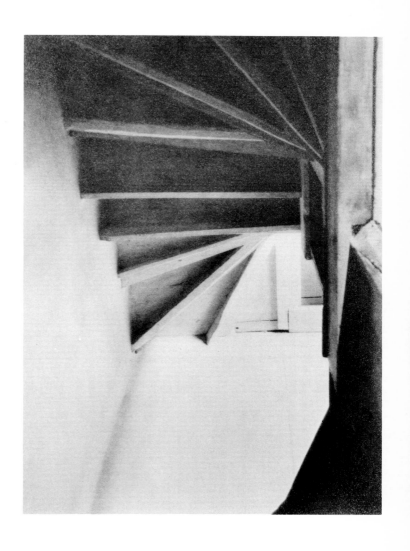

Charles Sheeler: "Staircase," c. 1915. The Metropolitan Museum of Art, New York; The Alfred Stieglitz Collection, 1933.

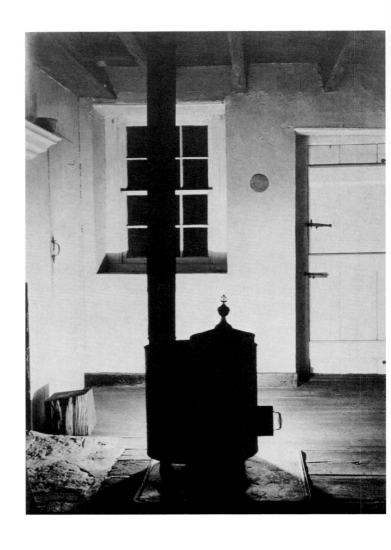

Charles Sheeler: ''Interior with Stove, Doylestown,'' 1917. The Metropolitan Museum of Art, New York; The Alfred Stieglitz Collection, 1933.

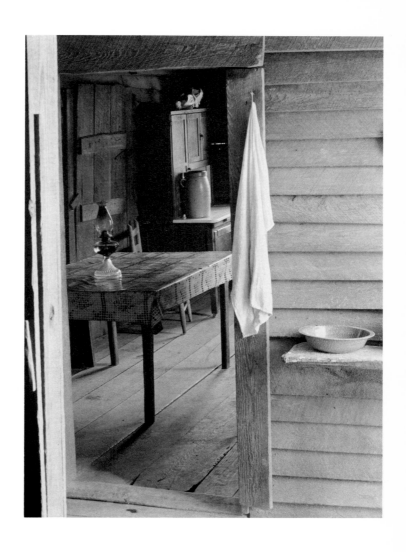

Walker Evans: ''Washroom and Kitchen of a Cabin, Hale County, Alabama,'' 1935. Courtesy The Library of Congress.

Walker Evans: "Edwards, Mississippi," c. 1935–1943. Courtesy The Library of Congress.

Jack Delano: ''On Hand to Help a Neighbor Plant Tobacco, Durham, North Carolina,'' 1940. Courtesy The Library of Congress. Print by Joe Maloney.

Russell Lee: ''Orange County, Vermont,'' 1939. Courtesy The Library of Congress. Print by Joe Maloney.

László Moholy-Nagy: ''Siesta,'' n.d. Collection of The Museum of Modern
Art, New York. Reproduced by permission of Hattula Moholy-Nagy Hug.

László Moholy-Nagy: ''Photogram (Shadowgraph),'' 1926. Collection of The Museum of Modern Art, New York. Reproduced by permission of Hattula Moholy-Nagy Hug.

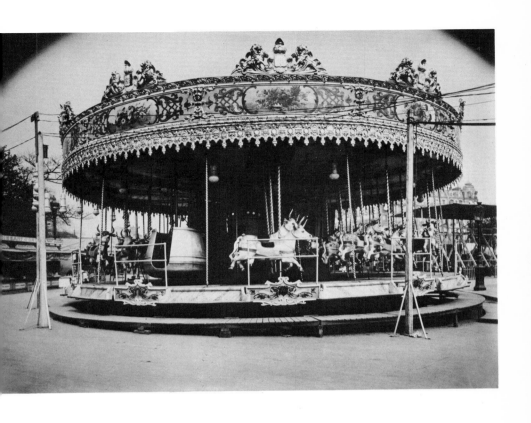

Eugène Atget: ''Merry-Go-Round,'' n.d. The Metropolitan Museum of Art, New York; David Hunter McAlpin Fund, 1956.

Eugène Atget: ''Store,'' n.d. Print by Joe Maloney.

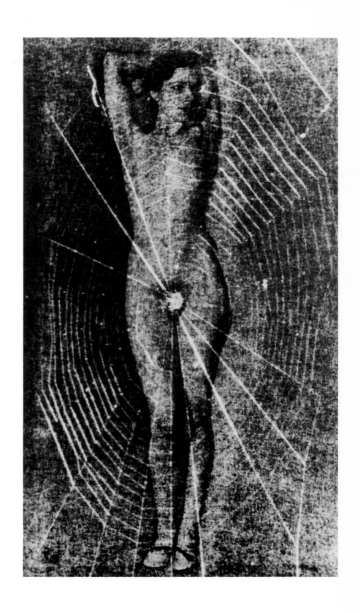

Man Ray: ''Woman in Spiderweb'' (solarized photograph), 1930. Courtesy Kimmel/Cohn Photography Arts, New York.

Man Ray: ''Untitled'' (Rayograph), 1946–1950. Courtesy Kimmel/Cohn
Photography Arts, New York.

Horst: ''Mistinguet,'' 1935. Courtesy Sonnabend Gallery and Photo-Artists, New York.

Horst: ''Odalisque,'' 1937. Courtesy Sonnabend Gallery and Photo-Artists, New York.

surpass Steichen's in abstract compositional force, never match his fellow photographer's work in evocation of personality. Perhaps the most important result of Sheeler's commercial work was that it often required him to produce groups of pictures of the same or similar subjects, a habit he carried over into his independent work in the creation of several series of pictures which he thought of as collective portraits of the subjects involved. In general, however, he struggled to free himself from the demands of commercial photography, and did so whenever it was financially feasible.

Toward the end of his early efforts as an architectural photographer, Sheeler took the first of his independently creative pictures. Although they may be seen as related to the architectural photographs, since they are interiors of the Doylestown house he shared with Morton Livingston Schamberg, these pictures are entirely different in concept. They are strongly lighted close-ups of interior details in which the sharp patterns of light and dark combine with shallow depth to create strong surface patterns of considerable abstract force. Taken in 1914, they perhaps reflect Sheeler's growing knowledge of, and interest in, avant-garde (particularly Cubist) painting, evidenced by his participation in the Armory Show of the previous year.

The final series of twelve photographs of the Doylestown house first attracted Stieglitz to Sheeler's photography. They were also to be the subjects of Sheeler's first one-man show, held by De Zayas in 1917. One of them, a picture of a window, won Sheeler the one hundred dollar first prize at the 1918 photography exhibition held by Wanamaker's in Philadelphia, the jury for which included Stieglitz and Arthur Carles. During this period Sheeler was also doing some still-life photography, as well as taking pictures of barns in the Bucks County countryside. Among these is "Side of a White Barn," one of his best-known photographs. By 1918, only six years after he had taken up photography, Sheeler's photographs had attracted sufficient attention to cause a Philadelphia critic to mention him as one of "the Trinity of Photography," the others being Paul Strand and Schamberg.

After his move to New York in 1919, Sheeler was engaged in two closely related photographic projects that brought him further professional and public attention. One was a six-minute movie evocation of New York, made with Paul Strand, which included titles from Walt

Whitman and was called *Mannahatta*. After a week's showing in New York in 1921, *Mannahatta* was chosen along with works by Apollinaire and Satie for an avant-garde program in Paris. Sheeler's other project was a series of still photographs of the city, mostly pictures of midtown buildings seen at a sharp downward angle. Sheeler again used the structural relationships of the buildings and the play of shadow and light to create surface pattern. For Edward Weston, who saw the New York pictures on his first trip to the city in 1922, these were "the finest architectural photographs I have seen," and "had a genuine grandeur—nobility."

During the period of his commercial work in the 1920s, Sheeler took few photographs purely for personal satisfaction. Notable among those few are a series of nudes made about 1922 and a few portraits of friends. This choice of subject was, again, related to the commercial, in this case, figure work in which he was engaged. As soon as he was released from the demands of commercial work, Sheeler returned immediately to taking pictures to please himself. On a trip to Europe in 1929 to see the German exhibition "Film und Foto" in which he was exhibiting, he took a series of fourteen pictures of Chartres Cathedral which are among the very finest of his work, and of which he himself was extremely fond. After the European trip, and with his increasing absorption in painting, Sheeler seems at last to have found a way to integrate his deep commitment to creative photography with the demands of painting and supporting himself. Whereas previously his best photographic efforts had been independent and his commercial work tended to be of lower quality, during the 1930s and 1940s Sheeler's best pictures were those made as studies for commissioned paintings. In 1935 and 1936, for instance, he spent time in Williamsburg, Virginia, making studies for the paintings now in the Williamsburg Inn. Out of this series came the beautiful photograph "Williamsburg Stairwell." Three years later he made a series of industrial photographs as notes for six paintings on the subject "Power" commissioned by *Fortune* magazine. One of his finest photographs, a picture of a locomotive called "Wheels," was part of this series. This was the picture chosen by Sheeler to be included in Weston's article in *Encyclopaedia Britannica*, and, indeed, was closely imitated by Weston himself in a picture of 1941 called "Santa Fe 4-8-4." Other outstanding photographs from the same series included pictures of Boulder Dam and the TVA power project at Guntersville, Alabama. Certain of his assignments for The Metropolitan Museum seem also to have been extremely congenial

to Sheeler, and his photographs of the museum's Assyrian reliefs are among his best work.

Among the best pictures of the last decade of Sheeler's creative life are those taken when he was making painting studies, notably a photograph of storage tanks taken in conjunction with a painting commissioned in 1952 by the Meta-Mold Aluminum Company. Architectural photography was again rewarding for Sheeler, most notably in pictures of Rockefeller Center, the United Nations, and Lever House. He also made most of his few photographic nature studies during this time. These included photographs made in Sequoia and Yosemite national parks, and a series of details of a beech tree in the side yard of his home at Irvington, New York.

The independent creative photography on which Sheeler's claim to importance as a photographer rests embodied a vision uniquely his own. Although his pictures shared a "straight," sharp-focused, uncropped quality with the work of other important photographers of his time, Sheeler's photographs are differentiated from those of his contemporaries by their lack of dramatic assertiveness and by their tendency toward surface composition, a tendency which evidences Sheeler's awareness of trends in contemporary painting. Sheeler did not use light and dark contrast to dramatize his subjects, but rather for the abstract two-dimensional cohesiveness the resulting patterns gave his pictures. He was a master of subtle gradations of tonality, which gives some of his best work a unifying silvery cast of extreme delicacy. In his earlier work, notably the African pictures, Sheeler sometimes used sepia toning to achieve the unity of effect he later produced by these gradations of gray.

The subjects of his best pictures were almost always overtly structural, often architectural, which tends to give an underlying tautness to his evanescent surface effects. To increase this tautness, Sheeler abstracted his subjects by composing them "without setting, foreground plane, environment, or identifying intermediaries, thus removing [them] the more from emotional response." The resulting nonassociational quality, combined with Sheeler's straight photographic technique, was what so impressed the Stieglitz group. It led Edward Steichen to remark that "Sheeler was objective before the rest of us were." Combined with the emotional force with which Sheeler invested his photographs, it is also the basis of their continuing appeal.

The relationship between photography and painting in Sheeler's work

is subtle and easily misunderstood. Because his paintings were so precise and superficially "photographic," it is easy to jump to the conclusion that they depended wholly on, and were an extension of, his photographs. Nothing could be further from the truth. Photography and painting were for Sheeler distinct expressive media, each with its own advantages and limitations and each appropriate to the solution of separate problems. He always considered himself primarily a painter and sought recognition in that field, but as early as 1914 he realized that photography was to be for him a useful expressive medium and recognized that the creative intensity that went into his independent photographs made them closer in quality and intent to his painting and drawing than to the commercial photography with which he was forced to support himself. Early in Sheeler's career, when he concentrated on painting, both commercial and creative photography tended to fall by the wayside, but as time went on he was increasingly able to carry on creative photography and painting in conjunction with one another. He did this by using photography as earlier artists had used drawing, to supply notes and studies for paintings. He thus was able to make photographs into which he could put his whole creative being at the same time that he served what he considered his principal art.

This more direct relationship between photography and painting seems to have started in the early 1920s, when Sheeler first made paintings and drawings after photographs taken several years earlier. This habit seems to have continued in a desultory way for more than a decade, and one has the impression that Sheeler sometimes stimulated himself toward painting by looking through old photographs and gleaning from them what seemed promising compositions. By the mid 1930s, the period of his stay in Williamsburg, he had quite consciously developed the practice of making photographic studies for paintings to be executed in his studio, a practice he followed with every subsequent painting commission. As he explained in conjunction with his *Fortune* magazine painting *Rolling Power,* taken from the photograph "Wheels," "since I could not camp beside [the locomotive] for the three months I required to paint it, I made a photo." This practice allowed him full creative freedom on the spot, as well as the greatest latitude in the later working out of the painting. In the 1950s Sheeler also developed the habit of making color photographs to have color notes for painted compositions, and Mrs. Sheeler remembers

his keeping a slide viewer next to him as he painted to check the colors of scenes he had photographed in other parts of the country.

Beyond this direct use of photographs for painting, it is apparent that certain specific visual effects were suggested to Sheeler by his photography. His attempts at color photography for The Metropolitan Museum were followed closely by more intense colorism in his painting. The overprinted "double-exposure" he made for The Museum of Modern Art triptych seems to have suggested such effects for his painting and they are common in his later work. Indeed, several photographic prints exist in which Sheeler seems to have been consciously manipulating such effects in the search for a painting composition. One such was taken over for the painting *Ore into Iron.* The way in which light and shade effects are distributed abstractly across the surface of some of his canvases, combining with elements of the subject to create an overall nonobjective pattern, also recalls his photography, and certain paintings suggest cropped photographic images or the acute upward, downward, or diagonal visual angles that Sheeler obtained with his camera. Ultimately, however, photography served Sheeler in relation to his painting as a fixative for his vision, and its most important place in his work is as a separate but equal expressive medium—a medium of which he was complete master and in which his achievement has been too long neglected.

Leslie Katz

Walker Evans (1903-1975) made photographs that comment on American life. He was against aestheticism and his ideas about documentary photography derive from the rigorous explicitness of straight photography. Evans extended straight photography by choosing images that literalized his evaluations. For him photography was a means to affect and chart social history. His publications include Let Us Now Praise Famous Men *(1941) and* Many Are Called *(1966), both coauthored with James Agee; and* American Photographs *(1938), with an essay by Lincoln Kirstein.*

In this interview with Leslie Katz, Evans describes his own and others' efforts toward making photography an instrument that informs and sensitizes.

Leslie Katz, writer and editor, also directs the Eakins Press, which published Message from the Interior *(1966), an album of Evans photographs.*

Walker Evans is a legendary master of the medium of still photography, one of the few practitioners recognized to have elevated that ubiquitous preoccupation to the level of high and serious art. He is an elusive and usually taciturn man who has the self-effacing air of a practicing magician, and interviewing him may be compared to interviewing a sphinx: you have to propound a riddle that interests him. But when he does answer, his statement, like one of his photographs, has authority, is literate, and tends to transcend the subject.

Evans now teaches at the Yale School of Art and Architecture. There he gives his encouragement to the young copiously when it is called for, but he does not suffer outside interviewing gladly. The occasion for the words of his that follow is the large and magnificent retrospective of his work now on view at The Museum of Modern Art, accompanied by the publication—by the museum—of an important new volume of his photographs. The museum is planning to reissue his famous book *American Photographs,* first published in 1938.

Q: Mr. Evans, do you understand the tape-recording process?

A: Understand it? I know all about that infernal machine. You talk

*Reprinted from *Art in America* (March/April 1971).

and it records inconsequential persiflage—illogical, totally misleading stuff. That thing would vitiate Bernard Shaw, Samuel Johnson, and Socrates. Well, all right, but you have to let me edit it. Even so, if I chirp it may come out bird-brained. Besides that, as soon as you transcribe from tape, the damned thing becomes a lie detector. But go ahead—you mean it's already on?

Q: Where and when did your interest in photography begin?

A: Well, I began to practice photography seriously just after returning to New York in the late 1920s, after living two years in Paris, where I went to classes at the Sorbonne. In Paris I made a few snapshots of streets, but nothing serious, nothing with my mind. I didn't give myself to it. When I came back to the United States, I began to make many photographs. Even then I didn't take it seriously, I suppose, until I showed them to other people. I thought maybe it was a left-handed hobby of mine. A few others made me take it more seriously.

Q: Who were they?

A: Well, there was Stefan Hirsch, a painter. Hirsch sent me to Stieglitz, who certainly didn't take fire over the work I had. Hart Crane, in his raving way, made a fuss over my things—my first publication, I think, was in the original edition of *The Bridge*. Ben Shahn and I saw a lot of each other. Lincoln Kirstein and Agee, Kirstein first, came into my work much more strongly. Kirstein was an aggressive, quite unrestrained young man, still a Harvard undergraduate, when I met him somewhere. He invaded you; you either had to throw him out or listen to him. As a matter of fact, I thought at the time he was great and still do. Oddly enough, what happened was that this undergraduate was *teaching* me something about what I was doing—it was a typical Kirstein switcheroo, all permeated with tremendous spirit, flash, dash, and a kind of seeming high jinks that covered a really penetrating intelligence about and articulation of all aesthetic matters and their contemporary applications. It's hard to believe, but as I say the man was essentially explaining to me just what I was doing in my work. It was immensely helpful and hilariously audacious. Professor Kirstein. Agee of course was another matter altogether. He didn't teach, he perceived; and that in itself was a stimulation. We all need that kind of stimulation, wherever it comes from. In a sense you test your work through that and it bounces back strengthened. My work happened to be just the style and matter for his eye. I could go on at length about Agee, but won't. Actually I think most artists are really

working for a very small personal audience. I always have. I think the artist's famous "solitude" is a vacuum. Psychologically you are communing and sharing with someone else, several others, that is.

Q: You took photographs of whatever interested you?

A: Oh, yes. I was a passionate photographer, and for a while somewhat guiltily. I thought it was a substitute for something else—well, for writing, for one thing. I wanted to write. But I became very engaged with all the things there were to be had out of the camera, and became compulsive about it. It was a real drive. Particularly when the lighting was right, you couldn't keep me in. I was a little shamefaced about it, because most photography had about it a ludicrous, almost comic side, I thought. A "photographer" was a figure held in great disdain. Later I used that defiantly. But then, I suppose, I thought photographing was a minor thing to be doing. And I guess I thought I ought to be writing. In Paris, I had been trying to write. But in writing I felt blocked—mostly by high standards. Writing's a very daring thing to do. I'd done a lot of reading, and I knew what writing was. But shy young men are seldom daring.

Q: Who were your favorite authors? Did they influence your photography?

A: Flaubert, I suppose, mostly by method. And Baudelaire in spirit. Yes, they certainly did influence me, in every way.

Q: Well, your photographs are known for showing an indigenous American aesthetic that doesn't even know it is an aesthetic—an archetypal classicism of the ordinary. It's almost as if Flaubert had a camera.

A: I wasn't very conscious of it then, but I know now that Flaubert's aesthetic is absolutely mine. Flaubert's method I think I incorporated almost unconsciously, but anyway used in two ways: his realism and naturalism both, and his objectivity of treatment; the nonappearance of author, the nonsubjectivity. That is literally applicable to the way I want to use a camera and do. But spiritually, however, it is Baudelaire who is *the* influence on me. Even though I haven't really studied Baudelaire very much I consider him the father of modern literature, the whole modern movement, such as it is. Baudelaire influenced me and everybody else too. Now that I think about it, mine was the first generation that went to Europe and got a European perspective and technique and came back and applied it to America. Who could be more wonderful masters than Baudelaire and Flaubert? That had really been lacking. Of course every-

one went to Europe differently. I don't think Scott Fitzgerald got anything much out of Europe, but Hemingway did. For one thing, Fitzgerald didn't pay any attention to the French language. Hemingway became a sort of master of languages; he could speak and *think* French and Italian and Spanish.

Q: When you began to photograph, how were you affected by the cultural atmosphere and the photography you found in New York when you returned?

A: I found myself operating direct from the French aesthetic and psychological approach to the world. I applied that to the problem of rendering what I saw. I think I operated in reaction to mediocrity and phoniness. In the late 1920s the battle against gentility in the arts and in behavior was still on. Everybody a little bit advanced was busy misbehaving in order to shock gentility. Mencken was still leading the attack. William Dean Howells was gone. The attack was a branch of *épater le bourgeois*. A kind of aesthetic and literary revolution was taking place. Anybody wandering in became a part of that. I did, I'm sure. It's hard to believe now, but we had barnacles of Victorianism hanging around that wouldn't scrape off. I was brought up with Victorian English standards of behavior. I thought that was something to hide. I was in rebellion against my parents' standards. In round terms, I was damn well going to be an artist and I wasn't going to be a businessman.

Q: How did you make a living?

A: I had a night job on Wall Street in order to be free in the daytime. It paid for room and food. You didn't have to sleep or eat much. In those days I was rather ascetic; I didn't lead the bohemian life Crane led. My friends were mostly Europeans. I shared an apartment with Paul Grotz and the German painter Hans Skolle. I was really anti-American at the time. America was big business and I wanted to escape. It nauseated me. My photography was a semiconscious reaction against right thinking and optimism; it was an attack on the establishment. I could just hear my father saying, "Why do you want to look at those scenes, they're depressing. Why don't you look at the nice things in life?" Nothing original about that, though. The Ashcan School of painting and Upton Sinclair and maybe Dreiser had already done it. Although I felt above having a "cause" like Sinclair. I disdained Sinclair Lewis too, thinking he lacked taste and breadth and cultivation—though he was a very gifted Yankee American word-slinger.

Q: When did you begin to take pictures that caught hold with you?

A: About 1928 and 1929. I had a few prescient flashes and they led me on. I found I wanted to get a type in the street, a "snapshot" of a fellow on the waterfront, or a stenographer at lunch. That was a very good vein. I still mine that vein.

Q: You're a collector; you collect postcards and found objects. Is there any relation between your collecting and your work?

A: A great deal. It's almost the same thing. A collector becomes excessively conscious of a certain kind of object, falls in love with it, then pursues it. I notice that in my work for a certain time I'm interested in nothing but a certain kind of face or type of person. You start selecting people with the camera. It's compulsive and you can hardly stop. I think all artists are collectors of images.

Q: There is an abstract quality about the most literal photograph of yours. Do you think in terms of composition?

A: I don't think very much about it consciously, but I'm very aware of it unconsciously, instinctively. Deliberately discard it every once in a while not to be artistic. *Composition* is a schoolteacher's word. Any artist composes. I perfer to compose originally, naturally rather than self-consciously. Form and composition both are terribly important. I can't stand a bad design or a bad object in a room. So much for form. The way it's placed is composition. . . . When you stop to think about what an artist is doing, one question is what is the driving force, the motive? In this country it is rather obvious; different, say, from European culture. The artist here is very angry and fighting. Everything makes him angry: the local style of living, and one's competitors. Even co-workers in the arts anger and stimulate him. I was stimulated by Stieglitz. When I got around to looking at photography, I found him somebody to work against. He was artistic and romantic. It gave me an aesthetic to sharpen my own against—a counteraesthetic. But I respect Stieglitz for some things. He put up a very good fight for photography.

Q: In literature or painting, the artist creates in a prolongation of time. Photography is an instant. Your photographs show the monumentality of an instant. What role does accident and what role does intention play? How do they come together? Or is that too mysterious a question to discuss?

A: In the act of photographing? It's all done instinctively, as far as I

can see, not consciously. But after having made it instinctively, unless I feel that the product is a *transcendence* of the thing, of the moment in reality, then I haven't done anything, and I throw it away. Take Atget, whose work I now know very well. (I didn't know it at all for a while.) In his work you do feel what some people will call *poetry*. I do call it that also, but a better word for it, to me, is well—when Atget does even a tree root, he *transcends* that thing. And by God somebody else does not. There are millions of photographs made all the time, and they don't transcend anything and they're not anything. In this sense photography's a very difficult art and probably depends on a gift, an unconscious gift sometimes, an extreme talent. Of course there are many extremely gifted and talented people who wouldn't think of operating with a camera, but when they do, it shows. You know, that runs through all art. What's great about Tolstoy? A paragraph of his describing a young Russian girl is universal and transcendent, while what another author writes on the same subject may amount to nothing much.

Q: In other arts one can speak of technique of hand or of mind, the draftsmanship of the painter, the craft of the author. In photography there is a mechanical instrument and a moment when the eye, having looked through the lens, allows the hand to click a lever. How can all that we've expected of literature and art find a commensurate expression in a medium that is basically a mechanism?

A: Well, that's what makes photography so special and interesting and unknown as an art, and that's why so many people don't see anything in it at all. The point is difficult and abstruse. And that's why I say half jokingly that photography's the most difficult of the arts. It does require a certain arrogance to *see* and to *choose*. I feel myself walking on a tightrope instead of on the ground. With the camera, it's all or nothing. You either get what you're after at once, or what you do has to be worthless. I don't think the essence of photography has the hand in it so much. The essence is done very quietly with a flash of the mind, and with a machine. I think too that photography is editing, editing after the taking. After knowing what to take you have to do the editing. The secret of photography is the camera takes on the character and the personality of the handler. The mind works on the machine—through it, rather.

Q: Do you take many photographs to get one photograph?

A: Quite often. I'll do anything to get one photograph. That's another

matter I would have to quarrel with a man like Stieglitz about. Stieglitz wouldn't cut a quarter of an inch off a frame. I would cut any number of inches off my frames in order to get a better picture. Stieglitz once made a very revealing remark to me. He said, "I would have been one of the greatest painters ever born." That gave me plenty of thought. I believe it revealed great insecurity on his part. And yet the same man, to his credit, stuck to pure photography and felt that the camera ought to be photographic and not painterly. He was a purist that way. The real photographer who is an artist would never produce a romantic print now, as so many early nineteenth- and twentieth-century photographers did, using tricks of soft focus and of retouching to disguise the photograph and push it in the direction of painterliness—which is ridiculous. Photography should have the courage to present itself as what it is, which is a graphic composition produced by a machine and an eye and then some chemicals and paper. Technically, it has nothing to do with painting.

Q: How important is the print and the variation in prints?

A: Very important. The printing technique is hidden and should be. A print has to be true and efficient too, and it can—photographically. You have to have taste and know what's right, about the rendition of light, for example—not too little. Take one negative and print it several ways, and just one will be right. It's a question of truth. You can make a very false picture from a wonderful negative, or you can make a true one.

Q: One notices that in your photographs people are unselfconscious before your camera and all the more themselves for that, formally unselfconscious. Also, in your photographs of things, you seem to seek and discover what you once termed *unconscious arrangements*. Do you efface yourself, or seek a quality of concentration?

A: No, but I do it psychologically, and again, unconsciously. It comes about through some quality of mine that I don't know how I bring into play. People react to me in one way, and to another kind of person in another way. They react the way I *want* them to when I'm doing it right. I'm often asked by students how a photographer can overcome self-consciousness in himself and in his subjects. I say any sensitive person is bothered unless his belief in what he is doing and motive is very strong. The picture is the important thing. In making pictures of people no harm is being done to anybody or deception practiced. One is carrying on a great tradition in a branch of art practiced by Daumier and Goya, for in-

stance. Daumier's *Third Class Carriage* is a kind of snapshot of actual people sitting in a railway carriage in France in the mid-nineteenth century. Although he didn't use a camera, he sketched those people on the spot, like a reporter, and they probably saw him doing it. What of it?

Q: Then photographs can be documentary as well as works of art?

A: *Documentary?* That's a very sophisticated and misleading word. And not really clear. You have to have a sophisticated ear to receive that word. The term should be *documentary style.* An example of a literal document would be a police photograph of a murder scene. You see, a document has use, whereas art is really useless. Therefore art is never a document, though it certainly can adopt that style. I'm sometimes called a "documentary photographer," but that supposes quite a subtle knowledge of the distinction I've just made, which is rather new. A man operating under that definition could take a certain sly pleasure in the disguise. Very often I'm doing one thing when I'm thought to be doing another. I've certainly suffered when philistines look at certain works of mine having to do with the past, and remark, "Oh, how nostalgic." I hate that word. That's not the intent at all. To be nostalgic is to be sentimental. To be interested in what you see that is passing out of history, even if it's a trolley car you've found, that's not an act of nostalgia. You could read Proust as "nostalgia," but that's not what Proust had in mind at all.

Q: People live by mythic images, by icons. Certain of your photographs have become classics, have found their way into what could be called national consciousness. They've found a permanent audience, not immediately as fashion does, but as art does, by a residual process. How did you come upon those images?

A: As I said, by instinct, like a bird, entirely by instinct. Like a squirrel too, burying and hiding, and divining where the nuts are. I've been doing that all the time. But I find it inhibiting to discuss this. It suggests speculation, and doubt, doubt of my own sure action.

Q: But millions of people feel they're performing an instinctual act when they take a snapshot. What distinguishes what they do from a photograph of yours?

A: I don't know. It's logical to say that what I do is an act of faith. Other people might call it conceit, but I have faith and conviction. It came to me. And I worked it out. I used to suffer from a lack of it, and now that I've got it I suppose it seems self-centered. I have to have faith

or I can't act. I think what I am doing is valid and worth doing, and I use the word *transcendent*. That's very pretentious, but if I'm satisfied that something transcendent shows in a photograph I've done, that's it. It's there, I've done it. Without being able to explain, I know it absolutely, that it happens sometimes, and I know by the way I feel in the action that it goes like magic—this is it. It's as though there's a wonderful secret in a certain place and I can capture it. Only I can do it at this moment, only this moment and only me. That's a hell of a thing to believe, but I believe it or I couldn't act. It's a very exciting, heady thing. It happens more when you're younger, but it still happens, or I wouldn't continue. I think there is a period of aesthetic discovery that happens to a man and he can do all sorts of things at white heat. Yeats went through three periods. T. S. Eliot was strongest in his early period, I think. E. E. Cummings seemed to go on without losing much. After all, poetry is art and these fields are related. It's there and it's a mystery and it's even partly mystical, and that's why it's hard to talk about in a rational, pragmatic society. But art goes on. You can defend it in spite of the fact that the time is full of false art. Art schools are fostering all sorts of junk, but that's another matter. There are always a few instances of the real thing that emerge in unexpected places and you can't stop it; there it is. Even in a puritan, materialistic, middle-class, bourgeois society like America. Because the country is like that, the artist in America is commonly regarded as a sick, neurotic man (and tends to regard himself that way). Until recently, true art in America was sick from being neglected. Now of course it's sick the other way: too much is being made of it. The period that's just finishing, of fame and fortune for a few artists, is outrageous. It's outrageous for a few to make hundreds of thousands of dollars while a number of very good artists cannot even make a living. It makes you sick to think about it. The art world is part of our very sick society. Think of what a man of letters is in Paris or in England and what he is here. Here he's either outrageously famous and rich, or treated as less than nothing, never understood, never honestly appreciated. In those countries everyone understands that there are many excellent, poor, almost starving artists, and they are very much respected, just as old age is respected. The unappreciated artist is at once very humble and very arrogant too. He collects and edits the world about him. This is especially important in the psychology of camera work. This is why a man who has faith, intelligence, and cultivation will show it in

his work. Fine photography is literate, and it should be. It does reflect cultivation if there *is* cultivation. This is also why, until recently, photography has had no status, as it's usually practiced by uncultivated people. I always remember telling my classes that the students should seek to have a cultivated life and an education: they'd make better photographs. On the other hand, Eugène Atget was an uneducated man, I think, who was a kind of medium, really. He was like Blake. His work sang like lightning through him. He could infuse the street with his own poetry, and I don't think he even was aware of it or could articulate it. What I've just been saying is not entirely true. Since I'm a half-educated and self-educated man, I believe in education. I do note that photography, a despised medium to work in, is full of empty phonies and worthless commercial people. That presents quite a challenge to the man who can take delight in being in a very difficult, disdained medium.

Q: What are the names of some of the photographers, past and present, you particularly admire?

A: That doesn't much matter. You're drawn to people who share your taste. My favorites are Brady and Atget. After I discovered myself, I found that they were working in ways that appeal to me and in ways that I would like to work too. I don't look at much contemporary photography. With occasional exceptions. I remember coming across Paul Strand's "Blind Woman" when I was very young, and that really bowled me over. I'd already been in that and wanted to do that. It's a very powerful picture. I saw it in the New York Public Library file of *Camera Work,* and I remember going out of there overstimulated: "That's the stuff, that's the thing to do." It charged me up. I don't look at much contemporary photography and I don't want to. I've watched Lee Friedlander and Robert Frank and Diane Arbus come up, though. I'm quite conscious of them; they're good. And there are many others, I suppose.

Q: An observable quality of your photographs is that whether they were taken in 1930 or 1970 they're essentially timeless. They don't date. Your recent photographs of street gutters and graffiti are, like your earlier photographs, each a world entire. Have your interests changed with the passing of time?

A: I find that my interests are amplified somewhat, but I haven't dropped and I don't think I've outgrown any of my original interests. You see I learned awfully fast without teachers. I was very lucky. I just

came upon my true line without going down bypaths or blind alleys or dead ends. I did do some wrong things when I first started to use a camera, but very quickly and very early on I learned the true straight path for me, the path of getting away from "arty" work, the obviously beautiful. When you are young, you are open to influences, and you go to them, you go to museums. Then the street becomes your museum; the museum itself is bad for you. You don't want your work to spring from art; you want it to commence from life, and that's in the street now. I'm no longer comfortable in a museum. I don't want to go to them, don't want to be "taught" anything, don't want to see "accomplished" art. I'm interested in what's called "vernacular." For example, finished, I mean educated, architecture doesn't interest me, but I love to find American vernacular. Museums have a wonderful function, but there comes a time when the artist had better stay out of them, I think.

Q: In your photographs there is often an extraordinary clarity, a quality of classicism, substance precisely defined by light and texture. Do you achieve that by instinct too, or do you have to work for it?

A: Well, you have to work for it, but I'm not interested in it technically, or not even interested in photography really—only in that I can make it do what I want, for example, as you just said, for its classicism and clarity. If I can bring it to that, I will; but for its own sake, no. Photography, I said before, really doesn't interest me, the technique of it either. I do know that I want to be able to do something with it, though.

Q: You don't believe that in order to do something with it the new improved equipment is of help?

A: No, not at all. But you do have to be able to make the camera do what you want it to do, instinctively and competently. That is a technical problem. You want to put this technical problem where it belongs, as something to serve you. Not as itself, a piece of technical mastery and virtuosity. For example, both Ansel Adams and Paul Strand are really great technicians. They sometimes show they're too great. They do the perfect thing with the camera, and you say ohh and ahh, how perfect. Then you don't get their content clearly enough, however. As in typography and printing, technique shouldn't arrest you. Something should be said through it, not by it. Your mood and message and point have to come through as well as possible. Your technique should be made to serve that, kept in place, as a servant to that purpose. That does require skill, knowl-

edge, and technical ability, and you have to have done the work in order to make it *not* show. You asked me if I was interested in texture and light. Not really. In fact, I feel that's what's wrong with a whole lot of photography. It's just a piece of texture and light. I could, anybody could, do excellent photography with rather poor and certainly inexpensive equipment. In fact, there is a danger in having thousand-dollar equipment. You fall in love with that, it becomes complex in another way. I want to keep it simpler. In photography you do reach a point where your equipment is somewhat like your motorcar. You learn the operation of the thing so well, it can submerge into an automatic reflex action—you can think about something else while you're using it. And I've gotten that way with my cameras. A certain period of time and practice is required, and you must do it as a drill. Once you do it, once you have learned it, if you change your instrument you have to learn all over again.

Q: I understand that Saul Steinberg once said you taught a generation what and how to see. In a sense you have been a recorder of the unconscious folk art that appears in the streets, in houses, in the cities, and in the hinterlands—unconscious art that is the root evidence and primal source of culture—

A: I don't know whether or how Steinberg said that of me, but I'm aware of the remark. It's a great exaggeration. No one could live up to it or make it true. There is always somebody around doing that for each of us. E. E. Cummings, for example, did teach me what to see, what was poetic. T. S. Eliot, particularly, did that for me too. However, there are certain artists whom I see nothing in, and they may end up by being perfectly great. . . . Look at Joyce. He had very poor judgment of everybody around. He was ignorant of Proust, of all the great writers of his time. Yet look who he was.

You know, I really think with a good part of myself that an artist shouldn't talk very much about his work, or himself, or his peers, as I've been doing with you. It may seem to be fun while it's going on, and doing it just once. But an artist is too special a man in society anyway. He thinks art is too important, and he thinks he's too important. For example, who *really* appreciates or understands Baudelaire, who I think is a kind of god? Spiritually and psychologically, the work of Baudelaire has become an important force, the source of a whole psychology and movement that in the end affects art and life. But the individual artist himself, being an

artist, goes around with a lot of stuff in his head that doesn't fit or count or act as part of the world. I could sum up most of all this by remarking that art is a very private thing. I hope that's not rude—to throw that remark into your talking machine.

An Interview Conducted by Robert J. Doherty, F. Jack Hurley, Jay M. Kloner, and Carl G. Ryant

Roy Stryker (1893–1975) developed the convention of documentary photography to inform about people and their environment. His definition of photography as a means to re-create reality worked for government and industry projects. In this interview with noted American historians, Stryker explains how the Farm Security Administration (FSA) photography project evolved to expose intolerable economic and social problems; and his later commercial work is compared to his pioneering government efforts.

Stryker headed the FSA photography project from 1935 to 1942. His staff included, at different times, Marion Wolcott, Dorothea Lange, Walker Evans, Arthur Rothstein, Russell Lee, John Vachon, Gordon Parks, and Jack Delano. Under his direction more than 200,000 photographs (now in The Library of Congress) *were made; these images of American rural slums became stubborn arguments for the necessity of New Deal programs. In* This Proud Land (1973), *edited by Roy Stryker and Nancy Wood, and* The Bitter Years: 1935–1941 (1962), *edited by Edward Steichen, are selected anthologies of FSA photographs.*

In editing the original transcript of the interview, every attempt was made to retain the actual statements of Roy E. Stryker (1893–1975), but for the sake of compression and readability, and to avoid redundancy, words, passages, and even whole sections of the interview were omitted. In some instances, words were inserted in brackets for grammatical purposes or passages were transposed for the sake of continuity. Questions often reflect the conversational character of the interview and are less in the nature of actual questions than they are responses.

A number of people were involved in the editing of the manuscript, including two of the interviewers. Jay M. Kloner, Director of the Allen R. Hite Institute, University of Louisville, Kentucky, edited the text. Carl G.

* Reprinted from *Image* (December 1975).

Ryant, Director of the Oral History Center, University of Louisville, read the original text and the final, edited manuscript. In addition, Marsha Bruggman, research assistant at the University of Louisville Oral History Center, compared the original tapes with the manuscript for possible errors and also typed the final manuscript.

The other interviewers were Robert J. Doherty and F. Jack Hurley. Doherty is now Director of IMP/GEH [International Museum of Photography/George Eastman House—Ed.]. At the time of the interview, Director of the Hite Institute, he was directly responsible for establishing the Photographic Archives at the University of Louisville. Hurley is a member of the history department at Memphis State University and author of *Portrait of a Decade* (Baton Rouge: Louisiana State University Press, 1972), a study of Roy Stryker and the Depression-era Farm Security Administration (FSA).

Copies of the original transcript and interview tapes are available through the Oral History Center, History Department, University of Louisville, Louisville, Kentucky 40208.

RYANT: Could you tell us just briefly about your background before you went to Washington in the 1930s?

STRYKER: Now, let's see. After I got out of high school, I started to go to the Colorado School of Mines. I went one year; I didn't like it too well. And then I went back for the second year. I made up my mind that I was not going to be a mining engineer. I was not cut out for it. My brother, Mitch, older than myself—we got into ranching. And I went in with him, we bought some cattle. Have you ever been in Montrose? Well, there was a very interesting spot that was a lot of open land and heavy grass. A beautiful spot up near Uray, and we got in up there and got ourselves by. It was the kind of land you'd have to stay on, like a homestead. We got ourselves about eight hundred acres.

RYANT: Now when was this? Right before World War I?

STRYKER: No, I was back from the Army.

So we picked up about eight hundred acres in there. And my brother and I started in. He ran the ranch down in the valley and this was up on top of the mountain. My job was up there putting in fence and getting cattle in to lease. We'd let their cattle in there to graze and we'd make a little money off of that. So I spent most of my summers up there and I was

alone a lot, but three horses and a dog, and lots of fencing to do, and lots of barbed wire to stretch. It was a very nice experience. I put in about seven years on that and it was an extremely interesting thing. Lots of time to think. We had a little shack up there, and occasionally the coyotes would come down chasing the dog and I'd get out in the middle of the night and help him chase the goddamn coyotes off. So, there was lots of interesting things going on.

And then I got restless. I had places where I could go and visit and stay all night with people, and get a free supper and have companionship. I remember I went over to this one family that I knew very well. The older boy was in class with me, and his sister and this Frasier girl had just come back from teaching and they came and stopped there. That night I walked out around and took this girl out. We walked out under the moonlight and looked at the trees and talked. I had no idea what was going to come out of this. Her father had a big ranch out on the mesa— Fruit Ranch. So I got to going out there and they had a nice great big davenport. I could sit there and with a reasonable amount of affection I could deviate a little once in a while, and so we had quite a time together.

Then I had to go back up to the ranch there, up on that place, because that was my summer job—taking care of that thing. So I had a couple of weeks up there and I got to thinking about it, and I made up my mind that I was going to go back to school. I didn't know how or where or what. And also, this girl was in my mind and I was going to talk to her. So I went down after about two weeks up there with the dog and me chasing the coyotes, chasing the goddamn cows—one thing and another. So we sat and talked and I told her—I said, "Listen. I want to go back to New York and I want you to go back with me. Will you marry me?" After ten minutes of thinking she said yes. Then, we made our plans to take off. Then the problem came that I had to settle my share of that ranch, that eight hundred acres of land. So, I went to the big cattle man. He was right below us. He was always trying to get us to sell him a part of that. I went to him and I said, "I need some money. I'm going to get married and I'm leaving. If you want to buy some of this, I need twenty-eight hundred dollars. And my brother has agreed that we'll let you have the lower section. And we'll all get together and settle."

I got twenty-eight hundred dollars and went back and told her. I was gone two weeks. I said, "Now we can get off and we'll get married." That

was it. So we took off. We went up the narrow gauge and went up to the change-over to the broad gauge and took our way back down, headed for New York. We stopped, after all, 'cause I told her you can't be newly married without a visit to Niagara Falls. That's always done. We went there and then we got back. And later on my bride said, "I couldn't hardly keep the tears back. I was so upset all the way down." That was quite a long trip down from up there down to New York. And she said, "You didn't even sit in the seat—you just floated down." I already had lined up with a man in Denver who had ties to a settlement house. We went then to a big settlement house.

HURLEY: Union Settlement House?

STRYKER: Yes, Union Settlement House. We went there and she got a girls' club to take care of. It was a place where a lot of workers had lunches. They didn't believe in what they were doing, but that's all right. And then later on they gave me a club of twenty boys. And I'll never forget one of them. We just got settled in, and this guy told them I was a cowpuncher. Of course, as an assistant director, I could have killed him. They were just little kids, you know, about fifteen or something like that, and this one boy looked me over for a minute after this guy had introduced me as a cowpuncher. This little devil said, "I bet I've seen more cowpunchers than you've ever seen." I said, "The hell you have—where?" "In the movies." Well, that started it. I had them for about four weeks and they were wonderful. One year at the settlement was all I wanted. . . .

HURLEY: You were at the same time taking courses at Columbia?

STRYKER: Not that first year. I was busy down there at the settlement house—about all I could do. Too many damn things going on. So I told Alice, "Let's get out. I want to leave." I was sick of it. It was a nice place. It was right next to Third Avenue. And there were the pushcarts and you could buy your food cheaply. We went around a lot. She had quite a lot of time and she was on the roam a lot, looking over New York. I was interested, too. We went back, and I was registered at Columbia. Went up, got myself straightened out and that's where I met [Rexford G.] Tugwell. That was my start. I had a little bit of advance credit from the Colorado School of Mines, but not too much. And so, the first thing I knew, I was teaching.

RYANT: About when was this?

STRYKER: Well, this would be early twenties.

RYANT: But you had known Tugwell for a long time?

STRYKER: No. When I registered at Columbia, I was new. Tugwell was a new man to me. I hit off with him. He was a quiet man and hard to know. So, when I was first in there he was not exactly distant, but reserved.

I had a sophomore class, so I did advanced work on it. So I had these students in economics. Things got along very nicely and I enjoyed my work there. Little by little, Tugwell came up with the idea of a book. You may know the book. We—Tugwell. Munro, and Stryker—did a book called *American Economic Life* [1925]. You can take a look at that book if you want to. That's where I started. That book is a very important book—'cause that was the start of my interest in the visual things. My wife did the charts for it. She worked on it too.

KLONER: It has many photographs in it?

STRYKER: Oh, yes, It was loaded.

HURLEY: It has Lewis Hine pictures in it. You knew Lewis Hine.

STRYKER: You see, I met Lewis Hine early. Lewis Hine had a hell of an effect on me; a terrific effect on me.

KLONER: Did you know Lewis Hine before you worked on the book?

STRYKER: No. Well, I had met him. You see, all these things came together at that time.

HURLEY: Columbia was the background for this whole thing. Hine was a student of his at Columiba.

STRYKER: Yes. He took pictures for me. He did a lot of pictures around the place for me. The book was my start. I told Bob [Doherty], "You can put that book in your library up there and realize that was one of the things that got me going."

There was a second and a third edition. The first one was just pictures that I used in classes.

There was a history professor and he had a remarkable library of [the] Yale . . . ["Pageant of America"] Series. And he gave me a key to his office and I lived in there. A wonderful set of books. So I spent a lot of time on that, and that had a terrible effect on me. And then, of course, doing this book with Tugwell—they wrote the book—and hunting the pictures, and then my wife doing the charts, and so on.

RYANT: Did you find it hard, when you were doing this first book, to find the pictures that you wanted? The right illustrations?

STRYKER: I handled them. We'd go downtown and go to a store or

someplace. I also found two or three places that had old photographs and so I was just on the run all the time. Alice, my wife, would go out and look up places for me. She had ideas and she'd try to locate a place so that she could take me down to it. Between the two of us, why, we worked on that book. But the book was the start.

Do you remember the little manual that I made for my students?

HURLEY: Yes. That's another fascinating story. They'd put in a system of taking students out on trips around the town to show them economics functioning.

STRYKER: Yes.

HURLEY: Roy was in charge of this program.

STRYKER: Also, I was tied to the professor of labor's problems. That was a great contribution to me. You see, they had a labor professor, a very brilliant and very interesting guy. I got a lot out of him.

And then I'd let these students out all the time. I guess I was a good teacher because I was alive. I'd say, "Now there are five of you who want to go out on a trip on this." And I'd divide them up and say, "What do you want to see?" The Ford plant was right across the river from us, so we would go over there, and there were all kinds of places that we could go.

HURLEY: And there was the stock exchange.

STRYKER: Yes. There was a place where all of the bums stayed down the Bowery there. I could pick out guys carefully, knowing we were going to spend the night down there. And we'd go down and stay with the bums, or go down to the big produce market. It was across the river. It was a huge produce market. God, it was a hell of a place. I'd take the students down there. And I'd take the boys that I knew I could take down to where those bums had those free places to sleep. We wouldn't sleep there; we'd just talk to them all night. And I'd take them out to the bank, and the Federal Reserve.

HURLEY: They were on a picket line once?

STRYKER: Damn right, they were on a picket line. It was a curious experience. I was teaching, there was the book to do, there was illustrations to do. New York was there waiting for us, every street, every alley, all over the place. And these students—I'd divide them up, I couldn't take the whole damn class. I'd say, "Those of you that want to go, you'll have to sign up here for it. I can only take so many of you, now show me you're interested." And so, I was running about New York, getting things I got

for this book, and I was having fun with the students and they were getting some additional things in education, and so it was quite an affair. I had a very close relationship with these classes. I put in there; I got my degree. Then Tugwell moved down—this was when the New Deal was starting—and Tugwell moved down to Washington.

HURLEY: You took your bachelor's?

STRYKER: I took my bachelor's. That's as far as I've ever gone.

HURLEY: You did work beyond that?

STRYKER: Oh, hell, yes. Right. I just wasn't interested.

HURLEY: You never put it all together.

STRYKER: No, I didn't. I didn't want a degree. There was too many things that I was interested in. I wanted to get out of New York. But I went down to stay one summer with Rex [Tugwell]—his wife and family had gone. It was a very interesting summer, because it was then that our relationship had warmed up. And that was a godsend, because that was the basis of what happened later. And so, I spent the summer there with him. Something I'll tell you about is that the Department of Agriculture were nice people, but orthodox, narrow-minded, and they were a nuisance to you.

HURLEY: They were interested in the big farmers.

STRYKER: Yes. And they didn't like some of the things that I was doing. Well, I just made up my mind that the orthodox boys over there in the Department of Agriculture weren't going to tell me a goddamn thing. I knew I didn't have to take any guff off of them, so I just dodged them.

KLONER: Roy, can I ask you a question?

STRYKER: Yes, indeed you can.

KLONER: How did Tugwell envision the FSA and how did you see it? The directions of the FSA at the very beginning?

STRYKER: I don't know what Tugwell was thinking about it, to be honest. But, I was taking them pictures. I had done this book. I was interested in pictures. I was interested in taking students to places to see. And the photograph was an idea. Right away, that book had a terrific effect on me, just a terrific effect. And then the picture began to be the thing of my life. The photograph was the way to reach your group, to reach the people.

RYANT: Were you responsible directly to Tugwell?

STRYKER: To Tugwell.

HURLEY: This is that first year. You were still working at the Department of Agriculture. Weren't you under Milton Eisenhower right then?

STRYKER: Oh sure, but I could get along with Milton. He was a nice, tolerant guy and he understood that I was a renegade.

HURLEY: Tugwell was what—Assistant Secretary of Agriculture? And you were living with him when you . . .?

STRYKER: That one summer there I was living with him. You're right. We pulled up stakes and moved down there. That was the start of the whole business down there with Tugwell. He divorced, and married his secretary. She was a secretary at Columbia University. And she had a hand in helping me grow up. She was my friend in the college and in my work with Tugwell because she was the [department] secretary there.

HURLEY: Grace Falke?

STRYKER: Grace Falke. She, I owe so much to. Too many things. When Rex sometimes didn't quite see, didn't want to be bothered, Grace did it. Then she married him and she was his secretary, but also his wife. So, things began to move and the Depression was on. I had been doing things for publicity, and then, all of a sudden, this thing blossomed. We were out in the big open spaces. I was getting photographers and I was given a spot over there. We had a place to go. We were adding photographers and it wasn't long before we were in action. I was the boss. I had about four or five photographers, Arthur Rothstein and Russell Lee, the engineer who was down at the University of Texas, and Dorothea Lange, who didn't come. She stayed in California, and she didn't come for some time.

HURLEY: Was Walker Evans one of the early ones?

STRYKER: Yes, he was one of the early ones. Walker and I used to walk home and argue. Walker was so damn conservative in so many ways. We had some wild times.

Things began to move. The farmers began to go. It was a complicated thing and it would be quite a job to have to dig it all out for you in order to give you the exact thing. But, just accept the idea that we went to work. My job was to direct. I wrote lots of scripts. My job was to get the way to go out. They had books to read. I rode them on books. They had to get their background. Some of them went out on shorter trips. Russell Lee went out for a year and never came back, till the end of the year. I went out and met him once, I'll never forget. He was up in the Northwest, up

by Chicago, and I went up. He and I did some work up there together and we had a very wonderful experience. We were coming back down, and he stopped and he saw a little woman in a farm there, in a little old house. He stopped there and wanted to know if he could take her picture. She said, "What do you want my picture for?" And he told her. I kept my mouth shut and just stayed back. "Say," she said, "how would you like to have lunch? I'm going to have lunch for you. You folks are going to stay for lunch and like it." It was Russell she liked. She was an interesting woman. She said, "I'm going to invite some of my neighbors over here. I'd like to have them meet you fellows." They came over and we stayed. There was plenty of time and it was quite an experience.

But I didn't get out much. There were a few trips I had out. But the way Russell handled that girl and the way he handled everything there was something, and it taught me a lot. It was interesting to see. Because I had to stay back, I could feel ready to direct, ready to write the scripts.

HURLEY: Russell Lee at that time, had been on the road at least eight months?

STRYKER: Absolutely.

HURLEY: It was unreal how long he could stay out.

STRYKER: He knew when to come in.

HURLEY: Had he and his first wife Doris just broken up when he took the job in this thing? She was up at Woodstock, wasn't she? She was a successful artist.

STRYKER: That's right. And then he married this other girl that was a godsend to him. She's a marvelous girl and she was a godsend. Joan was wonderful.

KLONER: Did Dorothea Lange send you her photographs at this time?

STRYKER: Yes. She was sending. I began to get these photographers lined up, and Dorothea sent her famous picture of her woman.

HURLEY: Did you see her work in *Survey Graphic?*

STRYKER: *Survey Graphic* was a very, very strong effect on me. You can put that in your interview. They were a great help to me. During all this time, a big help to me.

KLONER: Did you have virtual autonomy to develop that program on your own?

STRYKER: As I built the laboratory. . . . We had a wonderful laboratory staff. I had the nicest little secretary you've ever laid your eyes

on. Tough little devil. She was a little boss and she ran me sometimes ragged.

HURLEY: "Toots"?

STRYKER: We called her "Toots."

HURLEY: Clara Dean Wakeham.

STRYKER: Listen! You can remember more than I can.

HURLEY: I've read all your mail, Roy.

STRYKER: I got too many things to try to remember. And then, the pictures began to come in, and then we got started off. That was when the Depression started. That was bothering Tugwell, it was bothering the New Deal, it was bothering everybody. All that mess taking place out there on the open country. And it was a mess. I can tell you. If you weren't around, all you have to do is look at the pictures and you'll know what a mess we had out there. Let me tell you one little story, if you don't mind. I didn't make many trips. I forget who I was with, but I was out on a trip and we came up onto a little hill. There were two baby carriages and I stopped to talk to a man and a woman. And I said, "Where are you going?" And they said, "We're going to try to make it to California." I said, "With baby carriages?" She said, "Well, how we going to get our kids there?" In one carriage, two babies—one very young, just born, and the other just old enough. And in the other carriage were older kids. So I said, "Would you do something for me? If I give my address on a postcard and stuff? Would you tell me if you got there?"

They were pushing those children and going to California, and they made it. I got a memo from them—a letter that they made it. That's all I can tell you about it. But I tell you, that thing had a terrific effect on me. Russell wanted to take pictures and I said, "No, you can't. You just put that camera back." There was something about that situation I saw, that I couldn't stand the thought of a photograph of those two people and their two baby carriages. I didn't want it photographed. It was crazy, but I couldn't help it. It was a strange quirk in me not to have that photograph. I was so touched, so involved—it went so deep into me.

Well, the key region at that time I started to work was the whole country across from one side of the States right across to California. Everybody tried to get out of the mess they were in down there. They were starving to death. Their ranches were gone. Their places were gone, and they had heard that California was the mecca, on the West Coast.

KLONER: Did you send photographers up to New England?

STRYKER: Yes, of course. Arthur Rothstein went up there. Photographers came back and they took their turn up in New England.

KLONER: So you saw the migration as one key problem.

STRYKER: Well, that was one, but we also saw other parts of the United States. You see, we had a summer place up in New England, so I wanted them to go back up there. Arthur Rothstein came up and stayed with us. We had an old house up there in the northern part of Vermont. So Arthur came up. He took pictures up around there and went up through there, and two other photographers came up around there.

HURLEY: Every different section had its own individual problems.

STRYKER: Sure.

HURLEY: In the South, you had the tenant farmers problem. In the center part, the dustbowl problem. Out in the West, the migrant farmer and in the Northeast, farm displacement.

STRYKER: That's right.

HURLEY: There really wasn't a section of the country that you could afford to just ignore. Out on the West Coast it was basically Lange's country wasn't it?

STRYKER: Yes.

KLONER: We were talking about the beginnings, the very beginnings, of the Farm Security Administration when you hired four photographers. And you've mentioned scripts, but you really didn't go into any kind of detail about how you worked with scripts. Or, you didn't really talk about the way you built up the department and what directions you were interested in. Getting the photographers to work and things like that.

STRYKER: We were down in Washington and were getting ourselves organized. Literally, we were trying to get ourselves settled on that floor. We were trying to get a laboratory established; we were trying to get ourselves established. We had some pictures in and we were actually checking pictures on the floor. We didn't have a place; we didn't have an office; we didn't have anything.

RYANT: Didn't you move into the old Agriculture Building?

STRYKER: We moved into the old Agricultural Building and that's where we were first. And we were in the regular Department of Agriculture there. Our cabinets were outside. Our tables were outside. We had no facilities at all. We were just getting along the best we could. Then it

wasn't long after that before we got a building across the way. I forget what the building was, but it's right across from Agriculture and the second floor was given to us. Then we went to work and built a very nice laboratory. And built our file room and built my office. I got a secretary and got my own little office. So that was a big step. From that point on, things began to move on quite rapidly. Tugwell was moving in down there at the same time.

That was an important time because, really and truly, we were actually laying pictures on the floor and sorting them out. I'm not kidding you. But things picked up rapidly after that. We got our laboratory built fairly early. They built a damn good laboratory. I mean this right sincerely, we were most fortunate in finding ourselves three top-rated laboratory men. I can't tell you how important they were. They were so damn good that they just covered everything.

RYANT: Did you have any trouble getting the various photographers that eventually joined you to come? Were there problems in that, or were they excited and willing to come, or was it largely the Depression that made them come?

STRYKER: No, no. They had problems. They brought them. But they were not serious problems. The problems were getting their supplies and getting their prints. I'd sit down and I'd discuss prints with them when they came in. When a new set of prints came out, I'd discuss it with them.

KLONER: How did you assemble your photographers? How did you get your photographers together?

STRYKER: I didn't get them together. It was very seldom that those photographers ever came together at the same time. You mean how did I find photographers? Well, Russell Lee came in one day to see me. Somebody had sent him down. I took him home and talked with him for a couple of evenings and I just smelled and said, "There's my man." It was as simple as that. I liked him. And I was damned sure that I was right. And I was right.

RYANT: Is that pretty much what happened with the others too? They happened in and you could sense which one?

STRYKER: Well, now, that's going to completely different extremes. John Vachon came in and didn't know much of anything. He sat behind the desk and put the pictures in the places where they belonged. He did that for a while and then he grew up pretty fast. He could sell pictures. He and I had many a conversation together, talking about the future and

what he might be able to do. I said, after all, "When you do filing, why don't you look at the pictures? Pay attention to them. Get some idea, and if you ever decide that you want to take pictures, just remember, don't try to say, 'I'm going to take pictures like Russell Lee,' but say, 'I'm going to learn to take pictures.' Say, 'I've got some ideas.' " Not exactly, but that's more or less what I was saying to him. I was trying to educate him. I tried to stir him up. And it did.

KLONER: Did you feel that your relationship with these photographers was similar to the role of a teacher?

STRYKER: Yes. It was a teaching job.

RYANT: It really didn't change when you went from Columbia to Washington?

STRYKER: No. Because [at Columbia] I'd be teaching and we'd be in a certain section of the textbook. And I'd say, "Say, what are you kids doing tonight after the class? If any of you could, could you get away and go with me? Let's take a hike. I want to show you something." Or, "Let's take a walk along the river over here and on the docks." So maybe seven kids could go. The rest of them were in a snarl. Two of them came back and said, "Will you take us out on a trip like that?" Of course I could.

KLONER: Then when you worked with your photographers, did you use a similar approach?

STRYKER: After what I had done with students, it was the easiest thing in the world to move on over. And then the photographers—they were your students.

KLONER: So you tried to help through personal rapport with them.

STRYKER: Sure.

KLONER: You would try to help them grow in the direction that you felt . . .

STRYKER. Sure. Exactly the same as you do with a student. I had "bull" sessions, I'd pick up a photographer and say, "Let's go out and have dinner tonight. You come up to the house or I'll come around to where you're staying and we'll have a session. We'll have a couple of sessions." The thing is so damn logical.

KLONER: Informal?

STRYKER: Yes, informal.

RYANT: Did you find that different photographers had different personalities and styles so they might do jobs differently?

STRYKER: Yes. I wondered. Pretty soon, when they went to work, I

knew damn well what they were going to do. I could pretty well forecast how they were going to do it. But when they were new—when Russell Lee came in, I was curious about him. I liked him, I liked the forthrightness of him. I liked the way he came in. Russell Lee literally walked into the office one day. Somebody had sent him in. First of all, just in general conversation, I was impressed. Frank, healthy, open, whatever you'd want. We coordinated, just like that.

KLONER: Did he do more work for you than any other photographer?

STRYKER: I don't know. As far as numbers go, there's no use in my trying to say. But he did a hell of a lot of work.

KLONER: How did Rothstein come into FSA?

STRYKER: He was a student at Columbia when I was teaching. And he was taking pictures for me at the time for the book. Then we got to pushing a little further.

KLONER: Did he work with Hine at Columbia?

STRYKER: Yes. He was there, you see, as a student. He was taking pictures and I wanted some pictures taken. We started that way. Then he went down with me.

RYANT: When people went out to take pictures on assignments, did you assign specific people for specific projects because of the kind of treatment they gave? Or did they just go in order?

STRYKER: Well, in some respects, yes. But not as much as you would think. Because, there was a hell of a lot of versatility with all of these people. And with shooting scripts—the directions and conversations before they would go—you had a pretty wide range of a chance of pictures. Now, you knew that Arthur was going to do a certain kind of a thing. And that Marion Post would do something else again, and that they would be different. But, that was all right. You wanted that difference. You were glad to get that difference.

KLONER: Did you feel that Dorothea Lange should photograph the South and not just the West?

STRYKER: Well, I would've liked to have gotten her out, but her stuff was of such a nature that I wasn't going to interfere with it. I'd liked to have moved her a lot. It would've been good for her, but you couldn't do it. I went out to meet her and spent some time there and had dinner and stayed. I met her second husband and talked to him a little bit. Dorothea had to pretty much stay put.

Russell Lee could go from up by Chicago and he'd go on down [South]. There was a little town down there, I wish I could think of the name. [Possibly Pie Town, New Mexico, or St. Augustine, Texas.] He stayed down there and did a big job on that whole town. Russell could do that. Dorothea wasn't going to change suddenly.

I went down there with him. It was a very fascinating job. He ran into a farmer. All of a sudden the guy discovered Russell was asking about pictures, and then, all of a sudden, he turned loose and Russell stayed on for about three or four days, and he took him around and he did a whole lot of agricultural pictures because that guy was enamored with Russell.

KLONER: Were you particularly looking for photographers you felt would have a rapport with people?

STRYKER: Sure. Damn right. And when Russell showed himself, there was no second thought that I didn't want Russell. And Jack Delano the same way. Jack was different, but he had that same ability to see and to have a rapport with people.

KLONER: Were some of these photographers quiet and is this why you felt they had a rapport with people? Because they didn't intrude?

STRYKER: I think most of them were quiet people, were respectable, were thoughtful, were strange, because they were taking the pictures and wanted those people to do the talking. But if the people started to talk, some of them were more easy to have a conversation with than others.

RYANT: Did you feel that, by and large, most of the photographers had good rapport? Did they have much difficulty in getting people to let them photograph them?

STRYKER: They each had their own methods. I don't know what they were. I wasn't with them. I saw Russell in action. I told you about that. On the whole, I didn't go out with the photographers. I didn't have time. It was just as well that I didn't go out because I think I would've been a hindrance.

I took John [Vachon] out because I thought somebody needed to start him. His photography was new. I wasn't sure how it would turn out, but it came out perfectly. When I landed on that ranch, I could talk cattle because I was raising them. The man looked at me and said, "Well, you're rather experienced with cattle."

I said, "Look, I know what we're doing." I had some samples along, some pictures to show him. And I said, "This looks like the place that we

could get some. Will you help us? Will you let us go?" He said, "Sure." And he did. But I had talked to him about it. He said, "You know cattle, don't you?," and I said, "Aw, a little." So I said, "But my boy doesn't. I'll go with him and I want you to help me so we can get a nice story." We got a hell of a story and the man was delighted. It was just one of those rare things that happen, that John got that and got that experience. It may have never happened again.

KLONER: Did some people respond to the photographers negatively? Someone supposedly chased one of them off his land with a pitch-fork.

STRYKER: Well, I don't know. I'm sure that some people said, "We don't want any goddamn photographers around here." I have no idea. I wouldn't even make a statement on it, because I don't know. I think there's some men who just said, "I don't want a photographer around here. I've got a pitchfork and you'd better get the hell off of here." I think that's a part of human nature and that's a part of what you're going to find when you have ten little farms around and you hit the wrong farm. Yet, the little lady said, "I'll have lunch for you."

KLONER: When you talked to photographers did you develop a cer-tain kind of a feeling about things like reason and emotions?

STRYKER: Not in those words, no. I don't think I did. You talk to them in a dozen different ways. Look, I talked to them pretty much in the way I talk to you right here. There's no other way about it. Because I'm very sensitive, quite vocal, quite apt to talk, and I'm very responsive to people.

KLONER: Did you see yourself in the role of protector of these photographers?

STRYKER: Yes. If a congressman had taken out one of these photogra-phers, he had me to deal with.

RYANT: Did they ever go for any of them individually? Was there ever any objection to an individual photographer?

STRYKER: When we first got started, I had some troubles. I learned how to take care of them—just stayed away from them. I had a rough time there for a short time.

KLONER: Conflicts?

STRYKER: No, not exactly. People had projects and they wanted things. And I wasn't going to go through that kind of stuff where they were going to begin to tell me how to take pictures—what kind of pictures

they wanted. I'd say, "We're not takin' that kind of picture." I had to get out of it, but I had to be careful. I explained to them what I wanted to do, and I said, "Now, I understand what you want and I'd like to help you." We did actually put men out and help them a few times. It paid off because they were nice guys. They had a tough problem. But some of them were bastards. You didn't give them a goddamn thing. And I got an instinct for that. I can fast figure out who I'm going to get along with and who I'm not going to get along with. That's one of my traits and it was worth its weight in gold.

KLONER: Did you do the editing?

STRYKER: Most of it.

KLONER: What kind of photograph did you personally like the most? That you felt was most successful in terms of the FSA program?

STRYKER: Let's go back to something first. That book I did. People, places—I wanted life in the pictures. Someway, somehow I wanted life in the pictures. I wanted people in the pictures. I wanted cattle in the pictures. I don't think I could use any better expression—I wanted life in the pictures.

KLONER: Did you want the information photographed to be clear or explicit?

STRYKER: In most ways, yes. But there were pictures that came in at times that you had to look pretty damn hard and you had to have a pretty good imagination to know what they were doing. Those were limited. They were there for a reason. Because that was good photography. Everything didn't have to be like a goddamn newspaper picture. We didn't want that kind of photograph.

RYANT: Did you ever get any complaints or interference from other people in the Department or from Congress, because you were doing this kind of picture and it wasn't the kind for a newspaper?

STRYKER: A few congressmen gave us a little trouble. They looked at some of the pictures and complained about them. They didn't think we were doing very good photography. As I remember, we didn't pay much attention to them. They never got to me. I had to go up a couple of times for an interview with a couple of congressmen, but in the end I won the battle. I remember it quite well. I was sure I was right. They were human beings. One man was from one section of the country; one man was in the city. And I said, "What we're trying to do is to make pictures that will tell the kind of things you grew up with. You don't have to have the dullness

of newspaper photography." We wanted the picture as you take it. I had some pictures with me, and these two congressmen said, "You're right." They caught what I was after. They looked at the pictures and they said, "We'll go [along] with you."

KLONER: How did you feel about the quantity? Were you interested in doing a great quantity of pictures, or a restricted number of pictures that said more? Or did it depend on the situation?

STRYKER: I made no comments on how many pictures to take. That was their business. But if they ever took pictures wildly, they caught hell. They didn't do it. There was no problem. They learned awfully fast that they were there to do a job. To tell a story which might take ten pictures, or ten negatives, or twenty negatives, and so on. As I look back on it now, I recognize how well they did those things.

RYANT: All of you worked well together then?

STRYKER: Oh yes. Yes.

KLONER: One of the things you seem to talk about is the difficulty you had in getting quick results.

STRYKER: Well, don't misunderstand me on that. I wanted results—and I don't like the word *quick* in it. I question the word *quick*. I'd rather a man take a week to do his job . . . if he got thirty pictures. But the next time he may have taken a week and got a hundred pictures. But maybe we'd throw a lot out of the hundred. Maybe the thirty were very carefully thought about and they turned out to be good. You see my point? That was their judgment. That's why they were hired. That's what they learned.

RYANT: How structured were the scripts you prepared?

STRYKER: I wish I had brought down a handful of them that I have saved and let you look at them. Because they are very diverse. I made a remark to one guy, "You know, people sit on their front porches." My mind immediately began to run—We don't want a thousand pictures of people sitting on their front porches. I was busy trying to think how I could get a few of those and get good ones. And we got a few dillies. But you had to be careful not to get them going until they went through every town and just shot the thing on their way through the town.

KLONER: So many pictures of the people are shot outdoors. Did you feel you'd be too intrusive?

STRYKER: Well, I just felt there [were] limitations to what we could

do. Now we did get a few houses. One of the girls found a family. She had a feeling for it. She liked them and they liked her and she took some pictures.

It was a very wise thing to do—a few of those things—because that's a part of life. Well, on the whole, we were outside people. Not because we wanted to be outside. I'd have liked to have gone into homes more. I'd like to have found a family where we could've put a photographer in there like Marion Post, who had a wonderful feeling for families, and let her go with that family. Let her stay around for three or four days and go to church with them. But I thought to myself, "Roy, if you don't watch out, you'll be shooting the whole goddamn United States, down to going out to the toilet with them."

KLONER: How did you feel about letting them be photographed, when the photographers did deal with families?

STRYKER: I liked that!

KLONER: Was Walker with you then?

STRYKER: Sure. He and the man that went with him [James Agee] wanted to know if they could do it and I said yes. I think it was a hell of a nice book. [*Let Us Now Praise Famous Men,* 1941]

KLONER: I know [Archibald] MacLeish has done a book. He came to you and said . . .

STRYKER: "I like these pictures and I'd like to do a book on it."

HURLEY: He said he started out to do a book and to illustrate it by pictures. He got going in the photographs and he ended up doing pictures illustrated by a poem. [*Land of the Free,* 1938]

STRYKER: Yes. That was a real wonderful thing when that happened. The old boy was wonderful. He had a man working with him, Ed Rosskam. He was the one that was choosing the pictures and he was a very valuable man. Do you remember, we made the mural that went into Grand Central Terminal [in New York], and Rosskam designed that. It's a huge mural. Cost us a mint of money. It made a hell of a commotion.

KLONER: How did people react to it?

STRYKER: Very favorably. It was made by a man who had the ability to blend pictures and do a great big huge photograph, if you want to put it that way. A painting.

KLONER: Was this before or after the Grand Central Auditorium Show?

STRYKER: I don't know those dates: The exhibit that we were talking

about was different—a smaller, a tighter, thing. But this show was entirely different. We got a whole lot of publicity out of it. The pictures were around the room and, goddamn it, we didn't photograph them.

KLONER: Who mounted that show?

STRYKER: Arthur and Russell designed it. They wanted to know if I'd go in with them on it. I said, "You're damn right." So they came and started in to the files to pick the pictures and then they went down to Washington and made their listings. I've got all their correspondence, or most of it. They went to work on it and designed the thing; came back and made the enlargements. We got eight hundred and some comments, all kinds, cussing us out and praising us.

KLONER: Then you know what pictures were in the show?

STRYKER: No. I don't know every picture that was in the show. I had the listings that they had, but I can't tell you for sure what was in the show. That's the tragedy. We were too new at this business. I don't know why I didn't tell them to photograph the wall. Either one of them could have done it.

RYANT: You say that you were too new when you were doing it. Do you think your own reaction to the importance or the effect of what you were doing changed a good deal?

STRYKER: Well, I learned that you photograph a show. I learned it too damn late. This was all brand new to us. I had too many things that I was trying to encompass. It never would've occurred to me. Boy, we never made that mistake again. Once was enough. An error like that thing was enough to last me the rest of my life. I can make an attempt at construction, because I've got enlargements of every picture that was listed on the list.

KLONER: In the show, were the pictures blown up to different sizes?

STRYKER: Yes. Sure they were. But I was too goddamn dumb, at that stage of the affair, to go after the boys. And I guess I depended on them too much. It was a shock when I finally woke up to the fact that we didn't have any [full record of the contents of the show]. I've never quite gotten over it.

KLONER: Did any of the photographers mind at all about cropping photographs at any time?

STRYKER: They had the right to crop if they wanted to. It was so seldom that it happened. If they wanted to, they could kill a picture. They

had the chance to edit their pictures. The photographers saw all of their pictures before they went into the file. And sometimes they edited for us. And they said, "You must crop this picture."

KLONER: Most photographers tended not to want to change. . . .

STRYKER: They apparently didn't want to. They were satisfied with what they saw. And they also had confidence.

Now people would crop their pictures and make the photographers sore. I sent notes to people that would do it that said, "For Christ's sake, don't do that again." But that didn't happen often.

KLONER: Many of the photographs tend to have medium tones instead of having very rich, deep, dark blacks. Was this because they were intended for mass reproduction?

STRYKER: I guess so.

KLONER: Magazines?

STRYKER: Magazines and so on—yes. We were actually trying to get our contact picture within the file. So that when you looked at it, you got a sense of maximum quality. Now, they may come in and say, "We've got a special job. Will you make us a special print?" Then we could. We did lots of that. But the pictures that we made, the 8 by 10s, were an attempt to try to get the photographer's pass on those pictures. When a set of pictures were made, the photographer passed on them. He had to look at every set of pictures.

KLONER: So the photographs were proofed?

STRYKER: Oh, yes sir. Every set of pictures. They could say, "I think we ought to take this one out." And they had final liberties to edit. Indeed.

KLONER: Dorothea Lange would send in completed prints?

STRYKER: Yes.

KLONER: Because she was working so far out [West]?

STRYKER: Yes. Now it so happens that somehow or the other we got three different ones of the mother holding the kid. I'd like to kill those two pictures. I didn't know they got in here.

It's just that I think she's got one picture that's so damn good. What do we want with those others that aren't good pictures? She sent in the one that I treasure.

KLONER: Did she send in the other two?

STRYKER: I don't know how in the hell we got them negatives.

As a photographer you can go out and take twenty pictures if you want and select the one that you think is best. And I hope your judgment is good enough, that you're going to be right. I may see some of the others and I'll say, "I agree a hundred percent with you." Or once in a while I'll say, "I'm sorry, I don't agree at all with you." It just happens that the one of Dorothea Lange's I got to start with, I still think is a great picture. I think it's one of America's great pictures. I don't think the . . . [other two versions of that picture] have contributed much.

KLONER: Would you want to say anything about what that picture means to you personally?

STRYKER: I can, in two words. Mother and child. What more do I need to say? A great, great, great picture of the mother and child. She happens to be badly dressed. It was bad conditions. But she's still a mother and she had children. We'd found a wonderful family.

KLONER: Rothstein feels that "Dust Storm" is one of his most important photographs.

STRYKER: Well, I think he's right. "The Skull" was an important picture, but this was a greater picture. That told dust storms better than anything we had.

KLONER: Because of the interaction of the people?

STRYKER: They're ready to get in. That picture without the caption is not going to go anyplace. Words had to be used on that picture.

KLONER: How did you feel about captions in the newspapers? Did you have any control over the kind of things said in the newspapers?

STRYKER: No.

KLONER: Which magazines did you find responsive?

STRYKER: Well, *Survey Graphic* was one of the real responsive ones. It was a small magazine, but they had the sense of what we were trying to do with a lot of our people. Don't misunderstand me, a lot of the newspapers did wonderful jobs on the stuff that we took out of the big Depression series. Now that's different. They recognized a lot of that. I don't want to be unfair. Some of them did very, very good work with using our pictures. I'm not prejudiced against newspapers, but I'm prejudiced against some of them.

RYANT: How did the pictures circulate in the newspapers? Did you issue them in sets or did they come down and look at the files?

STRYKER: It was a fair combination—our promoting some things,

their getting ahold of them, coming after them. A lot of the newspapers had men down in Washington that would come around looking for our stuff. That's the way it got out. They sensed something different and something new. They sent their men in and we cooperated. We didn't do like some of the others today—just send them in and hope you get the newspaper.

KLONER: Did you have any directives from the Agriculture Department as to the sort of directions to take?

STRYKER: No. I went over to talk to the Department of Agriculture and I didn't find but about three or four guys that I could talk to. They were bureaucrats.

DOHERTY: Did you do any photographing of the subsistence homestead program when it got started?

STRYKER: Not too much. Some, not much.

DOHERTY: Would that have really fit into the kind of photography that you wanted to do?

STRYKER: Yes, I think so. Some of it would. We got enough of it to get a feeling for it, but it wasn't a big job of the Depression. We were trying to do the Depression. We just couldn't cover everything and that is what we were trying to do.

KLONER: Did you find that the photographers shied away from working on federal projects?

STRYKER: No, we did some. It depended on what it was. "Down Along the River" [probably the film *The River,* 1937] was a project that involved the Department of Agriculture and it involved a lot of government agencies.

RYANT: Were the photographers happier when they went out, say into the South, and shot what they saw than if they had been assigned to go out and take a picture for a reclamation project so that you'd have it for an illustration for a book or something?

STRYKER: If the illustration was wanted and the book was approved, they had a job to do. He'd been very happy to have done it. But to go out and do that kind of thing—I'd say no. We were not trying to illustrate that kind of a book. It was not our job.

RYANT: Did you ever feel caught up in political pressure in the New Deal? To show the New Deal working rather than show the Depression as it was?

STRYKER: Yes.

RYANT: Did any of that ever come from Tugwell, or did it come from elsewhere?

STRYKER: I'd say the Department of Agriculture.

RYANT: Were you able to resist that pretty much?

STRYKER: Yes. I told a couple of them that they could go to hell. They said, "Well, you're in the Department of Agriculture aren't you?" I'd say, "Well, I guess I am, but I'm sure technicians have told you to go to hell, haven't they?" He said yes. I said, "Well, I just happen to be a specialist."

RYANT: Did you ever get involved with any of the other departments? Did they ever try to interfere?

STRYKER: We offered our services to them, but they didn't seem to need them or want them. There are things I would've liked to have done for them. But we had about all we could do anyway, so I just stayed away. We made offers. We wanted to be reasonable. I went over to some of these places and said, "Look, are you in need of sometimes some special job when we're out on something? Could I be of any help to you if you knew where we were going to go? You got a project?" But they did pretty good jobs themselves, so I didn't see any reason why we should get messed up in that.

RYANT: Once you got started, got organized, did you have any serious budget problems?

STRYKER: Yes. We had to scrape several sides. Not too much. I'm going to back down on that. We were fortunate. We got money. Tugwell was very clever. He got the money. We had very little trouble.

RYANT: Do you think that the amount of money you had in any way influenced the kind of project you did, except in volume? Were there any that you would've liked to have done, except the money wasn't there?

STRYKER: Oh, of course. I know there was times when we wished we had a little more money, but on the whole I think we got all we needed—all we were entitled to. I don't think we ever suffered, to tell the honest truth. That's a strange thing to say, but I really do. I think we were most fortunate in the budget we got when we finally got rolling. When I think of what we did out on the open plains, the amount of money we spent and what we did, I think we were well treated on budget.

DOHERTY: How did you personally feel about the New Deal in that period?

STRYKER: Well, I guess I was for it. In fact, I know I was.

RYANT: Did anybody ever ask you your politics as part of the job?

STRYKER: They never bothered me. I had lots of conversations about things that were going on. There was various people high up and maybe we disagreed. When I went up to the president's office, we disagreed on a couple of things and he said, "Well, I'm not sure that you're right, but I'm glad to get your opinion."

RYANT: Did you have much, if any, direct contact with the White House?

STRYKER: Indirectly. Jonathan Daniels was the in-between man. He took care of me more than once. He covered us.

KLONER: What types of problems did you have with the White House?

STRYKER: Oh, once in a while, budget. Once in a while, the kind of pictures we took, where we were going. He knew exactly—I reported to him regularly—what we were doing. Took him the pictures and talked to him about it. So he was in a position to answer questions. He saw the pictures, most of the pictures, and he knew what our projects were.

KLONER: Did you have to go to him, say, with the problem of "The Skull"—the Rothstein photograph?

STRYKER: I showed it to him. It didn't bother him any. I took it over to him and told him how I handled it and he laughed. I told Rothstein to get it, to get a good picture and to hell with the newspaper. I told the editor of the newspaper that came down, "I think you're full of malarkey. I respect your opinions and respect you as a newspaper man, but I just happen to think that if you don't want that picture—you don't think that picture's good—well, to hell with it. I think it's a hell of a good picture and a very important picture. If you don't want it, it's your paper, don't put it in. What the hell else do you want?"

KLONER: Do you feel that all the publicity about that photograph benefited you?

STRYKER: I don't know. I didn't try to measure it because I didn't see any reason. It would've taken a large piece of the budget for a man to go out and study that thing to find out what it affected. I think the picture was an interesting thing. I don't think it was a great picture, in terms of being a great picture. But I don't think it was worth all the trouble we had, if you want my candid opinion. But Arthur got it, and it was rather interesting, rather unusual, but I don't think it was worth the fuss that

took place at first. I told the newspapers, "I think you fellows are a bunch of goddamn fools acting like this over a skull."

KLONER: What was public opinion like in relation to this incident?

STRYKER: Very little. The local newspaper was the only one. I happened to be told about it when I was up that way.

RYANT: Did you ever have the feeling that the president or anyone in the White House had taken any special interest, in your project?

STRYKER: Jonathan [Daniels] did.

RYANT: Were they generally sympathetic?

STRYKER: Jonathan was very understanding. I had a good contact with Jonathan. I was called over there a couple of times and I found him interested, and he complimented me. I said, "I wish you had time to look at some of this stuff, but I know you're a busy man and I don't think you want to be bothered."

RYANT: Did you like Roosevelt?

STRYKER: Very much.

KLONER: What did you think of him?

STRYKER: Well, I liked him as a man. The things he stood for. That's all I can tell you. If I was just a citizen, I'd vote for him and I'd be in back of him. If I had a little extra money, I wanted to contribute to him—I'd contribute to him. That's all. But, you see, I wasn't in that area. I was down low. I was down with these pictures. But I respected Roosevelt. I liked Roosevelt. And I liked Jonathan, because I happened to have had a hitch with him. Something happened that gave me a chance to see him and talk to him, and he understood some of the things that I was doing. It wasn't trying to get anything. It just happened. He asked me to bring over some pictures and I took them over, and he said, "I like them." That was the end of our relationship. I never bothered him.

RYANT: Over the period that you were doing this FSA work, do you think there was any kind of a change, whether major or minor, in the kind of thing you did? Were you doing the same kind of photography with the same kind of interest later on that you started out with, or did you make changes?

STRYKER: Well, I think the way to answer that is that there was a growth. We didn't make it change suddenly—we grew. The man grows up—he reads, he studies, he meets people. He talks—after a while, he's changed a little. He talks differently. And then after a while he brings a

new subject in and he talks about that. I think that was what happened to us. Do I get my point across?

RYANT: You developed your style?

STRYKER: Yes.

RYANT: When you left, do you think it was still changing and maturing? Did it continue or did it die?

STRYKER: Died.

RYANT: Why was that?

STRYKER: Well, the Department of Agriculture didn't want any part of us. That's number one. I thought we had about tripled our job and it was time to quit. The job is never done. But I thought the time had come when I had to quit and when I thought that we had accomplished sufficiently that I could afford to leave. I'm not trying to be critical. They had their ideas and they'd been there a long time. I'm not blaming them at all. I'm simply saying that I thought we had had a glorious time, we'd had a marvelous opportunity; we'd been given funds to work. And I thought it was time to quit—to end this job and say, "This job has come to an end." Someone could pick it up and change it over. It was exactly as I had hoped—that somebody would pick up a new version and would come in. I didn't know what was going to happen. But I knew that I was going, because I thought that I had everybody exhausted.

RYANT: When and why did you finally leave Washington?

STRYKER: Well, we had piled up an enormous number of film. We'd covered so much and I began to feel the pressure. Tugwell was getting fed up and I think he was ready to go. Then I saw the shadows of the goddamn guys that were on the stand, centered in the Department of Agriculture. They were narrow-minded, some of them, and they had their jobs. And they had nothing of what Tugwell had and nothing of what the rest of us had. And I saw it coming. We had piled up a lot of pictures and had done an awful lot of work—it was time to get out. I had a very wonderful time.

RYANT: What did you do when you left Washington?

STRYKER: I packed up the pictures and I got everything set. I made up my mind at the time to come to an end. I mean it was time for me to go. I knew that I had a pretty good chance in New York for something. A newspaperman and his family said, "Roy, I think it's time you moved." He was my advisor and I took him seriously. And so I went to work and

quietly began to get things ready to go. But I didn't tell many people about it. I didn't tell them anything about my plans. Except the man that sat in that very key spot. And I got myself ready to go and I got things ready to transfer. Then I had to be a little more public about it. Finally, all of a sudden, I said, "I'm leaving."

RYANT: Was there opposition? Did they try hard to keep you?

STRYKER: No, because I was pretty quiet about it. And the ones who got it first were ones who had heard about it—a couple of congressmen. And those who knew about it said, "We understand. We think you've done a great job." One congressman said, "We think you've done a superb job." They were very sympathetic about it. This man told me something I never will forget. He said, "You know, you've got sense enough to know when it's time to quit." I've never forgotten those words.

RYANT: Where did you go then when you left?

STRYKER: Well, you see, my friend Ed Stanley had ideas. And he was, at that time . . . with the Standard Oil Company. So, when I went up I had [it] all fixed up.

RYANT: So, you made the move easily on that one.

STRYKER: Absolutely. That turned out to be a good move.

KLONER: How did the Standard Oil project develop?

STRYKER: It was kind of hard on some of the old-timers in there who had just been having newspapermen take pictures for them without much thought. But, then we went in there and began to do a new kind of photography. They were a little disturbed.

RYANT: What, from the beginning, were you thinking of accomplishing with this Standard Oil project?

STRYKER: Well, I thought Standard Oil was an exciting thing; running oil. They gave me a quick trip down. I saw those drillers—fascinating people, a fascinating spot. I saw the oil coming up, down in the bayous down in Louisiana. I saw that and I said, "By God, something can be made of it. And oil is damned important." I knew about this tie in Arabia. I knew what our Alaskan situation was. I was sure that we could do something with it.

RYANT: Is it possible to say that you liked working with Standard Oil more or less than you did in Washington, or were they different types of experiences?

STRYKER: Different types. I enjoyed my time with Standard Oil very

much. I enjoyed working with my staff. I enjoyed making the pictures. I enjoyed the people that came to get the pictures.

First of all, it was a technical thing, more technical than anything we had ever touched. But with it all, it was still done by human beings. So those are two things that were in my mind. It had no comparison with some of the things we were doing for Farm Security. It was a technical job. They were getting that oil. And yet, you take drillers out of derricks where they were drilling and it was more like a Farm Security project.

KLONER: When you prepared your photographers for Standard Oil to go out in the field, did you prepare them in a different way than you did for FSA? Did you use scripts?

STRYKER: Sure. If a photographer was going out, I'd write a page or a page and a half and give him some ideas. He came in and talked about it.

KLONER: Did you want your photographers to read about the areas they were going into?

STRYKER: Oh, yes. Now this boy was going to Arabia and he had about two weeks to get ready to go. I said, "You're going to Arabia; you'd better damn well get yourself ready." He did. He just dug in. When he went there, he came back with a damn good set of pictures.

KLONER: Were you interested as much as you were in FSA?

STRYKER: Sure. The newspapermen had done such dull pictures of people. You see, they weren't even good newspaper photographers. They had no editors that were good editors. They just dragged out lousy pictures, passed them out, and they didn't get any publicity. It's as simple as that.

A big refinery is a beautiful piece of architecture, but there's the most interesting people there.

KLONER: The print quality of the Standard Oil photographs is a little better than the FSA photographs.

STRYKER: Yes. We had a little bit more. We had a marvelous laboratory. We had a laboratory that did our work for us in New York. It was run by a little old guy. He turned out stuff that was just terrific. He was one of the nicest guys I have ever known in my life. He was Achilles. Everybody called him Kelly and he was loved by everybody. He was a wonderful technician and a wonderful person.

KLONER: When a photographer went to a new place, who could guide him when he got there?

STRYKER: Now when he went to Arabia, he needed some very careful backing because it was a long way off and there were special problems. I had to find somebody in the Standard Oil Company that could help me protect this guy when he got down there and make sure that he didn't make any blunders.

When he got there, a man was waiting for him. He knew who he was going to meet. They knew damn well that this guy knew what he was doing, could protect him, and cover, and get the picture he wanted. And we got them.

RYANT: How many photographers did you have?

STRYKER: I suppose that we had, at one time, about six photographers, when things were going heavy.

KLONER: Why did you go from Standard to Jones & Laughlin?

STRYKER: Well, because there was nothing more to do.

DOHERTY: Did you do any urban documentary around Pittsburgh? The town and such?

STRYKER: Oh, yes. Sure. A lot of it.

RYANT: Was there any difference about what you did for Jones & Laughlin and what you did for Standard?

STRYKER: It was a different industry, and the kind of pictures we took had to be different because the whole element was different.

HURLEY: Of the photographers who worked for you under Farm Security, did anyone besides Russell Lee ever come back and work for you again? Russ came back and worked under Standard Oil. Did Rothstein?

STRYKER: No. He was out. It was all new people.

RYANT: How long were you at Jones & Laughlin? Was that your last job?

STRYKER: That was my last job. I would say that I was at Jones & Laughlin not more than two years.

HURLEY: You didn't move out to Montrose though until the mid-1960s. You lived in New York for a while?

STRYKER: That's right.

HURLEY: Didn't you occasionally go out to Missouri and help Cliff Edom with his seminars?

STRYKER: Yes. Cliff Edom was out at the University of Missouri. He

ran a very interesting program of seminars. I went out on two or three of those.

HURLEY: They'll take really experienced photographers, they'll have real experts in, and then they'll have young people that are just getting started. And they'll take a little town around there and do a documentary on the whole town. They send you out every morning with three rolls of film and an assignment. They develop the film that evening and project it. Then Cliff and people like this man proceed to just shred you in little pieces.

STRYKER: I thought that was just marvelous. He's really a brilliant guy and he has talent galore and he's a marvelous teacher.

HURLEY: Now you really kind of helped to set up that program, according to Cliff.

STRYKER: Well, I helped him a lot. He helped me, too. He broadened me. And he depended on me a lot, so I was always glad to go out. I enjoyed it so much.

KLONER: Obviously, you're very good at encouraging students. I think that from seeing the way you responded to the people here. In talking to students or to young photographers, developing or starting out, what kinds of advice would you like to give them?

STRYKER: First of all, photography has a technical side. You've got to be able to use the camera. You've got to know what film is. Now you come to the next thing. What are your talents; what are your instincts; what are your desires; what are your weaknesses; what are your prejudices? Those are the things that you have to face. But somebody has to face them for you. Somebody had better face them for you because you can't be trusted to face them yourself. Really. So, if I had to do this, I'd take my boy out. I'd say, "Let's talk about photography. Let's see what kind of things are in your bloodstream and running through your mind. And then, let's see if we can't analyze what kind of things you might take to with a camera."

HURLEY: Do you remember doing the same thing with me when I started writing? "Now what is it you've got on your mind to do now?"

STRYKER: That's what happened. A lot of them came down and wanted to talk. They wondered what I was doing. You'd be surprised how many people came down to interview me so they could put it in their files in Detroit or something. This man came down and I'd forgotten all about

it, and he came up suddenly with this script. I said, "Jesus Christ Almighty," and all of a sudden I almost fell out of my chair.

HURLEY: I didn't see you for four years. I played it all with Walker Evans. I just disappeared and did it.

STRYKER: When he gave me that copy to read, all of a sudden it all came back and I couldn't hardly believe it. But he was one of the unusual ones. But that's the way that I think you have to go about it.

RYANT: Let us ask a question I think people would probably like to know. How did it happen that your photographs came to be here at the University of Louisville?

STRYKER: You see, I had run into Bob Doherty incidentally somewhere, when I had them moved back to Colorado again, and I had run into him. He was just starting to collect. I had seen some things he had and I didn't know too much about him. For some reason or another, he stuck in the back of my mind. Then when we moved—it was about this time that we were closing down and my wife and I were headed back home again—back into Colorado, I began to wonder—when I left, I left all the negatives in The Library of Congress. I had an enormous amount of stuff shipped—it came with me. Stuff I was saving and stuff I'd hung on to. What the hell was I going to do with it? When we arrived in Montrose, you'd be astounded at the number of books I sold Bob Doherty. I've got the list of the books I sold. He bought a lot of the books because I had to get rid of that stuff. You remember our upstairs, I think.

DOHERTY: There was a marvelous collection.

STRYKER: Oh, yes. Good God, I saved everything. I had the stuff I carted out to Colorado. The stuff we hauled out to Montrose is just astounding, really and truly. You know, that upstairs I had out there was just filled with stuff. Then, I had just run into Bob Doherty, and then for some reason or another I sensed that this was the place I could send [trust] and I began. My wife was an orderly woman, and she began to organize things and get them into shape again.

When I moved in this place out there in Colorado, she began to do a lot of work, and I remember she got a lot of stuff out and said, "Why don't you send this stuff to this Mr. Doherty? Maybe he would like this." That is really how the start came, by trying to get some order out of this stuff. I remember when she said, "Why don't you let me get this stuff together and organize these films? We'll send those down to him. It might be a

good place for you to have these." She was the one that thought about it and she was the one that did it. She was the one that could see all this confusion of mine and she was worried. She began to get this thing collected. So, I can give my wife the credit for that.

László Moholy-Nagy
Translated by
F. D. Klingender and P. Morton Shand

László Moholy-Nagy (1895–1946) is noted as an innovator in various fields—painting, photography, sculpture, theatre design, abstract film, and art education. He participated in major European and American avant-garde activities. His use of modern technology and new industrial materials and processes to explore light, space, and movement anticipated current experimental artistic concerns.

Moholy defined photography as a radical instrument for knowing the world. For Moholy, photography is valuable for its "reproductive" and "productive" potential. That is, photography can "reproduce" information already known as well as "produce" perceptions knowable only through the photographic media. Moholy's photograms, photocollages, and photographs taken from unusual perspectives are examples of "productive" photography.

The ideas summarized in these statements are developed in depth in Moholy's major tracts: Painting, Photography, and Film *(1925) and* Vision in Motion *(1947). His photographic books include:* The Street Market of London *(1936) and* Moholy-Nagy: 60 Fotos *(1920).*

In photography we possess an extraordinary instrument for reproduction. But photography is much more than that. Today it is in a fair way to bringing (optically) something entirely new into the world. The specific elements of photography can be isolated from their attendant complications, not only theoretically, but tangibly, and in their manifest reality.

THE UNIQUE QUALITY OF PHOTOGRAPHY

The photogram, or cameraless record of forms produced by light, which embodies the unique nature of the photographic process, is the real key to photography. It allows us to capture the patterned interplay of light on a sheet of sensitized paper without recourse to any apparatus. The photogram opens up perspectives of a hitherto wholly unknown

* Reprinted from *Telehor* (1936).

morphosis governed by optical laws peculiar to itself. It is the most completely dematerialized medium which the new vision commands.

WHAT IS OPTICAL QUALITY?

Through the development of black-and-white photography, light and shadow were for the first time fully revealed; and thanks to it, too, they first began to be employed with something more than a purely theoretical knowledge. (Impressionism in painting may be regarded as a parallel achievement.) Through the development of reliable artificial illumination (more particularly, electricity) and the power of regulating it, an increasing adoption of flowing light and richly graduated shadows ensued; and through these again a greater animation of surfaces and a more delicate optical intensification. This manifolding of graduations is one of the fundamental "materials" of optical formalism: a fact which holds equally good if we pass beyond the immediate sphere of black-white-gray values and learn to think and work in terms of colored ones.

When pure color is placed against pure color, tone against tone, a hard, posterlike decorative effect generally results. On the other hand the same colors used in conjunction with their intermediate tones will dispel this posterlike effect, and create a more delicate and melting impression. Through its black-white-gray reproductions of all colored appearances, photography has enabled us to recognize the most subtle differentiations of values in both the gray and chromatic scales: differentiations that represent a new and (judged by previous standards) hitherto unattainable quality in optical expression. This is, of course, only one point among many. But it is the point where we have to begin to master photography's inward properties, and that at which we have to deal more with the artistic function of expression than with the reproductive function of portrayal.

SUBLIMATED TECHNIQUE

In reproduction—considered as the objective fixation of the semblance of an object—we find just as radical advances and transmogrifications, compared with prevailing optical representation, as in direct records of forms produced by light (photograms). These particular developments are well known: bird's-eye views, simultaneous interceptions, reflections,

elliptical penetrations, etc. Their systematic coordination opens up a new field of visual presentation in which still further progress becomes possible. It is, for instance, an immense extension of the optical possibilities of reproduction that we are able to register precise fixations of objects, even in the most difficult circumstances, in a hundredth or thousandth of a second. Indeed, this advance in technique almost amounts to a psychological transformation of our eyesight,[1] since the sharpness of the lens and the unerring accuracy of its delineation have now trained our powers of observation up to a standard of visual perception which embraces ultrarapid snapshots and the millionfold magnification of dimensions employed in microscopic photography.

IMPROVED PERFORMANCE

Photography, then, imparts a heightened, or (insofar as our eyes are concerned) increased, power of sight in terms of time and space. A plain, matter-of-fact enumeration of the specific photographic elements—purely technical, not artistic, elements—will be enough to enable us to divine the power latent in them and prognosticate to what they lead.

THE EIGHT VARIETIES OF PHOTOGRAPHIC VISION

1. Abstract seeing by means of direct records of forms produced by light: the photogram which captures the most delicate gradations of light values, both chiaroscuro and colored.

2. Exact seeing by means of the normal fixation of the appearance of things: reportage.

3. Rapid seeing by means of the fixation of movements in the shortest possible time: snapshots.

4. Slow seeing by means of the fixation of movements spread over a period of time: e.g. the luminous tracks made by the headlights of motorcars passing along a road at night: prolonged time exposures.

5. Intensified seeing by means of (*a*) micro-photography; (*b*) filter-photography, which, by variation of the chemical composition of the sensitized surface, permits photographic potentialities to be augmented in various ways—ranging from the revelation of far-distant landscapes

[1] Helmholtz used to tell his pupils that if an optician were to succeed in making a human eye, and brought it to him for his approval, he would be bound to say: "This is a clumsy job of work."

veiled in haze or fog to exposures in complete darkness: infrared photography.

6. Penetrative seeing by means of X rays: radiography.

7. Simultaneous seeing by means of transparent superimposition: the future process of automatic photomontage.

8. Distorted seeing: optical jokes that can be automatically produced by (*a*) exposure through a lens fitted with prisms, and the device of reflecting mirrors; or (*b*) mechanical and chemical manipulation of the negative after exposure.

WHAT IS THE PURPOSE OF THE ENUMERATION?

What is to be gleaned from this list? that the most astonishing possibilities remain to be discovered in the raw material of photography, since a detailed analysis of each of these aspects furnishes us with a number of valuable indications in regard to their application, adjustment, etc. Our investigations will lead us in another direction, however. We want to discover what is the essence and significance of photography

THE NEW VISION

All interpretations of photography have hitherto been influenced by the aesthetic-philosophic concepts that circumscribed painting. These were for long held to be equally applicable to photographic practice. Up to now photography has remained in rather rigid dependence on the traditional forms of painting; and like painting it has passed through the successive stages of all the various art "isms"; in no sense to its advantage, though. Fundamentally new discoveries cannot for long be confined to the mentality and practice of bygone periods with impunity. When that happens, all productive activity is arrested. This was plainly evinced in photography, which has yielded no results of any value except in those fields where, as in scientific work, it has been employed without artistic ambitions. Here alone did it prove the pioneer of an original development, or of one peculiar to itself.

In this connection it cannot be too plainly stated that it is quite unimportant whether photography produces "art" or not. Its own basic laws, not the opinions of art critics, will provide the only valid measure of its future worth. It is sufficiently unprecedented that such a "mechanical" thing as photography, and one regarded so contemptuously in an artistic

and creative sense, should have acquired the power it has and become one of the primary objective visual forms, in barely a century of evolution. Formerly the painter impressed his own perspective outlook on his age. We have only to recall the manner in which we used to look at landscapes and compare it with the way we perceive them now! Think, too, of the incisive sharpness of those camera portraits of our contemporaries, pitted with pores and furrowed by lines. Or an airview of a ship at sea moving through waves that seem frozen in light. Or the enlargement of a woven tissue, or the chiseled delicacy of an ordinary sawn block of wood. Or, in fact, any of the whole gamut of splendid details of structure, texture, and "factor" of whatever objects we care to choose.

THE NEW EXPERIENCE OF SPACE

Through photography, too, we can participate in new experiences of space, and in even greater measure through the film. With their help and that of the new school of architects, we have attained an enlargement and sublimation of our appreciation of space, the comprehension of a new spatial culture. Thanks to the photographer humanity has acquired the power of perceiving its surroundings, and its very existence, with new eyes.

THE HEIGHT OF ATTAINMENT

But all these are isolated characteristics, separate achievements, not altogether dissimilar to those of painting. In photography we must learn to seek, not the "picture," not the aesthetic of tradition, but the ideal instrument of expression, the self-sufficient vehicle for education.

SERIES (Photographic Image Sequences of the Same Object)

There is no more surprising, yet, in its naturalness and organic sequence, simpler form than the photographic series. This is the logical culmination of photography. The series is no longer a "picture," and none of the canons of pictorial aesthetics can be applied to it. Here the separate picture loses its identity as such and becomes a detail of assembly, an essential structural element of the whole, which is the thing itself. In this concatenation of its separate but inseparable parts a photographic series inspired by a definite purpose can become at once the most potent weapon and the tenderest lyric. The true significance of the film will only

appear in a much later, a less confused and groping age than ours. The prerequisite for this revelation is, of course, the realization that a knowledge of photography is just as important as that of the alphabet. The illiterates of the future will be ignorant of the use of camera and pen alike.

László Moholy-Nagy

I

The discussion, which is still going on, as to whether photographs should be sharp or soft has its roots in the very beginnings of photography. Daguerre made his pictures on metal plates which could be neither retouched nor copied. They were therefore exceedingly sharp, penetrating, documentary.

II

The talbotype, discovered at the same time, was a paper negative which could therefore be used to take positive copies, but as the structure of the paper had to be copied also, the talbotype could never achieve the exactness and sharpness of line, resembling an engraving, which distinguished the daguerreotype.

III

Talbot himself, Hill, the Scottish painter, and some excellent photographers, such as Salzman, achieved such admirably picturesque results by means of the Talbot process that people became accustomed to confusing the creative intensity of the photographer with the traditional conception of the creative work of the painter. Thus faults were sanctioned which arose only from the inadequacy of the technical process.

IV

New inventions, such as the glass plate, the dry plate, and the film, made it easier to learn the photographic craft, and as photographers grew more numerous, dilettantism increased.

V

The real promoters of photography in those pioneer days were not so much the small professional photographers as the amateurs and the scientists. The amateurs worked in order to master the methods of photogra-

* Reprinted from *Industrial Arts,* 1, no. 4 (Winter 1936).

phy. The scientists toiled without any artistic ambitions, out of purely documentary interest. Even police-record photographs, which were necessarily made as sharp and exact as possible, collaborated without intent in the building up of photographic knowledge.

VI

Technical improvements were evolved to meet the needs of documentary photography. The possibility of fixing the quickest movement came to the help of the photography of inanimate objects in time exposure, while the snapshot with an increasingly closer approach to instantaneous exposure was used by the reporter and the sports photographer.

VII

Again, the discovery of sources of electric light, the possibility of directing intense floods of artificial light upon the object, the high sensitivity of the photographic plate were all bridges to a direct light picture.

VIII

There has, however, grown up a danger that, through the general knowledge of photographic methods, an undesirable state of affairs may appear in photographic work. The idea may become prevalent that it is possible to make "beautiful" pictures without any difficulty by following a given list of directions.

IX

But the aim of the present should not be to make photography an "art" in the old sense of the word. On the contrary, the real photographer has a great social responsibility. He has work to do with these given technical means which cannot be accomplished by any other method. This work is the exact reproduction of everyday facts, without distortion or adulteration. This means that he must work for sharpness and accuracy. The standard of value in photography must be measured, not merely by photographic aesthetics, but by the human-social intensity of the optical representation.

There is no more surprising, yet—in its naturalness and organic sequences—simpler form than the photographic series; that is photographic sequences of the same object.

This is the logical culmination of photography. The series is no longer a "picture," and none of the canons of pictorial aesthetics can be applied to it. Here the separate picture loses its identity as such, and becomes a detail of assembly, an essential structural element of the whole, which is the thing itself. In this harmony of its separate but inseparable parts, a photographic series inspired by a definite purpose can become a most potent weapon, or the tenderest lyric.

The prerequisite for this revelation is, of course, the realization that a knowledge of photography is just as important as a knowledge of the alphabet. The illiterates of the future will be ignorant of the use of camera and pen alike.

Caroline Fawkes

Caroline Fawkes analyzes the relations between Moholy's varied activities and artistic and intellectual currents. Her discussion of Moholy in the context of cultural history is an approach few writers apply to photography. Specifically comparing Moholy to Marxist writer Walter Benjamin (see "The Work of Arts in the Age of Mechanical Reproduction," pp. 260–272), Fawkes's essay suggests the need for further interdisciplinary studies.

Caroline Fawkes is a senior lecturer in Complimentary Studies at St. Martin's School of Art in England. This essay was written for "Art and Photography," a special issue of Studio International.

I

A survey of Moholy's variegated career can leave the impression that he must either have been a twentieth-century incarnation of Renaissance man or merely an exuberant dilettante. His chameleon aspect has led to his work being discussed most often within some limiting predefined framework: his role as a Bauhaus teacher or as a Constructivist painter, his contributions to graphic design, or his status as a grand old man of kinetics. His photographs and photograms have been located in terms of the formal and technical development of the photographic medium, but what this kind of treatment cannot reveal, for obvious reasons, is a sense of Moholy's primary identity, and in the following discussion I shall concentrate on the general premises of his work in order to establish what photography *meant* to Moholy, and how it relates to his other activities, particularly in the first decade of his career. For Moholy was neither a photographer who indulged in other activities on the side, nor an artist who happened to take photographs: photography was central to his aesthetic, and gave the direction to many of his nonphotographic activities. Some of the ideas which preoccupied him from 1922 onwards emerge in

* Reprinted from *Studio International* (July/August 1975).

another form in Walter Benjamin's 1936 essay "The Work of Art in the Age of Mechanical Reproduction," and both Moholy and Benjamin regarded the development of photography as having radical consequences for twentieth-century art and sensibility. The differences in their outlook are as revealing as the similarities and may serve to throw certain concepts into relief.

For Walter Benjamin in 1936, what was at issue was not photography's status as an art form, but "whether the very invention of photography had not transformed the entire nature of art."[1] Photography had made works of art generally accessible in a form that was no longer dependent on the interpretative filters of manual reproductive processes; photographic reproduction was relatively neutral, besides being infinitely faster. But in curtailing the interpretative role of the reproducer's hand and eye, it filtered out the only possible qualities of uniqueness that a reproduction might transmit. For the "aura" of the original work of art itself, the "quality of its presence," was never reproducible.

Up until the development of photography (which occurred "simultaneously with the rise of socialism"[2]), art is seen as functioning across a spectrum between two opposing values. At one end of Benjamin's spectrum, there is the "cult value" of art, which is embodied at its purest in prehistoric art, where what mattered is likely to have been the *existence* of a representation and its ritual function, regardless of whether or not it was actually on view. The unreproducible *aura*, Benjamin's term for what can be transmitted uniquely by the presence of a work of art, has always had its basis in a residual ritual function; and he refers to the way early film critics felt the need to read ritual elements into the cinema experience in order to safeguard the film's status as art. At the other end of the spectrum is an overriding emphasis on what Benjamin calls the "exhibition value" or public presentability of art. Whilst the art of the past had spanned both these values, the mechanization of the reproduction industry underpins an exclusive cultivation of art's "exhibition value." Since the introduction of photography, the old spectrum has virtually ceased to be operative: "For the first time in world history, mechanical reproduc-

[1] "The Work of Art in the Age of Mechanical Reproduction," in *Illuminations* (New York: Schocken Paperback, 1969), p. 227. Benjamin's essay "Das Kunstwerk im Zeitalter seiner technischen Reproduzierbarkeit" first appeared in *Zeitschrift für Sozialforschung*, 5, no. 1 (1936).

[2] Benjamin, p. 224.

tion emancipates the work of art from its parasitical dependence on rit-
ual."[3] This radical change in the function of art, derived in the first in-
stance from photography's role as a reproductive medium, was to have
repercussions where photography appeared as art in its own right. Benja-
min observes that "free-floating contemplation" is inappropriate to
Atget's photographs of deserted Paris streets around the turn of the cen-
tury: "They stir the viewer; he feels challenged by them in a new way."[4]
The film medium not only makes this challenge more explicit, but re-
moves art from the private sphere of the individual to the political arena
of the masses.

By 1922 Moholy-Nagy was involved with related problems. His first
attempt to construct a theoretical framework for his preoccupations was a
statement of the antithesis between "production" and "reproduction,"
which will be discussed in more detail further on. But Moholy had ar-
rived at his conclusions by a very different route, and the change that he
gauges in the function of art finds a less analytic and more programmatic
expression than in Benjamin's writings. Moholy did not share Benjamin's
historical sense and his gift for exquisitely differentiated argument; his
strength lay in the forcefulness of his formulations and the consistency
with which he acted out his insights. His attitudes to the implications of
mechanical reproductive media rested, in the first instance, on modes of
thinking introduced into Berlin circles by itinerant Russian Constructi-
vists in the early 1920s, and the "Production-Reproduction" essay reflects
his awareness of the debate about "Production Art" which had come to a
head in Moscow a year earlier, before the label "Constructivism" became
generally adopted in place of "Productivism."[5] But his approach is con-
ditioned by his response to the situation prevailing in Berlin in the early
years of the Weimar Republic, where artists were free from the specific
kind of political pressure which determined the shift from Productivism
to Constructivism in Russia. By this time Stepanova, the Stenberg broth-
ers, and other Russian artists were throwing their weight behind the pro-
gramme for industrialization by channeling their energies into applied
design or education; meanwhile, those committed to the premises of

[3] *Ibid.*
[4] *Ibid.,* p. 226.
[5] See for example A. Filippov, "Production Art" (1921) in *The Tradition of Con-
structivism,* ed. Stephen Bann (London, 1974), p. 22.

avant-garde experimental activity were increasingly finding their work regarded as peripheral. It was natural that artists in this latter category should tend to seek an outlet in the West once the blockade was lifted, and Puni, Gabo, Altman, Lissitzky, Ehrenburg, Mayakovsky, and Roman Jakobson were among the many Russians active in Berlin in the years immediately following Moholy's arrival there from Hungary early in 1920. It is from the exchange of ideas opened up by the presence of such people that Moholy (despite language difficulties) would have taken over any concepts he felt able to use.

During the brief years of "Russian Berlin," the artistic, intellectual (and initially the political) climate was such that the way still seemed open for radical social reconstruction on the Russian model, the creation of new institutional forms on premises fundamentally different from those that had embodied the hierarchical society of the prewar years. There was a general feeling among artists that anything might happen and that they themselves had an essential role to play in making things happen. This sense of expectation temporarily overrode the ideological and aesthetic differences between the Russians, the Berlin Dadas, and the migrant De Stijl group; and even the Expressionist groups from which the original Bauhaus staff were recruited shared the general urge to make art a viable instrument of social renewal.[6] This open, expectant situation was not one in which free experiment was necessarily regarded as a romantic indulgence, as it increasingly was in Russia by 1922. And the challenge presented to Moholy would have been to formulate an approach which would not only justify free experimental activity on a par with design for production, but locate such activity as a vital factor in social reconstruction.

The common denominator of Constructivist tendencies, whether for or against free experiment, was implicit in the movement's new label: Constructivism meant the espousal of the modern engineer as a prototype of the artist. Where Constructivists differed was in their conception of what it *meant* to draw parallels between art and technology. The Russians who came to Berlin were by and large not those who came to accept the analogy between the artist and the engineer as a call to a utilitarian aesthetic. Gabo, whom Moholy greatly respected, was an idealist more concerned

[6] The Dada and Constructivist Congress of 1922 is an instance of this testing out of common ground. The Congress took place at Weimar—seat of the Bauhaus.

with the *precision* of the artistic process than with its applications: the artist was to construct his work "as the universe constructs its own, as the engineer constructs his bridges, as the mathematician his formula of the orbits."[7] Van Doesburg, a great pontificator who took up the cause of international Constructivism, claimed the catchword "machine aesthetic" as his own,[8] but his arguments were formulated within such a rigid rationalist framework that his doctrine of the machine as a means to social liberation remains a dead letter. Lissitzky, who was equally at home in Russia and Germany, embodied some of the contradictions inherent in the artist-engineer analogy: he claimed that his *Prouns* were not simply "painting," but he couldn't quite sustain their status as architecture. They were utopian blueprints for the new society, painted equivalents of the verbal "construction" metaphor which was so pregnant at the time (and which crops up again in the name of the Bauhaus). Social reconstruction could be symbolized by the processes of building or engineering construction; and painting, in turn, could be made to stand proxy for both of these at once.

Moholy's justification for painting and other forms of free experiment worked on a different level, largely independent of this kind of analogizing. His painting in fact owes much to Lissitzky's; but any symbolism in it is largely unconscious. He took what he wanted from the artist-engineer analogy, but didn't allow it to constrict his framework for a Constructivist aesthetic. Unlike Gabo or Lissitzky, he had had no technical training; as a drop-out law student brought up in rural Hungary, his enthusiasm for the new technology was basically naïve. His own prototype engineer-artist was more like a resourceful do-it-yourself enthusiast, master of the most economical solution, and with a sure instinct for exploiting given resources to the utmost. But Moholy's model was fundamentally an organic one: unlike van Doesburg and the De Stijl group, he did not recognize any dichotomy between nature and technology.[9] Technology was an infinitely promising *extension* of nature, not an attempt to overcome it.

[7] Gabo and Pevsner, "The Realistic Manifesto" (1920) in *The Tradition of Constructivism,* p. 9.

[8] Theo van Doesburg, "Der Wille zum Stil," *De Stijl* 5, nos. 2–3 (February–March 1922).

[9] His source would again have been Russian Productivism. See, for instance, the related ideas of A. Toporkov, "Technological and Artistic Form" (1921) in *The Tradition of Constructivism,* p. 25.

The engineer-artist was not there to impose an artificial utopian environment on his fellow human beings; he was there to sharpen their senses, stimulate their awareness, foster their natural potential for creativity. Moholy thought this potential was being increasingly eroded by the way in which technology was being applied in practice—but not by technology as such. He took a technologically suggestive metaphor of Russian origin, "production," and located its essential meaning in the quality of inventiveness, in creativity: the metaphor could be turned against technology wherever technology was being used in ways that inhibited creativity instead of liberating it.

Moholy's rather bald 1922 statement "Production-Reproduction" provides a useful starting point for demonstrating where he anticipates Benjamin's analysis and where he diverges from it, here and in later writings. On one level, Moholy means by "reproduction" what Benjamin means by it: he observes for example that the gramophone had been used exclusively to reproduce sounds originally produced in a different context, to provide a mechanical reproduction of a live performance. For Benjamin, the corollary of this kind of reproductive process was that through "meeting the beholder or listener in his own situation,"[10] it shatters the tradition in which the art form had been embedded; for such a tradition is transmitted through the quality of the "aura" or presence of an original artwork or interpretative performance. Moholy, following the Futurist-Constructivist precedent, took the shattering of traditions for granted. The corollary for him was in the nature of a challenge: to find a "productive" use for the same piece of ostensibly reproductive equipment. And he proposes a use of the gramophone which would allow a composer to reach his public direct, bypassing the performer-interpreter and therefore the necessity for secondhand experience of the recorded interpretation.[11] (There is a parallel in the way the language of video is now being explored as distinct and separable from the broadcasting content of television.)

This preoccupation with the "productive" potential of communications media might seem to be borne out in the popular image of Moholy as the man who—soon after publishing this essay—ordered his own paintings

[10] Benjamin, p. 221.

[11] Moholy was to expand these ideas in "Neue Gestaltung in der Musik," *Der Sturm* 14, no. 7 (July 1923).

over the telephone. Although Moholy himself is responsible for propagating the telephone legend in an autobiographical sketch,[12] he never claimed that it was the unexplored potential of the *telephone* that had sparked him off on this occasion. In fact, it was a problem that had specifically to do with painting: Moholy was trying to find out something about the way scale conditions the perception of colour and form. As Lucia Moholy has recently explained, he felt that manual execution would be inadequate where it was a question of producing a series of paintings that had to be absolutely identical in everything but size; so he farmed out his design to an enamel factory. It wasn't until the industrial artifacts were delivered that the telephone entered into it at all. What happened, apparently, is that he exclaimed in delight: "I *might* even have done it over the telephone!"[13] But even had he actually done so, this would hardly have implied a creative or "productive" extension of the potential of the telephone, for Moholy was not interested in the severance of conception and execution as an issue worth pursuing in its own right. What the baked enamel "paintings" opened up for him had nothing to do with the telephone; it is more likely that they pointed the way to his later investigations into the possible relevance of industrial materials to painting.

Moholy's first practical suggestions for a more "productive" use of the photographic medium were extremely vague, the reason being that in the summer of 1922 he was as yet no more of a photographer than he was a "sound artist." The "Production-Reproduction" essay, which provides the basis of his approach to photography, was a crystallization of ideas exchanged on holiday with his wife (who did know how to take a photo); and the first photographic experiments, the cameraless photograms, were the immediate practical outcome of these ideas, not their point of departure.[14] Photography is a more complicated case than the gramophone in terms of Moholy's "Production-Reproduction" antithesis, because the mechanical reproduction of original artworks is obviously only one of its accepted functions. As applied to photography, it soon becomes apparent that the terms *production* and *reproduction* in Moholy's early writings are

[12] "Abstract of an Artist" in *The New Vision and Abstract of an Artist* (New York: Wittenborn, Schultz, 1947), p. 79.

[13] Lucia Moholy, *Marginalien zu Moholy-Nagy, Marginal Notes* (Krefeld, 1972), p. 74ff. The series comprised three identical works in baked enamel: 33⅛″ x 23⅜″, 18½″ x 11¾″, and 9⅜″ x 5⅞″.

[14] *Ibid.*, p. 59.

stretched to bear connotations beyond their usual range of meaning; the terminological overlap with Benjamin is only partial. Photography could for instance be used as a medium like the gramophone, where the function is reproductive in a straightforward sense: the transmission of preexisting information in as precise a form as possible. But photography could also be—and unlike the gramophone, already had been—used for its own sake. Yet it is precisely where photography has aspired to fine-art status in its own right that Moholy condemns it as "reproductive," this time in the sense of reproducing accepted norms and conventions extrinsic to the medium. He accuses photographers of tending to concentrate on a verisimilitude dictated by the perspective corrections of realist painting (snapshots recording the true optical perspective in which a building is seen tend to be regarded as "mistakes"), or—worse still—of taking over wholesale certain stylistic conventions of painting, instead of making "productive" use of what the camera alone can do. On the other hand, ostensibly reproductive photography as used primarily to transmit given information had often made "productive" use of the medium. Moholy was to reinforce this point through his own extraordinary selection of photographs to illustrate his publications. A mass of photographic material from press agencies and scientific publications is reproduced in his Bauhaus books alongside photographs by students and artists, and reproductions of their work in other media (his own included).

Like Moholy, Benjamin regarded the "artistic" use of photography as inseparable from its "scientific" function, its capacity to make visible the invisible, and to show us the visible in ways our eyes are unaccustomed to.[15] He points out that photography reveals a dimension of experience which was previously inaccessible: "The camera introduces us to unconscious optics as does psychoanalysis to unconscious impulses."[16] Both Moholy and Benjamin regarded photography and film as the agents of an altered and heightened perception, and as effectively the most far-reaching media yet developed in terms of art's altered function. In a slightly earlier essay Benjamin quotes Moholy's famous dictum to the effect that the illiterate of the future will be someone who cannot use a camera, and not only someone who cannot use a pen. But Moholy's statement is not

[15] Benjamin, p. 236, and Moholy-Nagy, *Painting, Photography, and Film* (English ed. of 1925 Bauhaus book; London, 1969), pp. 7, 28.
[16] Benjamin, p. 237. See also Moholy-Nagy, "A New Instrument of Vision" (1932) in R. Kostelanetz, *Moholy-Nagy* (New York: Praeger Publishers, 1970), p. 50ff.

allowed to stand unqualified in this context: Benjamin characteristically shifts gear, asking whether visual literacy is not equally a necessary qualification for *looking* at photographs.[17] Benjamin's concern in the two essays I have referred to was first and foremost with the social and technological conditioning of modes of *response* to artistic expression; the activity of practising artists is necessarily seen as a corollary of changed modes of response rather than as an issue in its own right. This emphasis is reflected in Benjamin's terminology, since he discusses art in the age of mechanical reproduction in terms of its "exhibition value"—in other words, in terms that have primarily to do with the nature of public expectations of art.

Moholy, on the other hand, tended to treat the effect of art on the public as if it were functionally one and the same thing as creative activity— or should be. Both Moholy and Benjamin believed that the most effective art in an age of increasing mechanization was one that could prompt an active response, rather than provide an arena for passive contemplation. Benjamin was to point to the demands posed by the new medium of film, the shock effect "which, like all shocks, should be cushioned by heightened presence of mind."[18] But Moholy, who had advocated "dynamic" (and kinetic) forms with the same shock effect in mind,[19] went a stage further: he did not conceive of the effect of art on the public as "heightened presence of mind" alone. He was more interested in breaking down the barriers between "artists" and "public" than in the niceties of theoretical distinctions, and what he meant by the statement on visual literacy quoted by Benjamin was that if photography is to revolutionize vision, it will do so above all by prompting people to try it out for themselves, to use it for purposes other than the (reproductive) recording of the picturesque or the anecdotal. Just as literacy involves writing as well as reading, so visual "literacy" in the age of the visual mass media involves more than looking.[20]

The implication of Moholy's programme was not simply that a "productive" approach, in whatever medium, was more likely to produce

[17] Benjamin, "Kleine Geschichte der Photographie" (1931) in *Angelus Novus* (Frankfurt, 1966), see the final paragraph.

[18] Benjamin, "The Work of Art in the Age of Mechanical Reproduction," p. 238.

[19] *Painting, Photography, and Film*, p. 26.

[20] Lissitzky's admonition to the "readers" of his *Of Two Squares* (Berlin, 1922) is also relevant: "Don't read the story, take paper, sticks, your building bricks and put it together, paint it, build it."

fresh and vital results than an academic training within a traditional medium, nor that it could transcend the accepted distinctions between fine and applied art. Both these factors were obviously important to him, but the most far-reaching function of "productive" activity, the do-it-yourself approach, was not production at all in the material sense of actually coming up with the goods. The questions whether the end results of such activity could qualify for the status of art, or could be put to practical use, were of secondary importance. Like other artists involved with Berlin Constructivism or the Bauhaus, Moholy preferred the German term *Gestaltung* (a noun meaning "forming," or any formal means of expression; by extension, creative activity in general) to the qualitatively more absolute concept for *art*. For creativity and inventiveness were not the prerogative of the self-styled artist or the professional designer: Moholy's whole aesthetic is predicated on the assumption that they are latent in every normally endowed individual.[21] His emphasis on "productive" creativity is a function of his conviction that the level of awareness generated by fostering this creativity would prove to be the most effective weapon available to combat the alienating effects of living and working under a capitalist system of production, and that it would be the mainspring of any viable alternative to this system: "NOT THE PRODUCT, BUT MAN, IS THE END IN VIEW."[22] Moholy felt that the equalization of resources within a society built up on a cooperative basis would not, of itself, be able to guarantee a more satisfying mode of existence. He regarded individual wholeness as of paramount importance, and the cooperative society would need to promote a less exclusively academic and one-sided form of intelligence by ensuring that there was room for the individual to exist outside any specialization of function enforced in the name of progress. Russia was not the ideal model: the conveyor-belt principle, which in Moholy's view epitomized the atomization of skills most horrifically, was being promoted in post-revolutionary Russia just as avidly as in the West.

[21] Moholy's famous slogan "EVERYONE IS TALENTED," a paragraph heading in *The New Vision*, derives from the ideas of Heinrich Jacoby, a German educationist, who used to give lecture-demonstrations designed to prove to the man in the street that he was "musical" after all. Jacoby, like Moholy, operated with an antithesis between "productive" and "reproductive" activity (*Jenseits von "musikalisch" und "unmusikalisch,"* Stuttgart, 1925).

[22] See *The New Vision*, pp. 14–18. (This book is an English edition of Moholy's 1929 Bauhaus book *Von Material zu Architektur*.)

In short, where Moholy's approach diverges most fundamentally from Benjamin's is in playing down the distinction between the creative ("productive") activity of the artist and the heightened presence of mind of the public. The accent is on the function of creativity itself. For an artist—like Moholy himself—to produce work which could help to foster a heightened visual awareness of the environment was one side of it. Even more important was the pedagogic side, if that is not too restrictive a word: providing a more positive framework for other people to tap their own potentials, to find compatible means of expression for themselves. Moholy's writings belong in this category, just as his teaching does: right from the early suggestion that composers should try scratching a master disc for replication as gramophone records, they are full of projects and throwaway ideas which he can hardly have expected to follow through himself. He obviously regarded his own work as part of the same corporate enterprise as his writing and teaching; whilst he included several of his photograms in the 1925 Bauhaus book translated as *Painting, Photography, and Film,* he also reproduced two of Man Ray's. Benjamin saw that it was the mass media which were revolutionizing the function of art; Moholy, following the impetus of the short-lived productivist enterprise in Russia, was already pushing the consequences in the direction of a radical democratization of art and the integration of the artist within the fabric of society.

II

In an exuberantly Futurist proclamation published in 1926, Moholy proposed a new formula to supersede the more limiting "Production-Reproduction" antithesis of 1922. The title of the new manifesto has been translated as "Directness of the Mind; Detours of Technology." Moholy's new emphasis (later taken over wholesale by McLuhan) was on the way technology lags behind its potential because of the persistence of thought categories based on older technologies.[23] An example:

> Detours of technology: current attempts to look at planets and stars through larger and larger lenses, instead of working on electromagnetic photographic

[23] In Kostelanetz, p. 187. The same assumption also underlies Benjamin's discussion of reproduction techniques: see "The Work of Art in the Age of Mechanical Reproduction," p. 219. McLuhan's championship of nonlinear forms of communication develops a thesis central to Moholy's conception of the significance of photography and his ideas on graphic design, film and theatre: see for instance the section on "Typophoto" in *Painting, Photography, and Film.*

impulses. Prediction: all observatories will become obsolete, because they are equipped with traditional technology.

Starting out from the assumption that the use of pigment in painting "established the concept of colour as a sort of light terminus, crassly material," Moholy was able to convince himself in this essay that the history of Western painting was a "technological detour," and that pigment was a poor substitute for the direct use of coloured light. (He later predicted that the art schools of the future would, by the same token, be Academies of Light.) His new formulation seems to have been designed to tighten the thesis of his Bauhaus book of the previous year, *Painting, Photography, and Film:* he had a vested interest in reworking the theme of this book, because it provided a framework for the direction his own work was taking. The point of departure for *Painting, Photography, and Film* had been the conjecture that the advent of photography had necessarily freed painting from its representational function: painting would now be able to fulfil its purpose by pure colour composition.[24] Given that the use of pigment was a "technological detour," then direct projection of coloured light—demanding "productive" use of the new technology—could fulfil the same biological needs. Since, according to Moholy, kinetic light projection would require a more alert and differentiated response from the observer,[25] it was likely to fulfil these universal needs more adequately than painting, though he conceded that static colour composition would retain its validity. Painting was a good medium, Moholy felt, for trying things out in; but technology had thrown up a wealth of alternatives which were likely in the long run to prejudice its exclusive status, with the result that "in future periods only the man who produces sovereign and uncompromising works will be able to become and remain a PAINTER."[26]

Photography and its derivatives promised to be the most far-reaching of these alternatives. Having located the basis of the photographic process in the light-sensitivity of a chemical emulsion, Moholy's own investigation of the medium had started out from the action of light on the

[24] Moholy regarded the experience of organized colour-relationships (and of organizing colour oneself) as "biologically" and universally necessary to physical and psychological equilibrium. Yet he was himself obviously more sensitive to *value* relationships.

[25] *Painting, Photography, and Film*, pp. 23–24.

[26] *Ibid.*, p. 26.

emulsion direct. In other words, he had for the time being dispensed with the mediating optics of the camera lens. The first photograms of 1922 were made by laying objects, flat or three-dimensional, opaque or transparent, solid or open-textured, on daylight paper (printing-out paper).[27] The objects would cast shadows or reflect light across the surface; they (or the light source) could be moved during exposure; the light might be diffused or directed, and lenses or liquids could be used to concentrate or refract the light. The result (visible on this kind of paper *before* chemical processing) was a new kind of photographic space, ambiguous, devoid of references to conventional perspective, and defined by the modulation of light values from pure white (where no light had reached the paper) through a spectrum of greys to deep black where the strongest light had been concentrated for longest.[28] The photogram worked with a highly differentiated spectrum which is otherwise hard to isolate, given normal lighting and normal colour vision, and the cultivation of subtle relationships within this spectrum had a profound effect on Moholy's sensitivity to value gradations and modulations of light in other media. A curious footnote in *Painting, Photography, and Film* suggests that it must even have coloured his reaction to the urban landscape of Berlin in the early 1920s:

> The interplay of various facts has caused our age to shift almost imperceptibly towards colourlessness and grey: the grey of the big city, of the black and white newspapers, of the photographic and film services; the colour-eliminating tempo of our life today. Perpetual hurry, fast movement, cause all colours to melt into grey. Organized grey-relationships . . . will, of course, emerge later on as a new aspect of the biological-optical experience of colour. Intensive examination of photographic means will certainly contribute much to this.[29]

In the photograms, Moholy had not only hit on a "productive" use of the photographic medium (by no means new, but new to him),[30] but had also discovered the elusiveness of form as generated by the play of light

[27] Lucia Moholy, p. 61, describes the techniques she and Moholy-Nagy developed in collaboration.

[28] See also Moholy's own comments in "Fotografie ist Lichtgestaltung," *Bauhaus,* 2, no. 1 (1928).

[29] *Painting, Photography, and Film,* p. 15.

[30] The question of who "invented" the photogram is dealt with by Lucia Moholy, pp. 58–59.

alone. This discovery was to become his lifelong obsession. He soon came to locate the photogram (Man Ray's and his own) within the tradition of light projection from the early colour organs to the reflected light-play experiments of students at the Bauhaus, a tradition which promised to offer an alternative to the "technological detour" of pigment. Although the cameraless photogram fixes the movement of light in a static form, Moholy saw it as the point of departure for photographing light effects thrown onto a screen and for "light films which could be shot continuously," superseding the limitations of the animation techniques used by Eggeling and Richter in their early abstract films.[31] Moholy's aim was to articulate "a light-space-time continuity" in which light was not merely an adjunct of form but the artist's primary means of expression. For years he hoped to find someone who would let him loose with twelve projectors in a bare room, where he could work with the interpenetration of coloured beams in three-dimensional space.[32] No one would sponsor him; but he realized his aims in another form in the *Light-Display Machine*[33] of 1930, a kinetic work of immense sophistication which has survived the fads of the 1960s unscathed. It seems to have failed to make an impact in 1930, probably because few people were able to tune their perceptions to a complex yet unfocused form of experience in which the modulation of deep shadows and brilliant reflections on the surrounding walls was at least as important as the changing relationships between the light-modulating elements of the machine itself. On the other hand, Moholy's film *Light-Play Black White Grey,* made from close-ups of the machine in action, was an immediate success, and the reason could be that the film provides a ready-made focus and eliminates the challenge the machine itself poses to peripheral vision, the perception of transitions of light in three-dimensional space.

The *Light-Display Machine* is unthinkable without Moholy's photo-

[31] See *Painting, Photography, and Film,* pp. 20–21; also "Light—a Medium of Plastic Expression" (1923) in Kostelanetz, pp. 117–118, where Moholy locates the "highest development" of the photographic process in film.

[32] See "Light Architecture" (1936) in Kostelanetz, p. 115ff.

[33] It was originally exhibited encased in an apparatus providing a coloured light sequence but was later set up against a simple white spot lamp. The machine has more recently come to be known as the *Light-Space Modulator.* The original is in the Busch-Reisinger Museum, Harvard; there are working replicas in the Bauhaus Archive, Berlin, and the Stedelijk van Abbe Museum, Eindhoven.

gram experiments and his subsequent investigations into what he called "optical facture." "Facture" (in *The New Vision* rendered limply as "surface aspect" or "surface treatment")[34] was another Russian Constructivist concept which Moholy adapted to his own ends. "Optical facture" denotes any treatment (such as high polish) which results in an elusive, dematerializing effect, in contradistinction to the strongly tactile appeal of a more textural and light-absorbent facture. In a characteristic early construction Moholy allowed cuboids of various metals and other shiny materials to disappear into their own reflections in the polished baseplate. He sometimes even used paint with "facture" in mind: when working in oils on canvas (for instance in the 1922 Tate Gallery painting *K VII,* which owes much to Moholy's appreciation of value gradations in photography), he occasionally contrasted areas of bare rough canvas with the variable light absorption of different qualities of paint surface, ranging from forms brushed with a smooth glaze to areas of matte impasto. Increasingly, he turned to industrial materials as the ground of his paintings (though he continued in the main to use oil on canvas). On a metal or synthetic ground, the contrast in quality of surface between painted areas and ground would be much more marked, and the facture more "optical" in effect. Aluminum has a dull reflectiveness which allows forms worked in oil to give the illusion of floating as if disembodied; this kind of space was more reminiscent of that of the photograms than of paintings executed in conventional media. Occasionally Moholy seems to be playing with possibilities suggested by Malevich, whose work he greatly admired (along with Mondrian's). But where Malevich's Suprematist elements would hover ambiguously in an illusionistic white space of infinite depth, Moholy's coloured elements in the 1926 painting *G8* are made to float in real space, casting real shadows. They are painted on three levels: on the opaque ground, and on the under and upper surfaces of a transparent synthetic called galalith laid over the ground. Moholy's reading of Malevich is revealing: he saw the 1917 *White on White* purely as an exercise in optical facture, as the ultimate transitional work between (material) pigment and (immaterial) light. The white surface was an "ideal plane for kinetic light and shadow effects which, originating in the surroundings, would fall upon it."[35] It functioned like a film screen.

[34] The concept is discussed in *The New Vision,* p. 25ff.
[35] *The New Vision,* p. 39.

Moholy's recognition of the significance of the film medium had much in common with Benjamin's later observations: its nature as mass medium, transcending the limitations of the traditional artwork; the alertness required of the cinema audience (especially by early silent montage). But, whilst Benjamin was interested above all in the political implications, Moholy thought about film first and foremost in the context of its potential for exploring the medium of light. Film transcended the limitations of photography in providing a challenge to manage the complexities of light and space in *motion*. Following in the wake of the Italian Futurists and of Gabo's "Realistic Manifesto," Moholy was convinced that the most complete forms of expression in his own age would prove to be forms which worked in and with the dimension of time. But he found relatively little to impress him in the cinema of the 1920s, which struck him as being arrested at an extremely primitive stage in its evolution, aping the narrative forms of traditional theatre and the novel and showing little awareness "that the essential medium of the film is *light* not pigment." Even montage usually seemed to have been misunderstood; as the Russians used it, the effect tended to be "impressionistic rather than constructive," limited to individual sequences of striking effects at the expense of the overall structure of the film as a totality[36]—though Moholy repeatedly credited Vertov, among others, with an effectively "constructive" handling of the medium.

Moholy's own films and film projects of the 1920s tended to seek filmic equivalents for various rhythms of urban existence (the only two to be completed were shot in Berlin and Marseilles). *Dynamics of a Metropolis*,[37] a promising scenario written in Berlin in 1921–1922 (and never filmed), shows that Moholy started out with a conception that prefigures Vertov's 1929 *Man with the Movie Camera:* the montage of images was to be entirely devoid of narrative content, each being defined by its impact within the image sequence in which it occurs and by its function in terms of the shock tactics of the film as a whole. Moholy tended to single out situations with a potential for the filmic exploitation of disorienting light effects, and above all purely "camera-eye" situations: under a moving train; on a fairground big-dipper at the point when everyone closes their

[36] "Problems of the Modern Film" (1932) in Kostelanetz, p. 131ff.

[37] In Kostelanetz, p. 118ff. A "Typophoto" version appears as an appendix to *Painting, Photography, and Film*. (This is an attempt to demonstrate the possibility of a nonlinear [synoptic] organization of verbal and visual material.)

eyes on the switchback. In a station hall the camera was to be turned in a continuous circle both horizontally and vertically ("our head cannot do this"). The special value of the camera—whether in terms of photography or film—was to "complete or supplement our optical instrument, the eye." For whereas the eye tended to perceive in accordance with mental schema—expectation and ingrained habit—the camera could produce a "purely optical image."[38] In another context, Moholy suggests an impractical and (on the face of it) macabre study of skin facture: the face of a single individual was to be shot day by day, frame by frame, revealing those changes between childhood and old age which in reality are too subtle to be experienced *as* change. This particular use of film is really an extension of Moholy's interest in the serial use of photography, where "the separate picture loses its identity as such and becomes a detail of assembly, an essential structural element of the whole." As a result, "none of the canons of pictorial aesthetics can be applied to it."[39]

Moholy himself had only begun to use a camera once the photogram experiments were underway. His approach—which had much in common with Rodchenko's—was to present the ordinary in a new light, by whatever means occurred to him. He was not inclined to make an aesthetic point of manipulating the image in the processing, except in the case of positive-negative reversals, which had the effect of altering one's reading of the image simply by inverting the light values of the original print. His most characteristic approach was to effect the disorientation of space perception through light and shadow contrasts or unexpected perspectives (especially bird's-eye or worm's-eye views), or to concentrate attention on the surface quality of objects or materials through close-ups. As Benjamin, too, was to observe, an enlargement from a photographic close-up "does not simply render more precise what in any case was visible, though unclear: it reveals entirely new structural deformations of the subject."[40] Moholy found photography an ideal medium for exploring his interest in "facture," and the now famous juxtaposition of two anonymous photographs of a 130-year-old resident of Minnesota and of a wrinkled mouldy apple originally appeared in his 1929 Bauhaus book

[38] *Painting, Photography, and Film,* p. 28.
[39] "A New Instrument of Vision," in Kostelanetz, p. 54.
[40] Benjamin, "The Work of Art in the Age of Mechanical Reproduction," p. 236.

Von Material zu Architektur.[41] (Readers of the English edition, *The New Vision,* are unfortunately spared the apple and half the point.)

His own photographs of overflowing drains, of oozing mud, or of a pile of fishbones present the material *quality* of a surface in its own right by isolating it from the context in which it would naturally be seen. The pile of fishbones might be anywhere, and it might be any shape or size. All we see is the peculiar quality of these small jagged components as heaped up together, presented dense and flat across the surface of the photographic print. A similar preoccupation with facture was to emerge after 1930 in Polish Constructivist painting: Strzeminski's extraordinary little allover compositions employing textural impasto effects reminiscent of fabric weaves make an impact more directly related to that of Moholy's photographs than to anything in his own (or anyone else's) earlier painting, which had worked with the *relations* between separate forms across the surface.[42] The closest visual analogy to Strzeminski's "unistic compositions" is perhaps a photograph Moholy chose from a technical journal for reproduction in *Von Material zu Architektur:* a close-up showing dust as accumulated by the regular grid of a filter in a factory.[43]

In his facture studies Moholy tended to play down the editorial role of the eye behind the viewfinder: the surface is uniform and continuous. However, the structure of Moholy's photographic compositions usually derives from his perception of the dynamic function of the framing rectangle. The edge of the image is what animates his forms (far more forcibly than is the case with his painting). However arbitrary and startling they may have seemed in the 1920s, it would now be difficult to look at his photographs without invoking well-worn aesthetic criteria—but Moholy must be credited for his part in setting up these criteria in place of those he was originally trying to expose as "reproductive." Some of his photographs have been reproduced in varying orientations; none is neces-

[41] *Von Material zu Architektur* (facsimile edition, Mainz and Berlin, 1968), p. 41. Volker Kahmen borrows the same juxtaposition in *Photography as Art* (London, 1974)—a book which surely owes as much to Moholy in the organization of photographic material as it does to Benjamin in the introductory text.

[42] See the catalogue *Constructivism in Poland 1923-1936,* Museum Folkwang, Essen/Rijksmuseum Kröller-Müller, Otterlo, 1973. Moholy's painting had also displayed an interest in textural "facture"—but only as one of many ways of defining forms in space, not as an exclusive preoccupation in its own right.

[43] *Von Material zu Architektur,* p. 52.

sarily wrong, since Moholy regarded a print as something to explore further rather than as a finished statement of data seen and captured on film. In his juxtaposition of a positive and a negative print of a woman's body (or rather, a partial view of her lying on a bed, seen from above), Moholy has actually signed the print upside down. The signature (unusual on the front of his photographs) presumably serves to confirm the orientation which most effectively disturbs an uncritical naturalistic reading of the space. He was fascinated by how much a print could reveal that the eye might have missed, and is reported to have irritated Edward Weston (a photographer with a rather tighter approach to image-making) by turning Weston's photographs upside down and pointing out hidden forms.[44] Moholy's own photographs are, of course, highly composed; but seldom to the extent of manifestly setting up the subject before exposure, as Weston sometimes did. Moholy was more likely to go to some trouble in finding himself a near-impossible viewpoint than to allow the subject itself to *look* posed, though there is an exception in the case of the curiously Surrealist "Dolls,"[45] which Moholy placed in a setting that was also used for other subjects. The appeal of this particular setting for Moholy was clearly the way in which space perception is upset by the fact that the shadow thrown by the grid has—photographically—a solidity equal to that of the grid itself.

There is a film scenario of the later 1920s, *Once a Chicken, Always a Chicken,*[46] which also uses imagery in a way that is suggestive of Surrealism. It is in a different category from his other films and film projects, in that it would have involved a highly formalized use of actors. The film's structure would have been derived from contrived situations rather than from the editing of material observed and shot on location with a minimum of manipulation (as for instance in the 1929 Marseilles film). The situations themselves are menacing and enigmatic: colonies of eggs bounce around with a life of their own, chasing people down the street. Where Moholy's filmic treatments of the urban landscape and its rhythms are a development of the preoccupations of his photographs, and the short completed sequence from *Light-Play Black White Grey,* a ki-

[44] Beaumont Newhall, review of Moholy's achievement (1948) in Kostelanetz, p. 70.
[45] Though the mannequin-fetishism of the Paris-based Surrealists had scarcely made an appearance by this date (1926), except (by implication) in Max Ernst's work.
[46] In Kostelanetz, p. 124ff.

netic extension of the photogram, this scenario is more closely related to his highly individual treatment of the photocollage medium. (One of the points of departure for *Once a Chicken, Always a Chicken,* was in fact a 1925 photocollage of the same title.)

Whereas his photographs were usually given purely descriptive titles for purposes of identification, the titles of the photocollages have a part to play in the impact of the visual material. They are often untranslatable and, like the imagery itself, witty and enigmatic. Moholy's so-called photoplastics (*Fotoplastiken:* plastic in the sense of form, as in Neoplasticism) have little to do with photography as he conceived it, for they are in no way complementary to, or an extension of, the organ of sight, but food for the mind. They do not involve the photographic organization of light, but rather the selection and manipulation of preprocessed imagery. Often a photocollage would evolve further: it might be given a new title; or a new photocollage would be produced as a pendant to the original one (as in a series centering on the jealousy theme).[47] Like the Berlin Dadas, Moholy recognized that photocollage (and photomontage) could provide a basis for effective poster design as well as being (for Moholy) an ideal medium in which to explore personal associations. But, unlike the Dadas, Moholy used his imagery sparingly, with close attention to its positioning on the white surface. *How to Stay Young and Beautiful* (a photocollage which Moholy once had reproduced in negative)[48] uses a tiny splayed figure, glued on in conflict with its own centre of gravity, to set the ring spinning round the static figure trapped inside. Occasionally he worked with an apparently Dada- or Surrealist-derived confrontation of unexpected entities within the image, but the peculiar impact of his photocollages is usually determined by the way the images are related in an illusionistic and yet sometimes ambiguous three-dimensional space. The spatial framework implied by disparities of scale in the imagery is often further defined by pencilled lines. Sometimes the lines link the photographic fragments together and form themselves into further imagery: they may look like wires or define planes. In other photocollages, they serve purely constructional purposes. The images were often cut direct from magazines or other sources, but occasionally Moholy worked them up.

In one of the earliest, "Chute" (1923; The Museum of Modern Art,

[47] See Lucia Moholy, p. 69ff.
[48] In Franz Roh, *Moholy-Nagy: 60 Fotos* (Berlin, 1920).

New York), he prints up a single image in gradually increasing sizes so that the figure appears to loom out of the distance into the foreground in interminable repetition. Another photocollage called "The Law of Series" (1925) seems related to his interest in serial photography—except that he is here able to indulge in manipulations which would have been incompatible with his conception of photography proper. An image is repeated five times: that of a man photographed in foreshortened perspective so that his outstretched hands are larger than his head. This foreshortening conditions another optical surprise: one naturally tends to read a rapidly converging perspective into the imagery, the space of the photographic close-up; and yet the overlapping images are all the same size in real terms. Illusionistically, therefore, the images that appear to be further back loom larger than the ones glued on top of them (in front of them). A further twist appears in the fact that the images are not, in fact, the same, although identical in posture, expression, and actual size. The figure gives the impression of having been lit from different angles, although the five images appear to derive from the same exposure and not several different ones. Moholy probably worked up the apparently variable lighting by manipulation in the printing of a single negative before cutting out the images.

The more personal photocollages and Moholy's disparate treatments of the film medium should give the lie to any impression that his work tended to be a secondary outgrowth of his theoretical formulations. Admittedly, the early photograms had been his first solution to the specific problem of finding a "productive" approach to the photographic medium; but his thesis that art progresses from the material to the immaterial, "from pigment to light," from a sculpture of mass to kinetic construction of "virtual volume" in space, is clearly more derivative from his own personal preoccupations—an attempt to justify them and project them forward into the future—than vice versa. Moholy is sometimes represented as erudite and systematic in the theoretical area, and in the practical area as a calculating technician bent on lending art the precision finish of engineering procedures. He was obviously neither. For one thing, his own German usage was highly unorthodox, and he had little interest in ploughing through academic literature in German; he relied heavily on others not only to supply him with references and backup ma-

terial, but also to help in formulating his ideas.[49] Where, on the practical level, he advocates systematic investigation of the potential inherent in any material and any medium, old or new, what he conceives of as systematic appears as almost random by comparison with more recent neo-Constructivist and systems-based work. He laid great store by chance discoveries, and would generally set about working in an unfocused "what would happen if . . . ?" frame of mind. The extraordinary range of his own work and ideas is a function of what he conceived to be the role of an artist in a society increasingly dominated by the mass media and gross overspecialization of individual skills: by an irony, his commitment to working across this whole range was his most consistently systematic characteristic. He never—in considering painting, photography, film, or any other medium—commits himself irrevocably to the merits of a single exclusive approach. For any doctrinaire narrowing of potentials runs counter to the concept of "production," which, in one form or another, was the mainspring of all his ideas and all his activities.

[49] See Lucia Moholy, p. 54ff.

Atget and the City (1968),* an excerpt

John Fraser

Eugène Atget (1856–1927) was a French forerunner of documentary photography. He photographed in series, exploring Paris—its people, architecture, streets, shopwindows, brothels, and trees—with exhaustive thoroughness. His work is distinguished for clarity of detail and variety of camera angles and distances.

Virtually unknown during his lifetime, Atget was introduced to the Surrealists by Man Ray and his then assistant Berenice Abbott. Berenice Abbott, noted for her own photographs of city subjects, is responsible for preserving Atget's extensive work (some 8,000 negatives). Abbott brought Atget to world attention through exhibitions and publications. These publications include A Vision of Paris (1963) *by A. D. Trottenberg and* The World of Atget (1964) *by Berenice Abbott.*

In this essay John Fraser proposes that Atget's vision of Paris acknowledges the city's complexities as complementary, not antagonistic. Fraser's approach is interdisciplinary; he interprets Atget in the context of parallel and current developments in literature and painting.

John Fraser teaches at Dalhousie University in Nova Scotia. He has published articles on topics in photography and eroticism, and is the author of Violence in the Arts (1974).

I

Between 1898 when he became a photographer at the age of forty-one and his death in 1927, Eugène Atget made literally thousands of photographs of Paris and its environs.[1] He was unquestionably one of the su-

*Excerpted from *The Cambridge Quarterly,* 3, no. 3 (Summer 1968), pts. I, II, III, VI, VII.

[1] For details of Atget's life, the most helpful discussions so far are those by Jean Leroy "Atget et son Temps," *Terre d'Images,* no. 3, May–June 1964, pp. 357–372); R. E. Martinez ("Eugène Atget in Our Time," *Camera,* 45, December 1966, pp. 56, 65–66); and Miss Berenice Abbott, *passim.* Of these M. Leroy's appears much the most thoroughly researched. M. Leroy's dating of the start of Atget's photographic career in 1899 seems rather odd, however, since the albums of prints in the Bibliothèque Nationale that Atget himself made up are dated from 1898 on.

preme twentieth-century artists in any visual medium, he was one of the most heroic, and the image of him going out indomitably year after year under the "dreadful weight"[2] of his old-fashioned camera, wooden tripod, and glass photographic plates is as compelling to the imagination and deserves to be as well known as those of Van Gogh and Cézanne in the grip of their comparable obsessions with locales. What is more to the point, so does his work. Yet the very abundance of that work, given the fact of his genius, can have an intimidating effect on the would-be critic of it, at least if he suffers from a scholarly conscience. Only about five hundred different pictures by Atget out of those several thousand have been reproduced in books and periodicals, and the editors of one of those books has declared that "Atget's complete work has not yet undergone thorough scholarly scrutiny, and this immense store of visual source material for history, art, and architecture remains almost untapped."[3] Can one, then, reasonably offer to talk about an entity called Atget if one has not had the opportunity to inspect at least the greater part of what he did? I think that one can, and I propose to engage in some fairly substantial generalizations about his work—more substantial and more complex ones than have been attempted so far.[4]

Actually the undertaking is by no means so rash as it may seem. True, to judge from one or two surprises in the last few years, there may well be pictures still to come that are as great as any by Atget that we now have in print. It is particularly tantalizing, for example, to read of his "hundreds" of photographs of trees and flowers[5] and to have to imagine what his brothel series is like on the basis of half a dozen exteriors and one magnificent nude. (Is it in the latter series, for instance, that one finds the picture of "a negress which irresistibly recalls Gauguin"?[6]) But the very fact that

[2] Abbott, "Eugène Atget," *Creative Art,* 5 (1929), p. 656.

[3] Arthur D. Trottenberg, introd. to *A Vision of Paris* (New York: The Macmillan Co., 1963), p. 28.

[4] I suspect, however, that a whole monograph could be written by following up the tips given by Ferdinand Reyher in six pages of brilliant notes to an exhibition of Atget's work that he organized twenty years ago ("Atget," *Photo Notes,* Fall 1948, pp. 16–21), and I regret not coming upon them before the present article was finished.

[5] Abbott, "Eugène Atget," p. 654.

[6] Jean Leroy, "Who Was Eugène Atget?" *Camera,* special Atget issue, 41 (December 1962), p. 7. It is possible, however, that M. Leroy may have been thinking of a photograph by Atget of an anonymous painting, a print of which photograph is in the George Eastman House collection, Rochester, New York.

Atget worked so much in terms of series—Miss Berenice Abbott, the preserver of many of Atget's pictures, his most helpful commentator, and his best editor, reports that there are twenty-five in all[7]—is reassuring. Atget, says Mr. Arthur D. Trottenberg,

> took almost no isolated photographs. He treated his subjects in complete and varied series from a number of camera positions. It was not enough to take a photograph of a street. It was important for him to show the street as a viewer might see it if he turned his head in various directions. He felt the need to show the process of growth and decay in a great city, and hence would photograph a building, as for example the basilica of Sacré-Coeur, in various stages of construction. He applied the same technique to the demolition of several buildings in Paris. He continually varied his approach to a subject, not only with camera angles, but from a distance to extremely close up . . . Among the subjects he treated with exhaustive thoroughness and in series were trees, flowers, shopwindows, streets, cafés, brothels, monuments, buildings, street vendors, rag-pickers, St. Cloud, Versailles, the Bois de Boulogne, and architectural detail of every kind.[8]

Well, we now have a number of samples of at least twenty-two of the series,[9] and quite probably (depending on how they are defined) of all of them. And even where those tantalizing pictures of trees and flowers are concerned—almost the largest single series, according to Miss Abbott[10]—at least forty are now in print, displaying almost as wide a variety of approaches as seems possible with such subjects. Furthermore, having been able to go through some five hundred of the unreproduced prints,[11] I can testify that though Atget was a genius, he took a good many dull pictures. (Indeed, even a number of the ones that *have* been reproduced are relatively dull.) And by now at least eleven editors have had the opportunity

[7] "Eugène Atget: Forerunner of Modern Photography," *U.S. Camera,* 1 (December 1940), p. 70.

[8] *Vision of Paris,* p. 22.

[9] To the ones named by Mr. Trottenberg at least the following mentioned by Miss Abbott in her introduction to *The World of Atget* (New York: Horizon Press, 1964) must be added: vehicles, interiors, courtyards, the Luxembourg gardens, Fontainebleau, the Seine and its bridges, farms, old signs, and towns around Paris (pp. xxiv–xxv).

[10] "Eugène Atget," p. 654.

[11] I should like to take this opportunity to express my gratitude for the helpfulness shown me at The Museum of Modern Art, the Bibliothèque Nationale, and especially the George Eastman House in the course of my researches.

to make selections from his unpublished work, and there has been a substantial amount of overlapping in their choices. All in all, then, I judge that we have a fair enough idea of the range and quality of Atget's work. It seems time to take some fresh bearings in it.

Miss Abbott has said of Atget's oeuvre that

> Here is the great demonstration that photography is a cumulative art. The effect upon the mind, emotions, and aesthetic sensibilities of the still photograph is due to the superimposition of image upon image, of idea upon idea. The pictures made by Atget with his camera are deposited layer upon layer on the consciousness. The final total is similar to the vast range of Balzac's human comedy, where his hundreds of characters move in and out of complicated relations and the specific action or event described is richer because the reader remembers other actions and events in which these men and women participated. Only with Atget's photographs, the direct sight is at last seen, in intimate impact with a city, a civilization with all its amplifications, an epoch of history.
>
> Atget's realm of creative effort was not, however, the human comedy or the human tragedy, but the miracle of the city he loved beyond words.[12]

That is admirably put. At the same time, though, it can hardly be stressed too strongly that photography is an art in a perfectly straightforward way, that a brilliant picture is a brilliant picture and a dull one a dull one, and that the kind of cumulative effect that matters most (as with Cézanne, Utrillo, Van Gogh, Toulouse-Lautrec, Piranesi, and other artists who have "documented" locales) is the accumulation of major images. Weak images do not add to strong ones, they subtract from them, for they dull the mind of the viewer. Well, it is plain that for all the breadth of his subject matter Atget was not equally interested in everything—interested creatively, I mean. On the whole his photographs of public buildings such as churches seem unremarkable aesthetically, for example; so do those of upper-class exteriors and interiors; so do those of unrelievedly squalid scenes without people in them; so do those of towns outside Paris; so do those of architectural details; and so do those of groups of people in the Paris streets taken in candid-camera fashion unawares. They have their own kinds of interest, of course, both as historical documents and as examples of Atget's unselfconscious professionalism in gaining a living

[12] "Atget: Forerunner," p. 76.

from clients who had no interest in photography itself as an art.[13] (Indeed, that professionalism, that concern with capturing *any* object as clearly and as respectfully as possible, was obviously fundamental to Atget's total freedom from the kind of artiness in photography that consisted in trying to approximate it to painting and that was embalmed during those pre-war years in so many of the pages of Alfred Stieglitz's periodical *Camera Work.*) Furthermore, Atget in fact took some very distinguished pictures of almost all the subjects mentioned in this paper so far. Nevertheless, when one goes by the degree of originality, iconographical richness, and formal brilliance displayed, his finest pictures fall preponderantly into the following main groups: pictures of unpeopled or virtually unpeopled Paris streets, *quais,* and courtyards; pictures of commercial establishments; pictures of vehicles; pictures of the great public gardens and parks; pictures of trees and flowers in close-up; pictures of petit-bourgeois interiors; and pictures of workingmen and -women posing for their portraits in the streets in the course of their work. Furthermore, there seem to me to be some definite relationships between those groups. I propose to concentrate largely on those groups and those relationships with a view to establishing certain cardinal points in Atget's vision of the city; and I believe that those points will remain firm, however much additional work by him becomes available to us.

II

That the less well-to-do areas in the city should have been on the whole the more inspiring to Atget seems easily enough explicable: the things in them bore far more marks of human use than those in the "better" neighbourhoods. Yet if the felt presence of the human is an essential feature in Atget's best urban photographs, it is noteworthy how nonexistent or minimal is the part played by actual people in many of those pictures, and I think that this paradox gives us a valuable point of entry into his creative intelligence. To explain that absence on technical grounds alone won't do.[14] Atget was, as I have said, a professional, and if he persisted

[13] "This is a partial list of professions to which he catered: designers, illustrators, amateurs of Old Paris, theatrical decorators, cinema (Pathé Frères and many others), architects, tapestry makers, couturiers, theatre directors, sign painters, editors, sculptors, and painters, among them Bourgain, Vallet, Dunoyer, de Segonzac, Vlaminck, Utrillo, Braque, Kisling, Foujita, and many more." Abbott, *World of Atget,* p. xx.

[14] The case for such an explanation is put best in Miss Abbott's two articles.

throughout his career in using a camera that was cumbersome, obtrusive, and relatively slow, it was plainly not because he couldn't afford one of the smaller and technically far better ones on the market but because it suited his needs very well. And if he did a good deal of his work in the early morning or at other times when empty streets could easily be found, it wasn't because his camera simply couldn't cope with people in motion. It could cope with them surprisingly well, as a number of his pictures testify. I am aware that, given his subject matter and the need for relatively long exposures, it was in fact more convenient for him to work when few people were around. My point, however, is that we should assume that Atget did exactly what he wanted to do and that it makes no sense to think of "this man of violent temper and of absolute ideas [who] had all the patience of a saint with his photographing"[15] as chafing for thirty years against the restrictions of an unsuitable camera. A more persuasive argument, accordingly, would be that his fifteen years or so as an actor before he took up photography had affected his way of seeing: his pictures do indeed, as Miss Abbott points out, "repeatedly suggest the stage setting which one beholds after the curtain goes up,"[16] and the sense that people will be using the various "entrances" and "properties" is a powerful factor in the humanized quality of the scenes. (There is nothing, in any pejorative sense of the word, theatrical about those scenes, of course.) However, I think that the explanation needs to be more complex. If one is intensely conscious of ordinary lives interpenetrating those temporarily empty streets and squares and rooms, I suggest that this is because one is conscious of being there in an "ordinary" sort of way oneself. And I suggest too that if Atget engaged only very marginally in the kind of "candid" work that one sees in many photographs from the 1890s and early 1900s,[17] this was because what he was engaged in seizing was not directly a peopled city but certain basic aspects of the city as they impinged on someone actually living in it in an ordinary daily way.

More specifically, what Atget seems to me to have been fundamentally concerned with was the city as a place in which one moves around, consumes things, seeks mental refreshment, and rests. And from this point of view the "candid" approach in which other people are caught in more or less interesting action can be in a sense irrelevant, or at least very periph-

[15] Abbott, "Eugène Atget," p. 652.
[16] Abbott, *World of Atget,* p. xx.
[17] See, for example, Paul Martin, *Victorian Snapshots* (London, 1939).

eral, the product of a very special way of looking (partly journalistic, partly derived from artists like Degas and Toulouse-Lautrec) in which the observer has screwed himself up to an abnormal alertness to other people's movements and expressions. Looking on, in other words, has replaced the kind of seeing that accompanies *doing,* and a sense of distance results. When Atget himself, even, takes a candid photograph of a horse-drawn omnibus at rest with two or three men on top, the conductor fiddling with some mechanism, and a bystander lighting a cigarette,[18] one's reaction almost inevitably is "Ah, a bit of Old Paris . . . quaintness . . . *la belle époque* . . ." and so on, rather than the immediate kinaesthetic sensation that here is an object that one might at any moment climb aboard oneself or that, like Stieglitz's superb Fifth Avenue, one might knock one down if one doesn't step back on to the sidewalk. Normally, however, it is precisely such a sense of the kinaesthetic and tactile that Atget gives us with unsurpassed brilliance, and especially with regard to the activities I named at the start of this paragraph. Let me give an example.

It isn't, I judge, mere chance that one of Atget's best-known pictures should be of a cheap boot or boot repair store with several rows of boots displayed on shelves outside it (V24, A7, C33). The picture is in fact one of those characteristically subtle ones of his, of which I shall be giving a number of examples in the course of this paper, in which the eye is immediately drawn to one feature ("What a funny lot of shiny boots!") but in which all the features in reality interact as natural symbols or epitomizations. The leather of the boots is supple and highly polished, bringing irresistibly into one's consciousness the feet walking in them and the hands shining them. Below them are the worn-looking stones of the sidewalk. Resting on that sidewalk side by side at one end of the shelves and reinforcing the sense of muscular effort with hands and feet are a cumbersome pair of wooden clogs and a battered garbage pail with the lid slightly off. At the other end of the shelves is a chair. And glimpsed through the one small window of the store is what is presumably the white-bearded and becapped owner of the store quietly eating his lunch.

[18] *Vision of Paris,* p. 43; *Camera,* special Atget issue, p. 16. In the rest of the paper I shall designate these two works by *V* and *C,* respectively; and I shall likewise designate by their initials Miss Abbott's *World of Atget* and her *Atget, Photographe de Paris,* preface Pierre Mac Orlan (New York, 1930). The bulk of Atget's best published work is to be found in these four items.

The subtle evocations of movement and rest are so thoroughly and naturally a part of the objects that to introduce the term *symbol* here at all, with its by now almost inescapable connotations of over-ingeniously imposed abstractions, seems almost like an act of treachery. But the facts are that Atget does again and again work in terms of the juxtapositions of natural symbols and that the total effect in the boots picture is a simultaneous apprehension both of the lives of other people animating those boots and thousands of pairs like them, and of one's own shod feet upon the sidewalks.

As I said, it seems to me not mere chance that a picture so central to the city experience—and especially to the pre-1914 city experience, as Céline's *Mort à Crédit* testifies—should have lodged itself in the minds of admirers of Atget, just as it isn't merely chance that Atget should be represented so exclusively by his urban pictures in brief samplings from his work. (It is still far from a commonplace that some of his nature photographs are as great as any we have, not excluding Edward Weston's.) There is indeed something peculiarly compelling about Atget's city streets that seems to place the viewer in them almost physically, and I believe that it is intimately related to his technical means. As I suggested above, there is every reason to suppose that Atget used the particular camera that he did because it suited him, "faults" and all; and the most immediately obvious of those faults are of course the tilting of the ground plane and exaggerated foreshortening that the lens produced. At times the distortion is quite wild; at others it is almost unnoticeable; but it is there to a greater or lesser extent in many of the street scenes that I have looked at, and there seems to me no doubt whatever that it was essential to Atget's way of seeing. What he got with it was the sensation of things advancing, receding, and moving to left and right of one in a way kinaesthetically closer to normal seeing than occurs with the so-called normal lenses that virtually all other major photographers have used. I strongly suspect that he may have received the impulsion towards it from Van Gogh's work,[19] especially since I suspect that he may also have re-

[19] See, for example, "Van Gogh's Bedroom," "Van Gogh's Chair," and "The All Night Café." The possibility should be allowed for, of course, that Van Gogh himself had been influenced by camera distortions. However, after postulating Atget's indebtness to him, I was delighted to come upon a small black-and-white reproduction of a painting of a tree done by Atget in the late 1890s (Leroy, "Atget et son Temps," p. 359). According to MM. Leroy and Martinez, Atget had very briefly tried to succeed as a painter before turning to photography; and the texture of this painting is pure Van Gogh.

ceived from Van Gogh the impulsion to document a whole region in depth, a sense of the rich significance of the "everyday," and a tendency to polarize things into either scenes empty of people yet richly redolent of them, or posed studies of representative individuals. But whatever the cause, the effect is a continual vitalization of the walking areas that he presents—those sombre courtyards diminishing sharply away from one, only to open up again with a doorway or staircase or a tunnellike opening offering a glimpse of sunlit street beyond; those streets narrowing sharply away after their openings have been punched dramatically in facades viewed more or less at right angles, or shooting up or downhill; those interminable *quais;* and most important of all, perhaps, in a number of pictures, the cobblestones and flagstones themselves whose lines if projected forwards would pass a foot or two *below* one's own feet, and hence subliminally draw one's attention to them correctively.[20] Furthermore, not only the streets themselves but the users of them get vitalized by the lens in a number of important pictures. In one of the best known, in which an itinerant lampshade seller is posed in the middle of a sloping cobbled street, the surface of the street seems to flow down to and past the observer, and one of the vendor's professionally indispensable legs, ending in a slipper whose texture contrasts ironically with the hardness of the cobbles, is also elongated towards the observer, so that the man appears to be half in motion and at work even while standing still (A66). (See too the poignant and perhaps even finer picture of a boy flower seller thrusting his wares towards the camera [V98].) The same effect of movement occurs with the slightly elongated wheels of most of the parked vehicles—cabs, buses, delivery carts, and so on—that Atget photographed in close-up; and a number of those vehicles get further vitalized by seeming to extend out of the frame towards one, so that one's consciousness of them as potential transporters of oneself or of things that one might be interested in becomes intensified.

And the centrality of the city streets and of movement on them, thus dramatized, points one straight towards the centre of Atget's apprehension of the city as a whole. It wasn't, I judge, simply a quest for picturesqueness, or a need for well-lit models, or even a professional empathy that led him to take a whole series of pictures of street vendors in his first year as a photographer (it is one of his greatest series); and it seems to me

[20] It is noteworthy how important a role is played by street surfaces (snow-covered, rain-washed) in four of the most memorable city photographs of Alfred Stieglitz.

fitting that the four that have been the most often reproduced should be those of a bakery woman with her cart, the lampshade seller, an umbrella merchant, and an organ-grinder and his singer—caterers, respectively, to the need for food, light, shelter, and entertainment. I am suggesting that what drew Atget to the vendors in the first place was an intuitive perception of them as agents and embodiments of vital city processes that he was to go steadily deeper into. Human essentials being made available for consumption, waiting to be handled, chosen, used in the public places provided, or carried away through the streets into rooms like those into which his camera penetrated—it is the drama of the city's bounty and plenitude that stands out above all in Atget's finest work, and it is a drama that is at once physical and spiritual. As Mr. Trottenberg has well said, "the bittersweet nostalgia so obvious in the work of . . . Atget is not primarily directed to buildings, streets and parks. It is, rather, concerned with the pulsation of life in a city which once had time to nourish its inhabitants in more meaningful relationships than obtain today."[21] Let me try to define that pulsation. It is not altogether a simple matter.

III

A basic feature of the present Camp fad, I take it, is that by way of a good many of the older works that are being revived one is able to return to a relationship with the mechanical that appears a simpler and happier one than is generally possible nowadays. I mean, at a time when the dominant image of the mechanical is becoming that of something *enclosing* one—paradigmatically the control room or computer room, with its plethora of switches, lights, and dials, its flatness, its seemingly infinite complexity where the layman is concerned—it is a relief to turn back to works in which the machine is straightforwardly and picturesquely *out there,* a sharply delimited object that one can set in motion and that will then behave interestingly. *Batman, The Green Hornet,* the mad-scientist movies of the 1930s, and so on are all, whatever else they may be, works in which the gadget predominates and the machine becomes *fun.* And it is no coincidence, I think, that there should be so strong a current revival of interest in those reputedly golden years of the early 1900s, since it was in them that society passed decisively out of the phase of industrialism in which the machine was preeminently the factory machine, the locomotive, the steamship—in other words rather awesomely large and perhaps

[21] *Vision of Paris,* p. 14.

semihostile, in the sense that the economic forces required to set it in motion were so vastly beyond the range of the ordinary man and often inimical to him—and into the phase of smaller and more easily manoeuvrable machines that were much more within the grasp of individuals, at least in imagination.

Yet when one turns to Atget, one realizes how little he was concerned with the sort of "modern" aspects of city life that one comes across when flipping through the pages of pre-1914 illustrated popular journals like the *Strand Magazine* or *L'Illustration*—and how wise he was in this, or at least in what kinds of oversimplifications he was avoiding. The genuine drama of mechanical speed and force is brilliantly captured in the handful of pre-1914 photographs by Jacques Henri Lartigue;[22] it is genuine, that is, in the sense that the drama is as much that of the glimpsed racing motorists and motorcyclists as of their vehicles. But the emptiness of a romantic concern with mechanical speed and force by themselves, as demonstrated notoriously in the work of the Futurists, needs no underlining here; and the way in which the general speeding-up of city rhythms could work on individuals in a fashion very much the reverse of creative and romantic is recorded unforgettably in *Mort à Crédit,* a work that can serve as a very salutary corrective to tendencies to idealize the *belle époque.* Furthermore, as soon as the city becomes conceived of in terms of mechanical force and energy, anyone who attempts to reassert "human" values is apt to fall into either or both of two inadequate antitheses. Either he opposes the natural, simple, and pastoral to the noisy and mechanical, or (in view of the ends to which the force and energy are generally put) he opposes the heroic and romantic to the sordidly mercantile; and either way he is almost inevitably going to be opposing the past to the present. It seems to me that Atget's astonishing poise, his continual voracious interest, curiosity, wholly unsentimental love and respect for so many different forms of existence, his Rembrandtesque ability to treat in exactly the same spirit the conventionally beautiful and conventionally sordid issued from the fact that in *his* approach to the energies of the city he was able wholly to avoid these dichotomies. A good starting point is certain pictures in which he himself took explicit cognizance of what may be called the pastoral and heroic ideals.

A number of his photographs of the great formal gardens in and near

[22] See especially *The Photographs of Jacques Henri Lartigue,* introd. John Szarkowski (New York: Doubleday & Co., 1963).

Paris could in fact be cited (e.g. W38, W68, A31), but there is one that seems to me to epitomize almost all of them and to be one of Atget's most glorious materpieces. It is of an elaborately carved urn at Versailles (C34), taken from slightly below centre and from so close up that the top curve of the rim and the bottom curve of the base are largely cut off. On the side towards the camera the face of a sun-god in strong bas-relief stares out over our heads, framed by twined and leafy stone branches; his hair flames outwards, light rays stream out beyond it, the face is super-humanly pure, calmly certain of its strength, slightly contemptuous, un-pitying. On the right side of the urn, in profile against a blank sky and somewhat below the god, is the head of a ram or goat, with massive horns curving round in an almost complete circle; its Semitic, slightly demonic, yet likewise wholly self-assured and calm countenance hangs broodingly over the out-of-focus blacks and whites of a formal walk, a fountain basin, the end of a dense row of trees, all in dazzling sunshine. To the left of the urn is the almost total darkness of undifferentiated foliage. In its tension between Apollonian and Dionysiac energies, its celebration of light and its reminder of no less natural darkness, its seizing on energies made all the stronger through art because embodied in cool and orderly forms, and its juxtaposition of, on the one hand, natural things (the trees, I mean) rearranged by art and then overwhelmed by the natural force of light, and, on the other, the symbolical representations of natural things and forces that, in the crispness of the uneroded carvings, appear almost *super*-real, the picture seems to me one of the most brilliant succinct elu-cidations that we have of what may be called, loosely, the neoclassical ideal—an aristocratic ideal in which the heroic and the pastoral are al-most inseparably intermingled. But more than merely something that is past is involved. The urn, the statuary, and fountains and ornamental trees in the other photographs, and the great parks themselves, are avail-able still to the ordinary stroller, and not only testify formally to human yearnings for ordered energies and energized calms but also help to pro-mote such yearnings. And not only that: the transforming and shaping power of the photographs themselves serves to recall that there are other ways in which those cravings can find expression and promotion. Let me now turn back to Atget's photographs of the city.

Where more or less straightforward, untransposed pastoral and heroic forms (often intermixed) are concerned, one has a plethora of examples

in Atget's work: classical faces and figures surmount windows and door-ways, flowers intertwine in Art Nouveau, rococo, and even Gothic orna-mentation, horses rear up magnificently above rococo circus facades, a deep military drum looms over the doorway of a restaurant, a puppet show holds children rapt in the Tuileries gardens, and so on and so on. It is noteworthy, too, how Atget at times calls our attention to straightfor-wardly rural forms persisting in the city (an automobile and motorcycle emphasize by contrast the low-slung rustic-looking architecture of a courtyard), or dramatizes a rural object in such a way as to lend it heroic proportions (wooden ploughs look like field guns, a timber-wagon takes on an ominously martial air), or shows more or less straightforward yearnings for the rural in the city (a top-hatted cabby, brass buttons on his topcoat, trousers falling over incongruously heavy plebeian boots, pauses in front of a flower stall). But interesting as a number of these pic-tures are collectively as testimonials both to the persistence in the city of certain older forms and to the cravings of ordinary people for reminders of the rural and for more dramatic and artistic enlargements of their horizons, individually they seem to me among Atget's less memorable ones aesthetically. I suggest that it was when the forms had become the most thoroughly assimilated into and marked by ordinary lives that Atget's creative energies were the most fully aroused. And the resulting pictures, both singly and juxtaposed, can take us a good deal further into Atget's handling of the commercial. . . .

VI

This brings me finally to Atget's handling of people. If I have lingered over the street-corner picture, this is partly because in it a certain stiffness of line, sharpness of detail, and explicitness of form predominate in the buildings and are emphasized by the symmetrical composition and the evenly distributed light from the grey sky. The picture, as I have said, is replete with life, but it is obvious that this sort of urban scene, stripped of certain elements, could become oppressive and anti-human, and a num-ber of Atget's pictures of people or their surrogates seem to touch on this possibility. It is especially tempting to take a tip from those haunting images of store mannequins that caught the eyes of the Surrealists and were among the earliest of Atget's works to be reproduced. There is, for instance, the famous single figure displaying workclothes between cases of cheap shirts and dental items (A26)—headless, handless, its sleeves

hanging down limply, its feet mere shiny black wood and turned in upon each other in a slightly crippled-looking way, its waist cinched in tight by a very wide leather and canvas belt faintly reminiscent of straitjackets, its neck circled incongruously by a stiff collar. Or there is the equally well-known one of the better-class store window in which three impeccably dressed male mannequins in the upper half of the picture have been dissolved among the reflections on the window into little more than disturbingly individual faces (hopeful, sly, pensive), while below and in front of them bulk, successively, a much more solid *headless* figure and a row of neatly draped and labelled striped trousers running the width of the picture (W14, A79, C28). Or there are the slightly inane bewigged female faces lost among the shadows and reflections in the window of a ladies' hairdresser, or the menacing row of headless, white-jacketed figures, with a headless waiter in the centre, massed against the spectator, or the rigidly corseted hour-glass-shaped busts in another well-known picture (respectively, V51 and A80; V27 and A77; V49, A76, and C29). In other words, there would seem to be intimations enough in Atget's work of the fact that "heroic" city formalism and artificiality, if they enlarge existence in some ways, can also lead to their own kinds of entrapment, constriction, and dehumanization.

And where photographs of actual people are concerned, the ones of prostitutes would seem to contain some especially sharp and ironical juxtapositions. A gleaming handsome housefront, its lower-story windows all leaded stained-glass squares, its street number enormous between the two upper-story windows, runs the whole width of a frame, and it is only after a minute or two that the mind registers that the small white figure in the doorway to the far left is wearing a thigh-high white dress and little-girl white socks, that she is in fact no little girl at all, and that another woman, who is probably the madam, is leaning casually on the balustrade of the window above her (W123, A63). In another picture an elegantly dressed woman sits meditatively on a chair in a corner of a slum courtyard; heavy flagstones are underfoot, the doorway to her left in the grimy walls is black and sinister, bars stand in front of the tiny glimpse of sky in the extreme top left corner (W124, A62, C37). In a third, and one of Atget's finest, the juxtaposition of elegance and the tarnished is reversed again (V110, C39). The fifteen feet or so of windowless facade that occupies most of the frame consists of dark, massive, classical wooden

panelling, with a portico over the high central doorway; the curbstones and cobblestones that occupy the rest of the frame are massive too, the overall impression of strength in the *things* in the picture being intensified by the sharp oblique sunlight and a considerable lens distortion; and posed in the middle of the doorway is the only object with soft outlines, the slightly diffident figure of a prostitute in knee-high white dress and worn-looking boots over little-girl socks. Her hair is frizzled, her mouth seems painted askew, her nose (but this may be a distorting effect of the sunlight) looks as if it had been broken and slightly flattened, a worn-looking fox fur hangs round her neck, its strangely animated head resting on her forearm. This is the picture to which Atget gave the expressive title "Versailles."[23]

Yet it is still the balancing of forces that must be insisted on. Miss Abbott seems to me quite right when she says that "the material presentment of life so entranced [Atget] that he did not enter into satire or social criticism. He had a task large enough to re-create the whole visual world of Paris in photographs."[24] And in his treatment of people Atget seems to me no more a social critic than was Rembrandt. Even where the pictures that I have described are concerned, there are other elements that must not be overlooked. In the picture of the gentleman-mannequins, for instance, its peculiar richness and fascination derive from the dominant sense of *life* in it. If there are solid and rather inhuman-looking trousers at the bottom of the frame, at the top and overlaying the mannequins are the hardly less solid-looking reflections of the sky, a tree, a street front dominated by a neoclassical building; and if two of the faces have the kind of slightly suspect, smiling painted animation of early 1920s movie heroes, the third, turned away from them, is sensitive, meditative, wholly natural, and individual. Again, in the corset picture a corset on a bust hanging in the doorway (animated associatively by a blurred garment swinging free below it that in fact sets the key of the whole picture) opens downwards like the bell of a strange flower, while empty corsets in a row at the bottom of the window are spread out like seaweed or polyps, and tightly folded ones in the window to the left of the doorway seem strange abstract shapes carved in wood or plaster. And in this strange world of metamorphoses, its strangeness intensified by the blackness out of which

[23] Leroy, p. 8.
[24] Abbott, "Atget: Forerunner," p. 76.

these forms emerge, there is even a sort of dignity in the poised central bust, while three tiny photographs of fashionable ladies in the window recall that the elegance aspired to is not necessarily the less real because of the grotesqueness of the means used to attain it. Again, where the series of prostitutes is concerned, two more pictures should be mentioned (respectively, C37, V93).[25] One is of a couple of figures posed casually in a doorway, he a youngish soldier in undress uniform and cap, legs comfortably crossed, hand on hip, face moustached and good-humoured, she in a short, white, simple housedress, the door slightly ajar behind her, a faintly diffident half smile on her youngish-looking, unmade-up face. They are completely real and individual beings, posing for the camera in the course of a normal relationship. So are the three handsome, dark-haired, middle-aged "girls" in the second of the two pictures, posed in a doorway in a comfortably neighbourly fashion like three housewives who have been visiting each other. And even the other prostitutes and/or madams that I have mentioned have likewise posed for Atget, and been taken in a way that enables them to be there simply as individuals, not "types," viewed without indignation, contempt, sentimentality, or fuss of any kind.

And the same disinterested respect for identities informs Atget's better-known pictures of individuals in more reputable trades. Great portraiture, whether formal or informal, is almost certainly no easier in photography than it is in painting (the genre seems to me to be to photography what drawing is to the other graphic arts, namely the form in which faking is least easy), and one of the glories of the art is that it has given us the finest portraits of Mathew Brady, Julia Margaret Cameron, Paul Strand, Alfred Stieglitz, Walker Evans, Berenice Abbott,[26] Dorothea Lange, Henri Cartier-Bresson, and others. But there would seem to be special temptations for the photographer in the way of producing too obviously controlled a response. Dorothea Lange's individually moving but collectively all too uniformly decent, careworn, undeservedly suffering sharecroppers are obvious examples of this;[27] so, in the opposite direction,

[25] The series, it can be added here, was apparently commissioned to illustrate a book on prostitution by the painter André Dignimont. So far as I have been able to discover, the book never appeared.

[26] Miss Abbott's own superb portraits of Atget himself must of course be mentioned at this point.

[27] See Dorothea Lange and Paul Schuster Taylor, *An American Exodus* (New York, 1930).

are the grainy vacuous monsters of too many of Frank's pictures. Again, just as Cartier-Bresson when his genius flags tends to fall into a Family-of-Man cuteness or quaintness or slightly spurious "warmness," so Strand, in his ruthless eschewal of precisely that sort of thing, has too often imposed a glumness on his subjects that is even more irritating because done with such obvious deliberation and conviction.[28] With Atget these kinds of falsification don't occur. His subjects are simply *there,* taken in their professional clothes and for the most part engaged in the pursuit of their professions, sometimes smiling, sometimes pensive, occasionally a shade odd (like the little umbrella merchant, black-coated and hatted in the hot sunlight), or even, like one or two of the prostitute/madams, a shade sinister. And as far as the main emphasis goes, these are plainly not people entrapped and distorted by the city. As Miss Abbott puts it, "human dignity is expressed in each and all" of the pictures.[29]

Two pictures stand out especially in this respect. The first seems to me one of the unquestionable masterpieces of twentieth-century art, for all its relative simplicity and immediacy of impact. Heavily whiskered, middle-aged, expressionless under a shabby hat, a street musician stares towards the camera from behind a little street piano (W49, V116, A20, C24). His right hand blurs slightly as he turns the handle, his left hand rests on the other corner of the machine, and against or on that hand rests the hand of his tiny, long-skirted, black-scarved singer, who is gazing upwards, head thrown back, mouth half-open as if in song. Their clothes are heavy looking, redolent of dirt and perspiration; the man is not especially prepossessing, the woman is almost a midget; the positioning of the wheels of the piano emphasizes the travelling they do, the oilcloth cover on the piano recalls the weathers they face, and the bourgeois facade behind them is not hospitable. Yet the expression of radiant, exultant happiness and pride on the woman's face is unequalled by anything that I can recall in art except the closing shot of Marlene Dietrich in Sternberg's *Scarlet Empress;* and, with the incongruity in ages, yet manifest closeness of the couple, the picture seems to me one of the greatest pictorial images of *love* that we have. The second picture is even more relevant where the

[28] For the mingled benefits and drawbacks of Strand's approach, see especially *Un Paese,* test by Cesare Zavattini (n.p., 1955). Several of the portraits in it are masterpieces.

[29] *World of Atget,* xix.

essential preoccupations of Atget that I have been trying to trace are concerned (V79, C25). A working girl and a youngish street vendor or porter are standing talking in a courtyard, taken in profile, he capped and with a basket strapped on his back, another in his hand, she in an ankle-length long-sleeved black dress with a coarse-looking apron over it. (A couple of similarly attired older women look on from the right; it is, one guesses, a brief break from work.) The sunlight falls intensely on the scene, blotting out with its brightness most of the lines between the paving stones. The wickerwork of the basket on the man's back and the side of his head are crisp in the light, but shadow hides his eyes and a drooping moustache conceals whatever expression his mouth may have. The girl's face, in contrast, is framed against a black doorway in the rear of the courtyard, and in contrast with her formal-looking dress it is incongruously youthful. The opportunities for irony are obvious, but they are not taken. The two figures stand relaxedly, self-confidently, she a little taller than him but perfectly poised and very feminine, he very masculine, the two of them meeting as individuals and equals—and doing so, obviously, to a considerable extent *because* of the city trades whose ostensibly trammelling insignia they wear. It seems appropriate, too, in view of Atget's general emphasis on enlargement, enrichment, and nourishment in the city, that stretching in pleasantly flowery, slightly out-of-focus tall letters across the whole width of the rear wall of the courtyard above the couple's heads is the word *Dégustation*.

VII

Yet distinguished as are Atget's portraits, it is not really paradoxical that his subtlest and richest evocations of individual lives in the city should come by way of studies of the inanimate; I mean, of domestic interiors. Such studies are not as common in art as they deserve to be—indeed, there seem to be few of the first order to set beside those of Van Gogh and Bonnard—and a special kind of alertness would seem to be required for them. What has to be sensed by the artist, I think, is both the peculiar kind of triumph that the domestic mundane can represent and also a larger cultural dimension. As to the latter, I have touched already, apropos of that much beflowered interior by Atget, on the way in which a room can be simultaneously an expression of its occupants and (by way of the artifacts present in it) a revelation of cultural forces that have

helped to make those individuals what they are; and what an alertness to this sort of thing can result in, we have the brilliant photographs of Evans in *The American People,* as well as Atget's own, to remind us. But it is the other aspect that concerns me now, the aspect that is missing altogether from that book by Evans. When one turns to Atget's kitchens and bedrooms and dining rooms, it is the moral beauty and blessedness of *order* that speaks out in them, however humble the objects or incongruous the juxtapositions. In Atget's presentation of them, a cooking stove with an earthenware casserole on it can cohabit perfectly decently with an ornament-laden mantelpiece above it and a bed adorned with an elaborate lace coverlet; worn boots and a slop pail with the lid off can stand on a shelf under a wooden wash table and clothes hang jumbled on top of each other on nearby hooks without squalor and without any undercutting of the elegantly framed pictures on the wall; a concatenation of elaborately flowered wallpaper, a worn brocaded armchair with used clothing on it, a six-inch tasselled frieze hiding the rim of a knickknack-covered mantelpiece, a pair of old boots under the chair, and an alarm clock high on a shelf doesn't invite one's amused patronage or wincing away from a persisting badness of design. In all three of the pictures that I have just mentioned (respectively, A12; A64; W20 and C18), the elegant or would-be elegant items inspire one rather with a sense of their loved meaningfulness and life-enriching qualities for the rooms' inhabitants, the aesthetic incongruities keep before one's eyes the individually *made* ideals of domestic harmony and security embodied in those rooms, and the minor untidinesses remind one both of the human tendencies towards chaos that have in fact been held in check here and of the fundamental human activities that the rooms facilitate. And where those activities are concerned, the lovely chiaroscuro effects in a number of other pictures seem especially charged with significance. In a picture as lovely as any of Chardin's, light picks out a basket of loaves and groceries in a corner, a dresser top covered with cooking items, and dishes and folded cloths on a table next to it, in a symbolic juxtaposition of the raw materials, the means of transformation, and the place of consumption. In another, an elegant bed emerges like an island from a darkness that fills almost the whole lower half of the frame and surges part way up the majestically swelling coverlet (the three mentioned here are, respectively, A4; W19; W91 and A15). In another again, a bourgeois dining table set for one person blazes out of

the semi-darkness and is echoed by a handsome lampshade overhead, embroidered with heroic figures. The whole complex of crisply defined wine bottles and wicker bread basket and other "commonplace" items on the table, awaiting whoever will come through the door in the background, stands there as something which, though transitory and easily disruptible in itself, yet has behind it a whole powerful structure of values and activities making possible a civilized decency. And in all of the photographs that I have mentioned in this paragraph is discernible that mingling of heroic and pastoral elements that I have tried to elucidate in this paper. I shall not, however, enlarge on that point. I will simply suggest that, if I am right about Atget's indebtedness to Van Gogh, it is worth remembering that behind the latter stands the whole Low Countries tradition of painting, and that in that painting at its greatest, as in Brueghel and Vermeer and Rembrandt, one sees likewise a loving elucidation of the mundane that both brings out its heroic aspects and permits a harmonious fulfillment of the heroic aspirations of the artists. And even if I am wrong about the indebtedness, the parallel still stands.

There is one last picture that I wish to describe, since it can stand as a summation of so much that I have been saying (W135, C36). It is of the exterior of a ragpicker's shanty on the outskirts of Paris, in one of the poorest of all the areas of the city. The shanty almost certainly consists of only one room, and at its peak can be scarcely over eight feet high. Junk leans against one side, the walls are a patchwork of odd-sized planks and bits of canvas, the ground in front, trodden flat, is stony and barren-looking. A folding chair of the sort that one finds in the great public gardens stands in front of the open door, while inside the doorway is discernible a battered, rustic-looking milk can. To judge from the lighting, the square aperture in the front wall of the shanty is the only window, and probably is unglazed. Immediately below that window, however, is a small window box, and from the front of that box a number of strings run up to the wall above the window. A species of vine climbs up them. Above the level of that window, furthermore, at least twenty toy animals and dolls, salvaged presumably from some nearby dump or collected in the course of the owner's daily scavenging in the city, have been nailed in baroque profusion over the whole face of the wall. Just below the peak of the roof, too, is fastened a large stuffed bird, with one of its spread wings pointing sky-

wards. And on the front edge of the roof itself stand yet more animals, the uppermost one of which likewise gazes skywards. To complete the picture, standing on the surprisingly tidy ground at the corner of the house nearest the camera, is a pair of old boots. The picture as a whole is not remarkable formally, but that is beside the point—or rather, in a sense it is very much to the point. The very fact that the dwelling place itself has been so evolved and organized that no special selecting by the camera is required to bring out its symbolisms makes it an especially valuable—and moving—epitomization of those basic needs and aspirations that, in Atget's vision of it, have gone into the making of the city and that in one form or another continue very properly to seek outlets there.

Atget and Man Ray in the Context of Surrealism (1976/77)*

John Fuller

John Fuller's comparative study of Man Ray and Atget fills a gap in the literature on both artists. His discussion of their Surrealist affinities helps explain their different involvements with photography. Other literature on Atget mainly focuses on problems of biography and dating, and the writing on Man Ray only sketches his interests in photography.

John Fuller is associate professor of art at the State University of New York at Oswego.

Both in their lives and in their productions, the Frenchman Jean Eugène Auguste Atget and the American Man Ray are at poles, for one lived a nearly anonymous existence and practiced straight photography, while the other enjoyed fame and pursued experimental imagery with and without camera. Atget's avowed objective was to produce only documents, while Man Ray deliberately sought something beyond the type of representation associated with the photographic process. Yet, Man Ray collected Atget photographs and got several of them published in *La Révolution Surréaliste,* the first official review of the Surrealists.

Atget, whom Ray described as "almost naïve, like a Sunday painter," told him, "Don't put my name on it," referring to one of the photographs for publication.[1] Atget's strange wish for anonymity—a virtue from the standpoint of Surrealism—kept him essentially unknown except to artists, theatre people, and others who purchased his photographs for documents, but after his death, largely through the efforts of Man Ray's former assistant, Berenice Abbott, he has achieved a position that rivals, if not surpasses, that of Ray as a photographer. Man Ray has been thought of as an "experimenter" and, therefore, somewhat outside the mainstream of early twentieth-century fine art photography, but today he appears a forerunner of much of the current photography that bypasses the tradition fostered by Stieglitz.

Man Ray, a neighbor of Atget on the rue Campagne-Première in the

* Reprinted from *Art Journal,* 36, no. 2 (Winter 1976/77).
[1] Paul Hill and Tom Cooper, "Man Ray," *Camera* (February 1975), p. 40.

1920s, takes credit for discovering him and describes his contact printing process by daylight from glass plates 7 inches by 9⅜ inches. Ray claims the prints were like proofs which faded, since Atget fixed them in salt water.[2] Abbott, however, talks of Atget's fine-quality prints on "printing-out" paper, probably gold chloride,[3] which gave richer tones than the bromide papers Ray urged Atget to adopt. Ray found most of his thousands of prints uninteresting, but acquired thirty or forty which he later gave to the George Eastman House Collection. He says, "They're the ones that have been the most reproduced, because they have a little Dada or Surrealist quality about them."[4] Leroy and Abbott have likened Atget to a "Douanier" Rousseau and a Balzac, but Ray is much more reserved, saying, "I don't want to make any mystery out of Atget at all. He was a simple man and he was using the material that was available to him when he started around 1900. An old rickety camera with a brass lens on it and a cap. He'd just take the cap off and put it back."[5]

World War I slowed the demand for Atget's work, and by January 15, 1925, when *La Révolution Surréaliste* published his photograph of a circus wagon showing a muscleman sticking his bald head between the pried-open jaws of an alligator, this sometime painter and third-role actor was a sick old man with little money. The following year this Surrealist review published photographs of a corset shop, "Versailles" (a prostitute), and a crowd watching an eclipse, but it was also the year his wife died. Leroy tells of Atget's mind wandering, his drinking, and finally his death at seventy years of age on August 4, 1927.[6]

Photography was a good source of income for Man Ray, who photographed works of art, artists, celebrities, and fashion models. His photographs, often given away to fellow artists and writers, commanded high prices from editors, and his camera gave him entrée into the rarefied Parisian art-literature-social world. Commercial photography permitted him to paint and to live stylishly, though he could admit, "But I had already compromised myself with my photography in spite of some efforts to pull it out of the bread-and-butter or cheesecake limits."[7] These efforts

[2] *Ibid.,* p. 39.
[3] Berenice Abbott, *The World of Atget* (New York: Horizon Press, 1964), p. xxviii.
[4] Hill and Cooper, p. 39.
[5] *Ibid.,* p. 50.
[6] Jean Leroy, "Atget et son Temps," *Terre d'Images* (May–June 1964), p. 370.
[7] Man Ray, *Self Portrait* (Boston: Little, Brown, 1963), p. 198.

beyond the hackwork included the photograms he called Rayograms and "solarizations," although certainly his unusual lighting effects and posing of subjects raised much of his commercial work above the routine.

His photography, credited or not, appeared throughout *La Révolution Surréaliste,* and in the later review, *Le Surréalism au Service de la Révolution,* several notable photographs are reproduced full page, including a "solarized" reclining nude "Primacy of Matter Over Mind," in number 3, December 1931. Also in the number 5, May 1933, issue of this publication is his closeup photograph of buttocks around which have been drawn thin black lines to represent an inverted cross; the mixed-media work is titled "Monument à D.A.F. de Sade," which, perhaps, reinforces the claim that the marquis was Man Ray's hero.[8] In the late 1930s and early 1940s, when the Surrealists collaborated with Albert Skira to produce the lush review *Minotaure,* Man Ray's work was frequently featured, including portfolios such as *Aurore des Objets,* in number 10, 1937. By this time other photographers relatable to Surrealism were frequently included in *Minotaure,* such as Raoul Ubac, who explored "solarization" and photocollage, and Brassai, who provided a nighttime view of Paris. Such recognition given photography among the arts was rare for that period, a time when Stieglitz in America was still fighting the cause of photography as art.

Man Ray did make some attempts at street photography; the George Eastman House Collection has two of his street scenes, printed soft on bromide paper about 11 inches by 14 inches. One shows a rainy street lined with autos and a man semisilhouetted in the extreme right foreground looking toward the Vendome Column, which is positioned at the extreme upper left. Sunlight barely penetrating the clouds gives a soft backlighting which makes water bubbles on the street sparkle. The other untitled street scene seems to have been timed to record a somewhat triangular composition of three figures walking. Both works, however, suggest the type of efforts that serious amateurs in the 1930s and 1940s submitted to camera club salons, and it is by such images in comparison that we can measure the strength of Atget's vision.

Man Ray, then, is a studio photographer, a manipulator of lights, people, objects, and photographic materials, rather than a photographer who

[8] Roland Penrose, *Man Ray* (London: Thames & Hudson, 1975), p. 160.

discovers fragments of reality on the street and transposes them into visual experiences that go beyond mere recording. There is also a close interaction with the other media in which Ray worked, and he wrote, ". . . I photographed as I painted, transforming the subject as a painter would, idealizing or deforming as freely as does a painter."[9] In regard to painting and photography he claimed,

> There was no conflict between the two—why couldn't people accept the idea that one might engage in two activities in his lifetime, alternately or simultaneously? . . . I had declared flatly that photography is not art, publishing a pamphlet with this statement as the title, to the dismay and reprobation of photographers. When asked more recently if I still held to my opinion, I declared that I had revised my attitude somewhat: for me art is not photography.[10]

This revised statement makes photography more compatible with Surrealist thought, which opposed Art on the grounds that Art was too dependent on acquired technique. Artists had long vilified photography because it did not require the skill of the hand and was merely mechanical. Man Ray said, ". . . photography, after all, is nine-tenths mechanics and requires closer calculation than to paint and the result is more 'retinean,' as Duchamp would say."[11] This mechanical element does not seem necessarily detrimental from a Surrealist standpoint, and it would appear to be equatable with "automatic writing," so that the photographer could, if inspired, function more as a medium than as a mechanic. This would seem to be supported by Max Morise writing in the first issue of *La Révolution Surréaliste:* "What surrealist writing is to literature, a surrealistic plastic expression must be to painting, photography and everything which is made to be seen."[12]

Atget's and Ray's divergent approaches and philosophies, which seem to find a link within Surrealist theory, can be demonstrated through a Man Ray "Self-Portrait" and an Atget photograph, "Austrian Embassy, 57 Rue de Varenne," which may be considered a form of self-portraiture.

[9] Ray, p. 143.

[10] *Ibid.,* p. 227. See "Photography Is Not Art," pp. 236–245.

[11] *Ibid.,* p. 222.

[12] "Ce que l'écriture surréaliste est à la littérature, une plastique surréaliste doit l'être à la peinture, à la photographie, à tout ce qui est fait pour être vu." Max Morise, "Les yeux enchantés," *La Révolution Surréaliste,* no. 1 (December 1, 1924), p. 26.

Ray has used the Sabattier effect, which he calls "solarization," describing it as ". . . a process of developing by which the contours of the visage are accentuated by a black line as in a drawing."[13]

The alteration of tone, seemingly at random, greatly reduces detail so that the forms are accentuated and the planes are compressed. Unlike another version, three-quarter length, this one is cropped closely so that back and top of head, as well as part of the large camera lens, are bisected by the picture's edges. His face in profile close to the camera adds to the compression, which is relieved by open space defining almost a rectangle in the upper left of the photograph and an irregular negative space of softly modulated tones below the chin. A form, presumably a finger, rests on the bottom of the lens and directs the eye to the face.

Countering this claustrophobic scene, without the Rembrandtesque lighting of much portraiture, is the play of reflection on the lens, which suggests not simply a photographer's floodlights but some planetary bodies orbiting in space. The cosmiclike relation of tones and shapes on the "eye" of the camera and the Sabattier effect, which dematerializes the bellows and back of the camera and finger, are not highly controllable phenomena. Their effect is to elevate a rather standard pose for a photographer imaging himself into shapes that suggest dematerialization and spatial ambiguity.

Berenice Abbott made a sensitive portrait of Atget shortly before his death, but somehow the study he made of his huge camera aimed toward a mirror-lined fireplace at the Austrian Embassy tells more about the man than any conventional record of his face. The ominous shroud he used for focusing seems at first to encompass the photographer, but a closer study suggests the man has stepped aside during the exposure. Amid this expansive rococo salon the dark, simple camera and the heavy folds of drapery intrude upon a scene that emphasizes the curves, lightness, and elegance of the decor. The camera is in occult balance with a highly ornamental clock, and while both mechanisms are involved with time, the more somber, Cyclops-like machine seems more potent with myth than the clock, festooned with a cupid atop a shell-motif canopy. In a sense two cultures are juxtaposed, the eighteenth century with its clockwork universe still filled with frivolous putti and heads of classic gods, and the modern world with its instrument for capturing light and time.

Atget photographed another mirror-lined fireplace, but he was careful

[13] Ray, pp. 219–220.

to position his camera at an angle, so there is no trace of the machine. The mirror, instead, shows five chairs clothed with slipcovers and arranged as though engaged in conference. Visually present or not, Atget manages to leave his imprint on so many of his pictures that the term *document* seems an inadequate definition for such images that time and again take us to the other side of the looking glass.

Even on the contents page of *La Révolution Surréaliste* for June 15, 1926, an uncredited Atget photograph of a crowd watching an eclipse has all the basic characteristics of a news photograph, which quickly communicates the occasional ritual of viewing the sun through smoked glass. The camera is placed on the sidewalk and is aimed about eye level at the group; a curved stone railing appears on the right, and left of center is a streetlight, while office buildings are visible in the background. Yet Leroy describes this "document" as follows: "The surrealism of certain views still surprises, as in two particularly known photographs, one of a crowd at the base of the Juillet Column looking at an eclipse with smoked glass. . . ."[14]

In line with the crowd's gaze is a darkened, curved shadow area in the upper left, which has been rather obviously dodged out in the black-and-white prints produced by Berenice Abbott as *20 Photographs by Eugène Atget, 1856–1927,* in 1956. In the original print the vignetting effect of Atget's lens barrel works to advantage, for it seems to emphasize the fact that some two dozen people are looking through virtually opaque glass to see what will appear to be a black sun, an image which is appropriate to Surrealist sensibility. In the review the Surrealists titled this photograph "Les Dernièrs Conversions."

Man Ray makes a deceptively simple statement suggestive of universal forces, and perhaps their control, through not including people in a Rayograph of a gyroscope and magnifying glass against a black field. The motion of the gyroscope pattern as it rides a thin white line is charted by its shadowy replica, which flaunts gravity above the dominant image, while the magnifying glass serves as a steadying force, a compass with pointer (nail) on the North-South axis.

There is an important distinction between the forms in this image and those in the Atget, for the latter are produced by light rays reflected from

[14] Le surréalisme de certaines vues suprend encore, deux sont particulièrement connues une foule au pied de la Colonne de Juillet regardant une éclipse avec des verres fumés . . . ," Leroy, p. 369.

the objects and gathered by a lens onto sensitive material, whereas with the Rayograph an opaque or translucent object has blocked light directly from exposing the sensitive paper. In this cameraless image we have a light tracing of objects, or what Alexandrian calls "the first 'nudes of objects' in the history of photography, possibly in the history of art."[15]

While other twentieth-century photogram makers, such as László Moholy-Nagy, Christian Schad, and Francis Bruguière, explored this cameraless imagery, this technique can be traced to early explorations of image-making with light-sensitive substances, including those experiments of William Henry Fox Talbot (c. 1839). Ray, however, seems to be the one who has carried this process further to achieve a sense of depth and mystery through variance of tonal relationships, and with the exception of Bruguière, the others' results seem more clinical. Thus, Alexandrian finds that "in each rayography, Man Ray demonstrates that he is the scrupulous interpreter of the secret life of objects, the confidante of their inmost thoughts, the observer of their naïve ambitions, the arbitrator of their conflicts, the witness of their platonic love affairs with the beholder."[16]

Alexandrian's generous response to these images certainly links them to Surrealism, but it should be recalled that Tristan Tzara saw the first results of Ray's accidental "discovery" and pronounced them pure Dada. These Rayograms led Tzara to joint experiments with Ray in this medium but while Ray created geometric forms, Tzara's imagery included broken matches and actual burned holes in the photographic paper.[17]

Ian Walker apparently considers all the Rayograms as Dada, for he writes, ". . . the mere physical fact that the paper is turned black provides an ironic Dadist joke; light can create nothing but darkness."[18] It seems reasonable, however, to consider Tzara's nihilistic approach to photograms along with Ray's simple, humorous, anthropomorphic Rayograms as Dada, while grouping Ray's more constructive fantasies of tonal modulation as Surrealist in spirit, even when they were created prior to the "Manifesto" of 1924.[19]

[15] Sarane Alexandrian, *Man Ray* (Chicago: J. Philip O'Hara, 1973), p. 26.
[16] *Ibid.*
[17] Ray, p. 129.
[18] Ian Walker, "Man Ray and the Rayograph," *Art and Artists* (April 1975), p. 41.
[19] The Rayographs considered in this paper are from the period 1921–1928. In 1922, Man Ray produced an album of Rayographs called *Les Champs délicieux,* to which Tzara wrote the preface.

Ray's photogram of the gyroscope and glass has lost much of its original mystery through so many academic repetitions of this basically simple image-making process. An image still fresh is a Rayograph showing a cube form turned on edge, near the bottom center, so that it seems to balance a scene of shadow play above. Elongated black spots merging to form black streaks toward the top of the print suggest the spots from dice, somehow separated from their cube and moving across a cloud-covered sky, as though searchlights were projecting these images to create Futuristic effects.

A reading of the upper field of this print as "sky" is reinforced by the undulating forms silhouetted against a band of white which strongly suggests city lights and the outlines of buildings at night. Ray made a sharply focused night scene of an equestrian figure and a brightly lit obelisk at the Place de la Concorde, while this photogram suggests the type of scene in which the photographer has unsuccessfully attempted a long, hand-held exposure. While the work functions as pure form, there is an underlying sense of motion, drama, and night which conveys the idea of city life. Of such images Tzara could write, "These are projections surprised in transparence, by the light of tenderness, of things that dream and talk in their sleep."[20]

Atget's photography could not feasibly manage the long exposures required of night photography, yet his street scenes are often "surprised in transparence." Atget positions his camera before a store window showing a chest of drawers piled with shoes, chairs, and pictures hanging in dark space. One unlit electric bulb seems to float above this balanced but unnerving scene. Atop the gaudy, rose-painted chest, there are two shoes of vastly differing sizes whose toes point toward each other. Two chairs of likewise differing scale stand above the shoes, while two pictures of varying size both show men of great and small proportion. Light reflecting from two other pictures is too great for the print to show detail, so they exist, except for a few traces in the original, as *tabulae rasae* on which the viewer might construct his own comparison.

The work is titled "Le Geant. Fête du Trône," and in the lower left corner there is a black identification number, 86, which Atget scratched into the emulsion, so he probably intended it to be number 68.[21] Although the

[20] *Man Ray: Photographs*, introd. A. D. Coleman (New York: East River Press, 1975), p. 84, from Tristan Tzara, "When Things Dream."
[21] The full plate showing scratched numbers appears in Beaumont and Nancy Newhall, *Masters of Photography* (New York: George Braziller, 1958), p. 97.

numbers are frequently cropped in reproductions, these numbers have now lost all meaning and seem as illogical as the light bulb, which does not illuminate but only casts its shadow on the large framed picture.

Man Ray also incorporated pictures within pictures in a Rayograph composed almost entirely of strips of movie film which have been bent and superimposed to give a modulation of tone which only hints at specific images, so that the pattern of the film sprockets dominates the picture area of the film, except where an occasional close-up of a nude can be observed. Just below center left, Man Ray has placed a curled segment of film on the paper to emphasize the feeling of space. On the lower right inside of the film circle is a band of light tone which suggests the type of reflection frequently noted on a lens when a studio backdrop is used, while around this circle films seem to spin off, as though to suggest this circle is the source or gravitational center around which all the other images revolve. As a fresh image in its day, this incorporation of process and product and the destruction of images to create new ones seems to parallel Breton's ideas of "convulsive beauty."

Crime is a recurrent theme in Surrealism, and Atget's narrow alleys are so often shown deserted that the vacuum created makes one wonder if the quiet will be interrupted by violence.[22] Or, he can photograph simple street corners so they become highly charged, as in his photograph called "Newsstand."[23] Though a mere shack on the street, such a building becomes visually interesting because of the ever-changing collage of items displayed. Atget photographs this kiosk from a slight angle, concentrating on this crude structure while giving hint of a park, le square Boucicaut, surrounded by fine buildings in the background. Behind the display of magazines and pictures there is a dark opening from which can be seen the head of a newsboy who stares at the photographer. Above and to the right of his cap hangs a magazine, *Femina,* showing a smiling woman in evening dress, stage-lit and framed in an oval.

The events of the day and Atget's lens-cap exposures, however, combined to make this routine scene something more than a document. On a direct diagonal from *Femina* to the boy to the lower left area of the pic-

[22] See Annette Michelson, "Man with the Movie Camera," *Artforum* (March 1972), p. 68.

[23] In *Saint Germain des Près, 1900: Vu par Atget* (Paris, 1951), the photograph is titled "Marchand de journaux, devant le square Boucicaut."

ture is a broadsheet for *Le Matin.* During the exposure a breeze happened to blow this one piece of freely hanging paper so that the message is blurred and illegible, except for the top headline, which announces, "LE SABOTAGE A LA DYNAMITE." The purely photographic phenomenon of blurred motion and the verbal message have joined to ignite this mundane scene into drama.

No fortuitous breeze or dramatic message transforms Atget's "Rag-Picker," who functions as horse to his cart, as he poses to the side of a street. The ragpicker's eyes stare down and to the left of camera position, and depth of field falls off toward the back of the cart, so that buildings, trees, and other vehicles are rendered softly. The shadows of the vehicle and the man's legs break up the largely toneless, overexposed road, but in no way do these shadows imply more than a simple pattern. Unlike the other Atgets considered, this is an example of the straightforward documentary photograph giving us knowledge of one of the menial forms of labor.

Time and other images have a way of intervening, however, and can cause a present viewer to add richer associations to earlier images. In 1920, when Man Ray wrapped objects and titled the result *L'Enigme d'Isidore Ducasse,* the immediate associations were with Lautréamont's oft-quoted phrase concerning an encounter of disparate objects.[24] These images, visual and verbal, then interact with a later photographlike painting, *La Rue Férou* (1952), showing a back view of a bent man pulling a handcart down the narrow, wall-lined street from Man Ray's studio. The objects in the cart and the ropes holding them strongly suggest *L'Enigme d'Isidore Ducasse.* Juxtaposed with Atget's documentary photograph "Rag-Picker," the photograph and painting enrich each other, for one tends to attach a face to the figure in the Man Ray painting and to envision something more than rags on the cart in the Atget photograph.[25]

Woman, Desire, and Love are recurrent themes in Surrealist writing

[24] "Beautiful as the chance encounter, on a dissecting table, of a sewing machine and an umbrella," is from Isidore Ducasse (Comte de Lautréamont), *Les Chants de Maldoror.* Walker, p. 40, observes that, while *L'Enigme d'Isidore Ducasse* has disappeared, Ray's photograph of it remains, and, in a way, becomes the object.

[25] In Ray, pp. 380–382, he writes: "Impressed with my location [halfway between Montparnasse and St. Germain-des-Près], I made a rather academic painting of the street as I might have photographed it, including the work in an exhibition of my more imaginative work, much to the surprise of some friends."

and pictures. Breton in "Soluble Fish," for instance, writes: "The aurora borealis in one's bedroom, that's one thing accomplished; that is not all. Love shall be. We shall reduce art to its simplest expression which is love. . . ."[26] In the country which developed the cult of the Virgin, the fourteenth-century image of the Queen of Heaven haughtily displaying her child in Notre Dame of Paris has given way to an older image of woman as the basis of the universe, the primitive conception of an Earth goddess.

Man Ray could envision woman this way—perhaps with some help from Beardsley's Venusberg in *Under the Hill*—in a drawing accompanying Paul Eluard's "Les Tours d'Elaine," from *Les Mains Libres,* where woman is not a relief decoration, but the embodiment and overriding spirit of a medieval fortress. Ray also made striking closeup portraits of women and achieved notoriety as a fashion photographer, entering that world of fantasy-commercialism through the design house of Paul Poiret.[27]

Elements of Dada and Surrealism combine to produce a forerunner of the fashion photograph, a full-page study in *Minotaure,* number 5, 1934, of the exotic model in an implausible and potentially dangerous environment. Titled "Erotique-Voilée," the photograph shows Meret Oppenheim posing behind a huge printing press wheel, her left arm smeared with black ink. A thin black necklace counters the broken circle of the wheel, and her left breast is carefully suggested above the curved spoke, where shadow creates a curvilinear form on the body. To the right is the toothed outline of a gear wheel, which seems to relate this photograph to *Dancer (Danger,* 1920), an engraving on glass incorporating its title which also reads "Danger."

Woman before Atget's camera finds a link with Surrealism in photographs of prostitutes, a commission he accepted for a documentary study of the brothels of Paris for a book on prostitution by Dignimont.[28] An example is "Cabaret," which shows a nearly head-on view of a facade with a woman in white stockings standing in the doorway at the left. On the second floor (*premier étage*) and slightly to the right, a woman in black leans over an iron grille railing which is flanked by open shutters. This

[26] André Breton, "Soluble Fish," *Manifestoes of Surrealism,* trans. Richard Seaver and Helen R. Lane (Ann Arbor: University of Michigan Press, 1969), p. 63.

[27] Ray, p. 122.

[28] A. D. Trottenberg, *A Vision of Paris: The Photographs of Eugène Atget; The Words of Marcel Proust* (New York: The Macmillan Co., 1963), p. 25.

window is balanced on the right with a closed window showing carefully arranged curtains draped to define an almost ogival arch; one of the shutters is missing a number of louvers, which results in a black rectangular void. On the street level, courses of brick stretchers, rectangular paneling, and rough-textured glass present a neat, but closed-off setting which emphasizes frontality. The street pavement of square stones, viewed from the camera angle as diamond shapes, creates rows of diagonal lines which, with the slightly downward slope of the street and the diffuse lighting, lead the eye to the woman in the doorway.

The catalyst which transforms these elements is the repetition of number 5s, one of which appears in thin dark lettering above the head of the street girl; the other number, large and shaded to give dimension, fills a wall space between the two upstairs windows. In the transom windows above the entranceway two more number 5s appear. Through scale and repetition these numbers no longer seem merely informational, but interact compositionally and mythically with the human subjects. The square glass areas on the street level and these numbers make one think of the magic number squares which fascinated medieval philosophers. One also thinks of *Nadja,* where Breton's female seer looks up at a window and predicts it will light up red.[29]

Atget's photographs of other women included ragpickers' wives, peasants, shopgirls, bronze and marble goddesses of parks, and store window mannequins. Of mannequins, J. H. Matthews in *Toward the Poetics of Surrealism* notes, "Certain pages of Zola's, like those in *Au Bonheur des Dames* devoted to 'apotheoses of half-dressed *mannequins,*' anticipate the animism of the universe in metamorphosis, dear to the surrealists. Like the latter, Zola tried to communicate his impression of the fundamental forces that rule human existence."[30]

The bulk of Atget's works falls between Zola, who died in 1902, and the Surrealist "Manifesto" of 1924. In his own way Atget, too, revealed the mannequins in ways the shopper does not detect when attracted to a store window. The glass pane becomes an imperfect mirror which suggests space behind both the camera and the mannequins, an effect comparable to photomontage though stamped with the authority of the documentary image. The shopper's selective eye screens out a collage of

[29] André Breton, *Nadja* (Paris, 1963), p. 81.
[30] J. H. Matthews, *Toward the Poetics of Surrealism* (Syracuse, N.Y.: University of Syracuse Press, 1976), pp. 43–44.

signs, buildings, and trees, which impose themselves on the window, whereas the camera faithfully records light and reveals these store dummies enveloped in a cityscape.

Mabille writing on the subject of mirrors in *Minotaure* says, "Since the mirror is susceptible of providing an image of things one sees, it may be capable also of providing entities ordinarily invisible."[31] What Atget's camera does is to alter the normal planes of reality that we associate with the person standing on the pavement and the world beyond the window.

In "Coiffeur, Avenue de l'Observatoire, Paris," the blots against a light gray field read as reflections of leaves on trees and are less tangible than the plaster busts on pedestals, yet this record of motion implies a vitality denied the four figures. This sky area subverts the verbal message, for the key word, *Coiffeur,* is practically obliterated and *Messieurs* is now superimposed on the upper story of a building across the street, while *Salons* and *Dames* intermingle among leaves and patches of sky.

The interior space, essentially mysterious because of the curtain and the darkness, does reveal a "baldachin"-like machine suspended above the central, seated mannequin, the only one possessing a complete body. There is no eye contact between mannequins and photographer, nor does the reflection of the camera intrude on this scene. The normally plain, dark drapery acquires a scene of a well-lit pavement, which also tends to hover in space and "pass through" some of the mannequins, which adds to a sense of ambiguity and dematerialization.

Again, Mabille suggests the type of transformation which Atget so often achieves:

> In effect the region of the marvelous is always located on the other side of the mirror and banished to a virtual domain. . . . It is urgent to proclaim that Mystery and the Marvelous are not without but in the things and in the beings, and that one and another are being transformed at each moment, connected by continuous bonds.[32]

[31] "Puisque le miroir est susceptible de fournir l'image des choses que l'on voit, il doit être capable aussi de donner l'image des entités ordinairement invisibles." Pierre Mabille, "Miroirs," *Minotaure,* no. 11 (1938), p. 18.

[32] "En effet le pays du merveilleux se trouve toujours être situé de l'autre côte du miroir et relégué dans un domaine virtuel. Je dis qu'il est temps de mettre un terme à l'exploitation intolérable qui a été faite des phénomènes de la refléxion optique. Il est urgent de proclamer que Mystère et Merveilleux ne sont pas en dehors mais dans les choses et dans les êtres, les uns et les autres se transformant à chaque instant, unis qu'ils sont par des liens continus." *Ibid.,* p. 66.

Man Ray also used reflections, mirrors, and glass, but in a controlled studio situation, where his effects seem more consciously endowed with psychological meanings. Using a plaster, classic head, a shaving mirror, and a photoflood reflector with bulb, he has arranged a still life similar to what will become a classroom exercise and what was, perhaps, a carry-over from de Chirico. His lighting is not classic in the photographic sense, and he crops the head tightly and adjusts the mirror at a slight angle to repeat a play of oval forms and also to reflect the head. The mirror image, showing edge reversal along the classic profile, reflects a different expression, almost suggesting a face other than that of the three-quarter view of the cast. The reflector is transformed by "solarization" from a light source to a dark, circular form with concentric rings of light which convey vitality to this otherwise placid grouping. With this very basic arrangement, which all but defies a creative result, Man Ray manages to make a reference to narcissism and metamorphosis, as well as to the photographic process.

Through unusual cropping and lighting Ray can convert a live model into a store window mannequin. A model leans her head back on a board, long hair extended its entire length. He photographs perpendicular to the face, positioned near the top of the picture, on a dark background so that a sense of hovering in space is achieved. As we look directly down on the shoulders, arms appear amputated, giving further suggestion to the mannequin relationship. Inverted, the picture also suggests a ship's figurehead.

Ray's lighting is never conventional, although here he does use a strong light from high on right, which casts a shadow from the nose across the cheek, a fairly basic effect. However, when he presents the picture inverted, as it appeared on the ground glass, the lighting becomes more theatrical, even antigravitational. The film is incapable of resolving the brilliant light on the hair, and depth of field does not extend the full length of the hair. Neither of these technically imperfect elements detracts, however, but instead creates forms suggesting the motion of water. Man Ray often spoke of Leonardo as his favorite artist, and one may see a parallel here with the waves in the da Vinci drawing, *Leonardo Meditating on the Movement of Water* (Royal Library, Windsor Castle). The closed eyes also connote death, perhaps an Ophelia image, which is a reasonable assumption, given Ray's interest in Shakespeare.

Impressionism, Cubism, and Constructivism freed art from literary de-

pendency, but the Surrealists brought word and picture together again, though in ways quite different from nineteenth-century anecdotal art. Photography and words have usually suggested reportage in which the photograph serves to "authenticate" and dramatize the text. The use of poems and photographs to complement each other is not the rule, though Breton wrote:

> The photographic print, considered in isolation, is certainly permeated with an emotive value that makes it a supremely precious article of exchange (and when will books that are worth anything stop being illustrated with drawings and appear only with photographs?); nevertheless, despite the fact that it is endowed with a special power of suggestion, it is not in the final analysis the *faithful* image that we aim to retain of something that will soon be gone for ever.[33]

In the 1930s Eluard and Ray collaborated through their respective media and produced *Les Mains Libres,* a book of Ray's drawings which had inspired Eluard's poems. *Facile* in 1935, however, was a joint effort in which photographs of the poet's second wife, Nusch, became part of a series of love poems.[34] At the time the work was regarded as indecent,[35] though today this kind of typographical layout with high-key nude images helps sell bath salts or beauty cream in the mass media.

Ray's photographs present a flat, sensuous form boldly cropped and outlined by a thick shadow to create an effect somewhat similar to manuscript illumination. In the photograph accompanied by "A la Fin de l'Année," the body is severely cropped, so that the torso creates a horizontal mass at the top with leg and arm extending downward on either side of the poem, a pose resembling that of an Egyptian tomb sculpture for Ramses VI of Nut, the sky-goddess. Unlike the soap ad offspring of

[33] André Breton, *Surrealism and Painting,* trans. Simon Watson Taylor (New York: Harper Torchbooks, 1973), p. 32.

[34] The interaction of photography and poetry is suggested by Caws, who notes a passage in Paul Eluard's "Nuits partagées" from *La Vie Immédiate* which suggests parallels to photographic experimentation, such as that of Man Ray. "But the light has given me beautiful pictures of the negatives of our encounters. I identified you with beings whose variety alone justified the name that I wanted to call them by, always the same one, yours—beings whom I transformed as I transformed you, in total light. . . ." See Mary Ann Caws, *The Poetry of Dada and Surrealism* (Princeton: Princeton University Press, 1970), pp. 164–165.

[35] Penrose, p. 125.

this photograph, however, word and picture do not directly illustrate each other.

This type of marriage of word and photograph is quite different from Trottenberg's elegant attempt to link words of Marcel Proust with Atget photographs in *A Vision of Paris.* Fraser is rather harsh on this work, stating, "Mr. Trottenberg's misguided notion of yoking Atget to Proust, and his concern for a nostalgic period charm and prettiness, led him too often to what was marginal or even boring in Atget's work. . . ."[36] The sense of imposing word with picture rather than achieving a sense of complement is suggested in Atget's photograph of a corset shop paired with the following from Proust:

> While as for her figure, and she was admirably built, it was impossible to make out its continuity (on account of the fashion then prevailing, and in spite of her being one of the best-dressed women in Paris) for the corset, jetting forwards in an arch, as though over an imaginary stomach, and ending in a sharp point, beneath which bulged out the balloon of her double skirts, gave a woman, that year, the appearance of being composed of different sections badly fitted together. . . .[37]

"Badly fitted together" also describes this combining of text and photographs, which neither author nor photographer intended. A verbal description of the appearance of corseted forms is not helpful in reaching this photograph. Again, we are in the presence of mannequins, this time headless and armless torsos fitted with corsets. Outside the window near the entranceway, one such mannequin displays her wares in a state of levitation, while directly below an undergarment without dummy support waves in this otherwise frozen setting. Again, Atget's camera animates the mundane.

The words that belong with Atget's photograph are not the ones Trottenberg has selected; the words are already present in the picture. Not all words are legible, and even the store's large sign: "Corsets," is cropped, though *A. Simon, ouverts, Dimanche, Demandez, Catalogue Illustre, Oktis* are some words which immediately catch the eye. These simple, yet emphatic messages are subservient to the floating torso and waving garment,

[36] John Fraser, "Atget and the City II," *Studio International* (December 1971), p. 245.
[37] Trottenberg, p. 48.

which seem to have gone beyond the pragmatic world of commerce imprisoned behind the plate glass.

For Man Ray contradiction was a way of life, and given his involvement in many media and styles, it is difficult to assess this artist. Atget produced a large body of straight photographs, yet there is considerable contradiction within the small body of criticism of his work. Fraser talks of the potential for dehumanization in the "haunting images of store-mannequins that caught the eyes of the Surrealists. . . ."[38] He then concurs with Abbott that Atget is not a social critic and quotes her writing about the expression of human dignity in all of his pictures.[39]

Leslie Katz notes that Atget has been called a "primitive," and then suggests that he also can be called a "sophisticate," with the dubious reasoning that Paris street corners and prostitutes are "experienced."[40] By confusing the basic precepts of Surrealism, Katz separates Atget from the spirit of this movement, writing:

> Atget's photography is the antithesis of our contemporary fascination with the "new," the accidental, the fragmentary. Unlike Surrealism, it stresses the extremes of relation instead of disrelation, the objective thread that joins rather than the subjective chasm that separates. His images are not marred by conceptual fondness, or overclarified by sinister detail.[41]

In a letter in 1955, Man Ray says of Atget's work, "The blurred figures were not intentional, any more than the reflections in the window."[42] Abbott, herself a master of the view camera, insists that Atget must have been aware of the reflections in a large ground glass, adding, "A man who knew so unfailingly where to place his camera knew very well what he was doing."[43] Man Ray feels that Atget was an artist because he was not a perfectionist, though Minor White maintains ". . . Atget suffers from a lack of perfection."[44]

Outside the four photographs in *La Révolution Surréaliste* and Man Ray's guarded statements, there apparently is no evidence to suggest that

[38] Fraser, p. 240.
[39] *Ibid.,* p. 242.
[40] Leslie Katz, "The Art of Eugène Atget," *Arts* Magazine (May–June 1962), p. 35.
[41] *Ibid.,* p. 35.
[42] Quoted in Minor White, "Atget," *Image* (April 1956), p. 76.
[43] Abbott, p. xviii.
[44] White, p. 76.

the Surrealists proclaimed Atget a forerunner in the way that Breton calls Henri Rousseau a "precursor."[45] Certainly nothing is gained by forcing Atget into a Procrustean bed, especially a Surrealistic one. By considering Atget in relation to basic precepts of Surrealism, however, richer insights into his work are possible, as opposed to treating him purely as a documentarian with inadequate technique. When placed next to Ray, who holds a historic place in Surrealism,[46] his work does not suffer from possessing only a "little Surrealism," for there are often richer connotations in the seemingly direct statements of Atget than in the more extravagant images of Ray. At their best, Atget may function as a medium, while Ray may be the photographer-alchemist converting latent halide salts into pure silver images of beauty and mystery, with or without camera.

[45] Breton, "Henry Rousseau a Sculptor?" *Surrealism and Painting,* p. 369.
[46] José Pierre, *Le Surréalisme* (Lausanne, 1966), p. 190, notes that Ray was not actively involved in the Surrealist movement after his return to Paris in 1949.

Man Ray

Man Ray (1890–1976) made photographs as he did paintings, collages, assemblages, and films in an imaginative and rebellious spirit. As a member of the New York Dada circle and later a Paris Surrealist, Man Ray created art to defy and broaden the limits of conventional thought and perception. Uninterested in the techniques of photography for its own sake, he is noted for his varied experiments with solarization, blurred and distorted imagery, and cameraless photography. He called the latter Rayograms to personalize his version of the photogram.

Man Ray earned his living in New York and Paris as a portrait and fashion photographer. His more fanciful and provocative works are included in Les Champs Délicieux *(1922), preface by Tristan Tzara;* Le Photographie n'est pas l'Art *(1937), preface by André Breton; and* Portraits *(1963).*

This selection is an example of the humorous and nonsensical writing style of Dada and Surrealist manifestos. Man Ray wrote this statement for the New York–based Surrealist magazine View.

> I wish I could change my sex as I change my shirt.
> —ANDRÉ BRETON

I

Ask me, if you like, to choose what I consider the ten best photographs I have produced until now, and here is my reply:

1. An accidental snapshot of a shadow between two other carefully posed pictures of a girl in a bathing suit.

2. A close-up of an ant colony transported to the laboratory, and illuminated by a flash.

3. A twilight picture of the Empire State Building completely emptied of its tenants.

4. A girl in negligee attire, calling for help or merely attracting attention.

* Reprinted from *View* (April and October 1943).

5. A black and white print obtained by placing a funnel into the tray of developing liquid, and turning the light onto the submerged paper.

6. A dying leaf, its curled ends desperately clawing the air.

7. Close-up of an eye with the lashes well made up, a glass tear resting on the cheek.

8. Frozen fireworks on the night of a 14th of July in Paris.

9. Photograph of a painting called, *"The rope dancer accompanies herself with her shadows.* Man Ray 1916."

10. Photograph of a broken chair carried home from Griffith Park, Hollywood, at one of its broken legs the slippers of Anna Pavlova.

Do you doubt my sincerity? Really, if you imagine that I value your opinion enough to waste two minutes of my precious time trying to convince you, you are entirely mistaken.

Let me digress for a moment. Some time ago, in the course of a conversation, Paul Eluard proclaimed very simply, "I detest the horse." And yet the horse in Art . . . from Uccello to Chirico, the horse reappears again and again as a dream motive and as a symbol of woman. Its popularity is universal, from the most vulgar chromo of the racing fan to the painting full of implications by the psychologist. One of the reasons we have to thank abstract art is that it has freed us from this obsession. One would have thought that a single picture of the horse would have been sufficient once and for all to dispose of this preoccupation, and that never again would an Artist have resorted to the same motive. Noble animal! The horse a noble animal? Then are we by comparison nothing but dogs, good or bad, as the case may be. The dog's attachment to man is not the result of any similarity that may exist in physiognomy between him and man, nor even of odor. What attaches the dog is his own capacity for loving. The dog is such a complete lover. The horse, however, like the cat, is content with *being* loved. But *we* are not such good lovers, we humor the horse for his hoofs as we cater to the cat for her guts, and our affection and caresses are calculated to exploit their attributes. And so we kid the dog along for his doggedness. So agree; the dog is the only animal that knows what real love is. With his set expression, but unlike that of his determined master, he has no hope, no ambition, he has only the desire for the regular caress and the bone. Take the following example. It is a one-sided but true story of man's perfidy:

For fifteen years this woman has been raising dogs. Now she is twenty-four years old, and wishes to retire. She wants to sell her dogs, fifty-seven of them, all pedigreed, sell them so that she may retire and devote the rest of her life to writing poetry. She speaks,

> *Yesterday was a cocoon*
> *Tomorrow will be a butterfly*
> *Tonight as I sit and gaze at the moon*
> *I wonder and mutter "WHY?"*

II

Speaking of horses, personally, I admit I have never been able to draw a horse, nor, for that matter, photograph one. But that is merely a question of habit like so many other of our prized accomplishments. When I was called out to do a portrait of the Maharaja's favorite racing nag, I had considered myself fortunate to be living in an age that put the camera at my disposal. Leonardo and Dürer had racked their brains to produce an optical instrument, if only as an aid to their drawing. It was not their fault (nor very much to their credit) that they were unable to perfect a device that might have freed them entirely from the drudgery of reproducing the proportions and the anatomy of those subjects that served them as a vehicle to their full expression, vehicles that so many of us still admire and emulate. We, some of us, still repeat them, and with them we admire the drudgery that they involve. "What," do you say, "should we do today; draw autos and planes? This involves just as much drudgery, if we do not use the camera, which after all is not a sensitive instrument like the hand." I wish to point out here that the horse has one advantage over modern vehicles, and that advantage has confused the Artist down to the present time. The horse does not have to be built, he already exists. Whereas the automobile or the airplane must be drawn again and again to bring them to the state of perfection attained long ago by the horse. Once that perfection attained, the camera will come into its own, to record the perfected new vehicle. Yes, with all the variations of proportion, distortion, light and shade that have been applied to the interpretation of the horse. The camera waits for the human hand to catch up with it.

But why was I unable to photograph the horse, that already perfected

animal? Let me explain. I took him full-face, three-quarters, profile. I caught the white star on his forehead, his liquid eyes, his beautiful glossy skin with its nervous veins, the quivering nostrils (I'm sorry, the camera was too fast for that, but we know horses' nostrils quiver). However, when I showed the results to the trainer, his face assumed a worried look. "Ah, but you haven't got his soul." I ask you, now, how was I to know the animal had a soul like we humans. I have been told so often in my portraits of men and women that I have caught their soul. I do not wish to apologize, I simply conclude that I have no feeling whatsoever for the horse. I admit it, and from now on I shall loudly proclaim it, before any one else can accuse me of lack of feeling or imagination. In short, I detest the horse, and you shall hear no more about the noble animal!

Dear gentle but ruthless reader, if I seem to cover a great deal of ground in too short a space (of time), remember that I am a product of my times and proud of it. I travel in modern vehicles and avoid circumlocution. I have the choice of the means of locomotion. Nevertheless, I consent to stop again by the wayside for an instant, and introduce you to one of my oldest friends, THE ARTIFICIAL FLORIST. Realizing long ago that the perfect crime does not exist, any more than perfect love can exist, and if these existed, we would not call them either crime or love; realizing a state of things that opens the way to repeated effort, he cast about for an object capable of improvement, or of modification, in that it lacked at least one desirable quality. We all love flowers, that goes without saying, but I wish to state it, although others expect of me so many things without saying so. The flower, in all its perfection, lacks one quality, that of permanence. This has been one of the chief concerns in art for centuries, both material and aesthetic. Of course, nature has found a substitute for permanence, in repetition, but that is not an admitted human function. Anyhow, when man turns to imitating the processes of nature, he invariably tries to substitute permanence for repetition, just as he tries to reproduce all the various lever movements in nature with the principle of the wheel, which does not exist in nature. In the same manner, he carries the confusion even into such comparative human activities as painting and photography, to the extent of imagining that he is making a good drawing, when he is simply making a poor photograph, or that he is making a work of art with the camera when he makes a good automatic drawing with it. Here may I ask you, reader, to read this foregoing state-

ment several times to get my meaning. You see I ask you now to slow down your pace, just as you asked me to do previously, except that my trajectory enters into the realm of the permanent while you in the role of reader must practice the art of repetition at this time.

To return to my ARTIFICIAL FLORIST; loving flowers as he did, and being more human than nature-loving, he wished to assure himself of the permanence of certain blooms. The choice of two courses lay open to him, either to paint them, or to make the actual artificial flower, and he made his decision in the following manner: Looking one day at a painting that meant nothing to him, he asked me to explain what there was beautiful about it. I replied that I would, after he had explained to me what there was beautiful about a painting of flowers. "One can then still have them in wintertime," he answered. Thus we both skillfully parried the question of beauty. But his mind was made up from then on; he would make actual flowers, instead of painting them, flowers that would not fade, but be permanent, like painted flowers. The question of odor did not enter into the project, since no one had ever demanded of painted flowers that they smell. ARTIFICIAL FLORIST became very expert in the making of permanent flowers, so that at a short distance they were easily mistaken for nature's work. One day I came around with my camera and photographed the permanent flowers. I took them against the sky, I added drops of water to simulate the dew, and I even put a bee in the chalice of one of them. However, when I showed the results to FLORIST, his face fell. "Ah, but you haven't got their souls." Once again I had failed. Now I ask you, how can we ever get together on the question of beauty?

This dilemma, fortunately, no longer troubles a self-respecting Artist. In fact, to him the word *beauty* has become a red rag, and with reason. I am not being sarcastic, but mean it in all sincerity, when I say that the Artist, even when copying another, works under the illusion that he is covering ground which he imagines no one has covered before him. He is then necessarily discovering a new beauty which only he can appreciate, to begin with. (In this respect he really returns to nature, because he employs her time-honored mode of repetition, unconsciously. Only the desire to make a permanent work is conscious.) Aside from this, *the success with which the Artist is able to conceal the source of his inspiration, is the measure of his originality*. The final defense is, of course, "I paint what I

like," meaning he paints what he likes most, or he paints that which he fears, or which is beyond his attainments, in the hope of mastering it.

Happily, most of the pioneers of the past two generations have freed themselves from these obsessions and the rot of past performances. A few are still walking ahead with their heads completely turned around, looking backwards as they advance, in an impossible anatomical position in spite of their respect for the old masters. Then there are the few pessimists and disillusioned ones, bewildered and discouraged, who say, "What is the use, in medical parlance, whether the stool is easy and abundant or difficult and meager, the anus is equally soiled." As for the practical ones who are always ready with their washrag, soap, and water, they can take care of themselves. But it is useless to deny the future, and especially the present. . . .

Have you ever tried looking at a Veronese or a Vermeer through a red glass? They become as modern as a black-and-white photograph. And how often has a painter, upon seeing a black-and-white reproduction of his work, had a secret feeling that it was better than the original. The reason is that the image thus becomes an *optical* image. In the last few generations our eyes and brains have become *optically* conscious, not merely plastically conscious. Turner and the Impressionists were the first painters to develop this optical nerve in color. It was a mere hazard that photography began with the black-and-white image, perhaps it was even fortunate for the possibilities of a new art, or that a new art might become possible. The violent attacks by painters on photography were mitigated by its lack of color, of which they still had the monopoly, and they could afford a certain indulgence. Just as in writing, "l'humeur noir" had been considered the bastard child, a new black-and-white graphic medium could never be feared as a serious competitor. But, if this humor should assume all the colored facets of a serious form, like the present discourse, or if a photograph should break out into all the colored growths accessible to the painter, then the situation would indeed become serious for the exclusive painter. Then the danger of photography becoming a succeeding art, instead of simply another art, would be imminent. Or rather, the danger of photography becoming simply Art instead of remaining AN art. To complete this result, a little research and some determination could prove that whatever was possible in the plastic domain was equally feasible in the optical domain. The trained human eye, guiding one of

glass, could capture as wide a field as had been controlled by a more or less trained hand guided by a half-closed eye.

It is the photographer himself who is to blame for his lack of standing amongst art dealers accredited by their supporters, and self-accredited critics. Until now he has relied too implicitly on the shortsighted scientists who have furnished him the materials of his medium. His concern with *how* the thing is to be done, instead of *what* is to be done, is a repetition of the spirit that held in the early days of painting, when painters went about smelling each other's oils. Of course, painting dates back ten thousand years, while photography is barely a century old, and there is hope for it. The photographer has pulled his little Jack Horner, has pulled the chestnuts out of the fire for the scientists and the manufacturers, and it is time he kicked over the bucket and put out the fire. Wet chestnuts are better than singed fingers, a drop in the bucket cannot compete with a plum out of a pie, but even so, the greatest thrill can be obtained only by throwing the whole pie into the face of those who have arrogated to themselves the monopoly of intelligence, perception, and knowledge. Proverbs are at their best when they are reversed, as practiced by our most revered poets, who also have announced that poetry should be practiced by all. I remember one poet, especially, in the course of a talk, accused of irrelevance, and requested to stick to the subject of poetry, replying, "Damn it, this is poetry!" In another instance, the poet spits in the face of those who are charmed with the form of his writing and politely ignore the too inflammatory content. We can no longer be satisfied with the ivory tower of quality, but that does not mean we shall make a point of setting up our artistic headquarters in a steel skyscraper, which would be equally evasive. A cry or a song emanating from a palace or a prison, if they are loud enough, can stop us dead in our tracks. I do not think the architecture has anything to do with the message, with human functioning, any more than a sunset is motivated by aesthetic considerations on the part of nature.

We can only see, hear, feel what we have been in the habit of seeing, hearing, and feeling, or if it is a new and unfamiliar world, we must be prepared in advance and disposed for its reception. The optimistic subject that comes into my studio with the concentrated idea of having a successful photographic portrait of himself does not even see the, for him, weird and abstract canvases on the walls. The colored houseboy who

comes in to clean up the place, still throbbing from a night's dancing to his favorite swing, is spellbound by the colors and forms on the walls. The least he can do to express his enthusiasm is to offer to buy a painting, which, of course, I sell him in that same spirit of make-believe that children play store and trade with each other. But, a strange transformation has occurred in the houseboy, he becomes a full-fledged artist in his own right, a poet of the dust, which he disturbs with the greatest precautions, and only for a consideration, just as I condescend to interest myself in someone's physiognomy only for a consideration. He, the houseboy, assumes an air of efficiency and mock-usefulness, confident that the thin layers of precious and indestructible atoms will return to their accustomed places and thus assure him the future with its daydreaming, and its occasional discoveries. And as he dusts, he composes his poem in silence:

DUST TO DUST

For years these objects lie motionless
Though some are articulated for action
Performing satisfactorily
The function they were destined for—
Entailing no wear or tear
No supervision or directing
To which more living matter is subject—
Accumulating dust
Which is also an object
Of an amorous nature
That seeks its soul-mate
Everywhere and forever
And never will surrender
To our prosaic gestures. . . .

It will return to its accustomed place.

* * *

I said for a consideration, but there are two considerations in these cases, one of them secret. For, in the end, the object or the subject will play the final role and will determine the validity of the result. Therefore, the intentions of the self-appointed chronicler will be of little importance.

The inventor is the tragic figure, he who adapts and improves is the lucky guy. The inventors of the present war are doomed, for they have indicated merely the way, to be improved upon and turned against them with a hundredfold power.

This thing called time, beautiful, automatic dimension that relentlessly measures our steps, neither hastening them nor retarding, however short or long they may be, time will resolve all our problems. It is useless to rack our brains for the solution, we must live as if there were no problems, and as if there were no solution to be obtained. This is the final automatism, demanding no effort but that of living and waiting. To all this you will agree or disagree according to whether you have felt in a similar way, or not felt at all. I said living and waiting, and do not we perform all our necessary physical functions while awaiting the most desired results? Thoughtless wishing, you may say, but see into what blind alleys of action the contrary, wishful thinking, has led us.

And now, patient reader, it is time for me to meditate, to reassemble my memories, put my house in order, without further disturbance of the dust of past experiences, except for this stereotype, or photograph:

TIME IS

It was not a long walk
From the Place de la Concorde to the Champs de Mars
Not any longer than the transition
From white to black from peace to war
From water to blood

Cleopatra's Needle stood nakedly straight and white
In the night's projectors of the Concorde
Eiffel's Folly concaved black to a point
In the dimmed regions of Mars
Flashing its own light from minute to minute
Visible time inaudible

White shaft black shaft
With the eternal patience of inanimate objects
Wait for their transport transformation
And for their destruction
It is all one they have made their point

The supine Pont du Jour has already less time to travel
It has reversed the process of erection
Experienced by the obelisk recorded on its very base
Indeed there will be records of all transformations
A record will never equal the accomplished fact of an erection
Can never replace it
Will always be an obituary.

* * *

To conclude, nothing is sadder than an old photograph, nothing so full of that nostalgia so prized by many of our best painters, and nothing so capable of inspiring us with that desire for a true Art, as we understand it in painting. When photography will have lost that sourness, and when it will age like Art or alcohol, only then will it become Art and not remain simply AN art as it is today.

Joe Deal

Horst P. Horst (1906–) is noted for his fashion and celebrity photographs of the 1930s. The pupil of a Steichen disciple, George Hoyningen-Huene, Horst also developed a highly dramatic style. His innovative use of props and theatrical lighting is today taken for granted by fashion photographers. His books include: Photographs of a Decade *(1944)* and Salute to the Thirties *(1971).*

This interview shows the increasing interest on the part of art and photographic historians in fashion and commercial photography. Horst's comments are valuable as firsthand observations. His views on the relationship between Surrealism and fashion photography suggest the need for further comparative study.

Joe Deal is a photographer whose work was included in "New Topographers," an exhibition at the International Museum of Photography at George Eastman House in 1975.

After a long period of comparative neglect, fashion and celebrity photography of the 1930s are at last beginning to be reexamined carefully.

Horst (full name Horst P. Horst) was born in Weissenfels, Germany, and later moved to Paris where he was to become one of the select few fashion photographers whose work appeared regularly in Condé Nast publications, especially American, British, and French *Vogue* during the 1930s. After moving to New York prior to the outbreak of World War II, Horst continued his work for *Vogue* and also began photographing interiors for *House and Garden.*

Horst, who remains active, was examining tearsheets from a new issue of *House and Garden* containing several of his photographs when I arrived at his New York apartment to interview him this summer.

Q: What was the relationship of Surrealism to fashion photography in the 1930s?

A: At that time in Paris the dressmakers and the artists were all

* Reprinted from *Image* (September 1975).

246

friends and very close, so naturally everyone was influenced. Like Dali making dresses for Schiaparelli with a big lobster on the dress.

Q: But you didn't feel that you were participating in the Surrealist movement when you were making your fashion photographs during that period?

A: No, just occasionally a fashion would lend itself [to being photographed in a Surrealist manner], or you needed a new idea for photographing the fashion collections in Paris, and you would bring in a certain amount of Surrealism. But anything would influence the fashion collections. For instance, there was an exhibition of Italian art in Paris, the first great exhibition of Italian art. This influenced fashion and fashion photography.

Q: You studied art in Germany before moving to Paris. Where in Germany, and was photography part of your art training?

A: No, photography wasn't. But first of all, as a child in Weimar I started to know the people of the Bauhaus, and naturally I was influenced by it. Then I went to art school in Hamburg. Gropius at that time was designing the interiors of the big ships for Germany—the *Bremen* and the *Europa*—and as students we had to work on these with him. Then I became interested in Le Corbusier and I wrote to him in Paris and he said to come and study with him any time I wanted, so I left Germany and I never went back.

After a year I left Le Corbusier and that's where the photography comes in. I had lunch one day with Eric [Carl Erickson] who used to make drawings for *Vogue,* marvelous drawings, unbelievable. There was an American art director there called Dr. Agha [who worked for Condé Nast in New York and was visiting and] who asked me would I like to take photographs. It must have been 1931 approximately. He said, "You can have the studio twice a week for two hours, just go ahead and try." I said, "But I don't know anything about photography. I don't know anything about fashion. I've never seen an elegant woman." He said, "You go ahead."

Q: Had you interest been in architecture up until that time?

A: Yes, entirely.

Q: What made your interest change from architecture to photography, just the encouragement from Dr. Agha?

A: Just that. I went to the *Vogue* studio, and there was an assistant

who knew all about the lighting. He knew all about the exposures and all the technical things. I just posed the girl, bravely clicked the shutter, and they published it, full-page.

Q: Why did Dr. Agha happen to choose you?

A: He seemed interested in a young boy from Germany working in modern art and architecture. He thought maybe it was a good idea to take a chance. They probably needed somebody new on *Vogue* at that time. There was Cecil Beaton, Hoyningen-Huene, and of course there was Steichen.

Q: I had read that you had studied or known people at the Bauhaus, then looking at your photographs and seeing what to me is a relationship to Surrealism, it seemed to me that there must have been a time when your allegiance to the International Style of Le Corbusier and Gropius must have changed because Surrealism and Dali represented something totally different.

A: Yes. But of course the architectural interest and bit of training I had comes in handy in taking photographs: sense of composition and that sort of thing.

Q: But many of the photographs had the kind of props and fantastic, dreamlike things thrown in with them that seem to be in conflict with the reductiveness of Le Corbusier.

A: Yes, definitely, but working for fashion, you can't stick to one thing. You have to go with the fashion. So you have to be able to change. Like I said before, with the Italian exhibition, everything had to be Italian. Fifteenth-, fourteenth-century Italian.

Q: So you didn't feel yourself tearing away from your architectural interests to go to fashion photography, where, as you say, you had to change with the times, with the fashions?

A: No, exactly. I mean, for instance, as far as architecture is concerned, Le Corbusier is very interesting, but I wouldn't live like Le Corbusier, *ever*. If I had to choose where to live, my type of house would be Mediterranean, whitewashed.

Q: But at the time you must have felt differently.

A: Yes. Also, you have to think that when you are very young, you don't know the world yet, and then you find gradually what you really go for, what you like, and that develops.

Q: Apparently, when you found photography, you found what you wanted to stay with.

A: Not only that, but it was the only means at that time for me to make a living. Germany was down and out, my parents couldn't send me a nickel. Hitler had arrived on the scene. One had to do something. Since they offered me that job, I just worked like a beaver. I went to the Louvre, I went all over to find out why is an Ingres drawing so good: the proportion, the movement. All that sort of thing. I didn't know a thing about it. I studied.

Q: So you were drawing from an entire range of art movements and not really identifying with anything too specific at the time.

A: No, nothing really. Except that there was one thing that you had to stick to, as a photographer, according to Mr. Nast, and he knew a hell of a lot about photography. We had to use an 8 by 10 camera, and then you had the slow film that limited your work. Munkacsi, Cartier-Bresson, and others came along using the snapshot cameras, the Leicas. But we were not allowed to use them.

Q: That was Condé Nast's personal ruling, so you were really locked into the studio.

A: That's right. We only got onto the small cameras during the war because film got expensive and rare, and that's why we were allowed to use small cameras. No photograph could be cropped; the 8 by 10 had to be printed without any enlarging or any kind of fiddling or anything. It had to be right there on the negative. We were not allowed to do what Man Ray did.

Q: I was just going to ask you about that. Condé Nast never published Man Ray fashion photographs, then?

A: No, *Harper's Bazaar* did.

Q: Were you ever tempted to try solarization?

A: We were always tempted to try, sure, and how. I did later on, in the forties, when Condé Nast didn't have as big a hand in it anymore.

Q: In the foreword to *Salute to the Thirties* Janet Flanner wrote that during the 1930s photography and film became "the rage of the *beau monde.*" What do you think were the reasons for this sudden interest in photography?

A: Well, I suppose that it was the type of photography that George Hoyningen-Huene and I did that brought the interest.

Q: So it was the fashion photography in Paris at that time?

A: Oh, entirely. The whole thing. Fashion as well as photography. Most of it happened in France. There was hardly a dressmaker in

America. Steichen was the only photographer. Then later on came Louise Dahl-Wolfe and others.

Q: Condé Nast must have had a long reach over the ocean, because he was living in America.

A: That's right. We worked in Paris for American *Vogue*.

Q: Were you close to many of the people you made portraits of?

A: Yes, Chanel was one of my greatest friends. She was a wonderful woman. She had had a terrible row with *Vogue* and didn't let the *Vogue* people come near her place. One day she called up and she wanted to be photographed by me, and everybody on *Vogue* fell over backward. She was a big success at that time. She turned up and I photographed her and then she said, "Oh yes, you can publish it." But then she called up and said, "But you know it's a very good photograph of the dress but it isn't a good photograph of me." And I said, "Well, how can I photograph you? I don't know you." So she asked me to dinner, and then she said, "I'll come again and you'll make a photograph of me now that you know how I live." So I did the photograph and it became a famous photograph. Then she asked how much she owed me; she had ordered hundreds and hundreds of prints. And I said, "But you couldn't possibly pay me. Just that you like it is more than anybody could ask for." After that she gave me practically anything I wanted. Every time I went to lunch or to dinner with her, if there was an object on the table or a statue, and I'd say, "That's beautiful," she'd say, "It is yours."

Q: Were most of your portraits done on commission for magazines or did you do some on your own?

A: No, I didn't do many on my own. I did do some. In the thirties book [*Salute to the Thirties*] lots of those photographs had not been published in *Vogue* before. But I did them also because I liked to photograph those people or they asked me to do it.

Q: Did you know Man Ray in Paris?

A: Yes, sure.

Q: What did you think at the time of his manipulations of the photograph?

A: We thought that he was a darkroom photographer. Because *our* problems with fashion were one thing, whereas he just went and photographed whichever way he felt like it, which we were not allowed to do. And one of his friends who is now Lady Penrose, Lee Miller she was

called—very beautiful—modeled for *Vogue*. But we used to hang around the same places. He used to go to Montparnasse, the Dome, and the Coupole and sit around there. Obviously nobody thought anything of me at that time.

Q: Did he see your photographs, or did you show each other your work?

A: Yes, but it's typical that anybody interested in photography as art didn't like what we did in the magazines, because it was commercial.

Q: But he worked commercially also.

A: Yes, occasionally, but not much. He didn't have to have ten or twelve pages every month, for example.

Q: So he just wrote your photographs off as being commercial.

A: Oh, I'm sure.

Q: But yet there is something—You can identify a Horst fashion photograph as opposed to a Steichen, as opposed to a Hoyningen-Huene.

A: Yes, well I haven't analyzed that part very well. Because I don't photograph through the brain. I photograph through the eyes and the stomach.

Q: So the fact that you were making money for it didn't mean that they were any less valid?

A: No, you see, and the editors, there was very little contact with the editors. They had more or less to take what was produced. There were no other photographers. They couldn't say, "Well, the hell with that. Now we're going to switch to Mr. So-and-so."

Q: Did Mr. Nast ever reject photographs?

A: Well, he rejected one, I remember. It was rather funny. It was Mary Martin in her first success, a Cole Porter show [*Leave It to Me*]. She came and she had a short fur coat on and was supposedly naked underneath. And I set her down—since the show was about Russia—I set her down in the snow. Artificial snow. Her bottom was showing. It could not be published. It was too outrageous for that time. Or if there was something out of focus, he wouldn't publish it either. If there was a petal on a lily out of focus—right out! He fired me once for that. Well, we had an argument, sort of. I didn't think it was an argument. He had all my photographs out in this big office and went through every one of them. All the rejects, not just the published ones—everything. He said, "Oh, I suppose you think you're as good as Steichen." I said, "Well, if I didn't think I

would be as good as Steichen eventually, I wouldn't have started." I meant it very well. He thought it was the biggest arrogance on my part. He said, "You can take the next boat to Paris." He fired me. Then a few months later he hired me back.

Q: Did Condé Nast ever suggest how you might photograph a particular fashion or what props to use or not to use?

A: Yes, he did at one time. Because in Paris we used a lot of sets, depending on the mood involved. Jean-Michel Frank, who was the best decorator at that time, and also Emilio Terry, who was an architect, built grottoes and things for me. A sort of fantasy world. Mr. Nast wanted more realism. There was one particular incident. Mr. Luce, who later started *Life* magazine, was a great friend of Mr. Nast's. They had an argument: which type of photograph would sell better, the realistic one or the fantasy one, the studio type? They had Tony Frissell photograph two girls in two dresses [in natural surroundings] and had me photograph the same girls in the same dresses in the studio. The readers were asked, "Which type of photograph do you like better?" Seventy-eight percent of the readers answered they liked my photographs better. But Mr. Nast didn't ever let me know it. He said, "We must have put the question wrong." But still he insisted that I should photograph flats and houses. Helena Rubinstein's flat, and that sort of thing.

Q: I read in an issue of *Vanity Fair* from 1934 an article by Frank Crowninshield in which he was discussing a bill which was on the floor of Congress and was intended to modify advertising: "The bill was devised to prevent the manufacture of, traffic in, and what might be called the over-romantic advertising of certain foods, drugs, garments, cosmetics, and other articles intended to make life a little happier for the ladies." One of the bill's supporters, incidentally, was Rexford Tugwell, who was largely responsible for making possible the FSA photographic team. Was there ever pressure applied to put more naturalism or realism into fashion photography at that time, do you think, because of the Depression?

A: It might have had something to do with it. I don't know. I'm not conscious of that at all. I mean the whole trend was toward that thing, what they call realism. Where do you find it? You can make something fantastic out of a garbage can if you want to.

Q: But much of the fantastic nature of the fantasy photographs seemed to be aimed at people who were aware of the trends in art from

Surrealism to whatever comes next—to moneyed people and an aristocracy of taste. But during the Depression, with so many people out of work and no money, it might have seemed to be appealing to the wrong kinds of instincts.

A: Well, I think, rather on the contrary, it was a kind of escapism, a fantasy that people liked.

Q: Did you feel at the time that you were providing a kind of escapism?

A: Oh, yes. Everybody was trying to escape like that. What with Germany, and with Hitler on the rise. The war was coming. Everybody lived in a fantasy world.

Q: To try to blot out the realities of the time.

A: Right. You tried not to think about it. You knew what was coming.

Q: Do you think that the costumes and fancy dress balls were part of that?

A: Sure, very much. Today those fancy dress balls and things have no more meaning. There are still some here and there; nobody looks at them very much. Then they seemed vitally important to people.

Q: Did you ever stand back and analyze at the time what all of this meant when you were photographing people in fancy dress costumes and outrageous dress, or were you participating in it yourself?

A: No, I wasn't participating that much in it. Once in a while I was asked to some of these big balls. But anything to me was brand new. You must imagine, I was brought up in starving postwar Germany. When I started photographing, during the Depression, everybody was screaming how poor they were, and I, for the first time, made money. So I wasn't afraid of being poor because I knew what it is. I didn't make the switch of, all of a sudden: I'm one of the rich people, or something like that. They didn't know anything about me, anyway. I lived a very simple life then. Certain people liked me, and I got thrown into this sort of Lady Mendl and Cole Porter and Noel Coward type of life. But I didn't lead their lives. I saw them, or had lunch with them once in a while.

Q: Would you say the same thing of Hoyningen-Huene and Cecil Beaton?

A: They were two completely different characters. I myself, for instance, would go to the Café de Flore in the evenings, and sit there with Janet Flanner and her friends. You saw everybody: there was Picasso,

Malraux, Derain, Gertrude Stein. Nobody thought they were famous or tremendous people. George Hoyningen-Huene was born in top society. His father was Chief Equerry to the Czar. When he did his fashion photographs, he did it sort of with his tongue in his cheek.

Q: He was looking down, in other words.

A: Sure! He knew more about elegance than any one of them ever dreamed. Whereas Cecil comes from a middle-class English family. He took it very seriously. Whereas as far as I'm concerned, I was out of it. [Hoyningen-Huene] never went out. He wouldn't dream of going to Lady Mendl's. No good! He lived his own life. He traveled, he went to Africa, to Greece, all on his own. He walked hundreds of miles or rode on a donkey. "Because my world is finished," that was his attitude. "The aristocracy is finished. I'll lead a poor life." He was quite a character. Tongue in cheek against the pretension of the fashionable world. But not tongue in cheek about actual elegance. He believed in that.

Q: So in his photographs he did attempt to bring as much elegance to that as possible?

A: That's right.

Q: They're such severe, clean, and beautiful, stunning things.

A: Extraordinary. Absolutely extraordinary. Unsurpassed. And his feeling for women was real. Whereas Cecil's photographs were so much more like fancy dress balls, decoration, butterflies and lace.

Q: Did the three of you know each other quite well?

A: Oh, yes.

Q: And, I assume, used to discuss photography?

A: Yes, Cecil used to come over to Paris, and then George and I introduced him to Cocteau and Bérard and that sort of people. It was brand new to him because in England those people didn't exist.

Q: But he started doing fashion work before you and before George Hoyningen-Huene.

A: No, I think approximately the same time as George. Anyway in the twenties, middle twenties. I started in the early thirties, 32, 33, something like that.

Q: Cecil Beaton has written of 1930s fashion photography that it was only an "uninspired modification of 1920s photography." What do you think he meant by that?

A: I have not the foggiest notion. I don't think he knows either.

Q: Many fashion and commercial photographers during that time had connections with the theatre. Did you ever work in theatre at all?

A: No, I never did. Cocteau was starting his first movie, *The Blood of a Poet,* and he wanted George Huene to photograph it. George Huene said no, he wouldn't.

Q: Did George Huene ever work in motion pictures?

A: Yes, he did, in Hollywood. He gave up fashion. There are two funny stories. The way he quit *Vogue.* Dr. Agha came over to Paris and wanted to make a new contract with George. They were sitting together at lunch, and he said, "George, of course we know your photographs are marvelous, but we want you to behave." Now, George was very temperamental. You know what George did, he took the table and ssst! the whole spaghetti or whatever it was went right in Agha's face, and he said "Nobody tells me how to behave." He went out and called Carmen Snow, who was in Paris at that time, and he said, "I'm on the street. You can have me for any money you want." So he went to *Harper's Bazaar.* Carmen loved him, and he did very well there. But one day he said, "Elegance is finished; fashion is finished; all this life is finished. I'm going to Mexico." And he went—1945 or 1946. Then he went to California. George Cukor was a great friend of his and he worked with George Cukor. [He was color consultant on the remake of *A Star is Born, Bhowani Junction, Les Girls, Heller in Pink Tights,* and *Let's Make Love.*]

Q: What was Hoyningen-Huene's behavior that Dr. Agha felt he had to correct him on it?

A: Oh, for instance, they had sent him to Hollywood to photograph movie stars, and then he came back with the pictures and they absolutely adored the pictures. But Mr. Crowninshield said, "Oh George, we wanted—" I forget which now, either more full-length pictures or more close-ups. George wrote back and said, "If you don't like them, you know where to put them."

Q: So, I take it, no one told him how to make photographs.

A: No.

Q: He must have had some run-ins with Condé Nast, then. It seems that Condé Nast was an equally powerful personality.

A: Yes, but George didn't care. He was very proud. I mean then there was nothing to fall back on, except his own ego.

Q: Did the improvement of color-printing techniques, which made

possible color fashion photographs in the mid-1930s, create problems for photographers who had not worked in color?

A: Oh, yes. George Huene thought always that color photography wasn't right, that color was cheap and terribly limited. And I thought just the contrary. Maybe just to contradict George. But I worked much more in color than he did. But I do love black-and-white photography. Because it lasts better, to start with.

Q: What made you go to color and Hoyningen-Huene turn away from it?

A: We used to sit around and argue about color. For instance, Bérard would say, "Painter's aren't colorists anymore, like Van Gogh or Gauguin." That sort of intrigued me. When you see a Corot—a landscape that is all sort of bluish green, then there is a man or woman that is a little red dot, and you take [the red dot] away and you haven't got a picture. That type of thing. That intrigued me.

Q: But George Hoyningen-Huene thought that color photography was vulgar.

A: Yes. Then when he did do color things, they had pale, pale backgrounds with a woman in a pale dress. Also some very dark color photographs.

Q: I don't think that I have seen any of his color work.

A: It's not his best. Not at all.

Q: Do you still work in black and white?

A: Yes, occasionally. I love doing it. But now I photograph mostly houses. I never photographed a house in my life before I was asked to photograph the house of Consuelo Vanderbilt Balsan.

Q: Who asked you to?

A: Diana Vreeland, when she was editor of *Vogue*. I just took a Rolleiflex and started to work, and apparently it revolutionized the whole interior decorating photography, because most of the time they have done it with 4 by 5s, and wide-angle lenses which showed all the chair legs and all that stuff. I just gave impressions of rooms.

Q: Do you think that color photography could have had anything to do with Hoyningen-Huene dropping out of fashion photography?

A: No.

Q: He didn't feel that pressure was on to either start doing color or stop doing fashion photography?

A: No. Of course, there was a certain amount of pressure, with the advertisers buying color pages in the magazine. And Mr. Nast had special color engravers of his own and he wanted to promote it very much.

Q: Did you think of your portraiture as something apart from your fashion illustration, or were they part of the same thing?

A: Well, I think of everything as part of everything. I always try to get into the subject and try to understand, whatever it is.

Q: But in working in fashion photography you wouldn't have the same kind of interest in personality as you would in a portrait.

A: You must, in a certain sense. Definitely. The model, for instance, is very important. You have to have a relationship with her. You don't use her like a prop. You have to use her to a certain extent like a thing, because you have to correct the dress, but at the same time she has to look like a human being.

Q: It would seem that in the fashion photograph the purpose is to illustrate the dress, but the portrait is really completely the person.

A: Well, you've got to bring in the mood or something. At that time that sort of thing was called drama. Certain girls could do it. You have to know the girl and how far she can go and not have just a dumb look on her face.

Q: Do you have favorite photographs of yours?

A: Funny. The other day there was this show at Lord & Taylor. Each photographer picked out his favorite fashion photograph. Finally I found one, a corset picture.

Q: The one in your book, *Photographs of a Decade?*

A: Yes, that's the one. But then *New York* magazine printed it and said that's our favorite picture, too. It's very difficult for me to say which is my favorite. You see I'm not really one track. [Irving] Penn's great strength is going right after one thing. I like to play.

Q: Did you think at the time that your photographs would be exhibited in museums?

A: No, never. Once they were accepted and you got your money for them, that was it.

Q: Did you retain all your negatives?

A: No. Most of it is gone. I kept a few photographs here and there. My secretary in Paris kept a lot. My files are in a terrible mess.

Q: What do you think now of people wanting or buying your photographs?

A: Well, I think it's amazing. It was Madame Sonnabend who got the idea. It's very nice.

Q: Did you ever exhibit your work in Paris at the time you were making your photographs?

A: There was one little bit of an exhibition that Janet Flanner asked me to do because I had taken a photograph of her which she had liked, and she fixed it up in some sort of a bookstore, in a cellar. I think I had photographed about ten people at that time. And she went and wrote it up for *The New Yorker,* just a few lines. Mr. Nast saw it and said, "That Horst must be good because Janet writes so well of him."

Q: Then he hadn't seen your photographs before that article appeared?

A: No, not those. Just little bits and pieces. He didn't think much of me. Mr. Nast was a terrible snob. Very much impressed with Baron Hoyningen-Huene and Mr. Beaton. And the great Mr. Steichen.

Q: How well did you know Steichen?

A: Not too well. He'd been very nice to me, actually. When he wanted to leave *Vogue* [in 1937], he was the one who said to Condé Nast, "I think Horst can do my pictures." That was very nice. But I've seen him three times in my life since that.

Q: Did he train or, do you think George Hoyningen-Huene or Cecil Beaton learned a lot from Steichen? What I'm trying to find is some starting point for all this.

A: It was really Steichen, in connection with Mr. Nast. They both did it. It was much more Mr. Nast who insisted that people should do it more or less like Steichen. Some sort of studio way, with their own interpretation, of course. It was not Steichen who dictated things.

A: Do you think Condé Nast directed Steichen in taking the first fashion photographs, or do you think it was the other way around, and that Condé Nast accepted that as the norm?

A: I think so, yes.

Q: That Steichen set the standards.

A: Yes. Steichen was a very strong-willed man.

Q: What about Baron de Meyer?

A: I met him once. His career was finished on account of Steichen.

Because Baron de Meyer was very famous and I think, at that time, he got a thousand dollars a photograph. Unbelievable. Then Mr. Steichen came in and made a big splash in *Vanity Fair.* Baron de Meyer used back light and frills, and suddenly there were black, white, and gray panels and straight lines, and Baron de Meyer couldn't cope with all that. He suffered from it: "I'm finished. Mr. Steichen and his straight lines!" I kept away from the straight lines. I couldn't make a straight line. I couldn't have made a good architect!

Q: Hoyningen-Huene did seem to be a blend.

A: Yes, he had to copy, and then he went off on his own, also.

Q: But he seemed to combine the straight line—

A: —with charm, and elegance.

Q: Did you each work in the same studio?

A: Yes. But then, when George was still on *Vogue,* he did all the collections and all the important pictures. Then he was sent away to Hollywood or whatever, and I had to do whatever had to be done. When he left, then immediately I had to do a collection and I had never done a collection before in my life. All the dressmakers of Paris bring out their new clothes. March, August—twice a year. And the editors go around and pick the best dresses from each dressmaker's collection.

Q: You mentioned Hoyningen-Huene being sent off to Hollywood. Would that have been to make portraits for *Vanity Fair?*

A: Both *Vanity Fair* and *Vogue,* to make portraits. When he left *Vogue,* he went to *Harper's Bazaar,* and then he wanted to do only the collections in Paris for *Harper's,* and the rest of time he just spent anywhere in the world he felt like. Whereas I had to work on the collections in Paris, then take the boat and work in America—two months or so—and then go back to Paris, a couple of months or so, and back and forth, back and forth.

Q: How long did that last before you moved to the United States permanently?

A: Nineteen thirty-nine. The last boat. The *Normandie.* Just the day before the war was declared I arrived here.

The Work of Art in the Age of Mechanical Reproduction (1936), * an excerpt

Walter Benjamin

Walter Benjamin (1892–1940) was a Marxist literary critic. He associated with Thomas Adorno and Max Horkheim at the Frankfurt Institute for Social Research (Erich Fromm and Herbert Marcuse were sympathizers of that circle). Best known for his writings on Kafka and Baudelaire, his chief essay on the visual arts is "The Work of Art in the Age of Mechanical Reproduction." Written in 1936, the essay is highly regarded by American New Left critics.

Benjamin is interested in the social and political meanings of photography. In this excerpt and in his lesser-known Short History of Photography *(1931), he defines photography as a mass media that can radically alter the function of art. His thesis is that photography destroys an art object's unique existence or "aura," thus hastening art's politicalization. Influenced by Surrealism, he also suggests the future of photography as an art in its own right. Benjamin appreciates photography's potential to refresh and challenge the viewer's normal perceptions. Note that he is an early admirer of Atget's ability to confound conventional seeing.*

Benjamin's essays are translated into English and collected in Illuminations, *edited with an introduction by Hannah Arendt.*

Our fine arts were developed, their types and uses were established, in times very different from the present, by men whose power of action upon things was insignificant in comparison with ours. But the amazing growth of our techniques, the adaptability and precision they have attained, the ideas and habits they are creating, make it a certainty that profound changes are impending in the ancient craft of the Beautiful. In all the arts there is a physical component which can no longer be considered or treated as it used to be, which cannot remain unaffected by our modern knowledge and power. For the last twenty years neither matter nor space nor time has been what it was from

* Reprinted from *Illuminations* by Walter Benjamin, pts. I–VII. English translation by Harry Zohn (New York: Harcourt Brace Jovanovich, 1968), pp. 217–228.

time immemorial. We must expect great innovations to transform the entire technique of the arts, thereby affecting artistic invention itself and perhaps even bringing about an amazing change in our very notion of art.[1]

—PAUL VALÉRY, Pièces sur L'Art,
"La Conquète de l'ubiquité," Paris

PREFACE

When Marx undertook his critique of the capitalistic mode of production, this mode was in its infancy. Marx directed his efforts in such a way as to give them prognostic value. He went back to the basic conditions underlying capitalistic production and through his presentation showed what could be expected of capitalism in the future. The result was that one could expect it not only to exploit the proletariat with increasing intensity, but ultimately to create conditions which would make it possible to abolish capitalism itself.

The transformation of the superstructure, which takes place far more slowly than that of the substructure, has taken more than half a century to manifest in all areas of culture the change in the conditions of production. Only today can it be indicated what form this has taken. Certain prognostic requirements should be met by these statements. However, theses about the art of the proletariat after its assumption of power or about the art of a classless society would have less bearing on these demands than theses about the developmental tendencies of art under present conditions of production. Their dialectic is no less noticeable in the superstructure than in the economy. It would therefore be wrong to underestimate the value of such theses as a weapon. They brush aside a number of outmoded concepts, such as creativity and genius, eternal value and mystery—concepts whose uncontrolled (and at present almost uncontrollable) application would lead to a processing of data in the Fascist sense. The concepts which are introduced into the theory of art in what follows differ from the more familiar terms in that they are completely useless for the purposes of Fascism. They are, on the other hand, useful for the formulation of revolutionary demands in the politics of art.

[1] *Quoted* from Paul Valéry, *Aesthetics,* "The Conquest of Ubiquity," trans. Ralph Manheim (New York: Pantheon Books, Bollingen Series, 1964), p. 225.

I

In principle a work of art has always been reproducible. Man-made artifacts could always be imitated by men. Replicas were made by pupils in practice of their craft, by masters for diffusing their works, and, finally, by third parties in the pursuit of gain. Mechanical reproduction of a work of art, however, represents something new. Historically, it advanced intermittently and in leaps at long intervals, but with accelerated intensity. The Greeks knew only two procedures of technically reproducing works of art: founding and stamping. Bronzes, terra-cottas, and coins were the only artworks which they could produce in quantity. All others were unique and could not be mechanically reproduced. With the woodcut graphic art became mechanically reproducible for the first time, long before script became reproducible by print. The enormous changes which printing, the mechanical reproduction of writing, has brought about in literature are a familiar story. However, within the phenomenon which we are here examining from the perspective of world history, print is merely a special, though particularly important, case. During the Middle Ages engraving and etching were added to the woodcut; at the beginning of the nineteenth century lithography made its appearance.

With lithography the technique of reproduction reached an essentially new stage. This much more direct process was distinguished by the tracing of the design on a stone rather than its incision on a block of wood or its etching on a copperplate and permitted graphic art for the first time to put its products on the market, not only in large numbers as hitherto, but also in daily changing forms. Lithography enabled graphic art to illustrate everyday life, and it began to keep pace with printing. But only a few decades after its invention, lithography was surpassed by photography. For the first time in the process of pictorial reproduction, photography freed the hand of the most important artistic functions, which henceforth developed only upon the eye looking into a lens. Since the eye perceives more swiftly than the hand can draw, the process of pictorial reproduction was accelerated so enormously that it could keep pace with speech. A film operator shooting a scene in the studio captures the images at the speed of an actor's speech. Just as lithography virtually implied the illustrated newspaper, so did photography foreshadow the sound film. The technical reproduction of sound was tackled at the end of the last century. These convergent endeavors made predictable a situation which Paul Valéry pointed up in this sentence: "Just as water, gas, and electric-

ity are brought into our houses from far off to satisfy our needs in response to a minimal effort, so we shall be supplied with visual or auditory images, which will appear and disappear at a simple movement of the hand, hardly more than a sign" (*op. cit.,* p. 226). Around 1900 technical reproduction had reached a standard that not only permitted it to reproduce all transmitted works of art and thus to cause the most profound change in their impact upon the public; it also had captured a place of its own among the artistic processes. For the study of this standard nothing is more revealing than the nature of the repercussions that these two different manifestations—the reproduction of works of art and the art of the film—have had on art in its traditional form.

II

Even the most perfect reproduction of a work of art is lacking in one element: its presence in time and space, its unique existence at the place where it happens to be. This unique existence of the work of art determined the history to which it was subject throughout the time of its existence. This includes the changes which it may have suffered in physical condition over the years as well as the various changes in its ownership.[2] The traces of the first can be revealed only by chemical or physical analyses which it is impossible to perform on a reproduction; changes of ownership are subject to a tradition which must be traced from the situation of the original.

The presence of the original is the prerequisite to the concept of authenticity. Chemical analyses of the patina of a bronze can help to establish this, as does the proof that a given manuscript of the Middle Ages stems from an archive of the fifteenth century. The whole sphere of authenticity is outside technical—and, of course, not only technical—reproducibility.[3] Confronted with its manual reproduction, which was usually

[2] Of course, the history of a work of art encompasses more than this. The history of the "Mona Lisa," for instance, encompasses the kind and number of its copies made in the seventeenth, eighteenth, and nineteenth centuries.

[3] Precisely because authenticity is not reproducible, the intensive penetration of certain (mechanical) processes of reproduction was instrumental in differentiating and grading authenticity. To develop such differentiations was an important function of the trade in works of art. The invention of the woodcut may be said to have struck at the root of the quality of authenticity even before its late flowering. To be sure, at the time of its origin a medieval picture of the Madonna could not yet be said to be "authentic." It became "authentic" only during the succeeding centuries and perhaps most strikingly so during the last one.

branded as a forgery, the original preserved all its authority; not so vis-à-vis technical reproduction. The reason is twofold. First, process reproduction is more independent of the original than manual reproduction. For example, in photography, process reproduction can bring out those aspects of the original that are unattainable to the naked eye yet accessible to the lens, which is adjustable and chooses its angle at will. And photographic reproduction, with the aid of certain processes, such as enlargement or slow motion, can capture images which escape natural vision. Secondly, technical reproduction can put the copy of the original into situations which would be out of reach for the original itself. Above all, it enables the original to meet the beholder halfway, be it in the form of a photograph or a phonograph record. The cathedral leaves its locale to be received in the studio of a lover of art; the choral production, performed in an auditorium or in the open air, resounds in the drawing room.

The situations into which the product of mechanical reproduction can be brought may not touch the actual work of art, yet the quality of its presence is always depreciated. This holds not only for the artwork but also, for instance, for a landscape which passes in review before the spectator in a movie. In the case of the art object, a most sensitive nucleus—namely, its authenticity—is interfered with, whereas no natural object is vulnerable on that score. The authenticity of a thing is the essence of all that is transmissible from its beginning, ranging from its substantive duration to its testimony to the history which it has experienced. Since the historical testimony rests on the authenticity, the former, too, is jeopardized by reproduction when substantive duration ceases to matter. And what is really jeopardized when the historical testimony is affected is the authority of the object.[4]

One might subsume the eliminated element in the term *aura* and go on to say: that which withers in the age of mechanical reproduction is the aura of the work of art. This is a symptomatic process whose significance points beyond the realm of art. One might generalize by saying: the tech-

[4] The poorest provincial staging of *Faust* is superior to a Faust film in that, ideally, it competes with the first performance at Weimar. Before the screen it is unprofitable to remember traditional contents which might come to mind before the stage—for instance, that Goethe's friend Johann Heinrich Merck is hidden in Mephisto, and the like.

nique of reproduction detaches the reproduced object from the domain of tradition. By making many reproductions, it substitutes a plurality of copies for a unique existence. And in permitting the reproduction to meet the beholder or listener in his own particular situation, it reactivates the object reproduced. These two processes lead to a tremendous shattering of tradition which is the obverse of the contemporary crisis and renewal of mankind. Both processes are intimately connected with the contemporary mass movements. Their most powerful agent is the film. Its social significance, particularly in its most positive form, is inconceivable without its destructive, cathartic aspect, that is, the liquidation of the traditional value of the cultural heritage. This phenomenon is most palpable in the great historical films. It extends to ever new positions. In 1927 Abel Gance exclaimed enthusiastically: "Shakespeare, Rembrandt, Beethoven will make films . . . all legends, all mythologies and all myths, all founders of religion, and the very religions . . . await their exposed resurrection, and the heroes crowd each other at the gate."[5] Presumably without intending it, he issued an invitation to a far-reaching liquidation.

III

During long periods of history, the mode of human sense perception changes with humanity's entire mode of existence. The manner in which human sense perception is organized, the medium in which it is accomplished, is determined not only by nature but by historical circumstances as well. The fifth century, with its great shifts of population, saw the birth of the late Roman art industry and the Vienna Genesis, and there developed not only an art different from that of antiquity but also a new kind of perception. The scholars of the Viennese school, Riegl and Wickhoff, who resisted the weight of classical tradition under which these later art forms had been buried, were the first to draw conclusions from them concerning the organization of perception at the time. However far-reaching their insight, these scholars limited themselves to showing the significant, formal hallmark which characterized perception in late Roman times. They did not attempt—and, perhaps, saw no way—to show the social transformations expressed by these changes of perception. The conditions for an analogous insight are more favorable in the pres-

[5] Abel Gance, "Le Temps de l'image est venus," *L'Art cinématographique,* vol. 2 (Paris, 1927), pp. 94 f.

ent. And if changes in the medium of contemporary perception can be comprehended as decay of the aura, it is possible to show its social causes.

The concept of aura which was proposed above with reference to historical objects may usefully be illustrated with reference to the aura of natural ones. We define the aura of the latter as the unique phenomenon of a distance, however close it may be. If, while resting on a summer afternoon, you follow with your eyes a mountain range on the horizon or a branch which casts its shadow over you, you experience the aura of those mountains, of that branch. This image makes it easy to comprehend the social bases of the contemporary decay of the aura. It rests on two circumstances, both of which are related to the increasing significance of the masses in contemporary life. Namely, the desire of contemporary masses to bring things "closer" spatially and humanly, which is just as ardent as their bent toward overcoming the uniqueness of every reality by accepting its reproduction.[6] Every day the urge grows stronger to get hold of an object at very close range by way of its likeness, its reproduction. Unmistakably, reproduction as offered by picture magazines and newsreels differs from the image seen by the unarmed eye. Uniqueness and permanence are as closely linked in the latter as are transitoriness and reproducibility in the former. To pry an object from its shell, to destroy its aura, is the mark of a perception whose "sense of the universal equality of things" has increased to such a degree that it extracts it even from a unique object by means of reproduction. Thus is manifested in the field of perception what in the theoretical sphere is noticeable in the increasing importance of statistics. The adjustment of reality to the masses and of the masses to reality is a process of unlimited scope, as much for thinking as for perception.

IV

The uniqueness of a work of art is inseparable from its being embedded in the fabric of tradition. This tradition itself is thoroughly alive and extremely changeable. An ancient statue of Venus, for example, stood in

[6] To satisfy the human interest of the masses may mean to have one's social function removed from the field of vision. Nothing guarantees that a portraitist of today, when painting a famous surgeon at the breakfast table in the midst of his family, depicts his social function more precisely than a painter of the seventeenth century who portrayed his medical doctors as representing this profession, like Rembrandt in his *Anatomy Lesson*.

a different traditional context with the Greeks, who made it an object of veneration, than with the clerics of the Middle Ages, who viewed it as an ominous idol. Both of them, however, were equally confronted with its uniqueness, that is, its aura. Originally the contextual integration of art in tradition found its expression in the cult. We know that the earliest artworks originated in the service of a ritual—first the magical, then the religious kind. It is significant that the existence of the work of art with reference to its aura is never entirely separated from its ritual function.[7] In other words, the unique value of the "authentic" work of art has its basis in ritual, the location of its original use value. This ritualistic basis, however remote, is still recognizable as secularized ritual even in the most profane forms of the cult of beauty.[8] The secular cult of beauty, developed during the Renaissance and prevailing for three centuries, clearly showed that ritualistic basis in its decline and the first deep crisis which befell it. With the advent of the first truly revolutionary means of reproduction, photography, simultaneously with the rise of socialism, art sensed the approaching crisis which has become evident a century later. At the time, art reacted with the doctrine of *l'art pour l'art,* that is, with a theology of art. This gave rise to what might be called a negative theology in the form of the idea of "pure" art, which not only denied any social function of art but also any categorizing by subject matter. (In poetry, Mallarmé was the first to take this position.)

An analysis of art in the age of mechanical reproduction must do jus-

[7] The definition of the aura as a "unique phenomenon of a distance however close it may be" represents nothing but the formulation of the cult value of the work of art in categories of space and time perception. Distance is the opposite of closeness. The essentially distant object is the unapproachable one. Unapproachability is indeed a major quality of the cult image. True to its nature, it remains "distant, however close it may be." The closeness which one may gain from its subject matter does not impair the distance which it retains in its appearance.

[8] To the extent to which the cult value of the painting is secularized, the ideas of its fundamental uniqueness lose distinctness. In the imagination of the beholder the uniqueness of the phenomena which hold sway in the cult image is more and more displaced by the empirical uniqueness of the creator or of his creative achievement. To be sure, never completely so; the concept of authenticity always transcends mere genuineness. (This is particularly apparent in the collector who always retains some traces of the fetishist and who, by owning the work of art, shares in its ritual power.) Nevertheless, the function of the concept of authenticity remains determinate in the evaluation of art; with the secularization of art, authenticity displaces the cult value of the work.

tice to these relationships, for they lead us to an all-important insight: for the first time in world history, mechanical reproduction emancipates the work of art from its parasitical dependence on ritual. To an ever greater degree the work of art reproduced becomes the work of art designed for reproducibility.[9] From a photographic negative, for example, one can make any number of prints; to ask for the "authentic" print makes no sense. But the instant the criterion of authenticity ceases to be applicable to artistic production, the total function of art is reversed. Instead of being based on ritual, it begins to be based on another practice—politics.

V

Works of art are received and valued on different planes. Two polar types stand out: with one, the accent is on the cult value; with the other, on the exhibition value of the work.[10] Artistic production begins with cer-

[9] In the case of films, mechanical reproduction is not, as with literature and painting, an external condition for mass distribution. Mechanical reproduction is inherent in the very technique of film production. This technique not only permits in the most direct way but virtually causes mass distribution. It enforces distribution because the production of a film is so expensive that an individual who, for instance, might afford to buy a painting no longer can afford to buy a film. In 1927 it was calculated that a major film, in order to pay its way, had to reach an audience of nine million. With the sound film, to be sure, a setback in its international distribution occurred at first: audiences became limited by language barriers. This coincided with the Fascist emphasis on national interests. It is more important to focus on this connection with Fascism than on this setback, which was soon minimized by synchronization. The simultaneity of both phenomena is attributable to the Depression. The same disturbances which, on a larger scale, led to an attempt to maintain the existing property structure by sheer force led the endangered film capital to speed up the development of the sound film. The introduction of the sound film brought about a temporary relief, not only because it again brought the masses into the theatres but also because it merged new capital from the electrical industry with that of the film industry. Thus, viewed from the outside, the sound film promoted national interests, but seen from the inside it helped to internationalize film production even more than previously.

[10] This polarity cannot come into its own in the aesthetics of Idealism. Its idea of beauty comprises these polar opposites without differentiating between them and consequently excludes their polarity. Yet in Hegel this polarity announces itself as clearly as possible within the limits of Idealism. We quote from his *Philosophy of History:* "Images were known of old. Piety at an early time required them for worship, but it could do without *beautiful* images. These might even be disturbing. In every beautiful painting there is also something nonspiritual, merely external, but its spirit speaks to man through its beauty. Worshipping, conversely, is concerned with the work as an object, for it is but a spiritless stupor of the soul. . . . Fine art has arisen . . . in the church . . . , although it has already gone beyond its principle as art." Likewise, the following passage from *The Philosophy of Fine Art* indicates that Hegel sensed a prob-

emonial objects destined to serve in a cult. One may assume that what mattered was their existence, not their being on view. The elk portrayed by the man of the Stone Age on the walls of his cave was an instrument of magic. He did expose it to his fellowmen, but in the main it was meant for the spirits. Today the cult value would seem to demand that the work of art remain hidden. Certain statues of gods are accessible only to the priest in the cella; certain Madonnas remain covered nearly all year round; certain sculptures on medieval cathedrals are invisible to the spectator on ground level. With the emancipation of the various art practices from ritual go increasing opportunities for the exhibition of their products. It is easier to exhibit a portrait bust that can be sent here and there than to exhibit the statue of a divinity that has its fixed place in the interior of a temple. The same holds for the painting as against the mosaic or fresco that preceded it. And even though the public presentability of a mass originally may have been just as great as that of a symphony, the latter originated at the moment when its public presentability promised to surpass that of the mass.

lem here. "We are beyond the stage of reverence for works of art as divine and objects deserving our worship. The impression they produce is one of a more reflective kind, and the emotions they arouse require a higher test . . ." (G. W. F. Hegel, *The Philosophy of Fine Art,* trans., with notes, by F. P. B. Osmaston, London, 1920, vol. 1, p. 12). The transition from the first kind of artistic reception to the second characterizes the history of artistic reception in general. Apart from that, a certain oscillation between these two polar modes of reception can be demonstrated for each work of art. Take the Sistine Madonna. Since Hubert Grimme's research it has been known that the Madonna originally was painted for the purpose of exhibition. Grimme's research was inspired by the question: What is the purpose of the molding in the foreground of the painting which the two cupids lean upon? How, Grimme asked further, did Raphael come to furnish the sky with two draperies? Research proved that the Madonna had been commissioned for the public lying-in-state of Pope Sixtus. The popes lay in state in a certain side chapel of St. Peter's. On that occasion Raphael's picture had been fastened in a nichelike background of the chapel, supported by the coffin. In this picture Raphael portrays the Madonna approaching the papal coffin in clouds from the background of the niche, which was demarcated by green drapes. At the obsequies of Sixtus a preeminent exhibition value of Raphael's picture was taken advantage of. Sometime later it was placed on the high altar in the church of the Black Friars at Piacenza. The reason for this exile is to be found in the Roman rites, which forbid the use of paintings exhibited at obsequies as cult objects on the high altar. This regulation devalued Raphael's picture to some degree. In order to obtain an adequate price nevertheless, the Papal See resolved to add to the bargain the tacit toleration of the picture above the high altar. To avoid attention the picture was given to the monks of the far-off provincial town.

With the different methods of technical reproduction of a work of art, its fitness for exhibition increased to such an extent that the quantitative shift between its two poles turned into a qualitative transformation of its nature. This is comparable to the situation of the work of art in prehistoric times when, by the absolute emphasis on its cult value, it was, first and foremost, an instrument of magic. Only later did it come to be recognized as a work of art. In the same way today, by the absolute emphasis on its exhibition value, the work of art becomes a creation with entirely new functions, among which the one we are conscious of, the artistic function, later may be recognized as incidental.[11] This much is certain: today photography and the film are the most serviceable exemplifications of this new function.

VI

In photography, exhibition value begins to displace cult value all along the line. But cult value does not give way without resistance. It retires into an ultimate retrenchment: the human countenance. It is no accident that the portrait was the focal point of early photography. The cult of remembrance of loved ones, absent or dead, offers a last refuge for the cult value of the picture. For the last time the aura emanates from the early photographs in the fleeting expression of a human face. This is what constitutes their melancholy, incomparable beauty. But as man withdraws from the photographic image, the exhibition value for the first time shows its superiority to the ritual value. To have pinpointed this new stage constitutes the incomparable significance of Atget, who, around 1900, took photographs of deserted Paris streets. It has quite justly been said of him that he photographed them like scenes of crime. The scene of a crime, too, is deserted; it is photographed for the purpose of establishing evidence. With Atget, photographs become standard evidence for historical occurrences, and acquire a hidden political significance. They demand a spe-

[11] Bertolt Brecht, on a different level, engaged in analogous reflections: "If the concept of 'work of art' can no longer be applied to the thing that emerges once the work is transformed into a commodity, we have to eliminate this concept with cautious care but without fear, lest we liquidate the function of the very thing as well. For it has to go through this phase without mental reservation, and not as noncommittal deviation from the straight path; rather, what happens here with the work of art will change it fundamentally and erase its past to such an extent that should the old concept be taken up again—and it will, why not?—it will no longer stir any memory of the thing it once designated."

cific kind of approach; free-floating contemplation is not appropriate to them. They stir the viewer; he feels challenged by them in a new way. At the same time picture magazines begin to put up signposts for him, right ones or wrong ones, no matter. For the first time, captions have become obligatory. And it is clear that they have an altogether different character from the title of a painting. The directives which the captions give to those looking at pictures in illustrated magazines soon become even more explicit and more imperative in the film where the meaning of each single picture appears to be prescribed by the sequence of all preceding ones.

VII

The nineteenth-century dispute as to the artistic value of painting versus photography today seems devious and confused. This does not diminish its importance, however; if anything, it underlines it. The dispute was in fact the symptom of a historical transformation the universal impact of which was not realized by either of the rivals. When the age of mechanical reproduction separated art from its basis in cult, the semblance of its autonomy disappeared forever. The resulting change in the function of art transcended the perspective of the century; for a long time it even escaped that of the twentieth century, which experienced the development of the film.

Earlier much futile thought had been devoted to the question of whether photography is an art. The primary question—whether the very invention of photography had not transformed the entire nature of art— was not raised. Soon the film theoreticians asked the same ill-considered question with regard to the film. But the difficulties which photography caused traditional aesthetics were mere child's play as compared to those raised by the film. Whence the insensitive and forced character of early theories of the film. Abel Gance, for instance, compares the film with hieroglyphs: "Here, by a remarkable regression, we have come back to the level of expression of the Egyptians. . . . Pictorial language has not yet matured because our eyes have not yet adjusted to it. There is as yet insufficient respect for, insufficient cult of, what it expresses."[12] Or, in the words of Séverin-Mars: "What art has been granted a dream more poetical and more real at the same time! Approached in this fashion the film might represent an incomparable means of expression. Only the most

[12] Abel Gance, pp. 100–101.

high-minded persons, in the most perfect and mysterious moments of their lives, should be allowed to enter its ambience."[13] Alexandre Arnoux concludes his fantasy about the silent film with the question: "Do not all the bold descriptions we have given amount to the definition of prayer?"[14] It is instructive to note how their desire to class the film among the "arts" forces these theoreticians to read ritual elements into it—with a striking lack of discretion. Yet when these speculations were published, films like *L'Opinion publique* and *The Gold Rush* had already appeared. This, however, did not keep Abel Gance from adducing hieroglyphs for purposes of comparison, nor Séverin-Mars from speaking of the film as one might speak of paintings by Fra Angelico. Characteristically, even today ultrareactionary authors give the film a similar contextual significance—if not an outright sacred one, then at least a supernatural one. Commenting on Max Reinhardt's film version of *A Midsummer Night's Dream*, Werfel states that undoubtedly it was the sterile copying of the exterior world with its streets, interiors, railroad stations, restaurants, motorcars, and beaches which until now had obstructed the elevation of the film to the realm of art. "The film has not yet realized its true meaning, its real possibilities . . . these consist in its unique faculty to express by natural means and with incomparable persuasiveness all that is fairylike, marvelous, supernatural."[15]

[13] Séverin-Mars, quoted by Abel Gance, p. 100.
[14] Alexandre Arnoux, *Cinéma pris* (1929), p. 28.
[15] Franz Werfel, "Ein Sommernachtstraum, ein Film von Shakespeare und Reinhardt," *Neue Wiener Journal,* cited in *Lu,* November 15, 1935.

PENINAH R. PETRUCK was born in New York, in 1951. She received an A.B. in art history from Barnard College in 1971; an A.M. in modern art and criticism from the Institute of Fine Arts at New York University in 1973; and a Ph.D. from the Institute of Fine Arts in 1979.

Ms. Petruck has taught art history at The New School for Social Research and Queens College in New York, and a course in twentieth-century photography at Ramapo College in New Jersey. Her curatorial experience includes working as a researcher for the exhibition "The Painter's America" (1974) and as an assistant in the Prints and Drawings Department at the Whitney Museum of American Art and researching the exhibition "American Impressionism" (1972–1973) for the National Gallery of Art. She is now employed as a Program Officer for Visual Arts Services of the New York State Council on the Arts.